Essays on Piero della Francesca, Joan Miró, Francisco de Goya, Gerard Houckgeest, Hans Holbein, Paul Cézanne, Andrew Wyeth, Michelangelo de Caravaggio, El Greco, Rembrandt van Rijn, Jean Baptiste Chardin, Balthus de Rola, Pierre Joseph Redouté, Henri Rousseau, Winslow Homer, James Whistler, Gregorio Valdes, Henri Matisse, Giorgio Morandi, Paolo Uccello, José de Creeft, Georges Braque, Edward Hopper, Claude Monet, Jane Freilicher, Wayne Thiebaud, Jacopo Tintoretto, Alfeo Faggi, David Smith, Pablo Picasso, J.M.W. Turner, Romare Bearden

Essays by Italo Calvino, Zbigniew Herbert, Ford
Madox Ford, Jean-Paul Sartre, Aldous Huxley,
Stephen Koch, Jean Genet, Susan Sontag, Marcel
Proust, André Malraux, Robert Pinsky, Katherine Anne
Porter, Kenneth Rexroth, Guy Davenport, Stanley
Plumly, Joyce Carol Oates, Rainer Maria Rilke,
William S. Wilson, D. H. Lawrence, Michel Butor,
Gertrude Stein, Norman Mailer, Francis Ponge,
Eugenio Montale, Mark Strand, Eudora Welty,
Charles Wright, Ernest Hemingway, Elizabeth Bishop,
Marianne Moore, John Updike, Frank O'Hara, Albert
Camus, Ralph Ellison, Leonard Michaels, John
Ashbery, Cyril Connolly, Randall Jarrell, Octavio Paz,
Willa Cather, and José Ortega y Gasset

Edited by Daniel Halpern

WRITERS
ON
ARTISTS

North Point Press · San Francisco

North Point Press
850 Talbot Avenue
Berkeley, California
94706

CONTENTS

Preface

The notion of gathering a group of essays by writers on artists occurred to me in May of 1972, when I had the considerably good fortune of accompanying Elizabeth Bishop through the Unicorn Tapestry exhibit at the Metropolitan Museum of Art in New York City. We moved from tapestry to tapestry, and at each Ms. Bishop stopped to take in the panorama before her; pointing here and there, she commented on a detail that caught her eye, the juxtaposition of figures in a landscape, or the posture of a unicorn. For me, it was one of the rare occasions in which the importance of an experience is grasped at the moment of its occurrence. It was suddenly clear to me that a poet, a writer, if he or she is good, has a unique ability to describe the visual. Through Ms. Bishop's words and relentless eye, I have continued to see the unicorn and its territory in a way that has remained brightly alive these past sixteen years.

After reading through the essays that follow, it will become clear that many important writers have spent a significant part of their non-writing time thinking about painting and sculpture. Also evident are the variety of ways in which writers feel an affinity to the work of artists. Could it be that in some rather intriguing ways the bonds between writers and artists are as strong, and often stronger, than those between fiction writers and poets?

This volume is a necessarily small—and perhaps idiosyncratic—selection, but it will at least suggest the extent of the ongoing relationship between writer and artist. Some of these pieces appeared originally in a special issue of essays on artists in the literary magazine *Antaeus*. I have included only essays written by twentieth-century writers, and only those essays that bring to bear the writer's distinctive

mode of engagement with a particular artist's work or life, or art in a more general sense—an approach like Elizabeth Bishop's, which strikes me as less *critical* in nature than celebratory, alert to the attendant impulses behind a work of art. I don't mean to imply that only writers can write well about art; however, it does seem that certain aspects of art are underscored by writers who come to their own craft with a very different set of tools than artists. Although writers and artists may work similar quarries, they dig for different artifacts.

What these essays have in common is what writers who understand their art have to offer readers of their fiction and poetry—the power to evoke through language the world of the senses—the visual world of the artist.

Daniel Halpern

Acknowledgments

Every effort has been made to trace the ownership of copyrighted material and to make full acknowledgment of its use. If errors or omissions have occurred, they will be corrected in subsequent editions upon notification in writing to the publisher. The editor wishes to thank and acknowledge the following sources and individuals for the essays in this volume:

The Ecco Press, New York: "The Birds of Paolo Uccello" by Italo Calvino, translated by Patrick Creagh, from *Antaeus 54*; Spring 1985 issue.

Carcanet Press, London: "Piero della Francesca" from *Barbarzyńca w ogrodzie* by Zbigniew Herbert. Copyright © 1985, 1962 by Zbigniew Herbert.

The Ecco Press, New York: "Hans Holbein the Younger" by Ford Madox Ford, from *Antaeus 54*; Spring 1985 issue.

Pantheon Books, a Division of Random House, Inc., New York: "Tintoretto: St. George and the Dragon" from *Between Existentialism and Marxism* by Jean-Paul Sartre, translated by John Mathews. English translation copyright © 1974 by New Left Books.

Harper & Row, Publishers, Inc., New York: "Variations on El Greco" from *Themes and Variations* by Aldous Huxley. Copyright © 1943, 1949, 1950 by Aldous Huxley.

Stephen Koch: "Caravaggio and the Unseen" from *Antaeus 54*; Spring 1985 issue.

The Ecco Press, New York: "Something Which Seemed to Resemble Decay" by Jean Genet, translated by Bernard Frechtman, from *Antaeus 54*; Spring 1985 issue.

"Beauty is not so plentiful that we can afford to object to stepping back a dozen paces to catch it."

Willa Cather

Writers on Artists

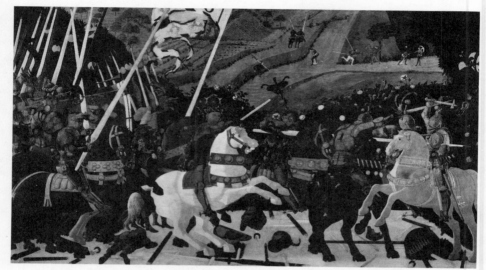

Paolo Uccello (c. 1397–1475): *Niccolò Muruzi da Tolentino at the Battle of San Romano*, 71½″ × 126″. National Gallery, London.

ITALO CALVINO

The Birds of Paolo Uccello

We see no birds in the paintings of Paolo Uccello. In all his teeming world the skies are empty. One looks up in hope, and sees no feathered creatures in flight or perched on the branches of trees. Lowering one's eyes onto a tranquil landscape peopled by hermits, one can discern, at the most, a pair of wading birds and three swans.

What has become of the birds that according to Vasari once studded his canvases, so much so as to earn him his nickname of Uccello? Who has scared them away? Most certainly it is the soldiers, who render the highways of the air impassable with their spears, and with the clash of weaponry silence trillings and chirrupings.

Fled from the colored surfaces, the birds are hiding or fluttering invisibly outside the borders of the paintings. They are waiting for the right moment to make a comeback and occupy the canvas. Following the Vasari tradition, Giovanni Pascoli in a narrative poem and Marcel Schwob in one of his *Vies imaginaires* have depicted the aged painter surrounded by birds born of his brush. But what we ourselves can testify to is exactly the opposite. In Paolo's most famous surviving works what catches the attention is the absence of birds, an absence that lies heavy on the air, alarming, menacing and ominous.

The most frequently depicted scenes of Paolo Uccello that are still to be seen today presuppose others, which he may have painted but which have since been lost: scenes that precede the above—a world all trillings and peckings and beating wings, taken by surprise and scattered to the winds by the invasion of the warriors—

and other scenes that follow them: the counteroffensive of the birds, who swoop down in serried flocks and perch on helmets, shoulder plates and elbow guards.

Are crows and vultures there at the end of the battle? Not at all. It has already been observed that in all Paolo Uccello's battle scenes we see only one dead man on the ground; and even he might only have fainted. Every man on the field is still alive when the sky darkens and the air is troubled by a great beating of wings. The horses become restive, uttering neighs of terror.

The battle between the two armies is transformed into a battle against the birds, the swords raise eddies of feathers, the lances are shaken to rid them of grasping talons, while the blows of beaks rain down on shields. To put a horse out of action is the work of a moment: a magpie steals its glittering studded blinkers, a kestrel rips off its girth, ringdoves remove the saddlecloth. So you find yourself on foot, with a crow's wings wedged twixt sallet and chin strap, a capercaillie pecking off your throat-piece, a hoopoe perched on your crest. Your mouth fills up with jay's feathers, and by now you no longer know how much of you is armor, is man, is bird.

You holler for help. Here comes another warrior, no matter whether friend or foe: we are all allies now against the birds. The warrior lifts his vizor and out pop the beak and two round eyes of an owl. You cast around for a shield to protect yourself and find yourself grasping a wing with feathers spread. A sword is raised to protect you—but no, it is wielded by the talon of a bird of prey, and down it crashes on you.

Pointed or fan-shaped tails sprout under your flanchards, your greaves encompass slender shanks, while breastplates put forth feathers and the trumpets emit shrill bird cries, twitterings and chirrupings. There follows a chain-reaction metamorphosis of man into bird and bird into man. Or rather, on closer consideration, and seeing that men have already transformed themselves into crustaceans by donning their armor, it is between crustaceans and birds that the metamorphosis takes place; an exchange in which you do not know where—and if—man still exists.

1985

Translated from the Italian by Patrick Creagh

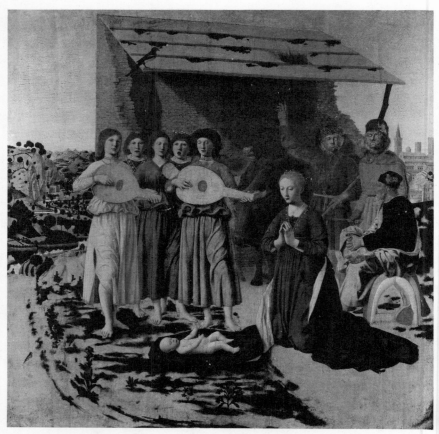

Piero della Francesca (active 1439–1492): *The Nativity*, 49″ × 48¼″.
National Gallery, London.

ZBIGNIEW HERBERT

Piero della Francesca

(For Jarosław Iwaszkiewicz)

Friends say: well, you've been there and seen a lot; you liked Duccio, the Dorian columns, the stained glass at Chartres and the Lascaux bulls—but tell us what you've chosen for yourself; who is the painter closest to your heart, the one you'd never exchange? A reasonable question since every love, if true, should efface the previous one, should enter, overwhelm and demand exclusiveness. So I pause and reply: Piero della Francesca.

The first meeting: in London at the National Gallery. A cloudy day. A choking fog descends upon the city. Though I did not intend to visit sights, I was forced to find shelter against the stifling damp. The sensation came unexpectedly. From the first room it was apparent: the collection surpasses the Louvre. Never had I seen so many masterpieces at once. Perhaps this is not the best way to become acquainted with art. A concert programme should contain, apart from Scarlatti, Bach, Mozart, a Noskowski—for instruction rather than out of perversity.

I stayed longest with a painter whose name I had only known from books. The painting was *The Nativity*, an unusual composition full of light and serious joy. The sensation was similar to my first encounter with Van Eyck. It is difficult to define such an aesthetic shock. The picture roots you to one spot. You cannot step back or move closer or (as with modern painting) smell the paint and examine the facture treatment.

The background of *The Nativity* is a humble shed, or rather a crumbling brick

wall with a light, slanted roof. The Christchild rests on a grass-patch worn like an old rug. Behind the child stands a choir of five angels, strong as columns, who face the spectator with their bare feet and earthly appearance. Their peasant faces contrast with the luminous countenance of the Madonna (as in Baldovinetti) who kneels to the right in silent adoration. The fragile candles of her beautiful arms are alight. Beyond we see the massive torso of a bull, a donkey, two "Flemish" shepherds and St. Joseph turning his profile to the viewer. At the sides are two landscapes like windows through which sparkling light pours. Despite some damage, the colours are as clear and resonant as stained glass. Painted in the last years of the artist's career, it is "Piero's evening prayer to childhood and dawn."

On the opposite wall *The Baptism of Christ*. One of the first surviving canvases of Piero. It has the same solemn architectural serenity as *The Nativity*, though painted earlier. The solid flesh of the figures contrasts with the light, harmonious landscape. There is a finality in the leaves cast like cards upon the sky—a moment becomes eternity.

Goethe's wise dictum: *"Wer den Dichter will verstehen, muss in Dichters Lande gehen."* As the fruits of light, paintings should be viewed under the artist's native sun. Sassetta seems out of place even in the most attractive American museums. Hence the pilgrimage to Piero della Francesca. Since my means were modest, I surrendered to chance and adventure. The story does not follow a chronology so relished by historians.

Perugia. This sombre town dwells in the green-golden Umbrian landscape. A most dismal town, imprisoned in dark marble. Hung on a high rock above the Tiber, it has been compared to a giant's hand—changing during its cruel and violent history into an Etruscan, Roman and Gothic town. It is symbolized by the Palazzo dei Priori, a powerful edifice with metal ornaments and a wall bent like molten iron. A fantastic labyrinth of streets, stairs, passages and dungeons—an architectural replica of the inhabitants' anxious spirit—lies behind the square which was once the site of the ruined Palazzo Baglioni but is now occupied by elegant hotels.

"I Perugini sono angeli o demoni," said Aretino. The town's coat of arms: a griffin with bared mouth and tenacious talons. At the height of its power, the Perugian Republic ruled over Umbria defended by one hundred and twenty castles. The temperament of its citizens was best exemplified by the Baglioni family whose members seldom died a natural death. They were vengeful and cruel though refined enough to slaughter their enemies on beautiful summer evenings. The first "pictures" of the Perugian school were military banners. Churches were bastions and the lovely fountain of Giovanni Pisano served during numerous sieges as a res-

ervoir rather than as an aesthetic object. After prolonged internal frays the town fell to the papacy, which constructed a citadel *ad coercendam Perusinorum audaciam*.

In the morning I had breakfast in a small bistro, cool as a cellar. Opposite sat a grey-haired man with a shaggy face, narrow eyes and the posture of a retired boxer. The picture of Hemingway. But as the proprietor proudly pointed out, it was Ezra Pound. The right man at the right place—an impetuous man who would feel at home in the company of the Baglionis.

In the middle of the fifteenth century, Piero della Francesca—a mature artist and, like his colleagues, a "wandering performer"—travelled to Rome to paint the chambers of Pope Pius II. On his way he rested in Perugia. His polyptych, *Madonna and Child with Four Saints*, remains in the Pinacoteca. Its astonishing golden background is the apogee of Quattrocento. Piero painted the saints in abstract glory, rather than against a landscape, to suit the conservative, eternal taste of the brethren of St. Anthony's monastery. Though it is not Piero's best work, it displays his characteristic tautness of human form with solid heads and shoulders like treetops. Most astonishing is the predella portraying St. Francis receiving the stigmata—a direct reference to the tradition of Giotto. Two monks in an ashen, desert landscape with a Byzantine bird above—Christ.

Arezzo lies halfway between Perugia and Florence. A town that clings to a hill capped by a citadel. Here Petrarch was born—the son of a Florentine exile—who later discovered the country of exiles: philosophy. Here was born Aretino "whose language hurt the living and the dead and who spared only God, explaining that he did not know him."

St. Francis's church is dark and austere. You must walk the length of an immense, unlit vestibule to reach the organ-loft and one of painting's greatest wonders: *The Legend of the True Cross*, a sequence of fourteen frescoes painted by Piero in full maturity between 1452 and 1466. The subject is derived from the apocryphal gospel of Nicodemus and Jacobus de Voragine's *Golden Legend*. Let us try to describe the fresco.

The Death of Adam. According to legend, the tree of the Cross grew from the seed placed under the tongue of the dying Father of All Living. Naked Adam expires in the arms of aged Eve. Piero's elders are unlike those ruins so willingly painted by Rembrandt. They possess the pathos and wisdom of dying animals. Eve asks Seth to return to the Garden of Eden to bring an olive which will cure Adam. On the left, Seth talks with an angel in front of the Gate of Paradise. Adam lies in the centre—lifeless under a bare tree as he receives the seed from Seth. Figures bend their heads over the corpse. A woman with outspread arms cries voicelessly.

Her lamentation carries not terror but prophesy. The entire scene appears Hellenic as though the Old Testament were composed by Aeschylus.

The Queen of Sheba's Visit to Solomon. A medieval tale relates that the tree of the Cross survived until Solomon. The King ordered that it be felled and used for a bridge over the Siloam river. Here the Queen of Sheba surrounded by her maids experienced a vision and fell to her knees. Piero depicted human form as a supreme master. His figures are as unmistakable as the women in Botticelli. Piero's models have oval-shaped heads set on long, warm necks and full, strong shoulders. Their heads are accentuated by hair closely moulded to the skull. Their faces are bare with all life concentrated in the eyes, features tensed. Eyes with almond-shaped lids almost never return a glance. Piero avoids the cheap psychology of theatrical gestures and airs. When he wishes to stage a drama (as in the Queen of Sheba's lonely vision), he surrounds his heroine with a group of surprised girls. For greater contrast, he adds horses under a tree and two henchmen who prefer hooves and manes to miracles. As in other works, the time of day is indefinite: a pink-blue dawn or noon.

The scene continues as Piero holds the story through a unified perspective similar to the conventional unity of place in classical theatre. Under a Corinthian portico, drawn with architectural precision, the Queen of Sheba meets Solomon. Two worlds: the feminine court of the Queen, colourful and histrionic; and Solomon's officers, a study of severe political wisdom and serenity. There is the Renaissance variety of dress, yet without Pisanello's ornament and detail. Solomon's men stand firmly on the stone floor; their long feet, seen in profile, recall Egyptian painting.

The bridge is dismantled in the next scene. Three workers carry a heavy log as though anticipating Christ's path to Golgotha. Yet, this fragment (with the exception of the central figure) is so weighted and painted in a naïve manner that art historians detect the hand of Piero's disciples.

The Annunciation accords with an Albertian architecture of perfect balance and perspective. The austerity of marble conveys the gravity of discourse. A massive God the Father in a cloud with an angel on the left side; and Mary, a calm, sculpted Renaissance figure.

The Dream of Constantine. Piero leaves the stone porticoes and paints the golden-brown interior of Constantine's tent, one of the first conscious chiaroscuro nocturnes in Italian art. The torches' glow gently chisels the forms of two guardsmen with a seated courtier and the sleeping Emperor in the foreground.

Constantine's Victory Over Maxentius evokes both Uccello and Velásquez,

though Piero applies a classical simplicity and loftiness. Even the chaos of the cavalcade is organized. He never uses foreshortening for exclamation, never disturbs the harmony of planes. Raised lances support the morning sky, the landscape rains light.

The Torture of Judas portrays Judas, who was thrown into a dry well by order of Helen, the Emperor's mother, for not divulging the hiding place of the tree of the Cross. The scene depicts two servants lifting a repentant Judas from the well with a pulley attached to triangular scaffolding. Seneschal Boniface holds him tightly by the hair. Though the subject suggests a study of cruelty, Piero speaks in a sober, objective voice. The faces of the *dramatis personae* are unmoved and inattentive. If anything appears ominous, it is the apparatus which binds the convict. Once more geometry has absorbed passion.

The Discovery and Proof of the Cross. The fresco is divided into two sections which form an inseparable thematic and compositional unity. The first shows the excavation of the three crosses by workers watched by Constantine's mother. A medieval town of spires, slanted roofs, with pink and yellow walls rests in the distant valley. In the second section a half-naked man touched by the Cross rises from the dead. The Emperor's mother and her maids-of-honour worship the scene. The architectural background comments on the event. It is not the phantom medieval town of the previous scene, but a harmony of marble triangles, squares and circles: the mature wisdom of the Renaissance. The architecture is the final, rational confirmation of the miracle.

Three hundred years after the discovery of the True Cross, the Persian King Chosroes captured Jerusalem and Christianity's most precious relic. In turn, the Persians were defeated by Caesar Heraclitus. Piero unfolds the raging battle in a confused knot of men, horses and war implements which only superficially resembles the famous battles of Uccello. Uccello's conflicts are loud. Copper horses stamp their hind legs, the massacre's uproar rises to the sheet-iron sky and falls heavily to earth. In Piero all the gestures are slow, solemn. His narration conveys an epic impassiveness as both sides conduct their bloody rites with the earnestness of lumbermen felling a forest. The sky above the contestants is transparent. In the wind the banners "bow their wings like dragons, lizards and birds pierced with spears."

Finally, the victorious, barefoot Heraclitus carries the Cross to Jerusalem leading a ceremonial procession of Greek and Armenian priests with their colourful, bizarre headdresses. Art historians wonder where Piero could have observed such fantastic costumes. Perhaps they were introduced for the sake of composition.

With his taste for the monumental, Piero crowns the heads of his figures like an architect capitalizing columns. Heraclitus's procession, the finale of the *Golden Legend*, resounds with a pure, dignified note.

Piero's masterpiece has been severely damaged by damp and a restorer's incompetence. The colours are faded as though rubbed with flour and the poor lighting of the organ-loft hinders contemplation. Yet, if only one legendary figure remained, one piece of wood, one splinter of sky, we could reconstruct from these scraps the whole, like the fragments of a Greek temple.

The key to Piero's mystery: he was one of the most impersonal, supra-individual artists in history. Berenson compares him to the anonymous sculptor of the Parthenon and to Velásquez. His human figures enact the grave drama of demigods, heroes and giants. The absence of psychological expression unveils the pure artistic movement within mass and light. "Facial expression is so unnecessary and sometimes so embarrassing that I often prefer a statue without a head," confesses Berenson. Malraux welcomes Piero as the inventor of indifference: "His sculpted crowd comes alive only during a sacred dance . . . which reflects the principle of contemporary sensitivity. Expression should come from the painting not from the depicted forms." Over the battle of shadows, convulsions and tumult, Piero has erected *lucidus ordo*—an eternal order of light and balance.

I thought that I might spare Monterchi, a small village twenty-five kilometres from Arezzo. A pond of stones covered by cypress trees and blue skies—like duckweed. But I was swayed by a friend's letter: "The cemetery and chapel are situated on a hill some hundred metres from the village in which a strange car is a sensational event. It is reached through rows of olive trees that pave the vineyards. The chapel and caretaker's house stand in line with the tombs and take their pastoral appearance from the rich vine vegetation. Girls and mothers with children come here for their evening strolls."

Outside the chapel is yellow, inside lime-white—perhaps baroque but really deprived of style. It is minute, with the altar's *mensa* situated in a niche. There is hardly enough room for a coffin and a few mourners. The walls are bare, with the sole ornament a framed, transposed fresco damaged at the sides and bottom. In their journey through the ages, the fresco's angels have lost their sandals, though some clumsy restorer has tried to replace them.

It is certainly one of painting's most provocative Madonnas. Her hair, pressed to her skull, uncovers large ears. She has a sensual neck and full arms, a straight nose and a hard, swollen mouth. Her eyes are closed, her eyelids drawn over black pupils which stare into her body. She wears a simple dress with a high waist open from

breast to knees. Her left hand rests on a hip, a country bridesmaid's gesture; the right hand touches her belly but without a trace of licentiousness, as though touching a mystery. Piero has painted for the Monterchi peasants the tender, eternal secret of every mother. Two angels briskly draw aside the drapery like a stage curtain.

It was fortunate that Piero was born neither in Florence nor Rome—but in small Borgo San Sepolcro, far from the tumults of history. For he would often return to his gentle, native town, would hold municipal office and die here.

Palazzo Communale retains two works by its greatest son. Focillon considers the polyptych *The Madonna of the Misericordia* Piero's first unassisted painting. The upper part depicts the crucifixion. Christ is seen in a tragic and stern posture; but at the foot of the Cross, Mary and St. John possess an emotive force unusual in Piero's later work. The gestures of their arms and spread fingers portray a violent despair without Piero's poetry of reserve and silence. The seed of his future style is revealed in the main painting: the Madonna shielding the faithful with her robe. As the central figure, she is tall, strong and impersonal—an elemental form. Her grey-green robe flows like warm rain down upon the heads of the kneeling believers.

The Resurrection of Christ was painted with the sure hand of a forty-year-old man. Christ stands firmly against a melancholy Tuscan landscape. A victorious figure. He holds a banner in his left hand while the other hand clasps the shroud which is like a senator's toga. He has a wise, wild face with the deep eyes of Dionysus. He rests his right foot on the edge of the tomb like someone crushing the neck of an enemy defeated in a duel. In the foreground, four Roman guards are paralysed by sleep. The two contrasted states are striking: the sudden awakening against the heavy slumber of men turned into objects. The sky and Christ are drawn with light; the guards and the background landscape are darkened. Though the figures appear static, Piero with a stroke of genius reconciles disorder and movement, energy and torpidity: the drama of life and death measured by inertia.

Urbino has been compared to a lady seated on a black throne covered with a green mantle. The lady is a palace dominating the small town just as its owners, the Montefeltro dukes, dominated its history.

They began as robber knights. Dante—an expert on last things—placed one of them, Guido, in an infernal circle occupied by the moaning sowers of discord. Gradually, their tempers cooled; and their dispositions became more gentle. Federico, whose rule began in 1444, was the example of a humanist general. If he engaged in wars, as for instance against the ruthless Malatesta of Rimini who murdered two wives (shown by Piero in a pious pose kneeling in front of St. Stephen),

he entered the arena with an obvious distaste for the blood sport. He was both valiant and prudent. Through his *condottiere* service for the Sforzi, the Aragons and
the Pope, he tripled his domain. He liked to walk alone, unguarded (a practised
propaganda trick) in a simple, red vestment and talk with his subjects in the duchy's
capital. Though the subjects had to kneel and kiss his hand during these friendly
chats, Federico was considered a liberal ruler for his time.

His court, renowned for its unusual moral purity, was the shelter of humanists.
He was the model for Castiglione's *The Courtier*. The Duke collected antiques, artists and scholars. He maintained close contacts with Alberti, the age's most prominent architect, the sculptor Rossellino, and the masters Joos van Gent, Piero and
Melozzo da Forli—in whose portrait the Duke sits in his library in full armour (but
this junk is only the embellishment of power) grasping a huge volume set on a
book-rest. A book lover of the highest standard, Federico demanded a Hebrew Bible as ransom after the Battle of Volterra. His library of rare theological and humanistic manuscripts was certainly richer than his armoury.

We mention Federico da Montefeltro since for many years he was Piero della
Francesca's friend and protector, which should entitle a posthumous fame. Perhaps Piero spent his most enjoyable years here. Vasari, an important source for lost
masterpieces, says that Piero painted in Urbino a sequence of small pictures that
were greatly to the Duke's liking though they have disappeared during the wars
which ravished the land.

Piero's diptych of Federico and his wife, Battista Sforza, resides in the Uffizi
Gallery in Florence. A striking contrast exists between the two figures. Battista's
face is waxen, drained of blood (thus the speculation that the portrait was painted
after her death), while the Duke's tawny face vibrates with energy: a hawkish profile—a head with raven-black hair set on a lion's neck, a strong torso in a robe and
red headdress. Duke Montefeltro's bust rises like a lone rock against a remote and
delicately painted landscape. Our sight must span an abyss—without any intermediate planes, without the continuity of space and perspective. The figure of the
Duke falls from an ineffably light sky like a hot meteor.

On the portrait's reverse are two allegorical scenes full of courtly poetry. They
depict the triumphal processions popular in Renaissance painting. Surrounded by
the four theological virtues, the coach of the Duchess is drawn by four unicorns.
The dimmed, grey landscape brightens at the infinite horizon's line—an evocation of death.

The Duke's coach is drawn by white stallions. Federico is accompanied by Justice, Power and Moderation. A fantastic mountain landscape radiates light. A blue
afterglow is reflected in the water's mirror. The allegory's inscription proclaims:

Christ. He leans against a column on which rests the stone statue of a Greek hero with a raised hand. Two henchmen simultaneously lift their whips. Their strokes will be regular and indifferent like the ticking of a clock. The silence is complete— without the victim's moans or the executioners' odious breath. There are two ob-servers: one turned away; the other seated showing his leftside profile. Were only this section to remain, it would be a box scene—a model sealed in glass, tamed reality. Knowing that geometry devours passion, Piero never placed important events in perspective (unlike the ironist Breughel, *vide Icarus*). The significant fig-ures of his dramas stand in the foreground as if in front of footlights. The picture's symbolic meaning is thus associated with the three men standing at the right with their backs turned to the martyr.

Berenson and Malraux were interested only in their compositional function. "In order to make this scene even more severe and cruelly impersonal, the artist introduced three magnificent forms which stand in the foreground like eternal rocks." Traditional interpretation connects this work to a contemporary historical event: the violent death of Prince Oddantonio Montefeltro surrounded by three conspirators. Behind their backs, their wishes are realized by the symbolic whip-ping. Suarez gives reign to his imagination and plunges into a risky explanation: the three mysterious men are the high priest of the Temple of Jerusalem, the Ro-man proconsul and a pharisee. Turning their backs to the momentous event, they consider its significance and consequences. In their cyphered faces Suarez sees three different states: the pharisee's restrained hatred, the Roman bureaucrat's stubborn righteousness, and the priest's cynical peace. Whatever key we may use, *The Flagellation* will remain one of the world's most closed and obscure paintings. We view it through a thin pane of ice—chained, fascinated and helpless as in a dream.

Madonna and Child with Saints and Angels is claimed to be Piero's last paint-ing. Though its authorship was the subject of controversy, it now rests with Piero's name in Milan's Brera Gallery. Ten figures surround the Madonna in a half-circle, ten columns of flesh and blood with the rhythm repeated in the background ar-chitecture. The scene is situated in an apse with a full arch and a cone-shaped vault opening above. From the top of the cone an egg hangs on a thin line. This may seem a trivial description but the unexpected, formal element is surprisingly log-ical and correct. The painting is Piero's testament. And an egg, as we know, used to symbolize the secret of life. Under the mature vault, this fixed pendulum on a straight line will strike for Piero della Francesca the hour of immortality.

Was the greatness of his art equally obvious to his contemporaries and descen-dants as it is for us? Piero was a recognized artist though he worked very slowly and

(Renaissance theoreticians often sneered at the chromatic chaos of the Middle Ages.) After Alberti, they played with light. The stress placed upon colour makes it impossible to define form by a sharp contour. Piero understood this lesson. He concentrates on an object's inner space rather than its outline. Seth's nakedness or the Queen of Sheba's head are surrounded by a luminescent lining like the edges of clouds. This bright contour is Alberti's theory in practice.

A painting's composition unifies objects and space. The narration can be reduced to figures, figures dismembered into elements, elements into adjoining surfaces like the facets of a diamond. However, this should not lead to a geometrical coldness. Venturi has observed that Piero's compositional forms aspire towards geometry without entering Plato's paradise of cones, spheres and cubes. He is, to use an anachronism, like a figurative painter who has passed through a cubist phase.

Alberti is attentive to narrative painting, though he declares that an image should act upon itself and charm the spectator regardless of plot. Emotion should be released through the movements of bodies and forms rather than facial expression. He warns against tumult, lushness and detail. This warning became the two rules governing Piero's most outstanding compositions: the harmonized background and the principle of tranquillity.

In his best paintings (*The Nativity*, the portrait of the Duke of Urbino, *The Baptism*, *Constantine's Victory*) the remote, absorbent background is as significant as his figures. The contrast between the massive human shapes (usually seen from below) and the delicate landscape attenuates the drama of man in space. The landscapes are deserted, with only the elements of water, earth and sky. The quiet chanting of the air and the immense planes are the choir against which Piero's personae remain silent.

The principle of tranquillity does not reside merely in architectural balance. It is a principle of inner order. Piero understood that excess movement and expression both destroy the visual painted space and compress time to a momentary scene, the flesh of existence. His stoic heroes are constrained and impassioned. The stilled leaves, the hue of the first earthly dawn, the unstruck hour present Piero's creations in their eternal armour.

Let us return to *The Flagellation*. It is Piero's most Albertian work. The compositional threads are cool, taut and balanced. Each person stands in an exact construction like a rock of ice, which at first glance seems under the rule of the demon of perspective.

The scene is divided into two parts. The main drama occurs on the left side under a marble portico supported by Corinthian columns where pure intelligence could walk. The rectangular floor tiles guide our sight towards the semi-robed

his doctorate in law and studied Greek, mathematics, music and architecture which were complemented by his travels. His fortune changed frequently, only improving when his humanist friend, Tommaso da Sarzana, became Pope Nicolas V. Alberti was praised equally for his beauty and intellectual virtues—an example of a Renaissance athlete and encyclopedic mind, "a man of outstanding mind, acute judgement and thorough knowledge."

This is how Angelo Poliziano introduced him to Lorenzo de' Medici: "Neither the oldest books nor the most unusual skills are unknown to this man. You can only wonder whether he is more gifted in rhetoric or poetry, whether his style is more solemn or elegant. He has studied the remains of ancient buildings so thoroughly that he has mastered the oldest ways of building while imparting these methods to his contemporaries. He has invented machines and constructed beautiful buildings; besides, he is considered an outstanding painter and sculptor." His last years (he died in Rome in 1472) were irradiated with fame. He was a friend of the Gonzagas and Medicis.

He left nearly fifty works: studies, dissertations, dialogues and moral treatises not counting numerous letters and apocryphal writings. His lasting fame rests upon his works on sculpture, painting and architecture. His main treatise, *De Re Aedificatoria*, is by no means a manual for engineers but a charming, learned book for art patrons and humanists. Despite its classical structure, technical subjects are mixed with anecdotes and trivia. We may read about foundations, building sites, bricklaying, doorknobs, wheels, axes, levers, hacks, and how to "exterminate and destroy snakes, mosquitoes, bed-bugs, flies, fleas, mice, moths and other importunate night creatures." Alberti's treatise on painting written in 1435 directly influenced Piero. In the introduction the author warns that he will not tell stories about painters since he wishes to construct the art of painting *ab ovo*.

Many sources claim that Renaissance artists were satisfied with mere imitation of classical styles and nature. Alberti's writings demonstrate that matters were not so simple. He states that the artist, even more than the philosopher, is the architect of the world. Though he may borrow from certain natural relationships, proportions and rules, his discovery is through his vision rather than mathematical speculation. "What cannot be perceived by the eye is without interest for the painter." The eye's image is a combination of rays which thread the object to the spectator in constructing a visual pyramid. Painting cuts through this visual prism. The result is a definite, operational chain based upon the logic of sight. One must locate the object in space and enclose it within a linear contour. Then the harmonized surfaces become the colour composition.

Colours issue from differences in lighting. Before Alberti, painters used colour.

Clarus insigni vehitur triumpho
Quem parem summis ducibus perhennis
Fame virtutem celebrat decenter
Sceptra tenentem

The gallery in Urbino contains two masterpieces from separate periods of Piero's life. *Sinigalia*, named after the church where it previously hung, portrays the Madonna with two angels. Despite the lack of evidence, it is considered one of Piero's last works. Though some see signs of senile decadence, it is difficult to agree with that judgement. One rather concurs with those who discover an attempted rejuvenation of style.

The new light came from the North. *Sinigalia* best conveys the dramatic encounter between the Italian master's imagination and the power of Van Eyck, to whom Piero turned in his youth. This influence is confirmed by Piero's unusual devotion to detail. The hands of the angels, Madonna and Child are painted with a typically Flemish love of detail. The scene is placed in a private interior (an exception for Piero). We see a fragment of a grey-blue chamber opening to a corridor on the right side. The corridor's perspective is discontinued; it stops abruptly at a slanted wall with windows. The penetrating light does not reach the foreground figures. It is a chiaroscuro study. Human forms are succinct and monumental. The Madonna has the common face of a nurse, the foster-mother of kings. Little Jesus raises his hand in a lordly manner and looks straight ahead with his wise, severe eyes—the diminished figure of the future emperor aware of his power and fate.

The Flagellation of Christ surprises us with its original treatment of subject and perfect harmony of composition, a synthesis of painting and architecture as yet unseen in European art. We have often repeated the term "monumental," to indicate the presence of architecture in Piero's work. We must look more closely at this relation, since the loss of architectural sense, the highest art organizing the visible, is the drama of contemporary painting.

The man who influenced Piero more than any painter (Domenico Veneziano, Sassetta, Van Eyck, his contemporary perspectivists: Uccello and Masaccio) was an architect, Leon Battista Alberti.

Born in Genoa in 1404, he came from a prominent, banished Florentine family whose importance can be expressed in a figure: the high price offered to slay its members by the vengeful Albizzis. Leon Battista received a truly Renaissance education in Bologna while living in student poverty after his father's death. He took

did not achieve the fame of his colleagues in Florence. He was praised mainly for his two theoretical works written at the end of his life. It comes as no surprise that he was quoted more frequently by architects than by painters or poets. Cillenio devotes one sonnet to Piero; Giovanni Santi, Raphael's father, mentions him in his rhymed chronicle; another poet alludes to the portrait of Federico da Montefeltro. Not much.

Vasari, born nineteen years after Piero's death, adds only a few biographical details. He stresses his expression, realism and passion for detail, which is a clear misunderstanding. Later, chroniclers and art historians issue a passionless murmur of quotations from his work.

In the seventeenth and eighteenth centuries, Piero's fame subsided. His name was buried as art pilgrimages streamed from Florence to Rome leaving aside Arezzo, not to mention tiny Borgo San Sepolcro. No one knows whether the large quantity of consumed wine or the taste of the epoch was responsible for the unfavourable insinuation in von Rumohr's *Italienische Forschungen* that the painter called Piero della Francesca was not worth mentioning. His rehabilitation was left until the middle of the nineteenth century. Stendhal (not the first case in which a writer precedes the discoveries of art historians) saved him from oblivion. He compared him to Uccello and stressed his masterful perspective, his synthesis of architecture and painting; but as if swayed by Vasari's judgement, he says: *"Toute la beauté est dans l'expression."* Piero's place amongst the greatest European painters was restored by Cavalcaselle and Crowe in their *History of Painting in Italy* published in England in the years 1864–66. Later, the studies start to flow: from Berenson to Roberto Longhi, Piero's exquisite monographist. Malraux says that the present century has rendered justice to four artists: Georges de la Tour, Vermeer, El Greco and Piero.

What do we know about his life? Nothing or almost nothing. Even the date of his birth is uncertain (1410–1420 with a question mark). He was the son of the artisan Benedetto de Franceschi and Romana di Perino da Monterchi. His academy was Domenico Veneziano's studio in Florence though he did not remain long. He probably felt most at home in his little Borgo San Sepolcro. He worked consecutively in Ferrara, Rimini, Rome, Arezzo and Urbino. In 1450 he fled from the plague to Bastia; in Rimini he bought a house with a garden; in 1486 he signed his will. He shared his experience not only with his disciples, for he left two theoretical treatises: *De Quinque Corporibus Regolaribus* and *De Prospettiva Pingendi* in which he discussed optics and perspective in a precise, scientific manner. He died on 12 October, 1492.

It is impossible to place him in a romance. He hides so thoroughly behind his

paintings and frescoes that one cannot invent his private life, his loves and friend-
ships, his ambitions, his passion and grief. He has received the greatest act of
mercy by absentminded history, which mislays documents and blurs all traces of
life. If he still endures, it is not through anecdotes of the miseries of his life, his
madness, his successes and failures. His entire being is in his *œuvre*.

I imagine him walking along a narrow San Sepolcro street towards the town
gate—with only the cemetery and the Umbrian hills beyond. He wears a grey robe
over his broad shoulders. He is short, stocky, strolling with a peasant's assurance.
He silently returns salutations.

Tradition holds that he went blind towards the end of his life. Marco di Longara
told Berto degli Alberti that as a young boy he walked the streets of Borgo San Se-
polcro with an old, blind painter called Piero della Francesca.

Little Marco could not have known that his hand was leading light.

1962

Translated from the Polish by Michael March and Jarosław Anders

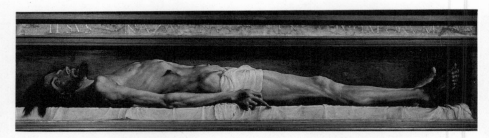

Hans Holbein: *The Dead Christ*, 1521. Oeffentliche Kunstsammlung Basel, Kunstmuseum (Switzerland). Colorphoto Hans Hinz.

FORD MADOX FORD

Hans Holbein the Younger

Holbein's lords no longer ride hunting. They are inmates of palaces, their flesh is rounded, their limbs at rest, their eyes sceptical or contemplative. They are indoor statesmen; they deal in intrigues; they have already learnt the meaning of the words "The balance of the Powers," and in consequence they wield the sword no longer; they have become sedentary rulers. Apart from minute differences of costume, of badges round their necks, or implements which lie beside them on tables—differences which for us have already lost their significance—Holbein's great lords are no longer distinguishable from Holbein's great merchants. Indeed the portrait of the *Sieur de Morette* has until quite lately been universally regarded as that of *Gilbert Morett*, Henry VIII's master-jeweller.

Holbein obviously was not responsible for this change in the spirit of the age: but it was just because these changed circumstances were sympathetic to him, just because he could so perfectly render them, that he became the great painter of his time. Dürer was a mystic, the last fruit of a twilight of the gods. In his portraits the eyes dream, accept, or believe in the things they see. Thus his *Ulrich Varnbuler, Chancellor of the Empire*, a magnificent, fleshy man, gazes into the distance unseeingly, for all the world like a poet in the outward form of a brewer's drayman. The eyes in Holbein's portraits of queens are half-closed, sceptical, challenging, and disbelieving. They look at you as if to say: "I do not know exactly what manner of man you are, but I am very sure that being a man you are no hero." This, how-

Ford wrote three critical monographs on painters and painting for the Duckworth "Popular Library of Art" series—*Rossetti* (1902), *Hans Holbein the Younger* (1905), and *The Pre-Raphaelite Brotherhood* (1907). The following is an abridgement by Sondra J. Stang, Washington University. —Editor

ever, is not a condemnation, but a mere acceptance of the fact that, from pope to peasant, poor humanity can never be more than poor humanity.

It is a common belief, and very possibly a very true belief, that painters in painting figures exaggerate physical and mental traits so that the sitters assume some of their own physical peculiarities. (Thus Borrow accuses Benjamin Robert Haydon of painting all his figures too short* in the legs, because Haydon's own legs were themselves disproportionately small.) One might therefore argue from the eyes of Holbein's pictures that the man himself was a good-humoured sceptic who had seen a great deal of life and took things very much as they came. On the other hand, Dürer, according to the same theory, must have been a man who saw beside all visible objects their poetic significance, their mystical doubles. But perhaps it is safer to say that the dominant men of Dürer's day were really dreamers, whilst those who employed Holbein were essentially sceptics, knowing too much about mankind to have many ideals left. . . .

We know . . . that what delighted him was Renaissance decoration, and this was a plastic delight, a personal taste, rather than an influence from without. And, deeper down in the boy, at the very heart of the rose as it were, there was slumbering the deep, human, untroubled, and tranquil delight in the outward aspect of humanity, in eyes, in lips, in the form of hair, in the outlines of the face from ear to chin. This delight in rendering produced the matchless series of portraits of his later years which for us to-day are "Holbein."

. . . In his portraits his method was the same throughout his life. He made a silverpoint outline of his sitter—put in light washes of colour on the face; just indicated the nature of ornaments; made pencil notes of furs, orders, or the colour of eyebrows; and then took his delicate sketch home with him to work out the oil picture probably from memory. . . .

The likeness [a chalk drawing of himself at twenty-three], which is a masterly piece of pastel work, is so like the mental image of the man that one forms from his works, that one may accept it as a portrait and retain it privately in one's mind as an image. It is the head of a reliable and good-humoured youth, heavy-shouldered, with a massive neck and an erected round head—the head of a man ready to do any work that might come his way with a calm self-reliance. The expression is entirely different from that in, say, Dürer's portrait of himself; from the nervous, intent

*It will appear later that this very defect characterised for several years the figures of Holbein's own design, though I have never, even in the works of German theorists, seen it imagined that Holbein was short-legged, or in love with a short-legged woman. I offer the theory to commentators.

glare and the somewhat self-conscious strained gaze. Holbein neither wrote about his art nor about his religion—nor alas! did he sign and date every piece of paper that left his hand. He was not a man with a mission, but a man ready to do a day's work. And the intent expression of his eyes, which calmly survey the world, suggests nothing so much as that of a thoroughly efficient fieldsman in a game of cricket who misses no motion of the game that passes beneath his eyes, because at any moment the ball may come in his direction.

Dürer signed each of his works, because a friend in early life suggested that in that way he should follow the example of Apelles. He added to his drawings inscriptions such as: "This is the way knights were armed at this time," or "This is the dress ladies wore in Nuremberg in going to a ball in 1510," as if he were anxious to add another personal note to that which the drawings themselves should carry down to posterity; as if he were anxious to make his voice heard as well as the work of his hands seen. Holbein once in painting a portrait of one of his supposed mistresses implies that he himself was Apelles. He calls her *Laïs Corinthiaca*, and Laïs of Corinth was the mistress of the great Greek painter. But he scarcely ever added notes to his designs, and he never seems to have troubled about his personality at all.

The eyes of his own portrait are those of a good-humoured sceptic, the eyes of Dürer those of a fanatic. Dürer attempted to amend by his drawings the life of his day; Holbein was contented with rendering life as he saw it. Dürer, after having plunged into the waters of the Renaissance, abandoned them self-consciously— because it was not right for a Christian man to portray heathen gods and goddesses. Holbein, if he gradually dropped Renaissance decorations out of his portraits, did it on purely aesthetic grounds. He continued to the end of his life to make Renaissance designs for goldsmiths, for printers, for architects, or for furniture makers. Dürer identified himself passionately with Luther, in whom he found an emotional teacher after his own heart. Holbein, in one and the same year, painted the *Meier Madonna* and designed headpieces for Lutheran pamphlets so violent and scurrilous that the Basle Town Council, itself more than half-Lutheran, forbade their sale. . . .

. . . As a rule, Holbein cannot be called one of these painters who can claim to have painted the "soul" of his sitters. For there are some painters who make that claim: there are many who have it made for them. The claim is on the face of it rendered absurd by the use of the word "soul." One may replace it by the phrase "dramatic generalisation," when it becomes more comprehensible. What it means— to use a literary generalisation of some looseness—is that the painter is one accustomed to live with his subject for a time long enough to let him select a character-

istic expression; one which, as far as his selection can be justified, shall be *the* char-
acteristic, *the* dominant note, *the* "moral" of his sitter. The portrait thus becomes,
in terms of the painter's abilities, an emblem of sweetness, of regret, of ambition,
of what you will. The sitter is caught, as it were, in a moment of action.

Holbein hardly seems to have belonged to this class. He appears to have said to
his sitter as a rule: "Sit still for a moment: think of something that interests you." He
marked the lines of the face, the colour of the hair, a detail of the ornament—and
the thing was done. It was done, that is to say, as far as the observation went.

If he wished to "generalise" about his subject, he did it with some material at-
tribute, giving to *Laïs Corinthiaca* coins and an open palm, to *George Gisze* the
attributes of a merchant of the Steelyard. I am not prepared to say whether the
method of Holbein or that of the painters of souls is the more to be commended,
but I am ready to lay it down that, in the great range of his portraits, Holbein, as a
painter of what he could see with the eye of the flesh, was without any superior. Oc-
casionally, as in the portraits of Erasmus in the Louvre, he passed over into the
other camp and, without sacrificing any of his marvellous power of rendering what
he saw, added a touch of dramatic generalisation, or of action. This was generally
a product of some intimacy with the sitter.

And it is perhaps this that makes the portrait of Amerbach so charming. It is as
if Holbein had had, not the one sitting that was all so many of his later subjects af-
forded him, but many days of observation when his friend was unaware that he was
under the professional eye.

In the course of a summer walk along the flowery meadows of the Rhine near
Klein Basel—as the German-hypothetic biographers are so fond of writing—per-
haps Holbein glanced aside at his companion. Amerbach's eye had, maybe,
caught the up-springing of some lark, and the sight suspended for a moment some
wise, witty, slightly sardonic and pleasantly erudite remark. Between the pause and
the speech Holbein looked—and the thing was done. . . .

The subject of Death was one that very much pre-occupied Holbein and his
world. There were then, as it were, so many fewer half-way houses to the grave:
prolonged illnesses, states of suspended animation, precarious existences in
draught-proof environment, or what one will, were then unknown. You were
alive: or you were dead; you were very instinctive with life: the arrow struck you, the
scythe mowed you down. Thus Death and Life became abstractions that were om-
nipresent, and, the attributes of Death being the more palpable, Death rather than
Life was the pre-occupation of the living.

In his most widely known designs Holbein, choosing the line of least resistance,

shows us this abstraction with its attributes. Employing little imagination of his own, he has lavished a felicitous and facile invention along with a splendid power of draughtsmanship upon an idea that could be picked up from the walls of almost every ale-house of his time. In the *Dead Man*, however, he takes a higher flight, showing us, not a comparatively commonplace abstraction, but nothing less than man, dead. It is the picture of the human entity at its last stage as an individual: the next step must inevitably be its resolution into those elements which can only again be brought together at the beginning of the next stage. It is the one step further— the painting of the inscription upon the rock and of the wound in the side—that identifies this man, dead, and trembling on the verge of dissolution, with that Man, dead, who died that mankind might go its one stage further towards an eternity of joy and praise. And, by thus turning a dead man into *the* Dead Man, Holbein performs, in the realm of literary ideas, a very tremendous fact with a very small exertion—for it is impossible to imagine a human being who will not be brought to a standstill and made to think *some* sort of thoughts before what is, after all, a masterpiece of pure art. It was that, perhaps, that Holbein had in his mind.

It may well be that he had nothing of the sort, and that having, as it were, exhausted, in the search for dramatic and melodramatic renderings of episodes in the life of Christ, every kind of violence that he could conceive of, he here comes out at the other end of the wood and—just as the Greeks ended their tragedies not in a catastrophe but upon a calm tone of one kind or another—so Holbein crowns his version of the earthly career of the Saviour with an unelaborated keystone. Or it may have been merely a product of his spirit of revolt. He may have been tired of supplying series after series of Passion pictures meant to satisfy the hunger of his time for strong meat in religious portrayals.

It was this appetite that caused the existence of the number of works in the Basle Museum—works which must make one a little regret that the Holbein who painted the portrait of Amerbach and the Dead Man had not a greater leisure, since, vigorous and splendid as so many of these conceptions are, they are yet upon a plane appreciably lower, whether we regard them as products of art or as "readings of Life," to use a cant phrase. In its present, disastrously restored state it is difficult to regard, say, the early *Last Supper* as other than a rather uninspired piece of journey-work. Without the early Passion series on linen one would feel inclined to say that it was of doubtful ascription. It is interesting because it is one more of Holbein's designs that has been "lifted" from an Italian master, and because it shows Holbein pursuing a sort of pictorial realism to supply the craving for strong meat that I have mentioned. But in the demand for designs for coloured glass he found

a refuge which tided him over dangerous years. It called forth, too, qualities, which if they were not amongst his very greatest, were yet sufficient to place him among the rare band of very great decorative artists. . . .

A busy man, Holbein was under the necessity of working quickly, and being neither a mystic nor a sentimentalist, he struck swift and sure notes. There was in him very little of what Schopenhauer calls *Christo-Germanische Dummheit*; he came before it and before the date of angels who are conceived as long-haired, winged creatures in immaculate gowns—before the date of prettification, in fact. But, being a busy man, he was naturally unequal in his work. . . .

During these years—to be precise, from June 1521 until October 1522—Holbein was engaged upon one of those tasks which, along with the Hertenstein frescoes, the Bär table, and the "Dance of Death," remained for some subsequent centuries wonders of the world. This was the decoration of the council chamber in the Basle Rathaus. The frescoes themselves have vanished so that no man living has seen more than patches of colour upon the walls: the pictures are in that heaven of lost masterpieces where, perhaps, we may one day see the campanile of Venice, the arms of the Venus of Milo, or the seven-branched candlestick of the Temple of Solomon. Vigorous and splendid sketches remain, some copies and many descriptions—but these afford us very little idea of what may have been the actual effect of the decorations, as decorations.

Regarded theoretically they cannot have been perfect or even desirable: here again plain walls were made to look like anything else but walls. But no doubt they were very wonderful things whilst they still existed.

Nevertheless I cannot resist a feeling of private but intimate relief that these tremendous *tours de force* are left to our imaginings. We lose them—but we gain a Holbein whom we can more fearlessly enjoy. For, supposing these things with their nine days' wonder of invention that Holbein shared with many commoner men and set working for the gratification of every commoner man—supposing these extremely wonderful designs still existed, the far greater Holbein—the Holbein of the one or two Madonnas and of the innumerable portraits in oil or in silverpoint—the Holbein whose works place him side by side with the highest artists, in that highest of all arts, the art of portraiture—that tranquil and assured master must have been obscured. Those of us who loved his greater works must, in the nature of things, have been accused of paradox flinging: the great Public must have called out: "Look at that wonderful invention: that compassionate executioner with the magnifying glass, seeking to take out his victim's eye with as little brutality

as might be!" And beside that attraction the charms of Christina of Milan or all the sketches at Windsor would be praised in vain. We should have gained another Shakespeare rich in the production of anecdote, we might have lost some of our love for an artist incomparable for his holding the mirror up to the men and women of his wonderful age. . . .

In 1523 the great troubles and upheavals that saw Rome herself sacked by Lutheran mercenaries were still comparatively at a distance. Writing of that year, one of the greatest of all the rather unsavoury politicians of that wonderful century sums up the topics that were then in men's minds:* ". . . By the space of xvii hole wekes . . . we communyd of warre, pease Stryfe contencyon debatte murmure grudge Riches pouerte penury trowth falsehode Justyce equyte discayte oppreseyon Magnany-myte actyuyte force attempraunce Treason murder Felonye consyliacyon and also how a commune welth myght be edifyed and continuyid within our Realme. Howbeyt in conclusyon wee haue done as our predecessors haue been wont to doo that ys to say, as well as wee myght and lefte where we begann. . . . Whe haue in our parlyament grauntyd vnto the Kynges highnes a ryght large subsydye the lyke whereof was newer graunted in this realme. . . ."

The point about this letter, which is addressed to Cromwell's "especial and en-tyrelye belouyd Frende Jno. Creke in Bilbowe in Biscaye," is precisely that at that date there was no burning question in England. Every possible subject was dis-cussed with academic calmness, and the country appeared to be outside the Eu-ropean storm-centre. And such letters went all over Europe in these years, holding out the promise of a halcyon state to such workers as Holbein whose means of sub-sistence vanished in storms like that of the Peasants' War, and whose very works were destroyed out of all the churches of Protestantism. And not only in Protestant lands, since even such a Pontiff of the plastic arts as Michelangelo was soon to find out that the Pontiff of the Church deemed it expedient to attend almost more to the affairs of his curé than to marbles, however deathless.

Of these bad times for artists we can find, as I have said, little or no trace in the career of Holbein—there are no pictures of his bearing the actual dates 1524 or 1525. It may be convenient therefore to speak here of the *Dance of Death* series and the *Death Alphabet*, although the Trechsels did not actually publish the for-mer until many years had elapsed. This is another of Holbein's wonder-works. It achieved and maintained a European celebrity such as perhaps no other work of art ever did. The only parallels to it that occur at all immediately to one are Bun-yan's "Pilgrim's Progress" in Western, and the "Labyrinth" of Comenius in Eastern

*"T. Cromwell to Jno. Creke," August 17, 1523.

Europe; and these two appeal to a comparatively limited class of races, however widespread. It has struck straight at the hearts of innumerable races, at the hearts of the lowest of peasants as at those of the greatest of artists. It was carried by chapbook pedlars to the remotest hovels of the earth, and Rubens declared that from it he had his earliest lessons in drawing—just as the first master of Michelangelo was, vicariously, Martin Schongauer.

It is easy to say that the appeal of the series came from its subject, and that its subject had been the common property of the mediæval centuries. Yet the mere fact that of so many *Gesta Mortis* only this of Holbein's held the popular imagination with any lasting firmness, the fact that it was the selected version of all the versions, would go to prove that it was some sort of technical excellence, some sort of technical appeal that caused its apotheosis. And excellent indeed is almost every one of these woodcuts—excellent in the simplicity of design which recognises so truly what the thick, unctuous line of the wood-engraver can do; excellent in the placing of each little subject on the block; excellent in the way in which each figure stands upon its legs; and above all, excellent in the appeal to the eye, in the "composition" of each subject.

It is, of course, open to one to say that story-telling is the least of all the departments of designing. But when once such an artist as Holbein sets himself to tell a story, the matter becomes comparatively unimportant. He was so true to himself that his designs had the proper, the individual "look," whether he were putting on paper something so purely arbitrary as the design for a coat-of-arms, or the figure of Death driving a weapon through a soldier. The subject simply did not hinder him: he could employ any object so as to form an integral part of his decorative purpose. And, what is still more to the point, having set himself to tell a story, he did tell it with a quite amazing lucidity. The detail essential to his idea is always what strikes the eye first—or rather it is "led up to" as skilfully as in the denouement of a good French *caste*. That is, of course, one of the lower merits: but that he took so much trouble over it is proof of how conscientious a worker he was—of how amply he deserved the enormous popularity that became his.

I have hardly space here to trace the evolution of the idea of the *Totentanz*. It originated, how far back we cannot tell, in a universal, and no doubt praiseworthy, religious desire of "rubbing in," to each mortal creature, the fact that he or she must die. It was a matter not merely of chalking upon, or carving out of, a wall: "Remember, oh man, that thou art mortal"—a lesson that each reader, like each hearer of a sermon, was apt to apply rather to his neighbour than to himself. The framer, or inventor of a *Totentanz* wished to bring the moral home to each beholder, and in order to do this he exhausted his knowledge of the human avocations

or estates. Thus a butcher who received a grim joy at seeing his friend the horse-merchant, the lacemaker, or the coney-catcher in the arms of a corpse, was expected to receive a shock and ensue no doubt a moral purging at the spectacle of the representation of all Butcherdom dancing in the embrace of a phantom ox-slaughterer. For, in the original conception of a *Totentanz*, each man or woman danced, not with Death the Abstraction, but with a dead mortal of his own kidney. Of such "dances" there were many on the walls of cloisters all over Europe: at Basle itself there is still one to be seen—and no doubt such perpetrations and the fact that they were continually beneath the eyes of men during successive generations did have a considerable influence on the trend of thought. They must, I mean, have smitten very hard the poetic and imaginative few during their childhoods. Perhaps to them may be ascribed the continual preoccupation of the mind of Montaigne with one idea—that of dodging the fear of death when it came by living all his days in a state of mitigated terror.

In Holbein the preoccupation was perhaps natural, since his name means "Skull," and at times, as in the picture of *The Ambassadors*, he proved that he was not oblivious of the fact. The "vein" cropped up from time to time in his later works: thus in the rather inferior and very much damaged portrait of Sir Brian Tuke, now at Munich, the hourglass is in the front of the picture, whilst the background is filled by a skeleton presentation of Death with his lethal instrument. We might almost regard the great *Meier Madonna* as containing one more of these warnings, since, with her shroud half-concealing her face, behind the living wife kneels the dead Dorothea Kannegiesser whom Holbein had so beautifully painted a decade before.

. . . What is interesting is that by this time [1526] Holbein, in his dated paintings, seems to have got rid of the trick of loading his backgrounds with Renaissance architecture and what not. The background of the Darmstadt *Madonna* is nearly simplicity itself; behind the head of Erasmus is nothing but a green surface with some decorative stars: behind the Dorotheas is merely a curtain. He seems to have realised that, by this time, his marvellous painting was a tower in itself and, from this date onward, it is only in "display" portraits that he troubles himself to be very elaborate.

These, it is significant to observe, are, first, *The Household of Sir Thomas More*, with which he "introduced" himself to the English on his first visit; secondly, the portrait of Gisze, with which he "introduced" himself, equally, to the German merchants of the Steelyard on his second coming here. The *Henries VII and VIII and Their Consorts* was also by way of being an introduction, and possibly also the

Ambassadors, since the two sitters might serve to spread his fame into whatever mysterious court they were accredited from. At any rate, from this time onward, except in such special cases, the master seems to have thrown his glove down to posterity: the human face, the human shape, these were the "subjects" with which he was to make his appeal. And this "subject" being the simplest and the most difficult with which a painter can deal, it seems to follow that the achievement is the highest possible. It takes to itself no adventitious aids: it relies upon painting pure and simple.

In the late summer of 1526, Holbein left Basle for England. His motives for so doing are not of the first importance and they have been fully discussed by many people. Some will have it that he was unhappy at home; some that his imbroglio with Dorothea Offenburg drove him away. One authority credits him with an invitation to England from a great English lord: it seems more probable that More called to him. No doubt, too, times in Basle were very evil for him, since to all other painters they were very evil. Already painting was an art in disrepute in a Basle coming more and more rapidly under the sway of Lutheranism. Holbein, as I have said, served both masters impartially—for the one side he painted the Madonna, for the other he illustrated pamphlets so violent that they must needs be burned. But for the moment Lutheranism offered only pamphlets. To find room for paintings, Holbein must find a land where there were convents still and churches not whitewashed. It is an interesting little incident, as showing Holbein in contact with the troubles of his time, that, when he claimed the painting materials—and more particularly the gold—that his father had left in a monastery he was painting in before his death, the answer he received was that the monastery had been burned by the peasants and that if Holbein desired the gold he must go seek it amid the ashes.

Practically the only other Basle evidences of his life—save for the letter from Erasmus—are the *Dorothea* pictures. One may read into them what one likes. It is usual to consider that, since Holbein painted her first as *Venus* and then as *Laïs,* he must first have been guilelessly in love with her, and then have turned upon his mistress. The amiable apologists for Holbein write eloquently upon the wrongs that he must have suffered at her pretty, but itching palms. But it has always seemed to me, that if a man has enjoyed a woman's favours, it is discreditable of him afterwards to call her even well-deserved names, however excellent an organ his voice may be, and, if I were anxious to apologise for the painter, I should simply adopt another line. I mean that there is no documentary evidence to connect Holbein with Dorothea: thus the portraits may have been commissioned by some other of the very many ill-used lovers of the thus immortalised and beautiful Laïs.

I do not know that it is a matter of much importance. Holbein cannot very easily be whitewashed, since his will gives indisputable evidence of his having led a not strictly regular life in this country. Such things, of course, were not uncommon in those distant days, and Holbein might plead the "artistic temperament" to-day. And gossip says too that he was "unhappy at home"—so that, apparently, for once the desire of the critic to limit his remarks to the man's work, and the desire of the world and his wife to know about everything else, may be brought to coincide. For it would appear that the less we say about Holbein the man—the better.

It is, of course, true that the important thing about a picture is how it is painted, and that the subject matters, by comparison, very little. Nevertheless it is an added, extraneous pleasure—a pleasure added rather to what is called *belles lettres* than to the fine arts—when such a painter as Holbein comes upon "interesting sitters." I mean that the charm of Roper's "Life of Sir Thomas More" is infinitely enhanced by looking at Holbein's *Household*—just as the interest of the whole history of the period is made alive for us by Holbein's portraits of Henry VIII's court. Without the court to draw, painting only peasants or fishwives, Holbein would have been a painter just as great. Henry VIII and his men would be lifeless without Holbein. You have only to think how comparatively cold we are left by the name, say, of Edward III, a great king surrounded by great men in a stirring period. No visual image comes to the mind's eye; at most we see, imaginatively, coins and the seals that depend from charters. Thus, if oblivion be not a boon, an age may be thankful for such artists as Holbein. That most wonderful age in which he lived seemed, too, to be well aware of it—since so many of the great sought the immortality that his hand was to confer.

We who come after may well be thankful that Holbein paid when he did his first short visit to this country. Along with the portraits of the splendid opportunists who flourished or fell when the end of the old world came at the fall of More, he has left us some at least of the earlier and more attractive men of doomed principles. Along with More's there decorated then the page of English history the name of Warham, who, for mellow humanitarianism, exceeded Cranmer, his successor, as far as More exceeded Thomas Cromwell in the familiar virtues—and Fisher, Bishop of Rochester, who as far exceeded the later Gardiner. Being men of principle, set in high places, these were doomed to tragedy; and, if Warham died actually in his bed, it needs only Holbein's portrait to assure us that, if the shadows of the future can still affect us on our last pillows, this great man saw, on his deathbed, things enough to make him haggard. Fisher's head has about its eyes a greater intrepidity—but the expression on both is the same; and in these two heads we may see very well how two great men envisaged their stormy times.

Of the portrait of Warham there are two copies in oil extant—both apparently by Holbein, the one in the Louvre, the other at Lambeth: the latter is, I think, the finer example. The oil picture of the *Household of More* has, of course, vanished; but the drawing, a mere sketch with annotations by More, is in Basle, and there are studies for the heads at Windsor. Perhaps, however, the best portrait-picture of this visit to England is the Dresden *Thomas and John Godsalve*, in which the head of the elder man has always appeared to me to be one of the finest pieces of Holbein's painting. The Windsor portrait of *Sir Henry Guildford* is more generally preferred; to my taste it is too much overloaded with decoration—though this was probably to the taste of Sir Henry, a commonplace gentleman, whose successful career was much aided by the king's friendship, and whose position at court made him to a large extent *arbiter elegantiarum*. Thus the portrait has some of the nature of a "display" picture.

But upon the whole, and if no question of pecuniary value or labour expended need influence, I should be inclined to prefer to either, the wonderful, alert *Portrait of an Englishwoman*, in two chalks, in Basle, or the almost more wonderful body-colour *Portrait of an Englishman* in the Berlin Royal Cabinet. These little drawings of an hour or so are so inexpressibly alive in every touch that the more minutely you examine them, the more excited you will become. In the finished paintings one is presented with a mystery: in these drawings one has the very heart of the secret. Each stroke that one looks at seems to unfold an envelope of the bud—at each unfolding one discovers that the secret lies a little deeper. I suppose Holbein himself could not have told how it was done.

But, of course, these drawings and all the earlier paintings take, as it were, their hats off to the portrait of Holbein's wife and children. . . . As in the case of most of the really impressive portraits of the world, there is here no background, no detailed accessory to worry the beholder's eye. The figures in the picture exist just as at first sight a great human individuality exists. One has no eyes for the chair he sits in nor much for the kind of clothes he may wear. He overcomes these things and makes them so part of his individuality that they are as much taken for granted as are the number of his fingers. And it is precisely the property of the great portrait that it makes its subject always a great man. It brings out the fact that *every* man is great if viewed from the sympathetic point of view—great, that is, not in the amount of actions done, but in the power of waking interest. It brings out, in fact, in what way its subject is "typical," since great art is above all things generous, like the strong and merciful light of the sun that will render lovable the meanest fields, the barest walls.

And such a great portrait as this is notable as explaining what must be, always,

the artist's ambition—that his work shall look "not like a picture." When one stands before it one is not conscious of a break in atmospheric space: one does not subconsciously say: "Here the air of the room ends: here is the commencement of the picture's atmosphere." The figures in the picture are figures in the room. It is not, of course, a matter of a Pre-Raphaelite attempt to "deceive the eye" by a kind of stippling as if the painter had attempted with cuttle-fish to smooth out the traces of his tool, for the tool is frankly accepted and the brush marks visible enough.

The large, plain woman, with the unattractive children, lives before us, luminous, throwing back the light with that subdued quality of reflection that all human flesh possesses. . . .

One so exhausts superlatives in these days that there seem to be none left in which to speak of the almost perfect drawing of the woman's shoulders and head, of the harmony of the whole design, on whose surface, or rather, in whose depths, the eye travels so pleasantly from place to place. The woman's hands are particularly worth looking at—the masterly way in which the one on the boy's shoulder shows in its lines that it rests heavily, and the way in which the pressure on the baby's waist is indicated. . . .

The magnificent *Samuel and Saul* . . . is to my mind the finest of all Holbein's quasi-decorative subject pictures. The way in which, in this drawing, the figures of the marching troops, of the king, and of the arresting prophet are rendered actual, and at the same time blended into one composition with the strictly decorative scrollwork of smoke from the blazing background, proves that Holbein had at this time reached the very high water mark of genius—of genius which is the comprehension of the scope possible to a certain class of design. It is decoration achieved not by the multiplication of arbitrary details and not by the arbitrary treatment of actual forms—but by the selection of natural objects fitted to fill and to make beautiful a certain space. It is the sort of selection that is given to most of us at rare moments. Thus I remember seeing, whilst I was making a final tour for the purposes of this book, a number of workmen taking a siesta along the bottom of a sunlit wall. There may have been thirty of them in various, but similar attitudes, on the ground, and nearly all of them wore blue blouses. This similarity of their attitudes and costumes and the straight line that they made brought to my lips at once the words: "If only Holbein had seen that!" I suppose that I had my mind full of the little frieze of *Dancing Peasants* that there is in the Basle Museum. . . .

I opened this little monograph with a pseudo-comparison of Dürer with Holbein: of course the two are not comparable. For if, to continue the use of a simile of my

first page, Holbein be a mountain peak in a chain of hills, we must write Dürer down as a Titanic cloud form, one of a range that on a clear day we may see towering up behind the mountain. The two men differ in kind and in species. Holbein could no more have conceived the *Great Fortune* than Dürer could have painted the *Christina of Milan*: Dürer could not refrain from commenting upon life, Holbein's comments were of little importance.

That essentially was the ultimate difference between the two: it is a serviceable thing to state, since in trying to ascertain the characteristics of a man it is as useful to state what he is not as what he is. Dürer, then, had imagination where Holbein had only vision and invention—an invention of a rough-shod and everyday kind. But, perhaps for that very reason, the subjects of Holbein's brush—in his portraits—are seen as it were through a glass more limpid. To put it with exaggerated clearness: we may *believe* in what Holbein painted, but in looking at Dürer's work we can never be quite assured that he is an unprejudiced transcriber. You will get the comparison emphasised if you will compare Holbein's drawing of Henry VIII with the etching by Cornelis Matsys of the year 1543. The drawing is an unconcerned rendering of an appallingly gross and miserable man; the etching seems as if, with every touch of his tool, the artist had been stabbing in little exclamation notes of horror. The drawing leaves one thinking that no man could be more ugly than Henry: the etching forces one to think that no artist could imagine any man more obscene.

Holbein, in fact, was a great Renderer. If I wanted to find a figure really akin to his I think I should go to music and speak of Bach. For in Bach you have just that peculiar Teutonic type of which Holbein is so great an example: in the musician too you have that marvellous mastery of the instrument, that composure, that want of striving. And both move one by what musicians call "absolute" means. Just as the fourth fugue of the "Wohltemperierte Klavier" is profoundly moving—for no earthly reason that one knows—so is the portrait of Holbein's family. The fugue is beautiful in spite of a relatively ugly "subject," the portrait is beyond praise in spite of positively ugly sitters. And there is in neither anything extraneous: the figure, unaided by "programme," is pure music: the portrait, unaided by literary ideas, is simply painting.

The quality of the enjoyment that we can get from the works of these two is also very precisely identical. I do not know how long the Duke of Norfolk's portrait of Christina of Milan has hung in the National Gallery: it must have been there many years, since I can hardly remember a "myself" in which the idea of that "symphony" in blues and blacks did not play an integral part of my pleasures. I would rather possess that painting than any other object in the world, I think, and I have

visited the National Gallery, I do not know how many times, simply to stand in front of it—simply to stand and to think nothing. It is not for me a picture; it is not even a personage with whom I am in love. But simply a mood—a mood of profound lack of thought, of profound self-forgetfulness—which assuredly is the most blessed thing which Art, in this rather weary world, can vouchsafe to a man—descends upon me in front of that combination of paints upon that canvas.

It is not merely this portrait that can evoke this mood in us—it is the very quality of Holbein. I happen to possess a very excellent set of reproductions—made for a private person—of the series of Windsor sketches for portraits. One can pass hours with such things as these on the floor before one's chair. Here is the court of Henry VIII from the Groom Falconer to the Earl Marshal. But it is not the former careers of the dead queens, the tiny features of the little prince, or the heavy jowl and weary eyes of the most unhappy king—it is not the history, the intrigue, the gossip of a small kingdom then barbaric and insignificant enough. Here is Regina Anna Bulleyn: but this is not the queen who was done to death by false witnesses. A comely, large featured, slightly sardonic face looks down not very intently upon a book. But it is neither queen nor face that hold those of us who are attuned to the quality that we call "Holbein": it is a certain collocation of lines, of masses.

We are, literally, in love with this arrangement of lines, of lights and of shadows. The eye is held by no object, but solely by the music of the pattern—the quality that we call "Holbein." It is a quality; it is a feeling; it is a method of projection that one admires—and that one might well speak of—in the peculiar phraseology that is reserved for one's admiration of musicians. Thus when one asks another, "Do you like Beethoven?" he implies, not "Do you like an old, sardonic, deaf man?" or "Do you like the Ninth Symphony or any other individual work?"—but "Are you pleasurably affected when the name Beethoven calls up in you certain emotions—emotions that you have felt when certain notes followed certain others in an intangible sequence; a sequence that cannot be analysed but which is 'Beethoven'?"

The quality, the power of Holbein is similar. When we recall him to mind, no particular work of his "sticks out" in the mind's eye. His is a mass, or a force; he calls up a mood.

This characteristic is most marked when one considers the work that he did after his final establishment in England. One may use a cliché phrase so that it becomes, in this case, vivid and actual: he poured out a stream of pictures. They are better or worse than each other only in accordance with the beholder's private preferences; just as, in a stream, different men standing at different points on the bank and seeing different facets of the ripples see differing lights and shadows differing.

You may above all things care for the *Ambassadors,* which moves me very little; I shall never be contented with praise of the *Duke of Norfolk* of Windsor, or the *Unbekannte Dame* of Vienna. Yet, in the mass, and after the review, you and I may both set the abstraction we call "Holbein" at the same very high level.

He always seemed to me to be the earliest of "modern" painters—to have looked at men and women, first of all, with the "modern" eye. If you glance rapidly along the series of sketches at Windsor you will be astounded to see how exactly they resemble the faces you will pass in the Windsor streets. If you compare them with, say, Lely's portraits of a later court, the characteristic becomes even more marked, since Lely's men and women died a century or so later than Holbein's—and have yet been dead so much longer. He got out of his time—as he got *into* our time—with a completeness that few painters have achieved—hardly even Velásquez or Rembrandt.

The claim is not, really, a very high one: the modern eye looking at things in a rather humdrum and uninspired way. But, of course, the praise appears more high if we put it that Holbein's works may be said to have compelled us to look at things as we do, just as, after Palestrina, the ears of men grew gradually accustomed to hear music only in the modern modes. Artistically speaking it means that Holbein, penetrating, as it were, through the disguise of costume, of hair-dressing, and of the very postures of the body and droop of the eyelids, seized on the rounded personalities—the underlying truths—of the individuals before him; so that when one looks at the portrait of de Morette, or the wonderful sketch of a dark girl with a figure that rakes back, one neither notices the clothes of the one nor the absence of clothes of the other. Aesthetically, of course, the painting of the clothes and ornaments has a value of its own—in the portrait of de Morette it leads up to and supports the heavy and sagacious face—but, until we consciously examine it for our own æsthetic ends, we are not really aware of the clothes at all, and the figure before us might be that of any prime minister, plumber, or book publisher of to-day. . . .

Nothing was further from Holbein's spirit—and nothing indeed is further from the spirit of his nation and age—than any idea that great results can be obtained with small means. He belonged to a nation to whom display was and remains the readiest means of indicating value of whatever sort. Simplicity and severity were probably distasteful enough to him. Thus nothing could have been further from his sympathy than what is best in modern decorative art, and he had little or no idea, beyond that enforced by the exigencies of space, of adapting his design to the form of the object to be decorated or of reducing the amount of ornament further and

further until the best decorated space be that which contains the least ornament. *His* dukes would never have been the worst-dressed men of a house of peers.

His is the other end of our line, in this as in so many other things, and to appreciate him thoroughly we have to make mental efforts of one kind and another. As we might put it, he was vulgar, which we are not, but he had more blood and more hope, so that he achieved the impossible so many times, and climbing in places where we are accustomed to say that climbing is wrong or hopeless, he appears on peaks more high than any of ours. That, of course, is what the master does in the realm of the arts.

I have employed freely the words "actual" and "realist" in speaking of Holbein's work, and in that I have followed the example of many who use the terms either panegyrically or in contempt. But in the modern sense he was little of a realist, dealing rather in the typical. One can exemplify this best in such drawings as the very beautiful and celebrated "ship" design. Our present-day "realist" would give us some moment from the career of some actual ship. But Holbein's is hardly an actual ship at all. It can hardly have been drawn from the life, since, even in that day when ships absurdly unmanageable, top-heavy, and unsteerable made voyages the mere idea of which turns the hair of the modern sailor grey—even in that day no ship so absolutely unballasted would have set sail from any port. But Holbein had got into his head, had made part of his ideas, a representative ship. He had seen ships perhaps at Lyons, perhaps in the channel, and he evolved from his mind a typical form. Equally, too, he had seen ships set sail, had seen men being seasick, had seen fat warrior-sailors on board embracing fat women, had seen bumboats casting off, had seen pots of beer handed up to a masthead and gigantic standard-bearers casting loose their flags to the breeze. But in bringing all these things together into his design he overwhelms one with the idea that he could never, upon any one setting sail of a ship, have seen so much at one moment. Thus, admirable and actual as each detail of the drawing is, it impresses one not as a realistic shadowing of any incident, but as an almost didactic portrayal of what it might be possible to see. It is as if he wished to show men of the inlands who had never seen a ship as much as possible in one drawing.

Of course his real purpose may have been no more than a note to remind himself, as in the case of the *Bat* and *Lamb* drawings. But that semi-didactic spirit is visible in much else of his work. It seems to fill the *Dance of Death* series, which, as it were, exclaims continually, "See what Death can do!" And it is the real "note" of all his portraits. Whilst going to the bottom of each individual, whilst absolutely searching out his most usable qualities, he seems to be selecting those saliences

which will make the individual really noticeable. Dürer wrote upon his drawings: "This is how the Knights rode in armour in 1515." Holbein tries to force us to see in his portrait of the Lady Parker: "This is how women of the narrow-eyed, small-nosed, wide-mouthed, tiny-waisted type looked in the year 1537." Or, in an exaggerated form the *George Gisze* shows us the merchant with all his arms around him.

This last is, of course, merely material—but it is a material indication of the artist's psychological approach to his sitters. He does not, as I have said, take them in their "moments," he does not show them under violent lights or in the grasp of strong passions. He rounds them off, catching them always at moments when the illumination, both of the actual atmosphere and of their souls, was transfused and shone all round them. Thus he has left us a picture of his world, as it were, upon a grey day.

Other artists are giving us more light, others again have given us both more light and more shadow or more shadow alone. But no other artist has left a more sincere rendering of his particular world, and no other artist's particular work is compact of simulacra more convincing, more illusory, or more calculated to hold our attentions. He has redeemed a whole era for us from oblivion, and he has forced us to believe that his vision of it was the only feasible one. This is all that the greatest of Art can do, whether it takes us into a world of the artist's fancy or into one of his fellowmen. And, by rescuing from oblivion these past eras it confers upon us, to the extent of its hold, a portion of that herb oblivion, a portion of that forgetfulness of our own selves, which is the best gift that Art has to bestow.

<div align="right">1905</div>

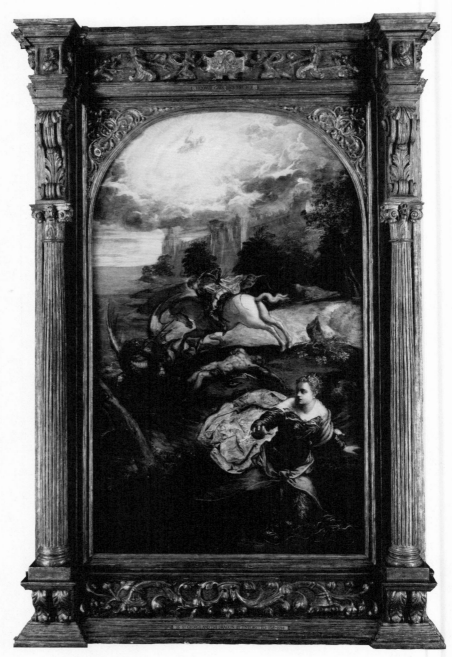

Jacopo Tintoretto (1581–1594): *Saint George and the Dragon*. National Gallery, London.

JEAN-PAUL SARTRE

Tintoretto: St. George and the Dragon

Tintoretto knew or anticipated everything that his predecessor was lucky enough to ignore. What account of himself did this painter of passions give when asked by his clients to commemorate an act? For an answer let us question the painting in the National Gallery.

Jacopo begins by relegating the soldier and the animal to the half-light of the middle-ground. This is a favourite procedure of his: as a rule he makes use of it to rob us of our time. Not so in this case: after all, what believer would not ardently seek out a Christ or Virgin Mary in the depths of a crowd? Yet however great may have been St. George's contribution to the welfare of Venice, the most serene City has loftier protectors—among others, St. Mark. No one will take the trouble to peer into the half-light to discern the shabby and indistinct scuffle there: St. George isn't popular enough. If a painter wants to impose him, let him bring him into close-up, out in the light! This is what Carpaccio did, and this is what Robusti re-fuses to do. Out of sullenness, I believe. This George is the painter's personal en-emy, the protagonist of every drama, the adventurer who is called in treatises on morality the *agent*. Tintoretto's brush will exile this captain, who disturbs the uni-verse of *pathos* by the incongruity of an act.

A double and contradictory distension expels him and propels towards us the sumptuous sign of that blindest of passions, fear. On the right, in bright light, a woman throws herself against the glass frontier of the painting. A tilt-shot from be-low accentuates her. This is where the canvas begins: it is impossible to ignore or

pass beyond her. We first contemplate this range of every visible quality—light and form, colour, modelling; we imagine the object endowed with the density and weight of this beautiful, fair flesh. And then diagonally we cross a rarefied waste-land to reach the site of the curious combat. Our itinerary for the moment goes from right to left, from foreground to background. The painter will not let go of us until he has first impressed this luxurious flight on us. A flight, a fall, a collapse, a swoon—it is all these at once. The girl is running straight like a mad thing ahead; but matter resists, sticks to her shoes, slips or crumbles; under her skirt, her shapely legs stumble—one knee is about to hit the ground. Tintoretto keeps us here a moment longer: floating behind this dread he has painted the proudly billowing waves of a cloak. In this remarkable but sombre painting, the only bright plumage is that of fright—fright alone is allowed to be pink. Why? Is an attempt being made to demoralize us? Yes—in a way. For just at this point the canvas opens up: it is time for us to go right into it.

On the left of the painting, by the shore of a putrescent lagoon, we discover a sizeable reptile with gnarled, mangled wings. Our look immediately connects this vermin with the fugitive girl; a slither, a flight or a leap would be enough—and Beauty would be devoured by the Beast. This fulgurating relationship flashes from right to left and from front to back; but it is not reciprocal. The animal has excellent reasons for temporary distraction; it is the girl whose long ostensible rout denounces the evil intentions of the monster. We no sooner glimpse the monster, however, than the time-sequence of the painting is overthrown. So long as we did not know the reasons for it, the girl's attempt to escape was not simply a wild passion—she might have decided, albeit trembling, on the wisest course. She seemed to be losing her balance. Was she about to stumble or would she regain her footing? That such a question can be put implies that an enterprise unfolding in time has suddenly been broken by a false step—the breakage is an instant. Sheerer fissures exist—vertical or scythelike; and Robusti knows how to summon the necessary angles of our bodies from them. But this time he has other intentions: he deftly compensates for the threat of a fall with the hint of a recovery. Our uncertainty tempers our expectancy—we are not disturbed either by the postponement *sine die* of a too-awaited disaster, or by the perpetual promise of a reprieve forever deferred. In short, our eye demands nothing; the moment of rupture fades into a flabby suspense; it even becomes the guarantee of the temporal dimension of the painting. For since the immediate future is indeterminate, we can guess that a durable enterprise is afoot. Freed from all physical impatience, we have been forewarned that an act will be accomplished or aborted, according to whether events take this course or that.

This initial illusion lasts for less time than it takes to describe it. This is where our itinerary starts, that is all; although it is also where it always begins again. In short, this is a moment—a moment made to disappear. In effect, no sooner is the dragon noticed than the instant triumphs. Not that the girl definitely falls—Jacopo is too crafty for that. He merely puts her enterprise in parentheses: Beauty will not escape from the Beast without the intervention of Providence. What then does it matter to us whether she finally tumbles or recovers? We are shown the passive abandonment of a body disordered by fear; as for the fate of the young person, it is being decided a hundred metres behind her. In short, the instant retains its delicate balance, but duration decamps from the scene. For the rest, on the left of the painting, in the middle-ground, a corpse suggests a prophecy: the die is cast—if the finger of God does not crush the reptile, the maiden will die. In fact she is *already dead*. The instantaneous violence of her flight and the eternal repose of death balance each other. It was not for nothing that Tintoretto placed this cadaver in our path, between the fugitive and the animal—his canvases are covered with signs whose function is to foretell the future of the principal characters and to figure its imminence. Other men perform what they are about to do, suffering the fate that will overtake them, or which they will only just escape. Robusti had to depict the inevitable downfall of the girl for us—a Natural inevitability, before the intervention of the Supernatural. But he profits from it to suggest that the swift transience of the instant is identical to eternal rest.

The dragon would only have to be on the lookout, would only have to deign to give his attention to the frightened scramblings of his future repast, to pull the whole of the canvas over towards him. It would disappear down his gullet and we would follow it. It would suffice for him to be steady, but ready to spring, and the dramatic action would revolve about him; we would feel the depth of the painting as a threat. But he is not on the lookout—God has rendered him so deaf that he cannot hear the charge of the holy lancer. Now it is too late—the pike has pierced him; he has been killed. No, it is too soon—he has not yet had time to die, only to suffer. We are enclosed by the instant—his start of wild terror, his jaws wrenched apart with pain, between the visible shock and legible death (foretold, moreover, by the sacred legend itself). Yet another suspended death. Although baleful still, he no longer threatens anyone—his only concern is his own predicament. In short, this dragon disappoints us, as the maiden did before him: she was not really seeking safety from him, just as he is not a real threat to her. At a stroke, the armed intervention of the saint disqualifies the flight of the girl—she runs on, though now out of danger. Terror has driven her mad; she will career forward aimlessly, without stopping, until she faints. Her flight, provoked by an external cause whose

disappearance forms the very subject of the painting, survives her; it will continue indefinitely, for want of any inner ability to halt itself. Is this not the definition of inertia? Scientists would soon establish the principles of it. Robusti knows nothing of science. Yet on his canvas he depicts death, fear, life as inert appearances—borrowed, maintained, removed: always from the outside.

Robusti's itinerary conducts us through a complex play of deceptions: each presence points to the next, and is disqualified by it. The beast and the corpse condemn the princess to death—and the death of the beast transforms the deceased maiden into a mechanical system gone wrong. At the outset one presence—a splendid and massive terror—dominates from the foreground on our right. But we do not have to go very deeply into the picture to see this as the mere residue of an effect that has survived its cause. In fact, once we have discerned the agony of the beast, the true present is revealed while the other slips into the past. The painter's message is clear: everything on his canvas is taking place at once. He encloses everything in the unity of a single instant. But to conceal its too brutal cleavage, a phantom succession is pressed upon us. Not only is the course of events traced in advance, but each successive stage devalues its predecessor and denounces it as the inert memory of things. The repose of the corpse is memory—prolonged, repeated from one moment to the next, forever identical, useless. As for the dragon, his ugliness demonstrates his wickedness. He suffers; his agony distracts or suspends his faculties—and his wickedness passes. His ugliness loses its function, but lingers on—etched in his leather. The time-trap works, and we are caught in it. A false present greets us at every step and unmasks its predecessor, which returns, behind our backs, to its original condition as petrified memory. We believe that we are encountering the true present each time, and that it flows in living form behind us into the past.

Just one thrust of a lance has to produce all these cracks in inertia at once. The painter's itinerary forces us then to go from the flight of the girl all the way back to the death blow of the saint. What do we find? Is the saint performing an act, or is he merely the passive vehicle of an event? Let us look closer: for this soldier of God can scarcely be seen. I notice that he is charging from right to left, as in Carpaccio's painting. But this time he is more knowing, less bold. Rather than confront the monster candidly, he stabs it by stealth from behind—to make victory more certain. The position of his lance-head testifies to this: It has just struck the beast above the eye. The years have transformed the knight-errant into a condottiere. I see nothing wrong in this—the girl had to be saved, audacity would have been criminal in such circumstances. But something has been lost. Carpaccio's dragon was a sort of prodigy, the child of the devil and of paganism. The two supernatural

beings, one the emissary of Providence and the other the instrument of the Devil, had to fight it out face to face. In this Manichean confrontation, the painter pitted Heaven against Hell—the beautiful prey in her robes was merely a pretext. Here, in this place, as everywhere, God had to triumph over idolatry. Such, moreover, was the meaning of the legend—once the Beast was dead, the whole city was converted to the Christian religion.

Tintoretto believed in the All-Powerful, in original sin, in God's abandonment of man. About the Devil, we cannot be so sure. In any case, he conceived his dragon as a product of nature, a Loch Ness monster. While George, despite the phosphorescent wave that encircles his head, became the victim of a brush determined to naturalize the supernatural. Human, all too human, George grips his lance. It is not he that is the driving force behind the blow, but his horse: the soldier merely uses its momentum to the full. All he does is grip tight with his thighs and bend low over the neck of his mount to cushion the recoil. I am well aware that this was standard procedure in tournaments; but at least those jousts pitted combatants of the same species and the same arms against each other, while the same signal alerted both of them together. A trace of this age can be seen in Carpaccio's painting—he was known for his aristocratic tastes, and took pleasure in depicting a champion striking cleanly, in style. To show the champion's style, he had to show his act, and to show that he had to depict his hands: the saint's left profile is turned towards us, but he is holding up his right hand and all can see his iron fist, the symbol of every human endeavour, gripping his lance and thrusting it at the beast. Carpaccio was so intent on showing us that the saint's weapon was wholly articulated with his hand, that he forced the hand to point the lance obliquely, across the courser's neck. On reflection, it is evident that other modes of attack would have been faster or more certain in their outcome—but from Carpaccio's point of view they all suffered from the same drawback: the saint would have to drive his lance to the right of his horse, so that a few inches of its length would be blocked from view by the horse's head—enough, anyway, to break the durable unity of this lightning stroke. Carpaccio the aristocrat preferred to cheat a little—hardly at all, for the public to see Force in the service of Order.

Tintoretto's tastes were plebeian. What he liked best, I think, was the sweat of artisans struggling with intractable matter: I have said that it was their troubles and the drama of their lot that he depicted. Thus he made his soldier, without even thinking about it, into a good workman, labouring hard and perspiring profusely. In fact, the saint's enterprise changed radically from one canvas to the other: for Tintoretto, George is wholly occupied with charging, lance downwards, a piece of vermin off-guard and stupefied by Providence, that offers no resistance apart from

the thickness of its hide and the hardness of its bones. In a word, for Tintoretto, George is a workman driving in a nail.

If only we were shown his hammer and his five fingers gripping it! But this is carefully avoided. Observe the position of the lance. Tintoretto could not prevent it being a foreshortened, rectilinear vector, but he promised himself that he would not let it dominate the painting. In the church of San Giorgio degli Schiavoni, he must, I imagine, have become much more aware of the problem, and may even have glimpsed its solution: two opposed ends could be achieved by the use of opposing means. In his painting, therefore, everything had to be the contrary of what Carpaccio had done. Robusti would conceal the lance, and he would hide George's right hand, because he guessed that his predecessor had gone out of his way to show both of them. Tintoretto deliberately constructed his painting around a leftward-pointing axis—so that our gaze penetrates it at an angle—in order to project the left-hand side of the saint to us and deprive us of this image of practical efficacy—the closed fist gripping and aiming the instrument. As a consequence the lance is three-quarters hidden behind the opaque mass of horse and rider; the dim light does the rest—you need good eyes to see the lance's fourth quarter. All we pick out is a vague glimmer of steel beneath the soldier's bent elbow—the end of the lance; and between the horse's head and the dragon, a black streak—its shaft—whose head has already disappeared into the monster's skull. Everything takes place as if Jacopo had taken the precaution of removing all straight lines from his painting.

What he actually did was worse: while scrubbing out these foreshortened lines, these pins that fix people and things to the canvas like multicoloured butterflies onto cork, he contrived by a stroke of ingenious malice to leave an insubstantial trace of them—optical phantoms of what they had once been. The axis of the action thus disappeared, but in its place he painted, in the far distance, two privileged spectres—horizontal and perpendicular—in order to figure, in the form of mirages, our absolute impotence. Before coming back to St. George, we must concentrate for a moment on the background of the painting. Let us consider this distant town, pale with fear, less substantial than a puff of smoke. The verticality of its tall ramparts proclaims the abandonment of the princess. Here we may recall the story of this unfortunate maid. The cowardly citizens of the town have been paying the Beast a tax in the form of virgins—a diet, it appears, particularly delectable to dragons. One day Fate picked on the king's daughter, and this interesting sovereign, instead of beating drums and issuing calls to arms, decided that it would be more honourable to bow to the common destiny. A democrat from funk, the enlightened despot had his own child led to the water's edge and there abandoned.

Abandoned? That's putting it mildly—her fellow citizens delivered her to the dragon. With tears in their eyes, according to the legend. Indeed, they were still crying, I don't doubt, when an hour later they had raised all the drawbridges and gone home to sleep behind bolted doors. Then St. George happened to pass by. Outraged by these events, he decided to stay. On Tintoretto's canvas, everything is finished: it is for God to make the next move. The community has shut itself up—it is distant, inaccessible. The terrorized maid flees from the dragon, but each step also takes her further away from the capital that rejected her. For the soldier and the princess, the business has to be settled out here in the wasteland, without the assistance of men—where the alternatives are to kill or to die. Such is the meaning of the insubstantial rigidity of those sharp-edged ramparts. "Don't count on us!" At the beginning of our century, another craftsman called K . . . , a surveyor by trade, happened upon a castle built on a hill; it too had elusive ramparts, hewn out of the same matter. Grace alone, the divine concourse, allows those on earth to know and accomplish what must be accomplished. What would the sixteenth century see in a distant figuration of absolute verticality? It would see grace, revealed and erased in a single movement. Why not? Tintoretto is the epic painter of solitude. Like all great solitaries, he was a man who inhabited crowds. He who had been so often humiliated and betrayed, and so often a betrayer, believed that the human community without grace became a den of thieves. In order that man might cease to be a wolf for men, a transmutation of his being was necessary, that verticality could figure and abundant grace alone could accomplish. But God tarries and life rushes by; it passes without His ever appearing, and without our ceasing to await Him. Look closely at the mirage of those vertiginous walls—the mirage is that of Godot. But a Godot rooted to the spot—who will not come.

As for the horizontal, here things are worse. If man is nothing but a savage beast, then absolute verticality, even reduced to a spectre of itself, does not prevent him from communicating his hopes to God. But that straight line across the horizon represents precisely such a prohibition. Its office is to separate earth from heaven. Let us look at it more closely: the dead water and the clouds above it fade away in a single movement. But the artist has no liking for sea voyages; the sombre indistinction of the lagoons and their banks holds no interest for him. The proof: he makes no effort to interest us in them. The sky is his destination: it is there he would like to travel. What emptiness! The tender tormented pink is a summons: "Flee on high, flee! I sense that the angels are drunk. . . ." Fine. But why does he have to go so far? One need only live a few weeks in Venice to find this nostalgia suspicious. If the artist was fond of the rarefaction of being, all he had to do was to take a walk around the Fondamenta Nuove, at dusk or dawn, to encounter it everywhere, vir-

tually tangible—it is a Venetian speciality. In Venice the sky shimmers around the pale fingers of the city, crackles dryly at eye level—while up there above the stratosphere it appears as a series of loose, grey silken folds receding out of sight. Between this delicate silken scarf and the rooftops there is a void, a wasteland crisscrossed with scintillas of light. Even when the heat is intense, the sun remains "cool"; yet nowhere in the world does it erode so much. It can make an island vanish, disintegrate a district, fall into a canal and evaporate its water, turn the gentle lapping of the waves into a sparkling stammer.

This was Tintoretto's one great love: all his work testifies to it. The lagoons of air above the lagoon he was born in, these precipitates of inert azure, tumbling into the dead water out of pure space—he loved them so much he wanted to paint them everywhere. Critics have grumbled that Tintoretto never breathed a word of his native city in his paintings. Not a word? But he spoke of nothing else. Not of the gondolas certainly—you will find none in his canvases. Nor of the old wooden bridge of the Rialto. But no matter how you approach it, Venice must give itself to you wholly or not at all. That is its character, and what differentiates it from, say, Rome or Palermo. Jacopo collected up his city and diluted it into a cone of translucidity. He preserved the mottled impenetrability of its palaces in such a dazzling transparency that they hurt your eyes. It was Venice once more that he depicted in his *St. George*—a lagoon of air wafting its pink folds above a lagoon of water. Later paintings—the majority—would depict the Pearl of the Adriatic for us as an attack of the sky against the earth. In these, a deadened blueness, tinged with grey and salmon-pink, is blasted through the interminable purity of space, against a stagnant expanse of water. Why? Doubtless to destroy all germs of life in it, utterly to mineralize the gelatinous morass quivering between the walls of the canals. There is no suggestion of this yet in the *St. George*: the next phase of Venetian painting would witness a sumptuous return to the vows of poverty. The full-blown colours would be faded or, still more frequently, eroded by exploding lights. Such was the evolution dictated by local history and the inner logic of the art, and in this period they designated their reformer: Tintoretto. This hallucinated weight-lifter was accorded a mandate to give plastic representation to the decompression of matter into luminosity. To confer a mandate is not difficult—all that is necessary is to plant in the depths of the mandated a few insurmountable contradictions; he will always manage to contrive a mandate out of them. Thus it was, we may be sure, in the case of Jacopo. To transmute weight into grace was natural to him; but to show how the latter was no more than an attenuated guise of the former was his mission. One which had, clearly, only very indirect links with man's surroundings—his environment of things and material products of his labour. Critics long ago ceased to

look for the secret of Sienese painting in the strange relief of the Apennines. Everything was floating, everything now has weight, everything will flow away: the painter must dive into the Adriatic and flow with it to discover its luminous energy. This is the order of the questions with which we are confronted. Nevertheless the negation of a negation does not of itself—whatever may have been said—change it into an affirmation; a "no" is never surpassed towards a "yes" save under the impulse of a premonition. Without a mandate, signs cannot be deciphered; without signs, a mandate remains what it is—an abstract and stuttering mission. Where other than in Venice could Jacopo find the weight of fire and the heat of being, the hopeless proximity of walls, the aimless wandering in a labyrinth and then, suddenly, the cinemascopic vision of a pale glow in the distance? He would merely have seen blue there, of course, had predestined interests not made him invent the ordinary. But he would have had no idea of the "terrible wonders" he was about to produce, if his disquiet had not previously discovered them about itself, as the brute response of things.

Now let us take a brief look at something that troubles me. The light in Venice—in other words, the metamorphosis of light into the city, and of the city into light—is to be found on all his canvases, even where the subject demands an interior decor. In spite of appearances, it is not flaming torches that illuminate the great halls of his banquets: sham suns flood them with the blond light of the Venetian dusks, or with the steely tint of its dawns. Yet the sky itself is blocked off. Even today in Venice the devotees of tenuity merely have to lift their heads for inspiration—the air is made of nothing. Didn't Jacopo ever lift his? Yes, he had to. His gaze too would have been lost in this rarefied gas. But this did not deter him: he preferred to bottle up his local firmament, this glittering island above his city, with heavy traffic—inky, gravid, immobile clouds. Better yet when he could bar our look with a ceiling. He allowed himself to paint the distillation of this volatile light—such as it was, floating above his head—but only on condition that he cast it out, beyond our reach. In his paintings of the Last Supper, the apostles gather in a long low room to drink Christ's blood and to eat his body. Robusti does not spare us a single detail of the ceiling. But for the background he puts a door in the wall, opening onto a luminous void. On the horizon, the sky is an airy summons—to be engulfed, to soar into it. *On the horizon*: in other words, this impossible relief (for who can boast of having reached the horizon?) provides the measure of our distance from it. All of us are born in exile. This, again, is what he attempted to depict in his *St. George*. The dragon, the soldier and the princess are fighting under a leaden sky: we cannot make the mistake of confusing the supernatural light emanating from beneath it with a natural transparency. This halo comes from a plung-

ing angel piercing through the flattened dome of clouds. Farther on, much farther on, above the horizontal line, we see Venice, a delicate bouquet of radiance, the rose of the winds. It opens up—and all the pleasures of gliding in the air seem to await us. They will continue to wait until the day of the Last Judgment: man must win or lose his trial beneath the bituminous lid of an enclosed sky.

What is the origin of this vision of Tintoretto's? The religious symbolism is plain and I grant that it implied these procedures to some extent; but I do not believe that it was powerful enough to ensure their adoption. Still less so inasmuch as the macadam laid down on the celestial avenues seems to me a trifle Huguenot at the edges: those who are called are without number, but who knows if there have ever been any elected? Tintoretto's original obsession, moreover, must be remembered: relief looms overhead; depth, in general, is a tidal ebb and flow which we shall never rejoin. At a distance, weight diminishes, and can be defeated. By the same token, distances can raise man up to God—on condition that he reach them. A condition Tintoretto pitilessly refused his clients. Obsession and prejudice are the driving forces behind his composition. But they cannot explain everything. If an object or a character becomes heavier close up, and lighter in distance, well and good: there is a perfect concordance with our experience of Venice. But Robusti must have been oddly made to catch handfuls of ancestral sky and then cast them into the background of his canvas, till they nearly disappear. After having swept his canvas of light, subtle spirit of his homeland, as if it were unclean, it is stranger still that he should have filled the hole it left on high with tar. Did the subject demand this sort of treatment? One could hardly believe so. Horror, after all, can be solar too. The proof is that, in the case of Carpaccio, small clouds—scattered, moreover, along the *horizon*—are merely employed as extras: the saint transfixes the Beast under an avalanche of gold. The sinister aspect of the painting lies elsewhere—in the corpses, for example, and the patient and sadistic care with which Carpaccio painted them. No; one can certainly be eviscerated in the sun. One man alone demanded that the sky should be leaden, so that the clouds form a ceiling above our heads, and that man was Tintoretto. I cannot help seeing this systematic betrayal of his City of Light as the effect of a secret bitterness, of a nameless resentment.

Did he love Venice? Passionately. He lived there, and he hoped to die there, in the midst of those he knew. He found the wide world frightening, and sequestration suited him. He would not have complained of his fate, in short, had he been quite sure of not finding, up above in heaven, the city he preferred to all others down here on earth. Unfortunately this would hardly be likely. When one enjoys the conspicuous glory of belonging to the Serenissima, it is for all time—death

does not count. This man of the people painted too many official Paradises not to know that each national community maintains a permanent commission by God's side: new recruits, after a brief session at the reception and sorting centre, are ushered in the direction of their reconstituted homeland. The Venetian dead, in particular, were attached officially to the celestial Serenissima, which resembled its terrestrial counterpart in every detail, save that deceased doges formed a college in Paradise, and the number of senators was multiplied by the succession of generations. Against the anarchism of the apostles, celestial Venice saved moral order by preserving its social hierarchy. It provided new arrivals with jobs equivalent to those they had left behind, and conferred the same honours they had received on earth.

For Tintoretto there were no honours—Titian had taken them all. Tintoretto had to endure snubs, he felt disgust, he fawned on people without pleasing them, and displeasing himself. A dog's life. This was how he dreamed: if he had to keep company forever with the old man who poisoned him, and if Caliari* the forger, the usurper, was coming to join them, what could distinguish heaven from hell? Of course he would enter the wheel of souls, and revolve around the All-Powerful—but his neighbour would be Veronese, predictably managing to steal God's smiles from Tintoretto. And then, in any case, his neck would have to bear the weight of a patrician bearing the weight of a doge. In reality, the still-medieval servility of the artisan marked an uneasy liberalism whose origins lay in economic competition, and a morose egalitarianism born of his social intercourse with the bourgeoisie. He painted Elysian fields for high bureaucrats and this was repugnant to him. To die in Venice, of course, would be a fine dream. But in the end he dreamt of something finer: the angels would receive his soul and, at the end of a long oblique ascension, introduce him clandestinely into heaven via other heavens. He would live through a few centuries as a tourist, without settling down in any one place, comparing institutions and regimes; then, if he came across a homeland he liked, he would have himself naturalized discreetly before even the college of doges was notified of his arrival.

This was not what he thought? Agreed: it is what he painted. With the result that in his *St. George* he figured the impossible universe of verticality in the distance, and everywhere else erased all straight lines from space, as if they were so many whalebones corsetting it. Space, without axes or tutors, collapses into a rounded huddle. It buckles. Any being or movement introduced into it—a lump, a puffiness, an inflammation—is bent by irresistible forces. The curved line became the shortest distance between two points.

*Translator's note: Paolo Caliari was the original name of the painter Veronese.

Let us return to the one-way itinerary the artist prescribes: we discover a series of arcs. In the first place, the princess: it is possible to trace a semicircle from the tip of one hand, via her hair, to the other hand. On her left, we come across a series of characteristic domes: that formed by the upper edge of the spreading corolla of her cloak; that of the corpse; that of the shadowy lines running along the belly and mane of the horse; and that of the back of the saint. I mention only the essential. Observe, moreover, on the extreme left, the beginnings of an arch—simply a tree trunk—and up above, on the screen of the sky, those pink ellipses about an angel. There can be no doubt about it: Tintoretto has taken an old tale whose events occurred within our daily physical compass and, with the tip of his brush, projected it into curved space. At a stroke, the instant dilates and overflows. On both Carpaccio's and Tintoretto's canvases our eyes are forced to follow one-way paths—but the roads have changed. In Carpaccio's painting, our gaze slides promptly and immediately to the rigidity of a lance; in Tintoretto's, it wanders through valleys, pivots round a bulge, swings between rotundities in search of an exit, envelops the hindquarters of a horse and ascends to its neck by the only acceptable route—that of the least deviation. The painting admits no difference between a shortcut and the longest way round. This thickening of duration has at least one advantage: since the speed of time on the canvas is much faster than the real time of our ordinary experience, yet it is this real time that rules the behaviour of the princess and the saint, the instant evoked for us on the canvas—soft, stuffed with itself like prunes from Tours—no longer disturbs us. It is a molecule, of course, but a giant molecule, which exceeds and envelopes our fitful attention. Here Baroque time was born—that heavy time which the following century would try to slow down even further, and eventually die of the attempt. In short, Robusti painted the instantaneous, but a curved instantaneity which *we* identify as a duration.

To come back to our soldier, I concede that his heroism suffers somewhat from this metamorphosis. It is not very often that curved space is apparent to inhabitants of rectilinear space. But, as we can see from this example, in every case the confrontation is scandalous. The spectator is indignant: his time is confiscated, and to what purpose? To be wasted heedlessly—to be poured away. The duel between Man and the Beast would have finished long ago if the painter had not rounded each movement, replaced all straight lines by twirls and forced his creatures to telegraph their blows, to suspend them, or delay them indefinitely.

Is this action? Is this soldier performing an act? He is killing, I agree. But a fall of rock can kill as well, by chance. What is St. George doing? What can he do in this hemispherical world in which he is assigned residence? He *weighs*. But because Tintoretto has suppressed the practical axis of the lance, the knight merely

weighs on the horse rather than on the monster. This is only appearance, no doubt—but it is extremely legible: nothing seems to me more difficult for an artist than to banish false illusions from the illusory. In any case, the secret balance of the painting's forms evokes a dull heaviness, and reduces the saint to his weight. When one looks at a painting of this period, one starts, as we said, by perceiving an Apollonian range of fantasies: we recognize the characters in the painting, the locations, the events portrayed. Knowledge is our guide, even words—those of the title, for instance. In this way anecdotal meaning becomes a part of the process of seeing. However, a duller and darker world exists below: the same forms participate in its composition, but they lose their sense in it and become part of a subterranean and nonfigurative order which filters through the brilliant ceremonies of the eye and ends by conditioning our perception. From this point of view, the killer on his mount never ceases for a moment to be the secret dome which crowns, yet crushes, the superimposed arcades of the painting. In other words this providential saviour, rather than pillaging space at a gallop, is himself borne along by all the voussoirs of the canvas. The world bends about this true soldier, hero and lounger, like a brooding hen: hatched in a curved wasteland, he adapts himself by striking a pose and lets a mare carry him off to the scene of the crime.

However, Tintoretto was not so foolish as systematically to deny a saint the chance of being one of the subjects of History. He left suggestions and clues in the painting, which show virtually nothing, yet let us decide whether an act is actually occurring or not.

The suggestions first: the saint's lance and hand have not abandoned the canvas—their presence is masked. You will understand that your eyes do not demand that they be visible; they can accommodate themselves to not finding any trace of them. But experience tells us that they exist, that the saint has not had his right hand amputated, and invites us to a casual quest for the signs of combat. At a lower level, our knowledge and feelings come together: the former enlightens the latter, the latter condition the former. Our blind sensibility receives the information that the saint is not an inanimate mass, that he is a man and is leaning his weight on the dragon more than on his mount. By the same token, the centre of gravity shifts, and the delicate balance we thought we have surprised turns out never to have existed; our muscular sensations demand that a new distribution of weight be established—they seek a prop. But the painter has done his job well. We accord him complete freedom of action; neither our eyes—nor our muscles—demand that the support be visible; we will be satisfied if it is visibly *signified*. Tintoretto provides every possible appeasement: we know the lance is there—we can see a snatch of it. If the honourable onlooker insists on seeing all of it, together with the hand hold-

ing it, he is welcome to turn round and back into the painting. When he has got to the other side of the combatants, in the far depths of the painting, he can contemplate the limpid mystery of the captain's right flank. What will he see there? Whatever he wishes. Since this journey through the canvas can only be accomplished in the imagination, it is the latter, in the last analysis, which will be the final arbiter in each case. Conversely, each of us will be reflected wholly in this final option. It will be a projective test, in short. Tintoretto is no more responsible for what we imagine to be on his canvas than Rorschach for what we perceive in his inkblots. It is true: *from without and from the left side of the rider* we only know the saint by his mass. But only a curmudgeon could claim without proof that the view would not be the same from within and from the right side. The paintbrush has not prejudged the issue in any way: who says that weight, approached from the opposite direction, might not appear as the best helpmeet of men and saints, as their servant and mistress? Perhaps we might have the good fortune to surprise George in his true miraculous self. Suddenly he would teach us, perhaps, what we really are: unstable miracles, submitting the universe to our domination by intelligent control of the servitudes it imposes on us. Nothing should be excluded, so much is clear: not even the wild supposition that the painting is uninhabited, that all that can be discerned in it is the clash of inhuman forces, that man is a haunted mineral.

But, as the work was commissioned by a devout clientele, the most pious conclusion will no doubt be the closest to the truth. In short, Robusti was paid to paint a sacred action; he took pains to ensure that it did not appear on the canvas—knowing that frantic bigotry and conformity would suffice to ensure that every spectator saw action where there was none. The tailor who banked on courtiers admiring on trust a fine suit of royal clothes on a naked monarch was hardly more wily: he himself knew, of course, that His Majesty was opening the ball or presiding over his council in his birthday suit. But was Robusti, the trickster, any less cunning? If we looked at the saint from the other side, the painter's opinion is that we would see the same mass, borne along by the same momentum: neither lance nor hand could change matters in any way. "So then," you will say, "why wasn't he franker? He had nothing to fear: from one side or from the other, with or without a lance, the impotence of man is denounced." Ah! Quite so. If he were to denounce this impotence, he would lose his client. He was irksome to his clientele, without wanting to be, he knew it and was scared of that. Do you think he would want to make matters worse by a premeditated scandal? Stay out of trouble—that was his motto. If he had to paint an act that savoured of heresy, it was just as well not to paint it at all. And, rather than refuse the commission, the whole scene would be painted leaving out the act—a hierarchy of characters and events would usher us, from right to left

and from foreground to background, to the left-hand side of a patently right-handed soldier. At the same time, Robusti showed his guile by choosing a powerful protector—he let his customers know that he would reproduce, point by point, the composition of the great and pious Carpaccio, and that this was the only course open to him since his predecessor's *St. George* was and would remain (perhaps) unequalled. His clients congratulated him. The contrivance appeared triply guaranteed to them: it was fifty years old, it was the work of a dead man, another parish had tried it out and declared itself satisfied. Running-in expenses would be saved. As it happened, Jacopo did not lie: the new master was to draw his inspiration from the old, taking over from him the general features of his composition. What he neglected to say, however, was that he would push this composition to the limit, until it would rock and overturn. Robusti saw at a glance the weakness of Carpaccio's composition—the lance that crosses over the horse—and knew that all he had to do was correct it to obtain the result he wanted. His aim, as we now know, was to leave, in the midst of the most rigorous causal chain, a calculated indetermination—he *would not paint* the actual battle, he would depict an eclipse of the action by obscuring it with the very bodies which were supposed to be producing it. He would make a secret of the act—*the* secret of the canvas. He would exile this absence as far away as possible, to the ranks of all the other exiles, on the pallid ramparts, in the fleeing sky. He would decide nothing, but would leave the client with the task of assigning a name, an essence to the invisible event: the bewitching of a mass by a void, a wink of God to His soldier, or a drama, a conflict arising from man and engendering him.

"What a fuss," you're going to say. And it's true—Robusti did make a lot of fuss, an enormous amount, like all painters, though less than writers. But I can't help that: it's all there on the canvas. You can easily verify if you like. Of course, I have had to spell out what came to him in a flash. I have taken friends to see the painting, each time I've been in London, and all of them react in the same way: what astonishes them is Tintoretto's transparent desire to paint a dazzling action by starting with a rout and then proceeding to relegate the thrust of the lance off-stage. But if we restore the painting to its time—the last years of the painter's maturity—we will understand that this was a familiar disposition of Tintoretto's. In a way, he used it everywhere, and one could say that in the *St. George* he did not invent it so much as comprehend it. It recurred in his work for quite other reasons; but he understood the advantage, in this particular case, he could take from it.

1974

Translated from the French by John Mathews

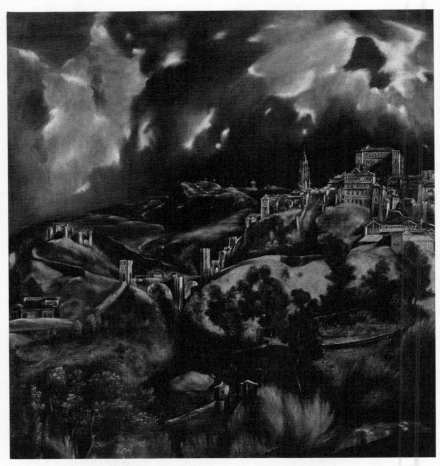

El Greco (Domenicos Theotocopoulos) (1541–1614): *View of Toledo*, c. 1595–1600. Oil on canvas, 47¾″ × 42¾″ (121.3 cm × 108.6 cm). The Metropolitan Museum of Art, Bequest of Mrs. H. O. Havemeyer, 1929. The H. O. Havemeyer Collection, 1929. 29.100.6.

ALDOUS HUXLEY

Variations on El Greco

In 1541, when Domenikos Theotokopoulos was born, his native island of Crete had been for more than three centuries under Venetian rule. Trade had followed the imperial flag, but not culture. In language, in thought, in art, the island remained as what it had been ever since the People of the Sea finally broke the Minoan power—a part of Greece. In the Cretan schools young men studied the philosophers of ancient Athens and the theologians of Christian Byzantium, Byzantine paintings and Byzantine mosaics adorned the churches, and even in the revolutionary sixteenth century the Cretan artists went their traditional way without paying the smallest attention to what had been happening in near-by Italy. Their pictures were two-dimensional, non-realistic, innocent of perspective and chiaroscuro. So far as they were concerned, Giotto and Masaccio, to say nothing of Raphael and Michelangelo and Titian, might never have existed.

Young Domenikos received a sound Greek education and studied painting under the best masters of the island. Not, however, for very long. In Candia one could see, along with the other importations from the mainland, examples of Venetian painting. The orthodox might shake their heads. What a way to treat the Mother of God! And that indecently human personage—was that supposed to be the Pantocrator? But to a young man of original and enquiring mind their very unorthodoxy must have seemed attractive. They were tokens from a world where the artist was his own master, where too he might make technical experiments, where he was free to see and represent all the things which, for the Byzantines, simply didn't exist. Moreover, this world of artistic liberty was also a world where a man could

make his fortune. Venice was rich; Crete, miserably poor. There was no future for a man in Candia; but on the mainland, on the mainland . . .

In the early fifteen-sixties, when the young immigrant from Crete first stepped ashore, Venice was at the height of her artistic glory. Titian was a very old man, but painting as well as, or indeed better than, he had ever done in his youth. Tintoretto, his junior by forty years, was hard at work, transforming the principles of High Renaissance composition into those of the Baroque. Still in his youthful prime, Veronese was effortlessly turning out enormous masterpieces of deocrative art. "Bliss was it in that dawn to be alive." But, all dawns—the artistic no less than the political, the religious, the sexual—give place to mornings, afternoons and nights. After having worked for several years as "a disciple of Titian" (to use the phrase by which he was later to be described) Domenikos came to be profoundly dissatisfied with Venetian art. It could hardly have been otherwise. By nature introspective, by nurture a Christian Neo-Platonist and a student of Byzantine art, the young man might admire Venetian technique, but could never approve the uses to which that technique was put. For his taste Venetian art was too pagan, too voluptuous, too decorative, too much concerned with appearances, insufficiently inward and serious. In search of an art more conformable to his own nature and ideals Domenikos migrated in 1570 to Rome. But Rome, alas, proved to be no less disappointing than Venice. The great masters of the High Renaissance were all dead, and their successors were second-rate mannerists, incapable of creating anything new and living parasitically upon the achievements of the past. For Domenikos, the living were without interest and even the mighty dead were not the masters he had been looking for. Of Michelangelo, for example, he complained that the man did not know how to paint—which is a rather violent way of expressing the unquestionable truth that Michelangelo was primarily a sculptor and that his paintings are in some sort translations of sculpture into a language which was not the artist's native tongue. To a young man whose vocation was to express himself, not in marble, not in transcriptions of sculpture, but in colour and the rich texture of oil pigments, the frescoes of the Sistine Chapel were not very instructive.

The artist's stay in Rome lasted for several years. Then, at some date prior to 1577, he undertook yet another migration, this time to Spain. Why to Spain? As usual, we do not know. And when, some years later, during a lawsuit, the same question was put to El Greco himself, he declined to answer. Evidently he was of the opinion that people should mind their own business.

The Cretan's wanderings were now at an end. He settled in Toledo, and there with his wife, Jeronima de las Cuevas, and his son, Jorge Manuel, he remained until his death in 1614. Of his life in Spain we know only a very little more than we

know of his life in Crete and Italy—that is to say, next to nothing. Here are some of the scanty odds and ends of information that have come down to us.

Professionally, El Greco was successful. Many commissions came his way and he was well paid for his work. On several occasions he went to law with his ecclesiastical patrons in order to get his price. He had the reputation of spending his money with a lordly extravagance, and it was said that he paid an orchestra to make music while he ate his meals. His apartment on the verge of the great canyon of the Tagus contained twenty-four rooms, most of which, however, were left almost completely unfurnished. Of his own genius he had no doubts. He knew that he painted superlatively well and he was quite ready to say so in public. Moreover, when Philip II and certain of the clergy objected to his pictures on the ground that they did not respect the norms of ecclesiastical art, he steadfastly refused to compromise and went on painting exactly as he thought fit. Like Tintoretto, he modelled small clay figures, with the aid of which he studied effects of lighting and foreshortening. Pacheco, the father-in-law of Velásquez, saw a whole cupboardful of these figures when he visited El Greco shortly before the latter's death. Needless to say, they have all disappeared and along with them has gone the treatise which El Greco wrote on painting. Among the painter's friends were poets, men of learning, eminent ecclesiastics. His library, as we know from the inventory which was made after his death, contained, among other Greek works, the famous *Mystical Theology* of Dionysius the Areopagite, together with more recent Italian books on Neo-Platonic philosophy. In the light of this fact, a curious anecdote recorded by Giulio Clovio, one of El Greco's Roman friends, takes on a special significance. "Yesterday," wrote Clovio in a letter which is still extant, "I called at his [El Greco's] lodgings to take him for a walk through the city. The weather was very fine. . . . But on entering the studio I was amazed to find the curtains so closely drawn that it was hardly possible to see anything. The painter was sitting in a chair, neither working nor sleeping, and declined to go out with me on the ground that the light of day disturbed his inward light." From this it would appear that El Greco took more than a theoretical interest in the mystical states described by Dionysius and the Neo-Platonists; he also practised some form of meditation.

Of El Greco's personal appearance we know nothing for certain. The so-called self-portrait may perhaps represent the painter's features; or, on the other hand, it may not. The evidence is inconclusive. At every turn the man eludes us. Only his work remains.

A representational picture is one that "tells a story"—the story, for example, of the Nativity, the story of Mars and Venus, the story of a certain landscape or a certain person as they appeared at a certain moment of time. But this story is never the

whole story. A picture always expresses more than is implicit in its subject. Every painter who tells a story tells it in his own manner, and that manner tells another story superimposed, as it were, upon the first—a story about the painter himself, a story about the way in which one highly gifted individual reacted to his experience of our universe. The first story is told deliberately; the second tells itself independently of the artist's conscious will. He cannot help telling it; for it is the expression of his own intimate being—of the temperament with which he was born, the character which he himself has forged and the unconscious tendencies formed by the interaction of temperament, character and outward circumstances.

Like most of his predecessors and contemporaries, El Greco was mainly a religious painter, a teller of old familiar stories, from the Gospels and the legends of the saints. But he told it in his own peculiar manner, and that manner tells another story, so enigmatic that we pore over it in fascinated bewilderment, trying to construe its meaning.

In looking at any of the great compositions of El Greco's maturity, we must always remember that the intention of the artist was neither to imitate nature nor to tell a story with dramatic verisimilitude. Like the Post-Impressionists three centuries later, El Greco used natural objects as the raw material out of which, by a process of calculated distortion, he might create his own world of pictorial forms in pictorial space under pictorial illumination. Within this private universe he situated his religious subject-matter, using it as a vehicle for expressing what he wanted to say about life.

And what *did* El Greco want to say? The answer can only be inferred; but to me, at least, it seems sufficiently clear. Those faces with their uniformly rapturous expression, those hands clasped in devotion or lifted towards heaven, those figures stretched out to the point where the whole inordinately elongated anatomy becomes a living symbol of upward aspiration—all these bear witness to the artist's constant preoccupation with the ideas of mystical religion. His aim is to assert the soul's capacity to come, through effort and through grace, to ecstatic union with the divine Spirit. This idea of union is more and more emphatically stressed as the painter advances in years. The frontier between earth and heaven, which is clearly defined in such works as *The Burial of Count Orgaz* and *The Dream of Philip II*, grows fainter and finally disappears. In the latest version of Christ's Baptism there is no separation of any kind. The forms and colours flow continuously from the bottom of the picture to the top. The two realms are totally fused.

Does this mean that El Greco actually found a perfect pictorial expression for what his contemporary, St. Teresa of Avila, called "the spiritual marriage"? I think

not. For all their extraordinary beauty, these great paintings are strangely oppressive and disquieting. Consciously El Greco was telling two stories—a story from the Gospels or the legends of the saints, and a story about mystical union with the divine. But, unconsciously, he told yet another story, having little or nothing to do with the two he knew he was telling. All that is disquieting in El Greco pertains to this third story and is conveyed to the spectator by his highly individual manner of treating space and the forms by which that space is occupied.

In the Byzantine art, with which El Greco was familiar in his youth, there is no third dimension. The figures in the icons and mosaics are the inhabitants of a Flatland in which there is no question of perspective. And precisely because there is no perspective, these figures seem to exist in a celestial universe having implications of indefinite extension. From ancient and conservative Byzantium El Greco travelled through time as well as space to modern Venice. Here, in Titian's paintings, he found the realistic representation of a third dimension travelling back from the picture-plane to far-away landscapes of blue mountains under majestic clouds. And in Tintoretto's compositions he could study those rocketing centrifugal movements that carry the spectator's mind beyond the picture-frame and suggest the endless succession of things and spaces existing in the world outside.

The nature of El Greco's personality was such that he chose to combine Byzantium and Venice in the strangest possible way. His pictures are neither flat nor fully three-dimensional. There is depth in his private universe, but only a very little of it. From the picture-plane to the remotest object in the background there is, in most cases, an apparent distance of only a few feet. On earth, as in heaven, there is hardly room to swing a cat. Moreover, unlike Tintoretto and the baroque artists of the seventeenth century, El Greco never hints at the boundlessness beyond the picture-frame. His compositions are centripetal, turned inwards on themselves. He is the painter of movement in a narrow room, of agitation in prison. This effect of confinement is enhanced by the almost complete absence from his paintings of a landscape background. The whole picture-space is tightly packed with figures, human and divine; and where any chink is left between body and body, we are shown only a confining wall of cloud as opaque as earth, or of earth as fluidly plastic as the clouds. So far as El Greco is concerned, the world of non-human nature is practically non-existent.

No less disquieting than the narrowness of El Greco's universe is the quality of the forms with which he filled it. Everything here is organic, but organic on a low level, organic to a point well below the limit of life's perfection. That is why there is no sensuality in these paintings, nothing of the voluptuous. In a work of art we

are charmed and attracted by forms which represent or at least suggest the forms of such objects as we find attractive in nature—flowers, for example, fruits, animals, human bodies in their youthful strength and beauty. In life we are not at all attracted by protoplasm in the raw or by individual organs separated from the organism as a whole. But it is with forms suggestive precisely of such objects that El Greco fills his pictures. Under his brush the human body, when it is naked, loses its bony framework and even its musculature, and becomes a thing of ectoplasm—beautifully appropriate in its strange pictorial context, but not a little uncanny when thought of in the context of real life. And when El Greco clothes his boneless creatures, their draperies become pure abstractions, having the form of something indeterminately physiological.

And here a brief parenthesis is in order. A painter or a sculptor can be simultaneously representational and non-representational. In their architectural backgrounds and, above all, in their draperies, many works, even of the Renaissance and the Baroque, incorporate passages of almost unadulterated abstraction. These are often expressive in the highest degree. Indeed, the whole tone of a representational work may be established, and its inner meaning expressed, by those parts of it which are most nearly abstract. Thus, the pictures of Piero della Francesca leave upon us an impression of calm, of power, of intellectual objectivity and stoical detachment. From those of Cosimo Tura there emanates a sense of disquiet, even of anguish. When we analyse the purely pictorial reasons for our perception of a profound difference in the temperaments of the two artists, we find that a very important part is played by the least representational elements in their pictures—the draperies. In Piero's draperies there are large unbroken surfaces, and the folds are designed to emphasize the elementary solid-geometrical structure of the figures. In Tura's draperies the surfaces are broken up, and there is a profusion of sharp angles, of jagged and flame-like forms. Something analogous may be found in the work of two great painters of a later period, Poussin and Watteau. Watteau's draperies are broken into innumerable tiny folds and wrinkles, so that the colour of a mantle or a doublet is never the same for half an inch together. The impression left upon the spectator is one of extreme sensibility and the most delicate refinement. Poussin's much broader treatment of these almost non-representational accessories seems to express a more masculine temperament and a philosophy of life akin to Piero's noble stoicism.

In some works the non-representational passages are actually more important than the representational. Thus in many of Bernini's statues, only the hands, feet and face are fully representational; all the rest is drapery—that is to say, a writhing

and undulant abstraction. It is the same with El Greco's paintings. In some of them a third, a half, even as much as two-thirds of the entire surface is occupied by low-level organic abstractions, to which, because of their representational context, we give the name of draperies, or clouds, or rocks. These abstractions are powerfully expressive and it is through them that, to a considerable extent, El Greco tells the private story that underlies the official subject-matter of his paintings.

At this point the pure abstractionist will come forward with a question. Seeing that the non-representational passages in representational works are so expressive, why should anyone bother with representation? Why trouble to tell a high-level story about recognizable objects when the more important low-level story about the artist's temperament and reactions to life can be told in terms of pure abstractions? I myself have no objection to pure abstractions which, in the hands of a gifted artist, can achieve their own kind of aesthetic perfection. But this perfection, it seems to me, is a perfection within rather narrow limits. The Greeks called the circle "a perfect figure." And so it is—one cannot improve on it. And yet a composition consisting of a red circle inscribed within a black square would strike us, for all its perfection, as being a little dull. Even aesthetically the perfect figure of a circle is less interesting than the perfect figure of a young woman. This does not mean, of course, that the representation of the young woman by a bad artist will be more valuable, as a picture, than a composition of circles, squares and triangles devised by a good one. But it does mean, I think, that nature is a richer source of forms than any text-book of plane or solid geometry. Nature has evolved innumerable forms and, as we ourselves move from point to point, we see large numbers of these forms, grouped in an endless variety of ways and thus creating an endless variety of new forms, all of which may be used as the raw materials of works of art. What is given is incomparably richer than what we can invent. But the richness of nature is, from our point of view, a chaos upon which we, as philosophers, men of science, technicians and artists, must impose various kinds of unity. Now, I would say that, other things being equal, a work of art which imposes aesthetic unity upon a large number of formal and psychological elements is a greater and more interesting work than one in which unity is imposed upon only a few elements. In other words, there is a hierarchy of perfections. Bach's *Two-Part Inventions* are perfect in their way. But his *Chromatic Fantasia* is also perfect; and since its perfection involves the imposition of aesthetic unity upon a larger number of elements it is (as we all in fact recognize) a greater work. The old distinction between the Fine Arts and the crafts is based to some extent upon snobbery and other non-aesthetic considerations. But not entirely. In the hierarchy of perfections a

perfect vase or a perfect carpet occupies a lower rank than that, say, of Giotto's fres-
coes at Padua, or Rembrandt's *Polish Rider*, or the *Grande Jatte* of Georges Seurat.
In these and a hundred other masterpieces of painting the pictorial whole em-
braces and unifies a repertory of forms much more numerous, varied, strange and
interesting than those which come together in the wholes organized by even the
most gifted craftsmen. And, over and above this richer and subtler formal perfec-
tion, we are presented with a non-pictorial bonus of a story and, explicit or im-
plicit, a criticism of life. At their best, non-representational compositions achieve
perfection; but it is a perfection nearer to that of the jug or rug than to that of the
enormously complex and yet completely unified masterpieces of representational
art—most of which, as we have seen, contain expressive passages of almost pure
abstraction. At the present time it would seem that the most sensible and rewarding
thing for a painter to do is (like Braque, for example) to make the best and the most
of both worlds, representational as well as non-representational.

Within his own Byzantine-Venetian tradition El Greco did precisely this, com-
bining representation with abstraction in a manner which we are accustomed to
regard as characteristically modern. His intention, as we have seen, was to use this
powerful artistic instrument to express, in visual terms, man's capacity for union
with the divine. But the artistic means he employed were such that it was not pos-
sible for him to carry out that intention. The existence of a spiritual reality tran-
scendent and yet immanent, absolutely other and yet the sustaining spiritual es-
sence of every being, has frequently been rendered in visual symbols—but not
symbols of the kind employed by El Greco. The agitation of quasi-visceral forms
in an overcrowded and almost spaceless world from which non-human nature has
been banished cannot, in the very nature of things, express man's union with the
Spirit who must be worshipped in spirit.

Landscape and the human figure in repose—these are the symbols through
which, in the past, the spiritual life has been most clearly and powerfully ex-
pressed, "Be still and know that I am God." Recollectedness is the indispensable
means to the unitive knowledge of spiritual reality; and though recollectedness
should and by some actually can be practised in the midst of the most violent phys-
ical activity, it is most effectively symbolized by a body in repose and a face that ex-
presses an inner serenity. The carved or painted Buddhas and Bodhisattvas of India
and the Far East are perhaps the most perfect examples of such visual symbols of
the spiritual life. Hardly less adequate are the majestic Byzantine figures of Christ,
the Virgin and the Saints. It seems strange that El Greco, who received his first
training from Byzantine masters, should not have recognized the symbolical value

of repose, but should have preferred to represent or, through his accessory abstractions, to imply, an agitation wholly incompatible with the spiritual life of which he had read in the pages of Dionysius.

No less strange is the fact that a disciple of Titian should have ignored landscape and that a Neo-Platonist should have failed to perceive that, in the aged master's religious pictures, the only hint of spirituality was to be found, not in the all too human figures, but in the backgrounds of Alpine foothills, peaks and skies. Civilized man spends most of his life in a cosy little universe of material artefacts, of social conventions and of verbalized ideas. Only rarely, if he is the inhabitant of a well-ordered city, does he come into direct contact with the mystery of the non-human world, does he become aware of modes of being incommensurable with his own, of vast, indefinite extensions, of durations all but everlasting. From time immemorial deity has been associated with the boundlessness of earth and sky, with the longevity of trees, rivers and mountains, with Leviathan and the whirlwind, with sunshine and the lilies of the field. Space and time on the cosmic scale are symbols of the infinity and eternity of Spirit. Non-human nature is the outward and visible expression of the mystery which confronts us when we look into the depths of our own being. The first artists to concern themselves with the spiritual significance of nature were the Taoist landscape painters of China. "Cherishing the Way, a virtuous man responds to objects. Clarifying his mind, a wise man appreciates forms. As to landscape, they exist in material substance and soar into the realm of spirit. . . . The virtuous man follows the Way by spiritual insight; the wise man takes the same approach. But the lovers of landscape are led into the Way by a sense of form. . . . The significance which is too subtle to be communicated by means of word of mouth may be grasped by the mind through books and writings. Then how much more so in my case, when I have wandered among the rocks and hills and carefully observed them with my own eyes! I render form by form and appearance by appearance. . . . The truth comprises the expression received through the eyes and recognized by the mind. If, in painting, therefore, the likeness of an object is skilfully portrayed, both the eye and the mind will approve. When the eyes respond and the mind agrees with the objects, the divine spirit may be felt and truth may be attained in the painting." So wrote Tsung Ping, who was a contemporary of St. Augustine, in an Introduction to *Landscape Painting*, which has become a Chinese classic. When, twelve hundred years later, European artists discovered landscape, they developed no philosophy to explain and justify what they were doing. That was left to the poets—to Wordsworth, to Shelley, to Whitman. The Presence which they found in nature, "the Spirit of each spot," is identical with

Hsuan P'in, the mysterious Valley Spirit of the Tao Te Ching, who reveals herself to the landscape painter and, by him, is revealed to others in his pictures. But the lack of an explanatory philosophy did not prevent the best of the European landscape painters from making manifest that

> Something far more deeply interfused,
> Whose dwelling is the light of setting suns,
> And the round ocean, and the living air,
> And the blue sky, and in the mind of man.

"This is not drawing," Blake exclaimed, when he was shown one of Constable's sketches, "this is inspiration." And though Constable himself protested that it was only drawing, the fact remains that the best of his landscapes are powerful and convincing renderings of the spiritual reality in which all things have their being. Indeed, they are much more adequate as symbols of spiritual life than the majority of the works in which Blake consciously tried to express his spiritualist philosophy. Much less gifted as painter than as poet, and brought up in a deplorable artistic tradition, Blake rarely produced a picture that "comes off" to the extent of expressing what he says so perfectly in his lyrics and in isolated passages of the Prophetic Books. Constable, on the other hand, is a great nature mystic without knowing or intending it. In this he reminds us of Seurat. "They see poetry in what I do," complained that consummate master of landscape. "No; I apply my method and that is all there is to it." But the method was applied by a painter who combined the most exquisite sensibility with intellectual powers of the first order. Consequently what Seurat supposed to be merely *pointillisme* was in fact inspiration—was a vision of the world in which material reality is the symbol and, one might say, the incarnation of an all-embracing spiritual reality. The famous method was the means whereby he told this Taoistic and Wordsworthian story; *pointillisme*, as he used it, permitted him to render empty space as no other painter has ever done, and to impose, through color, an unprecedented degree of unity upon his composition. In Seurat's paintings the near and the far are separate and yet are one. The emptiness which is the symbol of infinity is of the same substance as the finite forms it contains. The transient participates in the eternal, *samsara* and *nirvana* are one and the same. Such is the poetry with which, in spite of himself, Seurat filled those wonderful landscapes of Honfleur and Gravelines and the Seine. And such is the poetry which El Greco, in spite of what seems to have been a conscious desire to imply it, was forced by the nature of his artistic instrument to exclude from every picture he painted. His peculiar treatment of space and form tells a story of obscure

happenings in the sub-conscious mind—of some haunting fear of wide vistas and the open air, some dream of security in the imagined equivalent of a womb. The conscious aspiration towards union with, and perfect freedom in, the divine spirit is overridden by a sub-conscious longing for the consolations of some ineffable uterine state. In these paintings there is no redemption of time by eternity, no transfiguration of matter by the spirit. On the contrary, it is the low-level organic that has engulfed the spiritual and transformed it into its own substance.

When we think of it in relation to the great world of human experience, El Greco's universe of swallowed spirit and visceral rapture seems, as I have said, curiously oppressive and disquieting. But considered as an isolated artistic system, how strong and coherent it seems, how perfectly unified, how fascinatingly beautiful! And because of this inner harmony and coherence, it asserts in one way all that it had denied in another. El Greco's conscious purpose was to affirm man's capacity for union with the divine. Unconsciously, by his choice of forms and his peculiar treatment of space, he proclaimed the triumph of the organic and the incapacity of spirit, so far as he personally was concerned, to transfigure the matter with which it is associated. But at the same time he was a painter of genius. Out of the visceral forms and cramped spaces, imposed upon him by a part of his being beyond his voluntary control, he was able to create a new kind of order and perfection and, through this order and perfection, to re-affirm the possibility of man's union with the Spirit—a possibility which the raw materials of his pictures had seemed to rule out.

There is no question here of a dialectical process of thesis, antithesis and synthesis. A work of art is not a becoming, but a multiple being. It exists and has significance on several levels at once. In most cases these significances are of the same kind and harmoniously reinforce one another. Not always, however. Occasionally it happens that each of the meanings is logically exclusive of all the rest. There is then a happy marriage of incompatibles, a perfect fusion of contradictions. It is one of those states which, though inconceivable, actually occurs. Such things cannot be; and yet, when you enter the Prado, when you visit Toledo, there they actually are.

1943

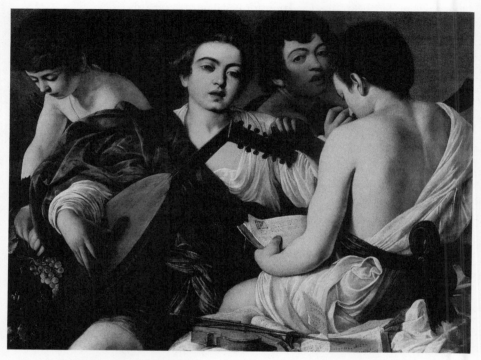

Michelangelo Merisi de Caravaggio (1573–1610): *The Musicians*, c. 1595. Oil on canvas, 36¼" × 46⅝". The Metropolitan Museum of Art, Rogers Fund, 1952. 52.81.

STEPHEN KOCH

Caravaggio and the Unseen

Caravaggio is the greatest realist of the Renaissance (*naturalista*, I concede, would be the less anachronistic term) and yet the biography of this shadowy genius of the concrete reads strangely like a dream. At any rate, there is something dreamlike in the few fretful scraps of fact about his life still visible in the historical chiaroscuro. Less is chronicled of Caravaggio than of any comparable figure in the Renaissance. His biography is a simulacrum assembled not from the annals and anecdotes of admirers and sycophants, but from court records, police reports, contractual squabbles, snide gossip. As in a dream, some surviving details are obscure to the point of being hermetic—whole years sink in the historical murk—while others are almost lurid with oneiric precision: For example, in a restaurant (we even know its name: the Osteria del Moro), April 24, 1604, Caravaggio is served a plate of artichokes. He asks the waiter whether they have been cooked in oil or butter—and gets sass: "Smell them and find out." Speaking to the West's greatest artist of the paroxysmal moment, the *cameriere* has sassed the wrong man. In one flash of fury, as if in a Caravaggio, the plate, artichokes and all, is flung at the offender. Flung: We seem to glimpse every detail illuminated in one strobe of violence before the darkness closes again.

Then too, as in a dream, these fragments *speak*. Even in their dissociation, they *feel* coherent, indeed, compelling. And, as in a deepening troubled sleep, they grow steadily more distressed, and finally tortured, as they sink toward nightmare.

The year is around 1592. An orphaned apprentice of around twenty arrives in Rome from a nowhere in the north. From nowhere, he is nowhere; he lives as an exploited studio assistant, very probably selling (even painting) his work on the

sidewalks and living in the streets. Though his genius would rescue him from those streets by the time he was twenty-four or so, Caravaggio's first years in Rome were surely spent on the rough side of the hustle, living in the underworld of the tough, rotten, opportunistic *ragazzi* whom he would see and depict as nobody ever had before or would again; the same whose look-alike descendants one still sees everywhere in Rome, careening under the plane trees on their Vespas, filling the tank in the Agip station. *Nec spes, nec metus* is the motto: "No hope, no fear." It was a demimonde, a world of kids and sharps and whores and hustlers, where all money was cadged and all position a kind of imposture.

Living in the streets, Caravaggio *watched* the streets. Let us be clear: the word "realist" did not exist in the seventeenth century. The ideologies with which the nineteenth and twentieth centuries freighted that word were unknown. Caravaggio and his followers *were* called "*naturalisti*," however. It is known that even as a teen-ager Caravaggio abusively—arrogantly it was thought—dismissed then prevalent Raphaelizing and manneristic notions that defined art as the depiction of an ideal beauty. When asked where, if he dismissed Raphael, he found his ideal types, he pointed peremptorily to a cluster of loiterers in the street.

Sharp eyes: His first important sale—the one that rescued him from that street—is *I Bari* (*The Cardsharps*, now existing only in a copy in London), in which a wonderfully watchful crooked *ragazzo* and his bearded shill are at the very moment of conning an unsuspecting young mark by means of a palmed eight of clubs. Caravaggio was always fascinated by the *exact* language of immediacy; *I Bari* shows the cheaters' precise moment of recognition: Turn the trick *now*. Sharp eyes: Caravaggio's body language, even at its most elevated, is always in the vernacular. Among the most powerful and widely remarked aspects of his great *Calling of Saint Matthew* in the Church of San Luigi dei Francesci in Rome is that the group of men disrupted by Christ's divine vocation is so obviously just a bunch of guys hanging out in some Roman tavern; that the reluctant saint is himself so obviously just another one of them, there in his sullen hunch at the end of the table, where his whole body, at the very verge of his exaltation, seems to say, *Hey, leave me alone. Get some other guy.*

When I speak of hustlers, however, I use the word in its classic double sense: hustlers on the make, hustlers being made. The bemused buyer of *I Bari* was no one less than Cardinal Francesco del Monte, a principal agent of the Medici family in the Sacred College of Cardinals, and a man whom history must honor as having defended Caravaggio—an obviously impossible individual—through his many trying vagaries from first to last. The cardinal was a man of high classic Renaissance refinement; he was also a connoisseur of boys, cheaters or no. It is per-

fectly plain that Caravaggio must have encountered the sexual demimonde in his life on the streets, one that certainly included a kind of prostitution, perhaps even on Caravaggio's own part. No scholar seems *quite* prepared to say so, but it seems to me very plain that the man-boy who before 1601 painted the great portraits of the *ragazzi* had at the very least seen and pondered a certain kind of organized sexual exploitation. A strong homoerotic strain runs through Caravaggio's art from beginning to end; I would argue that, without exception, all his *Saint John the Baptists* are meditations on this aspect of desire—all those, that is, that are not alternatively, and instructively, about the same saint's death by decapitation. Yet the eroticism of the boy John the Baptists changes as Caravaggio grows into manhood. The plangent and ravishing *Saint John the Baptist* in the Nelson Gallery at Kansas City, painted in 1605, Caravaggio's last year in Rome, is as deeply erotic as any picture ever painted, but it is untouched by the tiniest hint of seductiveness. The sad, shaded beauty here looks inward; the picture deals in a tragic dimension, a solitude wrapped somewhere inside desire. Not so the hot stuff of Caravaggio's late teens and early twenties. These *ragazzi* are poseurs; they are flat out on the make, they are playing out their rigged, rotten game to the end. *The Fruit Vendor*—still one of the most popular and frequently reproduced pictures in Europe—could hardly be more outrageous in the transaction it proposes. There are the languid players in *The Music Lesson* in the Metropolitan; or the explicitly seducing *Bacchus* in the Uffizi; or *The Boy Bitten by a Lizard* in London. The latter is Caravaggio's most explicit look at what Gore Vidal calls The Life; the shrieking boy is plainly effeminate; his shirt is shamelessly pulled down off his left shoulder (*the* sign of sexual availability in Caravaggio); and he is being bitten by the lizard—itself a sexual symbol—on that third finger which from Petronius to the American truck driver is digital vernacular for sodomy. Finally, and above all, there is the great and uncannily sophisticated *Self-Portrait as a Sick Bacchus* in the Galleria Borghese. These pictures offer a glimpse—and through a uniquely powerful eye—of an otherwise vanished Renaissance phenomenon: the homosexual underworld of the boy *mignon*.

This usually elided truth is surely even more striking than it at first appears. Has *any* major artist—even a modern—ever approached anything remotely comparable to Caravaggio's stature in terms that begin by being so profoundly compromised by the suggestion of the secret, the coded, the shameful? After all, these extraordinary paintings, executed when Caravaggio was barely out of his teens, are every one of them beguiling and corrupt icons that all too expertly mingle a double language of fact—street fact—with fantasy: wishing with being, desire with contempt. Intellectually freed by the very anonymity of their sitters, they are surely

among the most beautiful portraits of the Renaissance, and yet—*Self-Portrait as a Sick Bacchus*, indeed!

So there was sexual exploitation in his life that we cannot quite see. There was also deep neurosis, and who knows how the two were conjoined? We know only that Caravaggio was a man whose life, in his maturity, was torn to pieces by violent and, it seems, entirely unmastered feelings of rage. Most of what was recorded about him, even at the height of his career, is some record of some blind tantrum. Now of course, anger can be an instrument, and for somebody who wishes to be feared, it can be an instrument of power. But Caravaggio, I suspect, wished to be loved more than feared, and although he subdued his furies in his convulsive art—one cannot imagine that art without his rage—in life every recorded instance of his rage shows it working against him, and doing so with steadily more violent and self-lacerating power. Howard Hibbard reports an anecdote which, though of questioned authenticity, seems absolutely in character and, as Hibbard says, *ben trovato*. When the patron of his *Resurrection of Lazarus* (it was painted in Messina, one of his very last works) made some mildly critical remarks about some trivial detail of the work in progress, Caravaggio drew his sword and slashed the picture to shreds. Then, recovering himself, he promised to make a new picture, this time, "just what was wanted." One can hardly imagine a more telling illustration of the imbalance between rage and the wish to please in this violent, unloved man.

Caravaggio's rage was linked, destructively, not only to his wish to be loved, but to love's social concomitant, the wish to be admired. He was obsessed with a need for standing—I agree with Hibbard that this probably explains his disastrous sycophantic relation to the Knights of Malta. Long before that episode, he had insisted upon, without carrying off, all kinds of aristocratic airs. The truth is that his craving for legitimacy was undermined by an even more powerful need to violate that legitimacy the moment it came within his grasp. Obsessed with caste, Caravaggio's fury invariably carried him back into the role of outcast. Once he was famous, we find him being hauled in by the police every few months for some new nonsense or other: shouting matches, fisticuffs, thrown rocks, swordfights. Note well that these altercations do not date from his own rough days as a penniless *ragazzo*, when one might expect run-ins with the police. No: they begin with his fame. They coincide with his fame. It is as if the fury fed on celebrity.

And then his rage carried him beyond the pale to murder. On Sunday evening, May 29, 1606, in the Campo Marzio—at the height of his powers, recognized as one of the most important painters in Europe, at work on *The Madonna of the Rosary* (a work which in my opinion brings him as close as he ever would come to mainstream banality)—Caravaggio killed a man. A bet and a ball game were fol-

lowed by a quarrel; the quarrel by some asinine duel. Then, a sudden rage of knife play; a young man named Ranuccio Tomassoni was fatally stabbed—according to one report, in the groin. Once again, it is a Caravaggio—we seem to see the instant, bright with violence; we see the close-in thrust; see the victim's mouth, round with agony. Then flight, and darkness again.

This was no anonymous street killing. Tomassoni (not incidentally, a fervent admirer of Caravaggio's work) was from a quite notable Florentine family; and Caravaggio, *"celebrime pittore"* or not, was in short order a fugitive from the pope's justice. Exile was followed by exile from exile. Caravaggio's self-destructive pattern would be repeated now in ever-shortening cycles. From Naples to Sicily to Malta and back again, Caravaggio painted his way, chasing his vanishing celebrity, working in six-months stints here and there, first impressing the provincials with his name and skill, then invariably fouling the new nest, moving from flight to flight.

Here is where dream sinks toward nightmare. In Messina, he is expelled for having been caught—the detail is almost too poignant—staring too intently at a group of boys in the rough-and-tumble of some street game. *Celebrime pittore*, hell; the town fathers knew what *that* was all about. In Malta, he was imprisoned by the knights whose favor he had pursued, at first, at the cost of unlimited sycophancy. Typically, as soon as they knighted him, he picked a fight—assaulting one of the noble order's nobler big shots, only instantly to suffer the parvenu's reward. In Naples, a gang of thugs, quite possibly hired by the Maltese, beat him, outside a café, "beyond recognition." Recovering slowly—ominously slowly—he was now petitioning a new pope for pardon and permission to come home. This would prove to be his final delusion. When he embarked at last on his now desperately desired return, the felucca bearing him up the coast put into the tiny town of Porto Ercole, where he was arrested—by mistake. They were after some other unforgiven miscreant. Released two days later, Caravaggio rushed to the shore—only to see his ship pulling away, leaving him behind and bearing with it the work of his exile. It is a delirious moment. He gave chase: he literally pursued the vanishing, vanished ship down the coastline, running, stumbling across the rocks under the blazing, leonine sun. He ran for miles, miles. At length he was found collapsed on the beach. Two days later, he was dead.

In Rome, his pardon had just been granted.

So this tenebrous, half-seen man vanishes, leaving the forgetful traces of much pain, many petty—and one major—crime. That, and his work. Now I have insisted upon Caravaggio's half-absence in the historical record the better to promote a paradox. Compared to the much-annaled Michelangelo before him or the

much-annaled Bernini after, Caravaggio is the invisible man of the Renaissance. And yet in his work one is conscious of that man's palpable presence, one feels his breathing, hurt personality in the work, as one does with no other figure of his time.

This oddity is partly a matter of his visibly personal style, what his contemporaries called his "dark and dashing manner," so instantly recognizable as Caravaggio's—or as one of the *Caravaggisti*. Then again, Caravaggio's palpable presence in these paintings is partly an aspect of his realism. Just as the people seen in these paintings are not mannerist fancies but intensely real people, so it is an intensely real man who has seen them. The *noticing* in these pictures has not been aspirated into the ideal. Finally, his presence is literally depicted, part of his strong autobiographical bent, above all in the high pathos of the self-portraits concealed with more or less obvious Hitchcockian cleverness throughout his work. Caravaggio may be shadowy, but we know *precisely* what he looked like, man and boy. This great realist knew the mirror well, and his *autoritratti* are among the most compelling in the Renaissance tradition.

Among the several themes of the *autoritratti* is one I have already suggested in Caravaggio's treatment of Saint John the Baptist: a meditation, more than a little colored by eros, on the passage from boy to man. The self-portraits suggest trauma in Caravaggio's own passage to manhood. Only seven years pass between the *Sick Bacchus*, in which he shows himself a notably boyish nineteen, and the *Martyrdom of Saint Matthew*, in which his face, at twenty-six, seems prematurely aged, almost ravaged. In that picture, Caravaggio places himself in the rear of the alarmed circle of witnesses that has formed around the saint under attack—a circle that extends, in imagination, into the chapel space to include the spectator. His brow is furrowed; his comprehending eyes are in pain; he extends one hand in a gesture at once of balance and refusal. It also frames the space. In this artist above all others, there must have been something of quite special compelling power in the revisions and rites of passage from boy to man, a passage from hustler to celebrity, from object to witness, from sharp-eyes to visionary. It is a passage which seems to me most powerfully synthesized at last in the great and horrifying *David Holding the Head of Goliath* in the Borghese. The features once those of the little sick Bacchus are here again, but now they have become the defeated features of the brute's head, severed moments before, dripping blood and seeming for just a few more lingering moments still, just barely, alive in death. This object dangles from the firm outstretched fist of a fastidious, determined, angry, secretly saddened . . . boy. It is in the boy's sadness that we see the features of the man to come. I think it noteworthy that a shrewd contemporary, remarking as many did on the presence of

Caravaggio's face in the slobbering, decapitated, moribund thing, also suggested that the head was held by *"il suo Caravaggino"*—his own little Caravaggio.

Deep in this murdering meditation on man and boy, Caravaggio reached maturity with astonishing speed. He passed, after all, from being a painter of sexy little *mignons* to being arguably the greatest religious artist of the seventeenth century in something like seven years.

Nonetheless, he seems almost to begin with a particularly masterful and original style. The word original is noteworthy here, since Caravaggio can be called original in a slightly more modern sense of that word than would be imputed to most of his peers in the Renaissance. The originality of Caravaggio's predecessors consisted primarily in the mastering in some inventive new elaboration of a broad and ever more completely codified visual rhetoric. Since this rhetoric was wide and diverse, the mark of Renaissance genius was not, as it sometimes has seemed to be among moderns, some decisively personalized individual style—which to the Renaissance would look more like mere obsessive eccentricity. It was, precisely, diversity, a description of genius, for which the very type was of course Michelangelo.

Now, there *is* no diversity in Caravaggio. His genius is, in that sense, quite at odds with the Renaissance ideal of the universal man. He did one thing (apart from brawling), and one thing only: paint pictures. There are no frescoes; there is no sculpture, no architecture, no philosophical meditations. He does not seem even to have drawn; in any event, not one Caravaggio drawing survives. His originality lies elsewhere; it lies in the creation of the immediately identifiable, intensely personal style we have been discussing, a *look*, a look which is his, and his alone. We can spot that look from a distance, and we promptly identify it, revealingly, *with his name*, not unlike a stroller in the Museum of Modern Art can spot at ten yards, from its "look" alone, before really inspecting the picture at all, "a" Picasso; "a" Stella; "a" Johns. So Caravaggio is original in this rather new sense: *His style has a presence that bears his name.* This is invention not as diversity and multiplicity of talent, but as an impassioned personalized narrowness. It is genius as obsession. In a far more acute and obvious sense than is the case with Michelangelo, we have the impression of reading, in this personal style, a man's destiny. That is, we see precisely what is, for him, compelled and narrow in the otherwise wide diversity of life. It is in this sense that Caravaggio endows the picture surface, far more acutely than do his peers, with a legible dimension of himself. We are conscious in consequence of an interest in underwriting the work with that self; in meditating, in a rather explicit way, on his own relation to his work; in making that relation to his work—through *style*—one of his most felt subjects and preoccupations.

Paradoxically enough, this is a kind of originality that is very easy to imitate. In the sixteenth century, to learn from Michelangelo, to imitate him, even to outright copy him, merely meant the artist was using Michelangelo to master *the* style. He did not thereby become some sort of acolyte, a "Michelangelino." But the seventeenth century is riddled with *Caravaggisti*. Creating a style in a peculiarly modern sense, he initiated a peculiarly modern corollary. He started a peculiarly modern *fashion*.

It will surprise no student of modern realism that something so intensely subjective and personal as this style might proceed from realist—*naturalista*—motives. Yet the academically received has renewable truth. That Caravaggesque *presence*, that uncannily real unmediated thing, remains sufficiently strong and sunlit to impress itself on Frank Stella (in his Charles Eliot Norton lectures) as a Renaissance analogue to his own thoughts about the role of "the real" in abstraction. I find nothing fanciful about Stella's invocation of Caravaggio as a paradigm of the "real," even while insisting he is completely unconcerned with the *naturalisti's* question of depiction. Stella's meditation on Caravaggio, abstraction, and the real concern *presence*, presence and energy. About these, Caravaggio has everything to say.

What became a fashion began as a presence—and a presence of the "real" at that—which endows these works with their power. I already have spoken of Caravaggio's transformation between 1597 or so and 1600, from being the painter of the *Boy Bitten by a Lizard* to the painter of the Matthew Chapel. It was a movement from boyhood to manhood; it also marks the movement of this most shockingly secular great painter of the Renaissance to his role as a great religious artist. I do not mean to suggest that Caravaggio himself passed through a conversion or some analogous religious transformation. The record suggests nothing of the kind. On the contrary, I am struck by the continuity between his secular and religious art. The hunched reluctance of the saint in *The Calling of Saint Matthew,* and the deep erotic . . . grieving of the Saint John in the Nelson Gallery are both varieties of inwardness seen by the same master of inwardness.

Yet the authenticity of Caravaggio's religious feeling seems to me not open to doubt. I do not for a moment imagine that these images are mere pretexts for respectability, as for example, the Bacchi and Music Lessons had been mere pretexts for more boys. No: Too much that is too profound is seen here.

Yet the truth is that Caravaggio, this painter of boy whores, came to his task of religious vision in the Matthew Chapel and in the (if possible) even greater work in the Cerasi Chapel of Santa Maria del Popolo, in the very particularly driven fashion of a painter very particularly obsessed with the flesh. The flesh seen.

This being the case, it is not surprising that the visual language Caravaggio

brings to his task as a religious painter is one deeply engaged with the relation between the flesh and the spirit; and as a parallel, between the seen and the unseen. Or, to snare the discussion within an alternate critical vocabulary, between presence and absence. I find it particularly apropos—it is my final point about our invisible man—that in a number of Caravaggio's greatest paintings, the unseen is quite literally embraced.

I owe to a pleasant summer evening in Rome with the American abstract painter David Reed—Reed is a no less astute student of Caravaggio than Stella— confirmation of a simple observation which, once made, strikes me as being self-evident, but which quite inexplicably I have found nowhere in the literature. In the Galleria Doria in Rome hang Caravaggio's two earliest extant religious paintings. They were painted in the same year (1597) on the same commission, and used the same woman as a model. One is the *Repose on the Flight into Egypt*. Hanging directly beside it is a greater work, the *Magdalene Repentant*. In the *Repose*, the exhausted Virgin sits on a rock to the right of a serenading angel, holding her Child in the classic cradling embrace, her head tilted to our right. Her eyes are closed; she seems in fact to have fallen asleep; one of her hands (though the baby is still held firm) has slipped down slack in her lap. Hanging directly to the right of this picture is the Magdalene. She seems depicted from the model who served for the Virgin. She also is in the same pose. It is in fact almost *exactly* the same pose. She sits on a low stool. Her head likewise bends down to our right, not in exhaustion, of course, but in penance and pain. Most important, her arms are held in precisely the same cradling position as are the Virgin's. The difference, of course, is that she holds no child; she is, as it were, cradling a child not there. The arms are in precisely the classic maternal embrace; the crook of her left arm is in precisely the position to rest the baby's head, and the direction of her eyes, which are not closed but half open, is directly into what would be a baby's upward-looking gaze. In short, the emblem of the prostitute's simultaneous penance and redemption is an absent child, whom she simultaneously embraces and grieves over.

Once it is seen, one wonders how so obvious a fact ever could have been missed, so visible is the absence. As a parallel between the two Marys, it was of course an extraordinarily bright visual idea, with its very real significance for the theology of the Magdalene. It is also an absence that embodies—I choose the word advisedly—a particularly acute insight into the sexual iconography of Christianity, and Counter-Reformation Catholicism in particular. One can only speculate on the thoughts of the twenty-one-year-old orphan, working away in Del Monte's Palazzo Madama in the midst of his *mignon* phase, suddenly coming on it; *seeing* it. It must have been an exciting moment.

In any case, the absent presence the Magdalene embraces in the cradling oval

of her arms will reappear. I would argue it does so in a number of paintings, among them several that must be judged among the greatest in the canon of Western art. Caravaggio will use that circle to define absence again and again. It is seen once again, no longer a gesture of cradling but of grief—the grief of the Mary whose arms are uplifted at the top of the *Deposition*; it will be recapitulated by Saint Peter's gesture of astonishment and made—crucially—to extend into the spectator's space, in the great *Supper at Emmaus* in Potsdam. It is the circle of complicity and witness that Caravaggio himself frames at the rear of the *Martyrdom of Saint Matthew* and which, likewise, extends into the space of the chapel where the spectator hovers at the communion rail. The fascinating issue of that picture's placement in the chapel architecture combines the issues of light source, chiaroscuro, and the sculptured nature of the figures with an architectural definition of the spectator's space. For the sake of my argument, I regret that the *Narcissus* (just barely visible in the National Gallery of Rome) is now generally regarded as not by the master but by one of the *Caravaggisti*; the circle completed by the reflecting water of the yearning boy's arms is an ideal example, the best secular one I know, of the figure I have in mind.

But the most important instance of this absent presence is the one embraced in the *Conversion of Saint Paul* in the Church of Santa Maria del Popolo in Rome.

Whoever has seen this astonishing masterpiece knows it to be both beyond description and praise. (It is not, however, quite beyond criticism; it contains a number of quite visible errors in perspective.) It is surely one of the greatest pictures in the canon; it alone would be sufficient to place Caravaggio in the first ranks of the West. The embraced void I have in mind is of course in this case the one outlined by the saint's uplifted arms and the upper body of the horse that stands so very peacefully above—almost directly over—him. The light source is not naturalistic but mystical, though quite typically it is on the razor's edge of naturalism; it takes a bit of looking for us to be clear that the light really comes from within the oval void the picture defines. It is a light held, as it were, within Paul's uplifted embrace, although it is light his eyes are serenely closed to. Or is it on?

Indeed, serenity is what most powerfully marks everything in this great picture of transformation. It is of the utmost formal importance to remember that Caravaggio is, from *I Bari* on, an artist preoccupied with time, and in particular with the convulsive, paroxysmal moment, *the instant seen*. Not incidentally, the *Crucifixion of Saint Peter*, which faces the *Conversion* in the chapel of Santa Maria del Popolo, renders the convulsive moment in the most literal terms: a turning over. Now, time, like a number of things embraced in Caravaggio's sense of presence, is unseen. I would argue, however, that in all his work he contrives a way to, as it

were, visually measure the duration of the convulsive moment. This visual measuring of that unseen thing, the instant, is the meaning of time in all of Caravaggio. It is the meaning of time in his diciest work, as in *The Boy Bitten by a Lizard*—his fastest shot. It is the meaning of time, too, in *David Holding the Head of Goliath*, measured in the moments it will take for the moribund head of the Goliathself to reach brain-death and the extinguished light.

It is also a visual measuring of the instant that gives meaning to this, his greatest religious picture. Here the moment of convulsion—no, conversion—is construed as an absolute serenity. The saint's body armor has been flung down; though he still wears the leather halter for his breastplate, the metal shielding has been torn off, leaving his chest naked; his helmet and sword have been knocked aside. The man thus pacified has just experienced violence. His upraised arms and spread fingers show him in a state of absolute attention. But look at his face: The saint is in ecstasy, but it is an ecstasy like sleep. Caravaggio's body language, as I have said, is always in the vernacular. Sleep. Indeed, what is sleep but the time in which we all, every day, experience the dissolution of duration, the untimed dreaming space in which our consciousness of the moment itself dissolves? There is a gentle circle of silence that defines this great work, and inside that circle a moment is being measured—measured in immediately understandable terms against the flesh of the saint who would speak of the evidence of things unseen. Our *ragazzo* has made it a metaphor for eternity.

1985

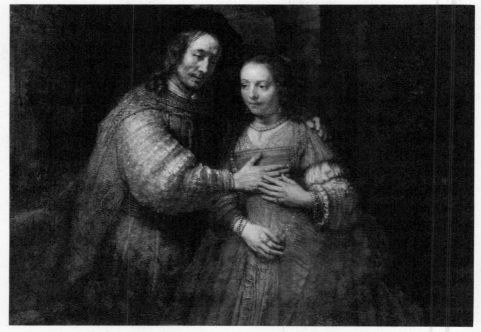

Rembrandt van Rijn: *The Jewish Bride*, c. 1665. Rijksmuseum-Stichting, Amsterdam.

JEAN GENET

Something Which Seemed to Resemble Decay . . .
[Rembrandt]

1.

A work of art should exalt only those truths which are not demonstrable, and which are even "false," those which we cannot carry to their ultimate conclusions without absurdity, without negating both them and ourself. They will never have the good or bad fortune to be applied. Let them live by virtue of the song that they have become and that they inspire.

Something which seemed to resemble decay was in the process of cankering my former view of the world. One day, while riding in a train, I experienced a revelation: as I looked at the passenger sitting opposite me, I realized that every man *has the same value* as every other. I did not suspect (or rather I did, I was obscurely aware of it, for suddenly a wave of sadness welled up within me and, more or less bearable, but substantial, remained with me) that this knowledge would entail such a methodical disintegration. Behind what was visible in this man, or further—further and at the same time miraculously and distressingly close—I discovered in him (graceless body and face, ugly in certain details, even vile: dirty moustache, which in itself would have been unimportant but which was also hard and stiff, with the hairs almost horizontal above the tiny mouth, a decayed mouth; gobs which he spat between his knees on the floor of the carriage that was already

filthy with cigarette stubs, paper, bits of bread, in short, the filth of a third-class carriage in those days), I discovered with a shock, as a result of the gaze that butted against mine, a kind of universal identity of all men.

No, it didn't happen so quickly, and not in that order. The fact is that my gaze butted (not crossed, butted) that of the other passenger, or rather melted into it. The man had just raised his eyes from a newspaper and quite simply turned them, no doubt unintentionally, on mine, which, in the same accidental way, were looking into his. Did he, then and there, experience the same emotion—and confusion—as I? His gaze was not someone else's: it was my own that I was meeting in a mirror, *inadvertently and in a state of solitude and self-oblivion*. I could only express as follows what I felt: I was flowing out of my body, through the eyes, into his *at the same time as he was flowing into mine*. Or rather: I *had* flowed, for the gaze was so brief that I can recall it only with the help of that tense of the verb. The passenger had gone back to his reading. Stupefied at what I had just discovered, only then did I think of examining the stranger. My examination resulted in the impression of disgust described above. Under his drab, creased, shabby clothes his body must have been dirty and worn. His mouth was flabby and protected by an unevenly clipped moustache. I thought to myself that the man was probably weak, perhaps cowardly. He was over fifty. The train continued its indifferent way through French villages. Evening was coming on. I was deeply disturbed at the thought of spending the minutes of twilight, the minutes of complicity, with this partner.

What was it that had flowed out of my body—and what had flowed out of his?

This unpleasant experience was not repeated, neither in its fresh suddenness nor its intensity, but its reverberations within me never ceased. What I had experienced in the train seemed to resemble a revelation: over and above the accidents—which were repulsive—of his appearance, this man concealed, and then let me reveal, what made him identical with me. (I first wrote the preceding sentence, then corrected it by the following, which is more accurate and more disturbing: I knew that I was identical with that man.)

Was it because every man is identical with another?

Without ceasing to meditate during the journey, and in a kind of state of self-disgust, I very soon reached the conclusion that it was this identity which made it possible for every man to be loved *neither more nor less* than every other, and that it is possible for even the most loathsome appearance to be loved, that is, to be cared for and recognized—cherished. That was not all. My train of thought also led me to the following: this appearance, which I had first called vile, was—the word is not too strong—was *willed* by the identity (this word recurred persistently, perhaps

because I did not yet have a very rich vocabulary) which was forever circulating among all men and which a forlorn gaze accounted for. I even felt that this appearance was the temporary form of the identity of all men. But this pure and almost insipid gaze that circulated between the two travellers, in which their wills were not involved, which their wills would perhaps have prevented, lasted only an instant, and that was enough for a deep sadness to fill me and linger on. I lived with this discovery for quite a long time. I deliberately kept it secret and tried not to think about it, but somewhere within me there always lurked a blot of sadness which, like an inflated breath, would suddenly darken everything.

"Behind his charming or, to us, monstrous appearance," I said to myself, "every man—as has been revealed to me—retains a quality which seems to be a kind of ultimate recourse and owing to which he is, in a very secret, perhaps irreducible area, what every man is."

I even thought I found this equivalence at the Central Market, at the abattoirs, in the fixed but not gazeless eyes of the sheepheads piled up in pyramids on the sidewalk. Where was I to stop? Whom would I have murdered if I had killed a certain cheetah that walked with long strides, supple as a hoodlum of old?

I have written elsewhere that my dearest friends took refuge—I was sure they did—in a secret wound, "in a very secret, perhaps irreducible realm." Was I speaking of the same thing? A man was identical with every other man, that was what I had discovered. But was this knowledge so rare as to warrant my amazement, and what could it profit me to possess it? To begin with, knowing a thing analytically is different from grasping it in a sudden intuition. (For I had, of course, heard people say, and had read, that all men were equal, and even that they were brothers.) But in what way could it profit me? One thing was more certain: I was no longer able not to know what I had known in the train.

I was incapable of telling how I moved from the knowledge that every man is like every other man to the idea that every man *is* all the others. But the idea was now within me. It had the presence of a certainty. It could have been stated more clearly—though I will be deflowering it somewhat—in the following aphoristic way: "Only one man exists and has ever existed in the world. He is, in his entirety, in each of us. Therefore he is ourself. Each is the other and the others. In the laxity of the evening, a clear gaze that was exchanged—whether insistent or fleeting—made us aware of this. Except that a phenomenon of which I do not even know the name seems to divide this single man ad infinitum, apparently breaks him up in both accident and form, and makes each of the fragments foreign to us."

I expressed myself clumsily, and what I felt was even more confused and stronger than the idea of which I have spoken. The idea was dreamed rather than

thought; it was engendered and drawn along, or dredged, by a rather woolly reverie.

No man was my brother: every man was myself, but temporarily isolated in his individual shell. This observation did not lead me to examine, to review, all ethical notions. I felt no tenderness, no affection, for that self which was outside my individual appearance. Nor for the form taken by the other—or its prison. Its tomb? On the contrary, I tended to be as pitiless toward that form as I was toward the one that answered to my name and that has been writing these lines. The sadness that had settled on me was what disturbed me most. Ever since the revelation that I had experienced when looking at the unknown traveller, it was impossible for me to see the world as in the past. Nothing was sure. The world suddenly wavered. For a long time I remained, as it were, sickened by my discovery, but I felt that it would soon force me to make serious changes, changes which would be in the nature of renunciations. My sadness was an indication. The world was changed. In a third-class carriage between Salon and Saint Rambert d'Albon it had just lost its lovely colours, its charm. I was already bidding them a nostalgic farewell, and it was not without sadness or disgust that I was entering upon ways which would be increasingly lonely and, more important, was entertaining visions of the world which, instead of heightening my joy, were causing me such dejection.

"Before long," I said to myself, "nothing that once meant so much will matter, love, friendship, forms, vanity, nothing that involves charm and appeal."

But perhaps the gaze with which I had looked at the traveller, a gaze so dreadfully revealing, had been possible owing to a very old cast of mind that was due to my life, or for some other reason. I was not very sure that another man could have felt himself flowing through his eyes into someone else's body, or that the meaning of this sensation would have been the same for him as that which I have been ascribing to it. I who had always been tempted to doubt the *fullness* of the world was perhaps now trying to slip into particular envelopes, the better to deny individuality.

"Before long, nothing more will matter . . ." Or perhaps nothing would be changed. If each envelope preciously sheathes a single identity, each envelope is individual and succeeds in establishing in us an opposition that seems irremediable, in creating an innumerable variety of individuals who are equivalent: each-other. Perhaps the only precious, the only real thing that each man had was this very singularity: "his" moustache, "his" eyes, "his" clubfoot, "his" harelip. And what if his only source of pride were the size of "his" prick? But this gaze went from the unknown traveller to me, and what of the immediate certainty that each-other were only one, both *either* he or I *and* he and I? How could I forget that mucus?

Let us continue. The knowledge of what I had just learned did not require that I direct my efforts according to the revelation in order to dissolve myself in an approximate contemplation. Quite simply, I could no longer avoid knowing what I knew, and, come what may, I had to pursue the consequences, regardless of what they were. Since various incidents in my life had forced me into poetry, perhaps the poet would have to make use of this discovery that was new to him. But above all I had to note the following: the only moments of my life which I could regard as true, ripping apart my appearance and exposing . . . what?

A *solid vacuum* that kept perpetuating me? I had known those moments during a few bursts of really holy anger, in equally blessed states of fear, and in the rays—the first—that shot from a young man's eyes to mine, in our exchange of glances. And in the traveller's gaze that entered me. The rest, all the rest, seemed to me the effect of a false point of view induced by my appearance, which itself was necessarily fake. Rembrandt was the first to expose me. Rembrandt! That stern finger which thrusts aside the finery and shows . . . what? An infinite, an infernal transparency.

I thus felt deep disgust for what I was moving toward and was unaware of and what I could not, thank God, avoid, and then a great sadness about what I was going to lose. Everything around me was losing its enchantment, everything was decaying. Eroticism and its transports seemed rejected, definitively. How could I be unaware, after the experience in the train, that every charming form is, if it contains me, myself? If I wished to recapture this identity, every form, whether monstrous or agreeable, lost its power over me.

"The erotic quest," I said to myself, "is possible only when one supposes that each human being has his own individuality, that it is irreducible, and that the physical form accounts for it, and it only."

What did I know about the significance of the erotic? But I felt disgust at the thought that I circulated in every man, that every man was myself. If, for a short time thereafter, every conventionally beautiful male form retained any power over me, it was, so to speak, by reverberation. This power was the reflection of the one to which I had so long yielded. A nostalgic farewell to it too. Thus, each person no longer appeared to me in his total, absolute, magnificent individuality: as a fragmentary appearance of a single being, it disgusted me more. Yet I wrote what precedes without ceasing to be troubled, to be haunted, by the erotic themes that were familiar to me and that dominated my life. I was sincere in speaking of a quest on the basis of the revelation "that every man is every other man, as am I"—but I knew I wrote that too in order to rid myself of eroticism, to try to get it out of my system, in any case to keep it at a distance. A congested, eager penis, standing erect in a

thicket of black curls, and what continues it: the thick thighs, then the torso, the whole body, the hands, the thumbs, then the neck, the lips, the teeth, the nose, the hair, and lastly the eyes, which cry out for the transports of love as if asking to be saved or annihilated—and does all of this fight against the fragile gaze which is perhaps capable of destroying that Omnipotence?

2.

Our gaze can be quick or slow, depending on what we look at as much as on us— perhaps more. That is why I speak of the quickness, for example, that thrusts the object toward us, or of a slowness that makes it ponderous. When our eyes rest on a painting by Rembrandt (on those he did in the last years of his life), our gaze becomes heavy, somewhat bovine. Something holds it back, a weighty force. Why do we keep looking, since we are not immediately enchanted by the intellectual liveliness that knows everything and all at once—about, for example, Guardi's arabesque? Like the smell of a barn: when I see only the bust of the sitters (Hendrijke, in the Berlin Museum) or only the head, I cannot refrain from imagining them standing on manure. The chests breathe. The hands are warm. Bony, knotted, but warm. The table in *The Syndics* rests on straw, the five men smell of cow dung. Under Hendrijke's skirts, under the fur-edged coats, under the painter's extravagant robe, the bodies are performing their functions: they digest, they are warm, they are heavy, they smell, they shit. However delicate her face and serious her expression, *The Jewish Bride* has an ass. You can tell. She can raise her skirts at any moment. She can sit down, she has what it takes. *Mevrow Trip* too. As for Rembrandt himself, the fact is even more obvious: starting with the first self-portrait, the mass of flesh increases from one painting to the next, until the very last, which it reaches in definitive form, though not void of substance. After losing what was most dear to him—his mother and his wife—it is as if this strapping fellow were trying to lose himself, unconcerned about the people of Amsterdam, to disappear socially. "To want to be nothing" is an oft-heard phrase. It is Christian. Are we to understand that man seeks to lose, to let dissolve, that which, in one way or other, singularizes him in a *trivial* way, that which gives him his opacity, in order, on the day of his death, to offer God a pure, not even iridescent, transparency? I don't know and don't care. As for Rembrandt, his entire work makes me think that he had not only to get rid of what encumbered him in his effort to achieve the aforementioned transparency, but also to transform it, to modify it, to make it serve the work. (To free the subject from his anecdotal self and to place him in a light of eternity. Recognized by today, by tomorrow, but also by the dead. A work that was offered to the living of today and tomorrow but not to the dead would be what? A painting by

Rembrandt not only stops the time that made the subject flow into the future, but makes it flow back to the remotest ages. By means of this operation Rembrandt achieves solemnity. He thus discovers why, at every moment, every event is solemn: he knows it from his own solitude. But he must also get this solemnity down on canvas, and it is then that his taste for the theatrical—which was so keen when he was twenty-five—serves him.) It may be that Rembrandt's immense grief—the death of Saskia—turned him away from all ordinary joys and that he observed his mourning by metamorphosing gold chains, swords and plumed hats into values, or rather into pictorial fetes. I don't know whether this beefy Dutchman wept, but around 1642 he experienced the baptism of fire, and his early nature, which was bold and conceited, was little by little transformed. For at the age of twenty the fellow does not look as if he were easy to get on with, and he spends his time before the mirror. He likes himself, he thinks a lot of himself, so young and already in the mirror! Not to spruce up and rush off to a dance, but to gaze at himself, complacently, in solitude: Rembrandt with the three moustaches, with the puckered brows, with the uncombed hair, with the haggard eyes, etc. No anxiety is visible in this sham quest of self. If he paints architectural settings, they are always operatic. Then, gradually, without departing from his narcissism or taste for the theatrical, he modifies them: the former in order to attain the anxiety, the frenzy, which he will transcend; the latter, to derive from it the joys—also haggard—of the sleeve of the "Jewish bride." With Saskia dead—I wonder whether he didn't kill her, in some way or other, whether he wasn't glad she died—anyway, his eyes and hand are free. From then on, he launches out into a kind of extravagance as a painter. With Saskia dead, the world and social judgments have little weight. One must imagine him—while Saskia is dying—perched on a ladder in his studio, grouping the figures in *The Nightwatch*. Whether he believes in God? Not when he paints. He knows the Bible and uses it. Obviously, all I have just said is of any importance only if one accepts the fact that all was, by and large, false. Intellectual play and insights on the basis of the work of art are not possible if the work is finished. The work would even seem to confuse the intelligence, or to restrict it. The fact is that I have been playing. In a certain way, works of art would make fools of us were it not that their fascination is proof—unverifiable, though undeniable—that this paralysis of the intelligence combines with the most luminous certainty. What that certainty is I do not know. The origin of these lines is the emotion I felt (in London, twelve years ago) in the presence of Rembrandt's finest works. "What's wrong with me? Why do I feel like that? What are those paintings that I can't shake off? Who is that Mevrow Trip? That Mynheer . . ."

No. I never wondered who those ladies and gentlemen were. And it is perhaps

this more or less definite absence of questions that shook me. The more I looked at them, *the less the portraits referred me to anyone.* To no one. No doubt it took me some time to reach the disheartening and thrilling conclusion that the portraits done by Rembrandt (after the age of fifty) have no reference to identifiable persons. No detail, no cast of features, has reference to a trait of character, to an individual psychology. Are they schematized and thus depersonalized? Not at all. One has only to recall the wrinkles of Margaretha Trip. And the more I looked at them, hoping to grasp or approach the personality, as it is called, to discover their individual identity, the more they fled—all of them—in an infinite flight and at infinite speed. Only Rembrandt himself—perhaps because of the acuteness with which he scrutinized his own image—retained an element of individuality: at least attention. But the others, *if I had regarded that profound sadness as negligible,* fled without allowing anything of themselves to be grasped. Negligible, that sadness? The sadness of being in the world? Nothing other than the attitude which human beings adopt *naturally* when they are alone, waiting to act, this way or that way. Rembrandt himself, in the self-portrait at Cologne in which he is laughing. The face and background are so red that the whole painting makes me think of a sun-dried placenta. You do not have room enough to move far back in the Cologne Museum. You have to take a diagonal view, from an angle. That is how I looked at it, but head down—my head—turned around, if you like. The blood rushed to my head, but how sad that laughing face! It is when he starts depersonalizing his models, when he prunes objects of all identifiable characteristics, that he gives them the most weight, the greatest reality. Something important has happened: the eye recognizes the object at the same time as it recognizes the painting as such. And it can never again see the object otherwise. Rembrandt no longer denatures the painting by trying to merge it with the object or face that it is supposed to represent: he presents it to us as distinct matter that is not ashamed to be what it is. Candor of the ploughed, steaming fields in the early morning. I do not yet know what the spectator gains, but the painter gains the freedom of his craft. He presents himself as the mad dauber that he is, mad about color, thus losing the hypocrisy and pretended superiority of the fabricators. This is perceptible in the late paintings. But Rembrandt had to recognize himself as a man of flesh—of flesh?—rather of meat, of hash, of blood, of tears, of sweat, of shit, of intelligence and tenderness, of other things too, ad infinitum, but none of them denying the others, in fact each welcoming the others. And I need hardly say that Rembrandt's entire work has meaning—at least for me—only if I know that what I have just written is false.

1964

Translated from the French by Bernard Frechtman

Gerard Houckgeest: *The Tomb of William the Silent*, 1651. Mauritshuis, The Hague,
The Netherlands.

SUSAN SONTAG

The Pleasure of the Image
[Gerard Houckgeest]

As satisfyingly elated as I become, roaming among the transfiguring masterpieces in the Mauritshuis collection, I still need to succumb to the spell exercised by some indisputably minor paintings: those that depict the interiors of churches. Among the pleasures these images offer, there is first of all a generic pleasure I associate particularly with Dutch painting (I first consciously experienced it before a skating scene by Breughel) of falling forward into . . . a world. And that flicker of an out-of-body, into-the-picture sensation I'm granted in the course of scrutinizing the renderings of these large, impersonal spaces populated with very small figures has proved, over decades of museum-going, to be addictive.

So . . . de-magnetizing myself with difficulty from the Rembrandts and the Vermeers, I might drift off to, say, *The Tomb of William the Silent in the Nieuwe Kerk in Delft*, painted in 1651, by Gerard Houckgeest, a *petit maître* who was an almost exact contemporary of Rembrandt, for some less individualizing pleasures.

The public space chosen for depiction here is one consecrated by two notions of elevated feeling: religious feeling (it is a church) and national feeling (it houses the tomb of the martyred founder of the House of Orange). But the painting's title supplies the pretext, not the subject. *The Tomb of William the Silent* is dominated not by the monument, of which only part is visible, but by the strong verticals of the columns and by the happy light. The subject is an architecture (in which the monument has its place) and, to our incorrigibly modern eyes, a way of presenting space.

All renderings of the large, populated by the small, that disclose the meticu-
lously precise, invite this imagined entry. Of course, savoring the miniaturizing of
a public space both deep and wide in a painting is a far more complex pleasure
than, say, daydreaming in historical museums over tabletop models of the scenog-
raphy of the past. Transcription through miniaturization in three dimensions
gives us a thing, whose aim is that of an inventory, completeness, and which en-
chants by being replete with unexpected detail—as true of a model railroad or a
doll's house as a diorama. The painting's surface gives us a view, which is shaped by
preexisting formal notions of the visually appropriate (such as perspective), and
which delights by what it excludes as much as by what it selects. And much of the
pleasure of *The Tomb of William the Silent* comes from how bold its exclusions are.

To start with, the painting is not just the view of something but (like a photo-
graph) something as viewed. Houckgeest made other portraits of the interior of the
Nieuwe Kerk, including a wider-angle picture of the same site, now in the Ham-
burg Kunsthalle, and presumed to be earlier than the Mauritshuis picture. But
this is surely his most original account of the space, not least because of the fea-
tures it shares with a photographic way of seeing. For in addition to its illusionist
method—that it records the site, with considerable accuracy, from a real view-
point—there is the unconventionally tight framing, which brings the base of the
column looming in the center almost to the picture's bottom edge. And while the
Hamburg version shows three windows, the main sources of light in the Maurit-
shuis painting are "off." We see only a dull bit of high window, just below the
arched top border of the panel; the potent light, which strikes the columns, comes
from a window beyond the picture's right edge. In contrast to the panoramic view
usually sought by painters documenting an architecture (or a landscape), which
invariably takes in more than could be seen by a single viewer, and whose norm is
a space that appears comprehensive, unabridged (if indoors—self-contained,
wall-to-wall), the space depicted here is one framed and lit so as to refuse visual clo-
sure. The very nearness of Houckgeest's viewpoint is a way of referring to, making
the viewer aware of, the much larger space that continues beyond the space de-
picted within the borders of the picture. This is the method central to the aesthetics
of photography (both still photography and film): to make what is not visible, what
lies just outside the visual field, a constituent—dramatically, logically—of what
we see.

The close point of view, which is the most immediately engaging feature of
Houckgeest's painting, produces an allied impression: an unusual fullness of the
space. Traditionally, church interiors are rendered as relatively empty, the better to
achieve the impression of vastness, which was thought to be the church's most el-
oquent visual aspect. Architecture was the framing, rather than the filling, of this

deep space, and it was the lighting that ensured that structures looked plausibly three-dimensional: without dramatic lighting, the architectural details tended to flatten out. In Houckgeest's painting, the foreshortened view—not the light, which is benign rather than dramatic—brings out the three dimensionality of the architecture. By being so close, and making the architecture so palpable, Houckgeest has forfeited the look that seems redolent of inwardness, aura, emotion, spirituality, as it is found in paintings by his contemporary Pieter Jansz Saenredam, most admired of all the Dutch painters of church interiors, or by an almost equally admired architectural painter of the succeeding generation, Emanuel de Witte. By the standard associated with the "poetic" emptiness of such paintings (also in the Mauritshuis) as Saenredam's *Interior of the Cunerakerk, Rhenen* (1655) and de Witte's *Interior of an Imaginary Catholic Church* (1668), Houckgeest's painting may seem under-evocative, perversely literal. Saenredam's achievement was to combine the atmospherics of remoteness with accuracy of depiction, depiction of a real church from a real viewpoint, though never from a near one—the eccentric choice Houckgeest has made in *The Tomb of William the Silent*.

Masking a portion of the real or nominal subject by architectural bulk, or interposing a screen or lattice or other grid-like barrier between viewer and subject, is a perennial strategy of photographic framing; and it is worth noting that Houckgeest, who has chosen an angle for his view that leaves a good part of the sepulchre behind the column in the center foreground, could have made his framing even more proto-photographic. For the next column to the right, the column that looms largest in the Hamburg version, should still be partly visible in the cropped composition of the Mauritshuis picture—both are painted from the same angle—and would, if it were there, further block our view of the monument. Houckgeest has preferred to be inaccurate, and to leave the right side of the picture's space more open.

To this space, more fully than usual inhabited by its architectural elements, are added a few inhabitants in the normal sense: eight chunky, bundled-up people with covered heads, two of whom are children; one animal; and a corpse-colored allegorical statue on a pedestal, the furthest-forward element of the partially obscured monument. We contemplate the space Houckgeest has rendered, which includes, inside the space, these diminutive figures, coming to see or already in position for seeing. In an architecture, looking at an architecture. Giving the measure of an architecture.

Although the people in Houckgeest's painting are larger (we are closer) and more detailed than the tiny staffage figures that classical landscape painters added to their panoramic views, they function in a comparable way, establishing the architecture's heroic scale. By setting scale, human figures also, almost inadver-

tently, create mood: they look dwarfed by the spaces they inhabit and are, usually, but few. In contrast to three-dimensional model worlds, whose miniaturized representations seem most satisfying when a very large number of tiny figures is deployed on the landscape, architectural space as a subject of painting is characteristically, if unrealistically, underpopulated. Indeed, a public space thronged with people is now a signature subject of the "naive" painter, who, by putting in lots of tiny figures appears to be making, as it were, a genre mistake. What seems mature in the depiction of the interior of grandiose buildings or of outdoor space enclosed by buildings is that the space, which always looks somewhat stage-like, be sparsely populated. This is the involuntary pathos of many portraits of architecture that are not laden with obvious affect, like *The Tomb of William the Silent*. All church interiors, even this one, become "metaphysical" interiors in de Chirico's sense; that is, they speak of a necessary *absence* of the human. It seems impossible for them not to suggest this pathos, this sense of enigma.

The presence of people, if just one person, makes this not only a space but a moment of stopped time. Of course, tableaux in which people are depicted in the throes of some ceremony or way of being busy project a different feeling from those in which they're resting or gazing or explaining. As befits a church, the mood is calm—but perhaps more than calm: becalmed, indolent, though not suggestive of introspection. We are far from the visions of alienation relished by the mid-18th century, when sublimity was identified with the *decay* of the grandiose architecture of the past, and staffage was turned into a population of spindly, dejected figures stationed among the ruins, lost in reverie. The full-bodied figures in Houckgeest's painting have a status, not just a size: they are citizens, townspeople. Where they are is where they belong.

Renderings of public space, whether in two dimensions or three, are usually shown being used in a variety of representative or stereotypically contrasting ways. In the Dutch paintings of church interiors, the use of the church is often, as it is here, wholly secular. The people in the Nieuwe Kerk we are shown are spectators, visitors; not worshippers. Except for the pair of men entering the picture at the left, they have their backs to us, the viewers. The father in the family group in the foreground with one hand raised, his head partly turned to his wife, seems to be in a posture of explaining. The two men on the far side of the barrier enclosing the sepulchre (one of whom, having turned to speak to his companion, is seen full face) and the child with the dog seem to be just loitering. This most un-Hebraic mode of Christianity does not require the continual re-performing of the separateness of the sacred; space designed for devoutness is fully open to the irreverent accents and mixtures of daily life.

Sacred space that is mildly profaned, grandiose space that is domesticated, made tender. . . . Children and dogs (often a child paired with a dog) are characteristic presences in the Dutch paintings of church interiors: emblems of creatureliness amid the marmoreal splendors. Compare the modest number of such emblems Houckgeest settles for (one dog, two children), having chosen to treat the site at close range, with the variety offered in a conventional wide-angle view, such as de Witte's *Interior of the Oude Kerk, Amsterdam* (1659), with its four dogs, one of them urinating at the base of the pillar on the left, and two children, one an infant at its mother's breast. Graffiti are a related if less regular presence—they, too, would invariably be read as the trace of small children. The most legible of the drawings in red that Houckgeest has recorded on the warm, whitish column in the center is a stickman with a hat (the same hat worn by all six males in the painting): the stereotype of the human figure as drawn by a child. And below, scrawled in the same red chalk or ink, is the painter's monogram and the date. As if he, too, were an artless vandal.

Devising ingenious locations for the signature or monogram is a strong Northern tradition, of which Dürer was a master, and the Dutch painters of church interiors play a witty variant of the game. In Saenredam's *Interior of the Cunerakerk, Rhenen*, the painter's name, the name of the church, and the date of the painting are to be deciphered, foreground center, as the inscription incised on the tombstone set in the floor. And in several other church interiors Saenredam inserts this information on a column on which there are some crude drawings. A brilliant example is the *Interior of the Mariakerk, Utrecht* (1641), in the Rijksmuseum in Amsterdam, where Saenredam's inscription (name of church, date of painting, painter's name) appears on a pillar far right in three colors, as if it were graffiti made by three different hands, along with several drawings of human figures in the same three inks or chalks. Saenredam's *Interior of the Buurkerk, Utrecht* (1644), in the National Gallery in London, is notable because he shows us, standing before the pillar on the far right (which already contains an amusing drawing in red of four figures astride a horse—below which, in another color, is Saenredam's carefully printed signature), a child, arm raised, who is starting another drawing. (And beside him is a seated child playing with a dog.) One imagines him, far from being engaged in a surreptitious defacing, embarking on a happy exercise of immature prowess, in the mood of the grinning child displaying his stick figure drawing in a painting done around 1520, *Portrait of a Boy with Drawing* by Giovanni Francesco Caroto, in the Museo di Castelvecchio in Verona—one of the other rare, premodern representations of children's art. Houckgeest's graffiti-plus-signature in *The Tomb of William the Silent* is not, then, original. But it is unusual because of

its placement—the center of the picture, not on a pillar to the side—and its simplicity, its lack of informativeness. It is just a self-effacing monogram, barely distinguishable from the child's drawings.

The graffiti Houckgeest has put on the central column signify childishness but are a piece of visual wit. Two spaces are being described. Two notions of presence. A child has made an inscription on the column; the painter has drawn on the panel—two spaces, logically, that can only be depicted as one space, physically. And two temporal relations of painter to church: as a vandalizing presence in the church anterior to the painting; and as the faithful documentarist of the church who, after recording the architecture as is, signs the document.

Hindsight instructs us that the ironic paralleling of the signature of a painter with the scribbling of a child on a public surface is potentially a very rich conceit, which was to have a long career in the visual arts and has perhaps never been so generative as in recent decades. But this could not begin to happen as long as graffiti were defined only privatively—as immature, embryonic, unskilled. Graffiti have to be seen as an assertion of something, a criticism of public reality. Not until the mid-19th century were graffiti discovered to be "interesting," the key word that signals the advent of modern taste, by such pioneers of modern taste as Grandville and Baudelaire. A self-portrait Grandville did in 1844, showing himself drawing alongside a small child on a graffiti-covered wall, makes a far bigger point than Houckgeest's paralleling of two kinds of inscription, which are here only *traces* (their perpetrators are absent).

Houckgeest's painting describes a world in which the abstract order of the state, of collective life (represented by gigantic space) is so assumed, so successful, that it can be played with: by miniature elements that represent the incursion of the personal, the creaturely. Public order can be relaxed, can even be mildly defaced. The sacred and solemn can tolerate a bit of mild profaning. The imposing main column in his portrait of the Nieuwe Kerk is not really damaged by the graffiti, any more than the less centrally located column in de Witte's painting is ruined by the dog peeing on it. Reality is sturdy, not fragile. Graffiti are an element of charm in the majestic visual environment, with not even the slightest foretaste of the menace carried by the tide of undecipherable signatures of mutinous adolescents which has washed over and bitten into the facades of monuments and the surfaces of public vehicles in the city where I live: graffiti as an assertion of disrespect, yes, but most of all simply an assertion . . . the powerless saying: I'm here, too. The graffiti recorded in the Dutch paintings of church interiors are mute; they do not express anything, other than their own naivete, the endearing lack of skill of their perpetrators. The drawing on the column in Houckgeest's painting is not directed

at anyone; it is, so to speak, intransitive. Even that red "GH" seems barely directed at anyone.

What this painting shows is a friendly space, a space without discord, without aggression. The grandiose before, or innocent of, the invention of melancholy space. Church interiors are the opposite of ruins, which is where the sublimity of space was to be most eloquently located in the following century. The ruin says, this is our *past*. The church interior says, this is our *present*. (It is because the beauty of the church was a matter of local pride that these paintings were commissioned, bought, hung.) Now—whether the churches have survived intact as has the Nieuwe Kerk in Delft, or not—the church interior also says, this is our *past*. . . . Still, even installed in those temples of melancholy that are the great museums of Old Master paintings like the Mauritshuis, they do not lend themselves to elegiac reverie. Attached as I am to the melancholy registers of space, as found in the architectural portraits done in Italy in the 18th century, particularly of Roman ruins, and in images of great natural ruins (volcanoes) and of space as labyrinth (grottoes), I also crave the relief offered by these robust, *un*soulful renderings in miniature of grandiose public space that were painted a century earlier in Holland. Who could fail to take pleasure in the thought of a world in which trespass is not a threat, perfection is not an ideal, and nostalgia not a compulsion?

1985

Jean Baptiste Siméon Chardin (1699–1779): *The Silver Tureen*. Oil on canvas, 30″ × 42½″ (76.2 cm × 107.9 cm). The Metropolitan Museum of Art, Fletcher Fund, 1959. 59.9.

MARCEL PROUST

Chardin: The Essence of Things

Take a young man of modest means with artistic taste, sitting in the family dining-room at that commonplace, dreary moment before the table has been completely cleared. His imagination full of the glory of museums, cathedrals, the sea, the mountains, he looks with distaste and boredom, with a sensation approaching disgust, a feeling not far from depression, at one last knife, lying next to an underdone, unsavory cutlet on a half-removed tablecloth that drags on the floor. A ray of sunshine, alighting on the sideboard, resting gaily on a glass of water still nearly full after having quenched someone's thirst, accentuates as cruelly as an ironic laugh the everyday banality of this unaesthetic sight. At the other end of the room, the young man sees his mother already settled down to her work, slowly unwinding, with her customary calm, a skein of red wool. And behind her, perched on a cupboard, next to a porcelain platter reserved for "company," a compact, fat cat seems like the petty evil genius of this scene of domestic mediocrity.

The young man looks away. His eyes fall on the brilliant, highly polished silver platters, and down below them, on the flaming andirons. Even more irritated by the order than by the disorder of the room and the table, he envies those men of wealth and taste who move only among beautiful objects, in rooms where everything, from the tongs to the doorknob, is a work of art. He curses these ugly surroundings, ashamed of having spent a quarter of an hour experiencing not so much a sense of shame as disgust and a sort of fascination. He gets up, and if he cannot take a train to Holland or to Italy, goes to the Louvre to look for the visions

of palaces *à la* Veronese, princes *à la* van Dyck, harbors *à la* Claude Lorrain which, in the evening, will serve only to aggravate the dullness of the young man's return to the daily scene in its familiar surroundings.

If I knew this young man I should not try to prevent his going to the Louvre; rather I should accompany him. But leading him through the La Caze gallery and through the gallery of eighteenth-century French painting or through the Rubens or some other French gallery, I would have him stop in front of the Chardins. And once he was dazzled by this rich painting of what he calls mediocrity, this zestful painting of a life that he finds tasteless, this great art depicting a subject that he considers mean, I would say to him: "This makes you happy, doesn't it? Yet what more have you seen here than a well-to-do middle-class woman pointing out to her daughter the mistakes she has made in her tapestry work (*La Mère laborieuse*); a woman carrying bread (*La Pourvoyeuse*); the interior of a kitchen where a live cat is trampling on some oysters while a dead fish hangs on the wall, and an already half-cleared sideboard on which some knives are scattered on the cloth (*Fruits et animaux*); and even less impressive, some kitchen or dining-room dishes, not only pretty ones like Dresden chocolate-pots (*Ustensiles variés*), but a shiny lid, all shapes and kinds of pots; sights that repel you like a dead fish sprawled on a table (*La Raie*) and sights that disgust you like half-emptied glasses and too many glasses left full (*Fruits et animaux*)?

If all of this now seems to you beautiful to look at, it is because Chardin found it beautiful to paint. And he found it beautiful to paint because he found it beautiful to look at. The pleasure you get from his painting of a room in which women are sewing, of a pantry, a kitchen, a sideboard is the pleasure he felt and caught in passing, isolated in time, deepened, immortalized, when he looked at a sideboard, a kitchen, a pantry, a room in which women are sewing. . . . Had you not already been unconsciously experiencing the pleasure that comes from looking at a humble scene or a still-life you would not have felt it in your heart when Chardin, in his imperative and brilliant language, conjured it up. Your consciousness was too inert to descend to his depth. Your awareness had to wait until Chardin entered into the scene to raise it to his level of pleasure. Then you recognized it and, for the first time, appreciated it. If, when looking at Chardin, you can say to yourself, "This is intimate, this is comfortable, this is as living as a kitchen," then, when you are walking around a kitchen, you will say to yourself, "This is special, this is great, this is as beautiful as a Chardin." Chardin may have been merely a man who enjoyed his dining-room, among the fruits and glasses, but he was also a man with a sharper awareness, whose pleasure was so intense that it overflowed into smooth strokes, eternal colors. You, too, will be a Chardin, not so great, perhaps, but great to the

extent that you love him, identify yourself with him, become like him, a person for whom metal and stoneware are living and to whom fruit speaks. And when they see how he reveals their secrets to you they will no longer avoid confiding them to you yourself. Still-life will, above all, change into life in action. Like life itself, it will always have something to say to you, some shining marvel, some mystery to reveal. Day-to-day life will delight you if for several days you pay attention to his painting as though it were a lesson: and having understood the life of his painting you will have conquered the beauty of life itself. In rooms where you see nothing but the expression of the banality of others, the reflection of your own boredom, Chardin enters like light, giving to each object its color, evoking from the eternal night that shrouded them all the essence of life, still or animated, with the meaning of its form, so striking to the eye, so obscure to the mind. Like the sleeping princess awakened, everything is restored to life, resumes its color, starts speaking to you, living, enduring. On this sideboard where, from the careless pleats in the half-folded cloth to the knife at the edge of the table, its blade hidden, everything is a reminder of the haste of servants, everything bears witness to the gorging of the guests. The tiered fruit dish, still as glorious and already as stripped as an autumn orchard, is piled high with plump peaches, as rosy as cherubim, inaccessible and smiling like the immortals. A dog, his head raised, cannot quite reach them, and by desiring them in vain renders them all the more desirable. His eye savors them and catches on the downy moisture of the skin, the sweetness of their flavor. As transparent as the day and as tempting as spring water, some glasses, in which a mouthful or two of sweet wine is caught in the throat of the goblets, stand next to some empty glasses, like symbols of burning thirst and thirst quenched. Bent, like a faded corolla, one glass is half tipped over; the felicity of its pose reveals the contour of its base, the delicacy of its stem, the transparency of the glass itself, the nobility of its form. Half cracked, free henceforth of the needs of men whom it will no longer serve, there is in its non-utilitarian grace the nobility of a Venetian vase. As delicate as a mother-of-pearl cup, as fresh as the sea water that they offer us, some oysters are spread on the cloth, as though on the altar of greed, offering their frail, delicious symbols.

Cold water is dripping from a wine cooler, pushed aside by a hasty foot that bumped into it abruptly. A knife that someone had quickly hidden in eager anticipation of pleasure, juts out from under golden slices of lemon seemingly placed there as a gesture of greed, the crowning touch to this display of sensual delight.

Now come as far as the kitchen where the entrance is strictly guarded by the tribe of pots and pans of every size—capable and faithful servants, a hard-working and splendid race. On the table, the busy knives, going straight to the point, are resting

in menacing but harmless idleness. Above you hangs a strange monster, still as fresh as the sea in which it undulated—a skate; the sight of it blends the hunger of the gourmand with the special charm of the calm or tempests of the sea, whose awesome evidence the fish symbolizes, at the same time that it recalls a memory of the zoo combined with something one has tasted in a restaurant. The skate is cut open, and you can admire the beauty of its vast and delicate architecture, tinted with red blood, blue nerves and white muscles, like the nave of a cathedral in poly-chrome. In front of it, some other fish, in their death surrender, are distorted in a taut and hopeless curve, prostrate, their eyes popping. Then some more oysters and a live cat, superimposing on this aquarium the obscure life of her more agile lines; the gleam in her eye focused on the skate, she steers her velvet paws in careful haste across the oysters, reveals the prudence of her nature, the covetousness of her palate and the boldness of her venture. The eye which, aided by a few colors, tends to combine with the other senses to reconstitute more than a past—a whole fu-ture—already smells the freshness of the oysters that will moisten the cat's paws; and one can already hear, at the moment when the precarious pile of fragile shells will give way under the weight of the cat, the little cry of their cracking and the thunder of their fall.

Like objects that we are used to, typical faces have their charm. . . . Go and look at the self-portraits Chardin painted when he was seventy. Above an enor-mous pair of eyeglasses that have slipped down to the end of his nose, way above the two brand new lenses that pinch it, the dimmed eyes with worn pupils are raised with an air of having seen, laughed at and loved a great deal. Tenderly, boastingly, they seem to say, "Yes, I am old! What of it?" Beneath the dim gentleness with which age has lightly covered them, his eyes still have fire. But the lids, as tired as worn-out shutters, are red around the edges. Like the old suit that covers his body, his skin, too, has hardened and gone by. Like the cloth, it has retained, almost brightened, its rosy tone, and in spots is coated with a sort of golden mother-of-pearl. And the wear and tear of the one brings to mind at every moment the wearing away of the other, suggesting the tones of all things approaching their end; from dying embers, rotting leaves and the setting sun, to worn-out clothes and aging men, infinitely frail, rich and sweet. It is astonishing to see how the puckering of the mouth is exactly controlled by the opening of the eye to which the wrinkling of the nose is also subject. The slightest fold of the skin, the slightest relief of a vein is the very faithful and special translation of three factors: character, life, emo-tion. . . .

In the portrait that we have just been discussing, the carelessness of Chardin's undress, with his head already covered by a night-cap, makes him look like an old

woman. In the other pastel that Chardin has left of himself, his costume attains the comical eccentricity of an old English tourist. From the eyeshade, firmly set on his brow, to the Masulipatam foulard knotted around his neck, the whole thing makes you want to smile without feeling any need of disguising it from this old character who would be so intelligent, so gently docile about taking a joke—above all, so much the artist. For every detail of this extraordinary, careless undress, all ready for the night, seems quite as much an index of taste as a challenge to convention. If this rose Masulipatam is so old, it is because old rose is softer. When you look at these rose and yellow knots that seem to be reflected in the jaundiced and reddened skin, when you recognize in the blue border of the eyeshade the somber luster of the steel spectacles, the astonishment that the surprising attire of the old man at first arouses melts into a soft charm; into the aristocratic pleasure, too, of rediscovering in the apparently disorderly undress of an old bourgeois the noble hierarchy of precious colors, the order of the laws of beauty.

But in looking more deeply at Chardin's face in this pastel, you will hesitate, you will be confused by the uncertainty of the expression, daring neither to smile, to justify yourself nor to weep. . . . Is Chardin looking at us here with the braggadocio of an old man who does not take himself seriously; exaggerating, in order to amuse us or to show that he is not a dupe, his high spirits springing from his good health, his rough humor: "Oh, so you think you young people are the only ones?" Or has our youth, perhaps, wounded his sense of helplessness; is he revolting in a passionate, useless challenge that is painful for us to see? One might almost believe this, for the intensity of the eyes, the quivering of the lips have a sombre expression. . . .

We have learned from Chardin that a pear is as living as a woman, that an ordinary piece of pottery is as beautiful as a precious stone. The painter has proclaimed the divine equality of all things before the spirit that contemplates them, the light that embellishes them. He has brought us out of a false ideal to penetrate deeply into reality, to find therein everywhere a beauty no longer the feeble prisoner of convention or false taste, but free, strong, universal, opening the world to us. And he launches us on a sea of beauty. . . .

I have shown through Chardin what the work of a great painter can be to us because of what it has been to him. Since it is not at all the display of special gifts but the expression of the most intimate things in his life, and the deepest meaning there is in objects, it is to our life that his work appeals; it is our life that it reaches out to touch, gradually leading our perceptions towards objects, close to the heart of things. I should like to add for the benefit of painters who are endlessly reproaching writers for their inability to discuss painting, and for the complacency with

which they attribute to painters intentions they never had: if indeed painters do what I have said, or to be more specific, if Chardin did everything I have said, he did it without intending to. It is even highly probable that he was never conscious of it. Perhaps, indeed, he would be very much surprised to learn that he had depicted so passionately the animation of life that was supposed to be still; had sipped at the pearly cup of the oyster shell, tasted the freshness of sea water, sympathized with the fondness of a cloth for a table, of darkness for light. Thus a gynecologist could astonish a woman who had just given birth, by explaining to her what had happened inside her body, by describing to her the physiological process which she had had the mysterious power to perform without being at all aware of its nature. Creative acts originate, in fact, not from a knowledge of their laws, but from an incomprehensible and obscure power that is not fortified by being explained. A woman does not need a knowledge of medicine to give birth to a child; a man need not understand the psychology of love in order to love.

1954

Translated from the French by Mina Curtiss

Francisco José de Goya y Lucientes (1746–1828): *The Funeral of the Sardine*. Museo de Real Academia de Bellas Artes de San Fernando, Madrid.

ANDRÉ MALRAUX

Goya

(To Pascal Pia)

No genius seems more spontaneous than his, for he invents his real as well as his dream world, his style, and that interrupted brush-stroke by which, even to-day, we recognise his hand at first glance. Then we realise that it took him forty years to become Goya . . .

When he made the first of his sketchbook drawings he was nearly fifty. Like other young painters of his age, he began by drawing in the Italian style, at once carefully and vivaciously. The first of these qualities is still in evidence at the beginning of the big Sanlucar album, the second in a few of his beautiful finished drawings. One wonders if he took to engraving because that medium released him both from care and from vivacity. The cursive quality of his line is by no means incompatible with baroque drawing: both rejoice in strong accents at the expense of outline; but the accents are different.

It is probable that at Rome he looked at the canvases of Magnasco, who was still famous at that date. In these he may well have discovered a taste for picaresque poetry—gypsies, monkeys, cock's feathers, scenes of torture in Piranesi land-scapes—the world of the Commedia dell'Arte, drawn by a hand more skilled than that of Callot, who started with grotesques and ended with the Inquisition. For Magnasco had already guessed what death gains by associating with masquer-ade—the emphasis given to the tortured face when it is surmounted by the Inquisi-

tion's humiliating conical hat. But Magnasco's genius was superficial and inclined to the decorative: he passed easily from masks to tortures, by way of quacks and barbers, to the accompaniment of a Venetian carnival music which, by surrounding them with an atmosphere of poetry, removed them from the drama of reality. The comments of the great Spaniards, faced by the characteristics of Italian art, have always been the same. In Rome itself El Greco expressed his regret that Michelangelo did not know how to paint; and Velásquez, when asked his opinion of Raphael, answered simply: "I don't care at all for that kind of thing." Thus one can imagine Goya thinking, in front of an *Inquisition* by Magnasco: "How good that would be, if only it were true! . . ."

The notion of truth, where graphic art is concerned, is admittedly rather vague. Goya confessed to only three influences: Nature, Velásquez, and Rembrandt. Did "Nature" here mean truth? Certainly he cared little for Nature in the other sense. One has to search all the engravings he ever made in order to find a single tree. His world is composed of human beings and stones. The arch obsesses him,—a shadowy form like a bridge or a porch, more often like the doorway of a cell. Occasionally the stone is a distant crag, the high place of some legendary Sabbath; or one of those desiccated fragments of an Arab town with Gothic belfries, revealed by a Judgment Day lighting, like the view of Madrid in the *Shootings of May 3rd*. Alone among artists, he can invoke the ghosts of towns without painting ruins.

Against his background of stone—arch, wall, gaol—everything belongs to Man. The "nature" to which he refers is himself.

Had Goya died at the age of thirty-five how could one have guessed that he had been born to destroy the art of decoration and luxurious pleasure? Like many others he had been a baroque decorator, a worldly painter of sometimes malicious portraits; and had made designs for tapestry of which the equivocal flavour would be less damaging to those of Bayeu if one did not feel in them the hesitant accents of a style soon to become more forthright. What genius has not transfigured his childhood? We can scarcely look at the drawing of a mantilla without being reminded of Goya. . . .

The appearance of his genius in his work was an abrupt one. Separated from other people by the sudden onset of his deafness, he found out that a painter can conquer everybody sooner or later, simply by struggling with himself alone. His loneliness, as he put it, "made room for observation." Observation of what? At this time, in 1793, he painted for the Academy of San Fernando, *The Funeral of the Sardine*, the *Madhouse*, the *Inquisition*. It seems probable that Spanish painters

endured the prestige of Italian art less patiently than has been thought. The two countries had reached agreement on the subject of baroque emotion, which combined sensuality with spirituality; but in Italy the result emphasised the sensual, while Spain had always wanted the two to be fused in the idea of God. Imagine, for example, what Saint Teresa would have said about Bernini's statue of her. It was a strange union—this of two countries, one of which had made of the human nude the very symbol of art, while the other punished it with a year in prison, exile and confiscation of property; so that the only example we possess (by the greatest painter of his time, Velásquez) was executed almost in secret, by special permission of the king. For Spain had remained essentially Gothic: its semi-popular art aimed at stamping each human creature with the only sign which relates it to God, thus forming a nation of faces Christian by inheritance from the Gothic Christian statuary. Whether good or bad, its courtly art, which often came from abroad, avoided the supplicatory quality of this *cante jondo*; but, for Goya, the soul of Spain did not reside at Court.

For centuries Italy had aimed at putting man in tune with himself, while Spain had tried equally hard to force him out of tune. To Nicolas of Cusa's phrase, "Christ, the perfect man," all the profoundest intellects of Spain had replied that man's worth is to be measured by the degree of his approximation to Christ. It is true that Goya did not continue the search for these divine attributes; but for him, as for the Middle Ages, the value of man consisted in his expression of that which transcends him.

He revealed his genius from the moment he had the courage to stop trying to please. His loneliness cuts right across the chatter of his epoch. (Before long, and in the same way, Constable, then Daumier, were to discover themselves—albeit more discreetly—in those "sketches" which expressed what they meant by painting.) Goya proceeded to offer in place of charm, a revelation; so that, when he again began to communicate with his public, he no longer replied but stated. He had discovered how vulnerable is the spectator, and how weak is civilisation, once its basis is questioned by the artist with his own vision of truth. *The Funeral of the Sardine*, although its subject and title are the same as those of the tapestry designs which preceded it, differs from these, and from the whole art of the time, by its refusal to charm. In one swoop Goya had unearthed the language particular to painting as a means of expression. He was still unaware of this; asserting only that he painted "in order to distract his thoughts from the misery of his condition," and "to continue bearing witness to the truth."

He might have done the latter equally well by painting the first woman he saw

in the street; but, once he had turned his back on charm, he was intent on coming out of his solitude and making himself felt. The artistic representation of a decorative world need not be merely pleasing: it can also provoke a fearful fascination. Without hesitation Goya chose the subject that was surest to achieve this effect: insanity. He was personally attracted by this, for he lived in expectation of its attack upon himself. Let others spread the story of his having caught cold in the mountains, if only to prove to the Duchess of Alba his talent as a blacksmith! He knew, for his part, what syphilis meant, and that the dull thudding in his ears was but the silent precursor of calamity. . . .

Between the best of his tapestry designs and the San Fernando canvases his genius did not deepen or widen, it made a clean break. Goya suffered a transformation, and rose from it a new man. From his earlier phase he kept only the popular figures—figures of comedy, like all the popular art of the day—and the stage spectacle, half-way between nightmare and reporting which was henceforth to furnish the world of his art. All his subjects save one—madness—he might have borrowed (some he did borrow)—from Magnasco. Carnival, Inquisition, torture itself, are things to look at. Madness only enters this category in so far as it seems like a series of antics,—which it does in Magnasco's case. The Italian comedy stopped short of what would have blasted its decorative quality. It was exactly this which Goya did away with. Seen against the background of his blank and lurid walls, the fancy-dress madman becomes a real one. At the same time Goya suppressed the arabesque, the one thing which had allowed several centuries of painters to confer decorative qualities on even the grimmest subject.

This motive had been ubiquitous ever since the Gothic era: one finds it even in Rembrandt. When baroque artists snapped off, as they so often did, the flowing line of the Renaissance, even their most staccato strokes remained obedient to the secret curve of a society which saw itself as pleasure-loving and decorative. In any case the strokes were at the opposite pole from the Gothic type of accent.

The arabesque was considered by baroque artists as representing final victory over the Middle Ages. The fluted draperies in which Gothic art drew to a close were in no sense a way of rendering vision, but, like the scimitar blacks of byzantine painting, simply a method of correlating the profane with the sacred. However mechanical drawing might have become, during the decline of the Middle Ages, it did go on attempting to express the difference between the human and the divine. The arabesque, on the contrary, expressed their union. This is why Spanish baroque—the baroque of a country which had never reconciled Man with God and which still believed in Hell—preserved, in its sculpture, a typically Gothic rhythm

of planes. And when it was conquered by the Italian style, it tried to throw off the yoke with the aid of real hair, the Seven Swords, and blood. Goya too reintroduced into painting the swords and the blood, together with that kind of "realism" which begins with beggars and ends with phantoms.

For years he had been struggling vaguely against the tyranny of the arabesque— against the Italian music to which his period danced. No doubt the figures in his cartoons are a good deal stiffer than any others painted at the time; but the world in which they move remains a gay one. *The Funeral of the Sardine* is the only enter- tainment in the San Fernando set; and, underneath its grinning flag, the fête looks like a witch's sabbath. From this the step is short to the frenzied carnival of *The Fla- gellants*, in the background of which the sinister banner looks as if it had passed on out of the one picture into the other. . . . Throughout the remainder of the series we are in a world of madmen and executioners; but both the subjects and the style arise from the same impulse. Rembrandt broke the outline of his design because he wanted his brushwork to culminate, decisively, in a point of light; Goya, on the other hand, put aside the aid which his mediocre draughtsmanship had given him, in order to produce with his brush equivalent accents of vivid colour. These ac- cents destroyed the traditional unity of the picture-space in the interests of a freer style which is fully exemplified in the *Field of San Isidro*, the reversed triangle of the crowd creating a dark mass that divides in two the foreground of light earth. To some of his lighter masses he gives as much weight as to his dark ones by the sheer richness of his paint—a richness derived from the opulent paint of Velásquez, from facial make-up, and from lacquer. It is a chromatic vision, in which colour reappears in its pure form, eschewing harmony in the same way as Goya's outline destroys the arabesque,—features that reveal how much more he owed to the Mid- dle Ages than to his immediate predecessors. Yet the vision is all his own.

What now seemed true ("real") to Goya was that aspect of truth which *dictates* a spectacle situated, by its very nature, on the borderland of dream. The maskers of the *Sardine* are not ordinary peasants, but still less are they the figures of Vene- tian carnival or of Neapolitan comedy. The clue to the difference between Goya's first *Inquisition* and those of Magnasco—that which brings it out of the realm of dream into that of the concrete—is the abandonment of the decorative touch for one that can only be called *haggard*. Those terrified faces shown against naked walls are the first sign of his personal style. The San Fernando pictures are drawn with the brush; in them the landscape characteristic of the century is in process of dissolution (even the trees in them are those of tapestry), and from it begins to emerge the background of the *Caprichos*, which are exclusively nocturnal.

By this time Goya was chronically ill. Worse, he seems (according to his friends) to have believed this to be his own fault. In any case his condition was incurable. But the voice which filled his deepening silence was no longer just his own: it was the lost voice of Spain herself.

Neither pencil, nor sepia, nor even the etcher's needle could yet give him what he had just obtained from the paintbrush. (Moreover he was not the first artist in whom painting preceded drawing—gave birth to it: one thinks of Velásquez, at Tivoli. . . .) But if he had discovered the style required by his dramatic vision, he had only glimpsed the technique proper to it. For him the subject had always been a means to expression, but only because he had discovered a style. Henceforward he knew that, if you want to create a ghost, genius consists in making one out of an ordinary face.

Goya's drawings arouse our curiosity in the first instance because we wonder what they were made for. A master's drawing is either an end in itself, or a tryout for a picture; or again it may form part of a scrapbook of suggestions for future works. The Prado drawings, on the other hand, are neither ends in themselves, as are some of Leonardo's; nor are they, in the proper sense, sketches. They are more like the *Caprichos*. But what is a *Capricho*?

An illustration? One has only to read the titles to perceive that many of these must have been added *after* the drawing was made. Some of them take the form of recollections or comments. "Bravo!—Who would have thought it?—Look how grave they are!—*Bon voyage!*" (under the *Caprichos*); "She looks an honest woman.—What does it matter to us!" (under the drawings): such phrases, far from dictating the scenes depicted, were clearly suggested by them. The frequent use of the demonstrative pronoun: "These people believe in birds—This woman knows it quite well—This woman has many relations"—seems to show Goya's surprise in the faces of people who were half strangers to him. But who does think of Goya as a mere illustrator? He drew as if in his sleep and even stated that, in the *Visions of a Night*, he had drawn what he dreamt. But sleep is not as neat as that: it is when Goya puts his nightmares in order that we realise he had reached the point of dreaming his drawings. This man of genius was in fact obsessed by his own creations, so that his too precise dreams are more like drawings than his drawings are like dreams. . . .

A psychoanalyst would consider Goya devoured by symbols; and it is true that he was almost brutally sensitive to those demons of terror which are immediately

recognisable as common to us all: not only physical torture, but humiliation, nightmare, rape, gaol. Padlocks too, here and there. . . . In his sketchbooks alone there are at least twenty dungeons.

Goya was the first great artist to dramatise the ridiculous. Of course the Court, as well as the town in which he lived, lent themselves to this interpretation. The queen filching the gunpowder set aside for the Portuguese campaign, so as not to deplete the national income, which ought of course to be spent on the theatre and opera; the late king (so the story goes) attempting to violate the corpse of his wife as it lay in state between rows of candles and praying monks. In the public squares is acted the sacred drama of the Annunciation, in which St. Michael doffs his cloak before the Virgin, disclosing a leg-of-mutton sleeve decked with ribbons and little mauve wings. The Virgin offers him a cup of chocolate, which he refuses, God the Father having promised him a fish-stew for dinner. Then the Holy Ghost enters, and the three persons celebrate their union in an improper fandango, while the foreign ambassadors look on flabbergasted. Like the Virgin, the Devil is ubiquitous.

Spain had long had a feeling for devilry in the grand manner. Philip II covered with freaks the vistas of catacombs with which he shut himself off from the world. Before the advent of Goya only Bosch and Breughel had brought up from the depths such convincing monsters as his. And even Breughel did not get beyond the picturesque aspect of the subject—battles of demons, Temptations, and so on—until, in the *Doele Greet*, he came up against the Scourge, that bloodthirsty virago who presides over the flames and swarms of Calamity. Goya puts less ferocious gusto into his symbols of war; he tries instead to exhaust every feature of it, to display its metaphysical absurdity. The uniforms of his French soldiery are imperceptibly French; what fascinates Goya is not the bravery of patriotic Spaniards, but that indictment of God implicit in the figures of men blinded, tortured, legless. Symbol of Evil in the triptychs of Bosch, the mediaeval screech-owl, single, ironic and threatening, breeds the noiseless horde which invades the night of his imagination.

At first Goya was admired for the fantastic quality of his art; but this is only important when supported by his sense of tragedy. His power of suggestion owes little to the paraphernalia that encumbers it, and everything to the universal terror created by those vast shadowy forms, the *Colossus*, the *Fear*, of the *Disparates*. Unquestionably he is the greatest exponent of agony that Western Europe has yet known; and agony is the unifying emotion which runs through all his most obsessional images, from the *Saturn* down to the *Female Prisoner* and the scenes of

strangling. The moment his genius seized the deep undertone of Evil he cared little whether or not his shadows were peopled with swirling spectres—the whole absurd world of owls and witches. . . .

Why are the witches there, since Goya did not believe in them? Because they are among the disquieting yet comic monsters which he was always trying to domesticate,—and also, perhaps, because they express the demoniacal element which he sensed in women. He even goes so far as to classify his demons: "These," he notes, under a plate entitled *Spectres*, "belong to another kind: gay, amusing, ready to help, perhaps a bit greedy, and fond of practical jokes; but, on the whole, good-natured, honest little beggars." Under another he wrote, with less irony: "If you had not come into being at all, it would not have mattered much." Some of his notes arouse our curiosity even more strongly. "It is odd how this particular breed won't show themselves except on a dark night. Nobody knows where they hide themselves away during the day. Whoever has the luck to uncover a burrow full of ghosts, to catch them and exhibit them in a cage . . ." and so on. As well ask why Baudelaire and Nerval, in their turn, surrounded the birth of modern poetry with a bevy of spectres and witches.

All truly profound art requires its creator to abandon himself to certain powers which he invokes but cannot altogether control. This procedure gives rise to misunderstandings. Goya, for example, thought of himself as a satirist. But of what? Of the politicians of his time, of high society, of feminine vanity, of doctors, priests, and the arrogance of the nobility: everything, in fact, which he considered spurious. Of course the repertoire of great comic figures always seems very restricted,—and this applies even to Molière. . . . The latter, nevertheless, since his genius was not of a religious or metaphysical order, aimed his destructive criticism only at the specifically comic side of man as a social being. The object of his belief was the sincere man. How petty the reveries of French vanity, when put beside the dreams of Don Quixote, to which all Spain is heir! Goya's satire has only one object: men and women—not as social beings, but as individuals. Especially women. . . .

His peculiar bitterness, tentative at first, found its focus at last; and the caricatures which, in the *Caprichos*, make one think of English prints, find no place in the *Proverbs*. No more old women seated before the looking-glass, but instead the grand visions: the spirit of war, Murder, Deformity, men sewn up in sacks, and that monster with three legs and two heads which is a symbol of marriage—perhaps of love itself. Henceforward the fraud against which Goya pitted himself more and more relentlessly was the accomplice, not of Vanity but of Injustice. Not that he

did not feel pity for the victims of the gaols, of the Inquisition, or of war; but his pity has the sternness of fellow-feeling on the run. He is not so much sorry for the victims as he is aware of being himself one of them. Life is essentially a prison, and those of its inhabitants whom Goya hates most are the traders in Hope. Politicians and doctors merely aroused a wry smile, though monks enraged him because they practised fraud in the name of Christ. Sometimes it even seemed to him that life itself—particularly his own life—was a cheat on the part of God.

Yet he believed himself to be a rationalist. "When Reason dozes, monsters come to life." That, no doubt, was why he covered his walls with pictures of them. In his notes on the *Caprichos* he states that the scenes depicted in them are the result of superstition and ill education. It is a mistake, he says, to believe in ghosts. Then why paint such convincing ones? We are reminded of Laclos, who asserted, at about the same date, that the *Liaisons Dangereuses* was a moral book. At the very end of the *Disasters* an odd marionette, which unites the ideas of Doll and Reason in the same way that the Duchess of Alba in the *Caprichos* unites the ideas of Duchess and Doll, stands as a symbol of reconciliation in the centre of a Jesuit gloria. Next he made haste to etch the *Old Man Wandering among Ghosts*. . . . Thus he was a rationalist in the sense that Cervantes was a picaresque writer, or Dostoyevski a political novelist. The rationalism disengaged by his commentary on the *Caprichos* is of a moralising order,—and indeed there are few prophets of the immitigable, from one end of the scale to the other, who would not wish to be thought moralists: for example, Pascal, Baudelaire, Dostoyevski, Tolstoy, Nietzsche. Not one of Goya's victims but implies the torturer, not a prisoner but suggests her judge, not a single figure that has not something of the devil about it. Just as Bosch inserted human beings into his hell, so Goya inserted hellish beings into his human world. To both painters the human race was a race of victims; but while Bosch saw cruelty only in devils, Goya discovered it in executioners as well. He is probably the only European painter who could manage the subject of war without appearing ridiculous or beside the point; and he is certainly the greatest poet of bloodshed. I have said elsewhere that for an agnostic one possible definition of the Devil is: That which in Man aspires to destroy him. This is the devil that obsessed Goya: for him Satan was not Bosch's enthroned figure, but a dying man with his arms and legs cut off, and underneath the legend: "I have seen this."

Our own age has taken upon itself to reveal to us the meaning of Goya's derision in face of human existence: it is the derisive sneer of the condemned man. The fields around the place of execution create their own brand of irony—a brand which resembles Goya's. Whenever he paints for himself alone , a single obsessive

emotion—that of dependence—welds the most disparate elements into a prison-like unity. His figures are almost all creatures possessed. If, true to the abiding genius of his country, Goya considered man to be of value only in so far as he bears witness to what surpasses him, that superior being was no longer God.

The romantics saw in Goya something he in fact never was: a miraculous draughtsman, in the manner of certain Venetian and of all Japanese painters. Baudelaire, in his essay on "Caricaturists," places Goya very high; since when he has usually been considered as a kind of Daumier, though even more dramatic. Of course it is true that both as a painter and as a draughtsman Goya is concerned with character; as an artist he is opposed to the Italians in distinguishing between Art and Beauty. On the other hand, most character-drawing aims at emphasising the individual, while Goya is so little interested in doing this that a century of specialist criticism has not yet made up its mind whether the Duchess of Alba did or did not sit for one or other of the *Majas*, although one knows what she looked like from the portrait he did of her. And if a decision is occasionally reached, it is based, not on resemblance, but on some remark or other in the painter's note-book. Where he did concentrate on expressing human character was in portraits. This was something no painter had dared attempt since the Middle Ages. What caricatures existed in Europe, had little to do with the ruling class. Breughel was exclusively interested in peasants. But where Goya approaches Daumier most nearly is in his portrait of the Queen.

Besides, nearly all his important drawings bear signs of having been done from memory. Not one of them suggests that he visited gaols in order to make sketches. Always on the alert for significant forms, he is never a slave to them; allowing his instinct to make choices between them. His exterior vision was merely the focus—a precise one—of the accusing shapes he carried within himself. Here we must recall Daumier's exclamation (though he always *seems* to be sketching): "You know quite well I can't draw from life!"

Goya's expressive power has been frequently noticed. Gautier, taking expressive power in the sense of "performance," admired him as a wonderful theatrical producer. This was a mistake: what Goya wanted was not to represent but to express. Indeed he was responsible for breaking down the representational art of his day, which expressed strong feeling through faces and gestures that were alike contorted by it. Everyone knows how important a place was held, in the drawing schools, by so-called expressive physiognomies—Fear, Joy, Sadness, and so forth. But quite often Goya's terrified people scarcely show fear in their faces. To move

the onlooker by reproducing the outward signs of emotion, was a cardinal rule of baroque procedure; but in the *Caprichos* it is virtually only the grotesques which express violent emotion. The baroque martyrs, all writhing muscles or fainting with ecstasy, were still very much in fashion. The art of Goya, however dramatic it may appear to us now, involved a tremendous simplification.

Painting was only just alive at this period, and drawing even less so. Of the latter a traditional form existed, alongside the final gasps of Italian genius and the academic art of Mengs, then at the height of its popularity in Madrid. Even Magnasco never dared to allow his pencil a liberty equal to that of his brush, which riddled his canvases as with splinters of light. His drawings show the baroque style at its most sober; in them he never employs the isolated dab. . . . Apart from Rembrandt, whose reputation was suspect, the technique of drawing was not nearly so advanced as that of painting: Guardi had not entirely freed himself from the merely decorative; Rubens's passionate line turned to arabesque when he exchanged the brush for the pen; and the two chalk drawings by Greco which survive have none of the strict stylisation of his painting. It was in the sketch, rather than the finished drawing, that Spain was seeking to free herself from foreign tradition. The age permitted more license to the brush than to the pen, and it is only in his sepias that Fragonard seems to assert his independence of traditional painting, and to submit his forms to a specifically plastic discipline. Yet even in his freest drawings Fragonard remains fundamentally guided by the kind of calligraphy that informs his painting. We have only to compare the mouths of his women with those of Goya's, to see how all traditional baroque drawing, from Michelangelo onwards, sets out to charm, in one way or another.

While Fragonard was content to express the values current in his day, Goya was concerned to break them down. However emancipated the former may strike us, he never freed himself from the cult of Woman. Goya knew just as much about her; but for him Woman was not the privileged instrument of man's pleasure, she was the daughter of Eve, the potential sorceress, possessed by forces from another world.

The expressive power associated with Goya's name is not that of a representational technique. His drawings are indeed among the most powerful ever made, but what they express—like the music of Vittoria and Beethoven—is their creator himself; not "The Prisoner" or "Pain" but the agonised constraint of Goya's own soul. For this artist went in search of his forms in the same way that a dramatist or novelist seeks his characters. At San Fernando he had found them only under the

disguises of the carnival, of madness, of the Inquisition. Apart from these, he was deeply aware of the one thing which had so long separated him from what he sought—the thing which obsessed the world of his time: the theatre. This art dominated all others to such an extent that Rousseau, in attempting to exalt Nature, ended by substituting the decor of an operetta for that of a tragedy. Goya, on the other hand, substituted, for grand opera in the Jesuit style, a theatre of masks.

Although he is in no sense a naïve painter, many of his figures have something of the doll about them. Spanish clothes have always lent themselves to that effect; and the inherited stiffness, combined with the flimsy vertical lines of the dresses, and with the hair-dressing fashionable in Goya's day, emphasised the doll-like quality. His duellists have it, and so, perhaps, has the Duchess of Alba (I am thinking, not of the two *Majas*, about which there is controversy, but of the official portrait),—unless Goya just chose to see her in that light. As he painted Doña Isabel in quite a different style, this seems unlikely. His figures are dolls which swell suddenly, like apparitions, to life-size. Even the puny, crucified arms of the dead man, in *The Third of May*, give this impression.

But, far more than the doll, the mask dominates Goya's work. Here, I think, lies the clue to his method, and even more in the etchings than in the drawings. Those painted faces of women pursued by monsters; the fancy-dress distortion of the monsters themselves, of the rakes and flirts, of the bawds, monks and witches: all these seem to be wearing masks. In the *Genealogy*, they are represented as such; then, in the animal-headed riders of "How they tear her!" they come alive; eventually the human body vanishes altogether, but the symbolic asses of the *Caprichos* put one in mind of a dinner table furnished with human heads. Sometimes the borderline is no longer distinguishable: the young woman in the second *Capricho* wears a mask, but what about the old woman behind her? Is she also wearing a mask, or is it her own features we are looking at?

In arriving at the mask, Goya discovered the *type*. Those of the grandiose but imaginary massacre are not much more numerous than those of the real one— to wit, the toothless crone, the witch, the frog-headed procuress, the doll-headed woman of fashion (women, all but absent from the San Fernando series, make their dazzling entry in the mature style of the *Caprichos*), and the series of burlesque figures one used to see, ten years ago, seated at café tables in little towns, facing a red church in the interior of which shadows of barbaric-looking chains, hung up as votive offerings, trembled in the heat. . . . His male types range from brainless horsemen to devils, by way of misers, equivocal monks and facetious dwarfs; the remainder tail off into twin-horned shadows, deputising for Satan over scenes of torture or coupling women. . . .

Astonishing, how little the individual face mattered to so famous a portrait-painter! In one possessed of a demon the person was of less importance to Goya than the demon; and throughout the whole series of *Caprichos* (eighty in number) there is only one real face: his own.

For Goya the mask is not something that hides the face, but something that holds it motionless. And he knows some dreadful ones. When Evil is present, all great art, whether Babylonian, pre-Columbian, Chinese or Romanesque, is to some degree an art of the Mask. But in early Romanesque art, the impression arises from the whole series of tympanums, rather than from any single figure in them, however individualised. Thus Goya too reconstituted a language of which his San Fernando works had not yet supplied the entire vocabulary.

Feelings were usually expressed, in those days, by *expansive* gestures—those, that is to say, of mime, in which they reinforced the words; and both gestures and words belong, once again, to the theatre. They were the kinds of gestures to be expected of actors who had to take distant spectators into account (a necessity from which the cinema has freed us). Now in the whole of Goya's work after the *Caprichos* you will not, I believe, find a single gesture of that kind. In *The Third of May* the arms of the man who has been shot do not fall backwards: Goya makes him raise them above his head. He expresses the sensation of imprisonment by a figure lying prostrate. Like the modern novelist, he realised that laughter may express the despair of the condemned man more poignantly than tears. Instead of inventing symbols, he reveals the truth directly. Bursting into anger over "line," he muttered that there was really no such thing, and that all he was aware of was "advancing and retiring planes." All the same, line was an important factor in his method,—but not the line of contour.

The graphic method he was seeking, by way of his nightmares, already existed. It was the method of Rembrandt, and it freed the body, the setting, the world of the imagination from theatricality, just as the mask had freed it from the tyranny of the human face. Rembrandt's graphic style possessed the scope of a whole culture: it was in fact an entirely new invention. Apart from a few of Titian's drawings, those of Rembrandt (who had probably never seen Titian's) were the first to dispense with contour and volume. He is usually said to have replaced these by light. It would be truer to say that he replaced the sensuous apprehension of objects by a system of expressive symbols. He seems to draw things "from the inside." Unlike Michelangelo or Tintoretto, who sought the individual likeness, Rembrandt was the first artist to turn his back upon this type of realism. Of course we find his etchings transfixed by sinister shafts of light; but it will not do to think of his etchings when criticising his sepia drawings: the former are as unlike the latter as they are unlike

the oil-paintings. Rembrandt engraved with the etcher's tool, but he drew with the brush. Goya took up that brush—and its peculiar technique of expression—where Rembrandt laid it down. For Goya too preferred the brush to draw with; sought the same particular means of expression; cared less for faces than for gestures, less for gestures than for the whole scene, less for the scene even than for a kind of complex dramatic symbol the unity of which holds the entire picture together and creates what he intended by a work of art. But in Goya's case there is none of that solemn biblical illumination which transfigures the personages of his master. In Goya there is no light, only lighting.

And he demolished what was left, in Rembrandt, of the arabesque. The difference between the two is primarily one of temperament; but it can also be seen in the fact that, whereas Rembrandt's drawing was not necessarily that of an engraver, Goya's was as intimately connected with his etchings as that of most Italian artists with their paintings. He may have been a maniac, but he was first and foremost an artist. There must be no mistake about this: however terrible the things to which he bore witness, he used his testimony as a vehicle of his draughtsman's genius, never for its own sake. Above all he wanted to create etchings; and if his art seems so close to ours today, that is because he subordinated his material, however sensational it might be, to a totality *of another order*.

From the San Fernando days onwards, we watch Goya's backgrounds becoming more and more stylised; in his drawings they are either completely blank or in the vaguest sense architectural. This was perhaps a memory of the white background representing the glaring sky in G. D. Tiepolo's *Flight into Egypt*; and in the same way the earliest of Goya's black grounds often suggest night. Their office, however, like that of the mediaeval gilt backgrounds, is to lift the subject away from actuality, so as to lodge it, like a Byzantine subject, in a world of expression more immediate than our own. Goya's black is the Devil's gold; it is also another substance—the engraver's ink. This substance, which in itself expresses reality without reproducing it, gives rise to a technique which also expresses reality without reproducing it. It is a technique which derives its value from the medium, from its broad or scribbled stroke, its interrupted flow, its inherently *engraved* quality. Like a romanesque tympanum, each one of Goya's plates has a unity of its own, of which the subject is only one element. His figures stand out against the night like the Christ of Autun Cathedral presiding over the fate of the world. He means his universe to be his and his only, but at the same time it must be an etcher's universe.

His drawings too, though they were not all intended for etchings, are essentially those of an engraver, in the sense in which we distinguish between the drawings of a painter and those of a sculptor. (By the time Rembrandt substituted for outline

expressive volumes in the manner of Leonardo, painters had ceased to be sculptors as well.) The considerable simplification to be observed in the *Female Prisoner* of the *Caprichos*, compared with the plate which precedes it, had a powerful effect on the drawings that come after it. From the moment when Goya attempts to do more than give an account of his nightmares, on however big a scale, his tense style acquires the engraver's stroke that was to prove its greatest asset. He is known to be one of the most unequal of great painters: his sketchbooks contain a little of everything—exorcisms, attempts to tame the lesser devils, rough notes, memories, satires, dreams. Many experiments with different kinds of stroke and dab, but few with effects of light. Henceforward the world, and what lay beyond it, existed for him only for the sake of his engravings. Although among the greatest of colourists, he was to observe that "in Nature there is only black and white." And the haggard, contracted features of his prisoners suffice to make the rest of contemporary drawing look merely decorative. . . .

The providential discovery of lithography (his eyes were by now too weak for etching) had a profound effect upon the technique of Goya's drawing, which, while continuing to evolve, was at the same time too tightly bound up with all the phases of his engraving not to be modified by it. The dabs become muzzy, the strokes blunted. Although he continued to avoid the finicking Italian style, which the neo-classical artists had taken over, Goya's first essays, like those of all the early lithographers, remained tentative.

His best brush drawings seem exploratory, as if he were seeking to attach his subjects to a world beyond them; but a ghost of one of his former sepias keeps slipping in between his vision (or model) and the pencil drawing, so that the latter seems but a copy of the sepia. This impression is strengthened by the fact that the subjects are the same. The style of his etchings was essentially an engraver's, that of his portraits and other canvases essentially a painter's; but, deprived of the blob of colour, his lithographical method had nothing to work with except a rather crushed and tremulous stroke, pale as that of the etchings in which he had imitated the technique of Tiepolo. In fact he seemed to be going back to the style of his youth,—until the day on which he discovered that the real substance of lithography is not black, but white.

It was the same discovery as he had made in the case of etching,—and of painting, too—when he broke with the "objective vision" of his portraits in favour of a style which used pure colour, relieved by sharp accents of black; a style which, by reviving the arrogant brushwork often practised by Rubens, Rembrandt and Hals,

enabled Goya to confer on his pictures an expressiveness as special as might have been achieved by primitive stained glass, if that had had the advantages of chiaroscuro and varied surface. He had tried to unite the weight and power of El Greco to the improvisatory freedom of Magnasco. For this purpose he had needed all those things—insanity, revelry, hell—which put man beside himself. Living cut off at the House of the Deaf, hemmed in by the battery of maskers and phantoms with which he had covered his walls, he would often interrupt his acrimonious conversation with these teeming ghosts to resume that communion with painting which he had started alone, thirty years before, and which he now continued alone. Was he still afraid of madness? It would certainly have been at home in that house! Stealthily at first, then more boldly, those ghosts had ended by taking possession both of the house and of Goya himself. He permitted them no more than a nocturnal existence, hardly less monochrome than the black and white world of his engravings and his dreams. Phantoms, they made little more than a dull murmur beside the voice, at once sovereign and guttural, of his colour inventions. His pursuit of those forms "which live only in the imaginations of men" had shown him how vulnerable facts are. At last he knew that, if some men are lonely because the world has abandoned them, others are so because the world has not yet joined them in their solitude. He understood now why the prophets went to the desert in search of strength, and that if his own desert gave him power to impose his visions on the rest of the world, it was by virtue of a far more sonorous language—the one he had invented, years ago, at San Fernando.

The exuberant freedom of Rubens and of Tintoretto had aimed at adorning the universe, while that of Rembrandt attempted to transform it into something else. No painter, before Goya, was as successful as Rembrandt in avoiding the ephemeral aspects of his age: the Aix and Bayonne portraits, like the *Old Men* of the Prado, are essentially "modern." But compare the *Woman Sweeping* of Rembrandt with Goya's *Milkmaid of Bordeaux*: the first might come out of a Holy Family, while the second is merely the pretext for a picture. Until Goya arrived on the scene, all portraits, though they were portraits, appealed also to the beholder's imagination. Twenty of Goya's portraits have none of this appeal—are just art at its most unadorned. This man, to whom dreaming was second—perhaps first—nature, freed the art of painting from dreams. Slowly and painstakingly, not with the sudden leap of the dying Franz Hals, Goya conferred on painting the right to consider objects as only the raw material with which to create, not the decorative realm of the poet, but the realm of essences evoked by music. He it was who first made the sitter subsidiary to the picture, and not the picture to the sitter; who preceded Constable, Corot, Daumier, and Delacroix in creating a type of sketch that was an end in itself;

who, by breaking the link with the imagination, overturned the established ideas of harmony in the interests of dissonance. Having started by imposing his visions on Spain, he ended by imposing upon her his method of seeing (*i.e.*, his own soul), which could better be conveyed through the relations of black to red than through a race of phantoms. Yet those teeming ghosts remained to assist, half-blinded, at Goya's obstinate quest of modern colour. . . .

At Bordeaux he drew all over again the monsters he had been unable to bring with him. Their tremulous outlines make them look as if they too had grown old. . . . Then, once more, as on that night at San Fernando when he invented the *Caprichos*, inspiration visited him, and he discovered what he had been looking for ever since first touching a lithographer's stone: the texture proper to the medium. After first spreading a layer of grey all over the surface of the stone, he would scratch out the high-lights with a scraper, then put in the oily blacks with bold, angry strokes, as if they had been accents of colour. He placed the stone, like a canvas, on an easel. He stopped sharpening his pencils, used them instead like brushes. He sought the kind of broad effect which compelled him to look at the stone from a distance, as he would at one of his pictures—an effect not required again by lithography for a long time. The finishing touches he inserted with a magnifying glass, not for fear lest some detail escape his notice, but because his eyes were failing. . . .

Thus, once again, the shaky line of the pencil drawings gives way to the old hand of the master. Not in the interests of monsters, but in those of the other great passion of his life, that passion which had possessed him before his phantoms arose and against which they were finally powerless. Through the accents of terror he could hear the beating of his blood, as it were a dying echo of the hubbub of war, of the age-old voice of devastated Spain. The bull had returned.

After the *Bull-fights of Bordeaux* Goya went on painting, obsessed by that peculiarly intense light which united Titian, Hals, Rembrandt, Michelangelo, as death drew near to each. Old men tired of living, but not tired of painting, they care no more for other people, and paint only to please themselves. Painters themselves know what old age means, but their work does not. . . . So Goya worked on, at the last portraits, at *The Monk* and *The Nun*. Loneliness, now haunted by desire for the peace of eternity, became one with his deafness, which was as complete as Beethoven's. The drawings, however, begin to give out. In order to revive them it would have been necessary to alter their technique, to discover—perhaps in gouache—the equivalent of those scratched high-lights. A few more dogs and men with wings, a laggard devil or two. . . . Even Spain, which (he knew) would have appeared different in the imaginations of men, had he never painted, was be-

ginning to withdraw herself. . . . Already he could scarcely see the world that he could no longer hear at all; scarcely see even his chalks. . . .

It was not long before painters forgot the anguish that had forced this man to erect a lonely and immitigable art in the face of the entire culture into which he had been born. All they preserved of those dazzling remains was the establishment of the individual artist, and the transformation of a world into pictorial terms. They set to work, with no passion save that of painting, to express anew, as Goya had done, a spirit at once more hungry for absolute values, and more independent of them, than any which art had ever known. . . .

At this point modern painting begins.

1947

Translated from the French by Edward Sackville-West

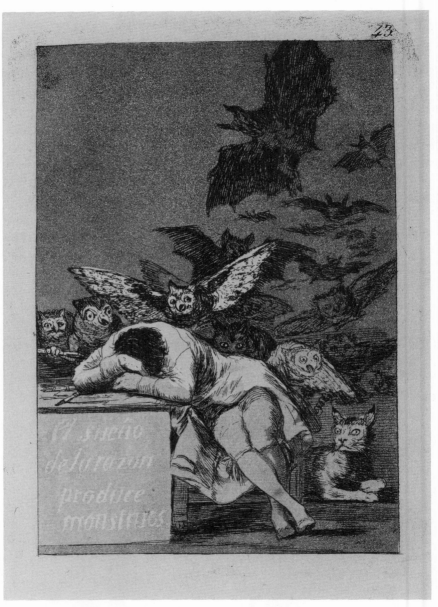

Francisco José de Goya y Lucientes (1746–1828): *The Sleep of Reason Produces Monsters* or *El Sueño de la Razon Produce Monstruos*. Engraving from *Los Caprichos*.
© Sotheby's, 1988.

ROBERT PINSKY

On the Prints
of Francisco Goya

Disparate: folly, the folly of disproportion. *Capricho*, caprice, *capriccio*: not a ca-
price, a playful composition or light Chevrolet but rather a head, *caput*, with the
hair standing on end as on a hedgehog, the little animal called *riccio*. Also, per-
haps, some sense of the capric, the bounding gait and sexual tradition of the goat.
Caprichos, *Disparates*, and *Desastres*: works on paper depicting, with an odd
glamour, human cruelty, stupidity, and excess—those, and human meaning.

Thus, a corpselike pair, dandy and cleric, ride piggyback on other cadavers, and
with wooden lances attack a fifth figure, crouched under a crude wicker bull.
Smirking whores pluck little puckered, vomiting chicken-men, naked and help-
less. A priest pulls his pants up, his face tilted as the force of gravity seems also partly
diagonal. Puppets, devils, witches, the human body worked by the legs like a bel-
lows, the little hole between the legs puffing, the immense hams of a giant, the las-
civious crone dangling a rosary over a whore's white leg, a monkey strumming the
back side of a guitar for a pleased donkey.

The first drawings that became Goya's *Caprichos* were called the *Sueños*, and
they are indeed like dreams; but they are dreams consistent in feeling and manner
with the prints of his *Disasters of War*. The atrocities are "nightmarish," the
dreams have a cool reportorial quality. The two modes depend on similar merged
elements.

For instance, in *Desastres* 30, depicting the explosion of a powder-magazine in
Zaragoza, the human bodies and furniture sprawl and tumble in the floating,

dizzy violence familiar from photographic stills and motion pictures of war: as if matter still had weight, mass and frangibility, but principles like up and down were broken. The same quality appears in the backward-leaning grotesques who dance in a ring in *Disparate Alegre,* or in the unleashed heaviness of the startled, floating bulls.

The value of documentation and the value of dreamlife come together in mass-produced works on paper: religious prints, celebrity magazines, *Female Boy Gets Self Pregnant,* comic books, chapbooks, novelizations, hobby books. Like published poems and photographs, Goya's *Caprichos* are works on paper, created with tools warmed by the artist's hand, but realized on paper by the mechanical impression of ink on paper. The white paper itself in these works functions as air and space, or as the whiteness of human flesh, living and dead.

Printed paper, unlike painted plaster or wood or canvas, and even more unlike carved wood or stone or cast metal, associates itself with meaning: visible, but a negative ground, the paper defers to what is on it: a check, a dollar bill, a message. And the words Goya has attached to these images are something more than titles. They are meanings, and if not exactly the meanings *of* the images, his terse slogans and morals are meanings that belong to the images. The words not only comment upon the images and their meanings, they assert that they have meanings. Goya's horror, the words emphasize, sometimes by their very inadequacy, is not the horror of meaninglessness. It may be the horror of dark or unknown meaning, but never of none. The world, he demonstrates, is a pig; but it is someone's pig.

"Even worse" ("*Tanto y mas*"), on a study of corpses; "One can't look" ("*No se puede mirar*") on a group of civilians, including women and children, about to be executed; "What more can be done?" ("*¿Que hay hacer mas?*") on the sexual mutilation of a corpse: the dry banality of the words throws a more than ironic light on the images. That is, the words are too summary and banal for mere understatement; they emphasize the two elements, reportorial and dreamlike, in what we see: the pit of black ink lightstruck with little dashes, under the corpse's upside-down trunk; the bright white paper sword angling into the thigh, the angle of the swordsman's leg lifted jiglike for leverage, profiled white against the black ink, the elegant theatrical Goya space that makes each print like a beautiful stage-set design.

"I saw it" ("*Yo lo vi*") says another *Desastre*—"And this too" ("*Y esto tambien*") says the next. But these refugees, crouched or leaning slightly backwards, with their pots and children, have the floating, grotesque attitudes and spacey, inappropriate expressions of the fools and libertines of the *Disparates.* Disproportion, folly, and disaster seem to manifest in different ways the same horror and elegance

of the visible world. Disproportion, folly, and disaster drive the human body and its artifacts to the elegant attitudes of the artist's dream.

In the great *Soldiers Frightened by a Phantom*, the soldiers, literally falling over one another, are an epitome of both the corpses and the perpetrators of the *Desastres*. To their left, tall as a house, the humped, shrouded, translucent hooded figure gestures, the menacing essence of Disproportion itself. And peeking from this creature's sleeve, leering like Punch, peeping out as if from a fallen tent, or under a flap in the diaphanous sleeve's torn paper, is the mocking mask of Folly.

Full of emotion, and of wrong emotion, full of disproportionate grace, *Soldiers Frightened by a Phantom* is an image of human meaning both overestimating itself—the little sword of the one figure who has kept his feet, the boots and bandoliers—and mistaking its antagonist. The overwhelming figure with its mocking truth up its sleeve, unreadable by the soldiers in the print or the calm viewer outside of it, is made mostly of barely stained, buff-colored wove paper.

1985

Pierre Joseph Redouté (1750–1840): *Rosa Indica Vulgaris*. Museum Histoire Naturelle, Paris. Photo: Giraudon/Art Resource, New York.

KATHERINE ANNE PORTER

A Note on
Pierre Joseph Redouté

*For the reproductions of his water colors, he invented a process
of printing in colors which he never consented to perfect to the
point where it would be completely mechanical. Each one of
these prints had further to be retouched by hand. They owe to
these light but indispensable retouchings the capricious illusion
and movement of life—a life prolonged beyond its term. In
effect, the greater part of the roses who posed for Redouté no
longer exist today, in nature. Rosarians are not conservators.
They have come to create a race of roses, they do not care
whether they shall endure, but only that they, the creators, shall
give shape to a new race. So the old species disappear little by
little; or if they survive, it is not in famous rosaries, which
disdain them, but in old gardens, scattered, forgotten, where
there is no concern for fashions in flowers.*

<div align="right">Jean-Louis Vaudoyer: Les Roses de Bagatelle</div>

Here is an eye-witness description of Pierre Joseph Redouté (1750–1840): "A short
thick body, with the members of an elephant, a face heavy and flat as a Holland
cheese, thick lips, a dull voice, crooked fat fingers, a repellent aspect altogether;
and under this rind, an extreme fineness of tact, exquisite taste, a profound sense
of the arts, great delicacy of feeling, with the elevation of character and constancy
in his work necessary to develop his genius: such was Redouté, the painter of flow-

ers, who had as his students all the pretty women in Paris." This is by Joseph-François Grillé, a lively gossip in his time.

A writer of our own time, looking at Redouté's portraits, by Gérard and others, concludes: "In spite of the solid redingote, the ample cravat and the standing collar of the bourgeois, his portraits make one think of some old gardener weathered and wrinkled like a winter apple."

Dear me: I have seen only the engraving after a painting by Gérard, and can find nothing at all strange, much less monstrous, in it. He seems a man of moderate build, in the becoming dress of his age, though plainer than most; with a very good face indeed with rather blunt features, and pleasant, candid, attentive eyes. Perhaps Gérard loved the man who lived inside that unpromising but useful rind, and showed him as he really was.

He was born in Saint-Hubert, Belgium, the son and grandson of artisan-painters, decorators of churches and municipal buildings. His two brothers became also painter-decorators. In the hardy fashion of the times, after a solid apprenticeship to his father, at the age of thirteen he was turned out in the world to make his own way. Dreaming of fame, riches, glory, he roamed all Belgium and Flanders looking for jobs and starving by the way. He took a year of hard work at Liège in the ateliers of famous painters and was sent to Luxembourg to paint portraits of his first royalties, the Princess de Tornaco and others. The Princess was so pleased with his work she gave him letters to present to certain persons of quality residing in Versailles.

In Flanders he studied deeply the painters of the ancient Flemish school. After ten years of this laborious apprenticeship, he joined his elder brother Antoine-Ferdinand in Paris; Antoine-Ferdinand had all that time been unadventurously earning a good living as painter-decorator. Pierre Joseph helped his brother decorate the Italian Theater, and painted flowers wherever he was allowed. He learned the art of engraving, and he managed to get into the King's Garden, a botanical wonder, in that time, of royal and noble gardens, in order to study, draw, and paint plants and flowers. There he met Charles-Louis L'Héritier of Belgium, a man of great wealth, an impassioned botanist and adherent of the classical methods of Linnaeus.

From this time Redouté's history is the straight road to fame, fortune, and the happy life of a man capable of total constancy to his own gifts, who had the great good fortune to be born at the right hour in time, in the right place, and with the pure instinct which led him infallibly to the place where he could flourish and the people who needed and wanted precisely the thing that he could do. The rage for

botanical gardening which had been growing for nearly two centuries had reached its climax. Only the royal, the noble, only the newly rich could afford these extravagant collections of rare shrubs, trees, flowers. There were no more simple adorers of flowers, but collectors of rarities and amateur botanists. It was an age of nature lovers, whose true god was science. Redouté was a botanist and a scientist, a decorator with a superior talent for painting. He stepped into the whole company of such combination scientists and decorator-artisans which surrounded and lived by the bounty of rich amateurs. Armed with brush, pencil, microscope, copper plates, stains, colors, and acids, they adhered mightily and single-mindedly to their sources of benefits—intellectual bees, they were. Nothing could have been more touching than their indifference to social significance: they hadn't got the faintest notion where the times were driving them, or why; theirs only to pursue their personal passions and pleasures with scientific concentration; theirs to invent new processes of engraving, coloring, more exact representations of the subject in hand. The gardeners were concerned only to invent new roses, the botanists to botanize them, the artist-artisans to anatomize and engrave them. They were good workmen to whom the employment and not the employer was important.

It is astonishing how a world may turn over, and a whole society fall into ruin, and yet there is always a large population which survives, and hardly knows what has happened; indeed, can with all good faith write as a student in Paris did to his anxious father in Bordeaux, at the very height of the troubles of 1792: "All is quiet here," he declared, mentioning casually an execution or so. Later, he gave most painful descriptions of seeing, at every step in the street, the hideous bleeding rags of corpses piled up, uncovered; once he saw seven tumbrils of them being hauled away, the wheels leaving long tracks of blood. Yet there was dancing in the streets (he did not like to dance), bonfires at the slightest pretext (he hated bonfires), and all public places of entertainment were going at full speed. A craze for a new game called Coblentz, later Yo-yo, came to the point that everybody played it no matter where, all the time. When the King was beheaded, in January 1793, Mercier tells how people rushed to dip handkerchiefs, feathers, bits of paper in his blood, like human hyenas: one man dipped his finger in it, tasted it, and said: "It's beastly salty!" (Il est bougrement salé!) Yet no doubt there were whole streets and sections where no terror came. Our student, an ardent Republican and stern moralist, got his four years of tutoring and college, exactly as planned. The Collège de France opened its doors promptly every autumn the whole time he was there.

Redouté, in the center of the royal family, as private painting teacher to the Queen, later appointed as "Designer of the Royal Academy of Sciences," designer in Marie Antoinette's own Cabinet, seemed destined to go almost as untouched by

political disasters as the student writing to his father. On the very eve of the revolution, he was called before the royal family in the Temple, to watch the unfolding of a particularly ephemeral cactus bloom, and to paint it at its several stages.

When the Queen was put to death in October 1793, it was David, patriot-painter, who made the terrible little sketch of her in the cart on her way to the scaffold: a sunken-faced old woman with chopped-off hair, the dress of a fishwife, hands bound behind her, eyes closed: but her head carried as high, her spine as straight, as if she were on her throne. We see for the first time clearly the long curved masculine-looking nose, the brutal Hapsburg jaw. But something else that perhaps David did not mean to show comes through his sparse strokes: as if all the elements of her character in life had been transmuted in the hour of her death—stubbornness to strength, arrogance to dignity, recklessness to courage, frivolity to tragedy. It is wonderful what strange amends David, moved by hatred, made to his victim. *

Her friendly, but preoccupied, painter-decorator happened to be in England with L'Héritier, who had done some very fancy work indeed getting away with a treasure of botanical specimens against a capricious government order. The two sat poring over their precious loot in perfect peace while France was being put together again. They returned, and went on with their work under the National Convention, which took great pride in the embellishment of the King's Garden, re-named the Garden of Natural History. (By 1823, after four overturns of the French government, this garden settled down for a good while under the name of the Museum of Natural History of the King's Garden.)

Josephine Bonaparte of course had the most lavish, extravagant collection of rare plants, trees, and flowers at Malmaison, and Redouté became her faithful right hand as painter, decorator, straight through her career as Empress, and until her death. In the meantime he was teacher of painting to Empress Marie-Louise; went on to receive a gold medal from the hand of Louis XVIII for his invention of color printing from a single plate; the ribbon of the Legion of Honor was bestowed upon him by Charles X, in 1825; he painted the portrait of the rose named for Queen Marie Amélie; and lived to see his adored pupil Princess Marie-Louise, elder daughter of Louis-Philippe, become Queen of the Belgians.

During one upset or another, his beautiful house and garden at Fleury-sous-Meudon were almost destroyed; he seems to have invested all the handsome for-

*In 1790, the Queen's lover, Count Fersen, wrote to his sister: "She is an angel of courage, of conduct, of sensibility: no one ever knew how to love as she does." He had known her since they were both eighteen years old, and had been her lover for more than five years. He had himself all the qualities he found in her, and more.

tune he had made in this place. Yet he simply moved into Paris with his family and went on working. In 1830 again there were the crowds milling savagely in the gardens of the Royal Palace, this time roaring: "Long live the Charter. Down with Charles X! Down with the Bourbons!" Charles went down and Louis-Philippe came in, the last king Redouté was to see. While royal figures came and went in the Tuileries, "that inn for crowned transients," as Béranger remarked, the painters Gérard, Isabey, and Redouté remained a part of the furniture of the Crown, no matter who wore it.

Such a charmed life! Only one of that huge company of men living in the tranced reality of science and art, was for a moment in danger. L'Héritier almost got his head cut off during the first revolution; in 1805 he was killed in the street near his own door—I have seen no account which says why. Did even those who murdered him know why they did it? Did L'Héritier himself know?

The story of Redouté's labors, his teaching, painting, engraving, his valuable discoveries in methods of engraving, coloring plates, and printing, is overwhelming. He worked as he breathed, with such facility, fertility of resources, and abundant energy, he was the wonder of his colleagues, themselves good masters of the long hard day's work. Redouté is said to have painted more than one thousand pictures of roses alone, many of them now vanished; it is on these strange, beautiful portrait-anatomies that his popular fame endures. He loved fame, and was honestly eager for praise, like a good child; but he took no short cuts to gain them, nor any unworthy method. When he invented a certain process of printing in colors, he saw its danger, and stopped short of perfecting it; he did not want any work to become altogether mechanical. All his prints made by this process required to be retouched by hand, for as a good artist he understood, indeed had learned from nature itself, the divine law of uniqueness: that no two leaves on the same tree are ever exactly alike.

His life had classical shape and symmetry. It began with sound gifts in poverty, labor and high human aspirations, rose to honestly won fame and wealth, with much love, too, and admiration without envy from his fellow artists and students. It went on to very old age in losses and poverty again, with several friends and a royalty or two making ineffectual gestures toward his relief. But then, his friends, both artist and royal, were seeing hard times too. On the day of his death he received a student for a lesson. The student brought him a lily, and he died holding it.

1950

J. M. W. Turner: *Rain, Steam, and Speed: The Great Western Railway*, 1844.
National Gallery, London.

KENNETH REXROTH

Turner: Painting as an Organism of Light

Until recently, when a wholesale revision of reputations and change of taste set in in the arts, people who prided themselves on being up-to-date looked patronizingly back on Turner as an artist for adolescents. Today, when it has become fashionable for a painter to speak of himself as a romantic abstract-expressionist, Turner is coming back into favor.

I think these attitudes point up certain more obvious qualities of his work—probably faults rather than virtues. They may both be summed up on one generalization: Turner was a plebeian artist with thoroughly plebeian tastes.

Taste can be a great obstacle to the appreciation of painting, as is obvious again in Turner's polar opposite, William Blake. It makes or breaks second-rate work, but it has little to do with the very greatest paintings, or at least painters. Cézanne, for instance, had no taste whatever. Turner's positive passion for trees with silky silhouettes, sunsets no artist could paint, snowstorms in the Alps that beat about the head of Livy's Hannibal, storms at sea that beset Captain Kidd, seems a little ingenuous and boyish to sensibilities corrupted by a century of black bile, alienation, and world ill.

Many people still think of Turner in terms of the reproduction which hung on the wall in high school. Before approaching him as a serious artist it is necessary to overcome a natural modern distaste for his taste. It would be easier for most people if he had painted ugly pictures. We have been taught to look through and past the

ugly. Unfortunately he painted very pretty pictures indeed, prettier than Russell Flint or Leon Kroll.

Once the initial shudder of repugnance is past, it becomes apparent that Turner was not only one of the climacteric painters, a genuine original and an undying influence, but that his plastic notions, his idea of space, and the ends which he envisaged as possible in painting are peculiarly modern—modern in this case meaning something very different from the Cubist-Classicism of the first quarter of the century or the psychologism of the second.

I am not going to talk about Turner's more famous paintings—the illustrative and picturesque landscapes, the heroic compositions, the battle pieces, and the sentimental anecdotes, like the *Téméraire* or *Sea Burial of Wilkie*. I think most of these are very great paintings. The last is a spectacular abstract composition in red, grey, and black. But they are endangered by their obvious appeal. Instead I shall try to trace, in terms of pictures most of which can be found in collections of reproductions, the evolution of Turner not only as an abstract artist but as a painter who was working toward a vision of a kind of space unknown in the Occident. Tintoretto and Tiepolo had preceded him, but their achievements were not understood. Turner's were not to be understood either. The nineteenth century appreciated him for his romantic, picturesque landscapes, the Impressionists for his divided and brilliant color, the early twentieth century smiled patronizingly.

Speaking of his color and of the necessity of discussing him as a painter in books, it happens that Turner had very little respect for his métier, or at least no knowledge of color chemistry. Practically all of the few paintings in American collections bear little resemblance to their original state. In mid life he began to take more care. Even so, hundreds of his paintings had disintegrated or faded hopelessly by the time of his death. The best are in the great Turner galleries in the Tate, in the National Gallery, and in a few English private collections. There are, though, many volumes of excellent color reproductions in any well-stocked public library.

I don't want to talk about Turner's technical means and his mastery of them. He was one of the first artists to use divided color consistently. He was one of the first artists to use pure spectrum color. He was one of the first artists to think of a painting as what has come to be called an abstraction. But these items in the history of art we have all learned in high school. Any revolutionary decorator could have accomplished as much. He is more important than this.

Leaving aside for a moment the main development of Turner's art, I would like to say something about an aspect of his life which has always embarrassed his British biographers and critics—his attitude toward people and toward sex. His human

figures have a strange inhumanity. This is something that seems to have been a late-eighteenth-century convention. They are like Longhi but less doll-like, more perhaps like Goya than anyone else, whose *Spain, Time, and History* (1799) might have been painted by Turner. This is an attitude toward people which will lead eventually to Giacometti or Tanguy, or, for that matter, Nadelman. These figures are the androids of science fiction—*Between Decks* (1827, Tate); *Jessica* (around 1830, Collection of Lord Leconfield, Petworth)—one of the most startlingly human figures in the world's art, she looks for all the world like a visitor popping her head out of a flying saucer; and the large, red, unfinished nude in the Tate, which certainly has none of the appearance of a calendar girl but is one of the hottest pictures ever painted—so much so that it is positively difficult to look at. I happen to have seen it the same day I saw Boucher's *La Petite Morphi*, which was in London on loan at the time and which is a very great painting in its own right. No chasm separates these two women, but a whole universe. I don't wonder that Turner couldn't finish it. But as far as he went he painted one of the world's most unforgettable thoughts.

With these pictures, which all seem to have been painted at Petworth around 1830, it is convenient to place *The Room at Petworth* (1830, British Museum), because of its color—red—and its treatment of interior light—shafts and whorls of sun motes. It is the most fashionable of Turner's paintings nowadays, one of his greatest, and the first intimation of the purely visionary style of his last years.

Looking into a book of Turner will impart something of the same sensation, but nothing can compare with walking into the great Turner galleries of the Tate. The sensation is not an aesthetic one but a human one. You feel immersed in the very being of a personality. It is like acquiring all at once a life-time of a close family relationship. The ideal classical painting is as impersonal as Poussin—the person simply does not exist behind the canvas. A gallery full of Poussins would be a gallery full of independent objects of art which might just as well have grown naturally like crystals. Only the full impact of room after room of intensely personal and expressionistic paintings like Turner's can bring home the full meaning of expressionism, personalism.

It is this personal power and personal integrity, fully as much as the plastic originality, which almost immediately override Turner's taste.

It is interesting to compare Blake and Turner. Once again, like Poe and Whitman, the culture reveals its polarity. Both of them were tasteless artists, yet with Palmer and Calvert they are the leading painters of Great Britain. They were tasteless artists because good taste was not so much bad as trivial. They were plebeian artists and upstarts because official society was not so much vicious or dishonest as

stereotyped. This is not always necessarily true, but looking back on the nineteenth and late eighteenth centuries, it is easy to believe that it has been.

Blake drew, rather than painted, objects in empty space. His work was a sort of small hypertrophy of the principles of Renaissance art. He was to Marcantonio as Marcantonio was to Raphael or Michelangelo—a reduction in scale, an increase in specialization. With all his hatred of Newton, he was an eminently Newtonian painter. Doubtless he would have hated Machiavelli too, but the figures of his mythology, whether plastic or literary, were isolated Renaissance men struggling with each other for mastery—Job, Los, Enitharmon, Satan are figures like the Borgias and the Medicis.

Turner painted, at least in his maturity, dynamic saturated space, all the forces of which were organically related like the strains and stresses, the vacuoles, vortices, and pseudopods which make up the living processes of an amoeba. Even in the heroic paintings, Ulysses is a scrawl of color, Polyphemus a cloud.

Both Turner and Blake started out as artists for the engraver and continued such work all their lives. Blake's excited polemic for outline, silhouette, sharp planes of black and white, is known to everyone. As for Turner, Pye, his best engraver, said, "The one great aim of landscape art is to enable the spectator to see, as it were, into space; and this can be done only by a perfect knowledge of light."

This is a description of emotional or even spiritual phenomena, rather than a statement of fact. If one compares Turner and his engravers with the work of Stothard and Blake, or even better with the contemporary French and Italian mezzotint and steel engravers, it is apparent that he was practically the inventor of the romantic vista which was to ornament the fine books of a century—the long receding stage sets of tonalities, late afternoon light shining through the whole meteorological collection of cloud forms—so different from the building-block landscapes, the cones, cylinders, and cubes, the representation of great mass, typical of the classical tradition as seen in Poussin. And, of course, different from the linear art of the best French engravers.

It is very seldom that an artist realizes immediately upon its invention the possibilities of a medium as Turner did those of steel engraving. The mezzotint technique of the *Liber Studiorum* approaches the later attitude toward light, but the medium sets definite limits—the limits, say, of the landscapes of Claude Lorrain or Rubens. The contrast of dark and light still looks suspiciously technical—*sfumato*.

All his life Turner painted Norham Castle. Compare the early paintings with the famous watercolor of 1835, the mezzotint of the *Liber Studiorum* with the engraving. This attitude toward reality as a complex of vortices of pure light reaches

its height in the engravings in pictures like *Llanthony Abbey* (1835) in the *England and Wales* series.

The next step plastically is *A Storm in the Mountains*, once in the Darrell Brown collection but painted before 1810. Only the lower-right sixth of the painting contains some trees and cows. The rest is a turbulence of mingled rock, cloud, and light.

By 1835, one of Turner's great years, many of the paintings and most of the watercolors have moved close to abstraction. This is the year of *Sunrise, A Boat Between Headlands, Hastings,* and the most abstract *Norham Castle.* From this point on, Turner moved steadily toward perfect mastery of a new vision.

It is exciting to take another subject like Norham Castle and trace it down the years: *St. Gothard Pass* in the *Liber Studiorum.* The sketches and watercolors of 1802, 1803, culminating in the *Pass of St. Gothard Near Faido* (1843), once in Ruskin's collection and now, as I remember, in the Tate. The last is like nothing else in the world of art except Turner. This is the light metaphysics of the neo-Platonists and the medieval mystics. In paintings like this, Turner may not be a greater painter than Sesshu, Ying Yu-Chien, Hsia Kuei, the dragon painters, Tintoretto, or Tiepolo. But he has fully understood the nature of his vision—certainly more fully than any Western European artist except Tintoretto or Tiepolo. The principal difference with Turner is, again, this time on a very high level, his plebeian taste. His concept of space is the same as Sesshu's. It is simply more simple-minded, less refined and less complex. In other words, less goes on in it and what does is more obvious.

I should say that the great paintings always to be found on exhibit in the Turner galleries of the Tate or the National Gallery and all reproduced somewhere in color are *The Burning of the Ships* (after 1840, Tate), *Snow Storm at Sea* (1842, National Gallery), *Rain, Steam, and Speed* (1844, National Gallery), *Sunrise with Sea Monster* (1845, Tate), *Mercury and Argus* (1836, Tate), *Juliet and Her Nurse* (1836, Tate), *Sea Piece* (1842, once in the Orrock Collection), and finally the great visionary paintings of his last years, his seventies, culminating in *An Angel in the Sun* (1846, Tate), *Queen Mab's Cave* (1846, National Gallery), *Mercury Sent to Admonish Aeneas* (1850, Tate), *Aeneas and Dido* (1850, Tate), *Departure of the Trojan Fleet* (1850, Tate), and *The Visit to the Tomb* (1850, Tate).

These are not just paintings of a special vision. They are visionary paintings of a transcendence curiously like Blake at his best, but the work of an incomparably more knowledgeable painter.

It is remarkable how un-Western-European Turner was. He lived all his life in great simplicity, with his working-man father, and two successive mistresses who

were both illiterate. He amassed an immense fortune and left it, with all his paint-
ings, the best of which he had refused to sell, to his native country and to charity.
(His will was broken by remote and greedy heirs.)

His life was an imperturbable march toward an always growing light—that real-
ity peculiarly Turner's—and an ever increasing mastery of the means of expressing
that vision.

There is not the slightest trace in his life of artistic vanity or worldly ambition.
In the sense in which the Greek philosophers meant it, in the sense of Lao-tze, he
lived unknown.

1959

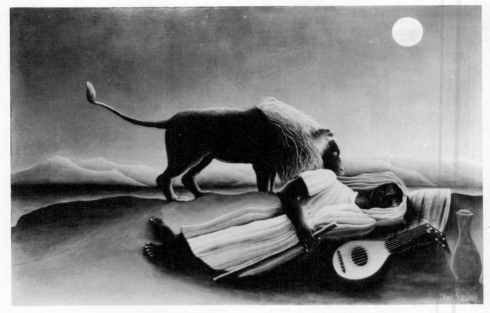

Henri Rousseau: *The Sleeping Gypsy*, 1897. Oil on canvas, 51″×6′7″. Collection, The Museum of Modern Art, New York. Gift of Mrs. Simon Guggenheim.

GUY DAVENPORT

Henri Rousseau

MEADOWS

Impressionism kept its innermost purpose a secret, being unaware of it: the idea of transition. There is scarcely an Impressionist canvas without a road, a river, a path. Locomotives appear in the unlikeliest places, behind mothers and daughters, in the far background of idyllic country scenes. It is true that roads were safe for the first time in European history, that commerce was expanding as never before.

Monet begins with the sea on the channel coast, moves on to the lovely roads cut through forests, train stations (St. Lazare was where you take the train to Vernon, and from there to Giverny), boats, harbors, cathedrals (way stations for the spirit). And then his study began to go backward in time. European agriculture is a matter of draining marshes to get a meadow. Before he turned to the primal marsh for his final great study, Monet painted meadows, haystacks, country rivers, poppy-filled fields. And with him, Renoir, Pissarro, van Gogh.

Of all the painters of meadows, Henri Rousseau was the most poetic. Dora Vallier is right to call him "the Master of the Trees," but in front of the trees are the meadows, flowery, bright with flat sunlight.

A meadow is the transition between forest and city. Rousseau spent his years as a collector of tariffs on farm produce at the old gates of Paris, where the city becomes meadow and farmland.

His career begins with the forest as a romantic place, where revelers dressed in commedia dell'arte costumes stroll under a white moon. He progresses toward the greatest of love affairs with French trees, particularly the acacia (his symbol of fem-

ininity) and the chestnut (masculinity), and, after his discovery of the hothouses in the Jardin des Plantes, the jungle, or primeval forest. And here he made himself not only one of the greatest painters of our time, but one of the greatest poets.

FATE

His most telling self-portrait is of himself as a jumping jack dangled by a child standing in a meadow, under an acacia. A chestnut stands in the middle ground, and behind it, a road. Beyond the road, a forest. The child symbolizes innocence, the jumping jack buffoonery. All add up to Rousseau's human condition: a squabble inside him of the childlike and the foxlike. The child has gathered flowers in the meadow, and has them in a fold of its dress: the artist appropriating and presenting Beauty. And yet the child must at the same time manipulate a toy, a Punchinello. The soul and its puppet, the body. The ideal and the real. Rousseau's great talent as a painter was such a problem: he had the vision. The means for accomplishing the vision were as intractable as a floppy, obstinate doll. The child's eyes are defiant. The meadow is a paradise. Acacia and chestnut stand guard.

THE ACHIEVEMENT

But, before we get further, the triumph. He hangs in the Louvre. He never doubted that he would. He was utterly alone in that belief. He also hangs in Prague, London, New York, Moscow. Soviet dogma, tedious at best in its artistic exclusiveness, takes him to heart. Of his contemporaries, all but a few would have been outraged to know that the world would come to consider him a master, to be spoken of in the same breath as Sassetta. The settling of history's dust is always full of surprises: Emily Dickinson, John Clare, Melville. Reputations change: the eighteenth century's Kit Smart, psalmist, drunkard, and lunatic, is not our Christopher Smart, author of the *Jubilate Agno*. Our Mark Twain, the author of *Huckleberry Finn* and *Life on the Mississippi*, is not the Mark Twain of his lifetime, author of *Tom Sawyer* and *Innocents Abroad*.

Henri Rousseau's metamorphosis from a divine fool who painted laughable daubs to a painter of immense stature is an aesthetic transformation we do not yet fully understand.

QUESTIONS

His paintings refuse to age. They grow in interest. *The Sleeping Gypsy*, not known until a decade after his death (stored as junk in the basement of the prefecture at Laval) belongs to our age all the more poignantly because we do not deserve it.

None of the fanatic energies of our century (Capitalism, Communism, Fascism) could have called it into being. Violence stands poised to kill the imagination, which is defenseless. Notice the absence of trees.

DAS BEDEUTUNGSPROBLEM

Of *Les joyeux farceurs* (1906, Philadelphia Museum of Art: Louise and Walter Arensberg Collection), Yann le Pichon writes: "In his painting *Joyous Jokesters*, Rousseau depicted monkeys scratching themselves and knocking over a bottle of milk; he also gave them anthropomorphic faces." They are not monkeys but gibbons, who are apes; they are not scratching themselves; they are not knocking over a bottle of milk; and God, not Rousseau, gave them anthropomorphic faces. Carolyn Keay: "This strange painting, with an upturned milk bottle and a back-scratcher in a jungle setting . . . " La Keay again: "What could Rousseau have meant in *Les joyeux farceurs* (Merry jesters) [sic] by placing an upturned milk bottle and a back-scratcher in a jungle scene which for once is peaceful and serene? There is no understandable motivation for any of these situations." That's still not a milk bottle, and the motivation is perfectly understandable if you look at the picture. Jean Bouret: "Exhibited at the 1906 Salon d'Automne, this was one of the works that Maître Guilhermet produced in court to illustrate his client's naivety. The composition is beautifully proportioned: the broad leaves frame the picture at right and left; the white yucca flower at left is balanced by the vividly colored bird sitting on a branch at right; the two monkeys—the jesters—huddle together in the center foreground. The canvas is filled with a mass of carefully painted leaves in varying shades of greens and greys, yet the impression is one of depth rather than suffocating confusion." There are five "monkeys," not two. All the leaves are green, none grey. Alfred Werner: "In many of Rousseau's jungle scenes, wild beasts are depicted attacking natives or weaker animals. This painting, however, offers a view of silent concord and amity: the creatures pose in complete harmony amidst the unspoiled primordial landscape. But what is the meaning of the inverted milk bottle, spilling its contents? Or of the back scratcher?"

Rousseau, who said of Matisse's painting that if it was going to be ugly it at least ought to be amusing, was eminently a dramatic artist. His paintings have plots that range from the hilarious to the sublime. Before *La bohémienne endormie* we are meant to feel the *frisson* of realizing that the gypsy is *not* asleep: the eyes are open a minim, watching the lion; the gypsy in terror is pretending to be dead, knowing that lions eat only live prey. Will the lion see through the ruse, or will it move on?

There is no hope of help. Only the indifferent moon gazes down. The lion, like the cats of Paris, has raised his tail in curiosity. Will the gypsy ever again play Hungarian airs on that mandolin, or drink from that water jug? See how gay and bright the coat of the gypsy is! Are we not reminded of Joseph in Scripture, whose blood-stained coat of many colors was brought by his wicked brothers to his grief-stricken father, as evidence that "an evil beast hath devoured him"? Pity and terror! You must realize it all in your imaginations, *messieurs et dames*. For sentiment, could Bouguereau have done better?

Until we are willing to enter Rousseau's world we are going to misread all his paintings. We must learn the tone of his sentimentality, his sense of humor, his idea of art. In *Les joyeux farceurs* we are in the comic world of *Tartarin de Tarascon* (1872), the Mr. Pickwick of France. Rousseau, knowing that his imaginary jungle realm admits of comedy as well as wonder and beauty, was aware of explorers in it, who, when not botanizing, tracing rivers to their sources, converting the natives, and being eaten by lions and crocodiles, must have had their light moments. Let us posit a lugubrious British explorer, deep in Africa. Having set up camp for the evening, he has a Scotch and soda. That's his syphon bottle in the painting. Rousseau has carefully made the bottle identifiable by its depressor shaft. He has not had any luck with the carbonated spray which the gibbons have frightened themselves with, just before being further hacked by the untimely return of the explorer from his bath in the river, or relieving his kidney.

The gibbons have perhaps watched the explorer from a distance before he stepped away momently. They have seen him scratch his back (who but a British explorer, to a Frenchman's mind, would take a backscratcher on an expedition?), spray soda water into his whisky, and being *singes*, they must live up to their immemorial comic reputation of aping. So they inspect the explorer's walking stick, try his backscratcher, and skeet each other with fizzing water. Delicious comedy! But, that's not all—they're caught at their mischief. That's the moment of the painting. See the tall leaves parted right and left by the explorer's foot. The gibbons drop the bottle and the backscratcher. The rightmost gibbon is still poking his fellow with the explorer's stick. Which way must we run to be saved? All eyes are on us, and on the explorer, including those of the bird in the tree.

CHARM

Personality, unlike character, is fractal. Its contours cannot be mapped, for in deciding upon the precision with which we should draw we betray a preconception. Mandelbrot's theory is that the more particular we are in depicting a coastline, the

longer it gets on a map. A man walking off a coastline with a pedometer measures a much shorter boundary than would a trained ant.

An artist can draw in outline (Lascaux, Greek vase decoration, Flaxman, Picasso) or in rich mimesis of chiaroscuro, texture, perspective (Leonardo, Ford Madox Brown). Personality, or charm, controls the former, and is its residual impression—we recognize a style of drawing as we recognize handwriting. Character controls the latter, in which meaning resides in the degree of visual resolution. Rembrandt's pathos, Braque's sincerity, Titian's voluptuousness, Leonardo's metaphysical curiosity, Vermeer's knowledge of the psychology of space: all are statements made with attitudes inherent in style. The glossy triviality of Dali is evident everywhere in the pointless and futile finish of his canvases. In van Gogh we can follow the work of the painter, and feel the movements of hand and shoulder, keeping the moment of painting as one of its qualities.

Rousseau's charm comes across before his character. He has both in great measure. He does not, as we might expect, have lines. He makes a line happen, as in nature, by arranging the finest contrast between contingent colors.

In the *Adam and Eve* (John Hay Whitney Collection, New York) the visual resolution is as in a Leonardo, but without chiaroscuro except just enough to give volume to bodies and trees. The composition, as Dora Vallier has noted, is from Léon Gérôme's *Innocence* (1852), which is a Romantic diversion of neoclassicism (naked girl and boy, fawn and a statue of Cupid above a fountain between them, style highly finished and academic). Rousseau did not have available to him the pedantic sentiment that informs Gérôme, but he had a ready Christian context, and translated them into Adam and Eve. The fawn he made into a dog, howling comically because Adam has hit a sensitive note on his flute. And so we are to be amused by the dog's howling along. Cupid has been rendered back into flesh. We are to understand him as Cain or Abel as an infant, or as Cupid. He holds one end of a vine which Eve is messing around with, making herself fortuitously decent. The painting has many good harmonies: the spray of reeds by Adam suggests the spray of notes from his flute. The dog is wearing a collar: if civilization has advanced in Rousseau's Eden as far as textiles for Adam's sash, a flute and the art of music, Eve's hairdo in a bun, shaving (Adam is beardless), why not dog collars?

Question: Is the painting sheer fun? Is it a conscious criticism of Gérôme? How much religious sentiment are we to read into the painting? "It is paradise" might have been all we could have got from Rousseau. Are we left with the exquisiteness of the trees, one already in autumn gold, two still green, the sweet path under the wood's edge, the clarity of the Bois de Boulogne about it all?

A ROUSSEAU BY RIMBAUD

Sur la place taillée en mesquines pelouses,
Square où tout est correct, les arbres et les fleurs,
Tous les bourgeois poussifs qu'étranglent les chaleurs
Portent, les jeudis soirs, leur bêtises jalouses.

—L'orchestre militaire, au milieu du jardin,
Balance ses schakos dans la *Valse des fifres*:
—Autour, aux premiers rangs, parade le gandin;
La notaire pend à ses breloques à chiffres.

Des rentiers à lorgnons soulignent les couacs:
Les gros bureaux bouffis traînent leurs grosses dames
Auprès desquelles vont, officieux cornacs,
Celles dont les volants ont des airs de réclames;

Sur les bancs verts, des clubs d'épiciers retraités
Qui tisonnent le sable avec leur canne à pomme,
Fort sérieusement discutent les traités,
Puis prisent en argent, et reprennent: «En somme! . . .»

Épatant sur son banc les rondeurs de ses reins,
Un bourgeois à boutons clairs, bedaine flamande,
Savoure son onnaing d'où le tabac par brins
Déborde—vous savez, c'est de la contrebande;—

Le long des gazons verts ricanent les voyous;
Et, rendus amoureux par le chant des trombones,
Très naïfs, et fumant des roses, les pioupious
Caressent les bébés pour enjôler les bonnes. . . .

To the square by the station, with its stingy patches of grass, its trees and flowerbeds laid out so correctly, the solid citizens, short of breath from the heat, which they say is suffocating, bring their mean-minded stupidities every Thursday evening.

The military band in the middle of the park nods its shakos to the *Waltz of the Fifes*: around it the village swell shows off, along with the notary, who swings like his own watch chain.

Landlords, peering through pince-nez, criticize the band's sour notes; balloon-shaped petty bureaucrats roll along with their fat wives in tow; and behind them, like busybody elephant-drivers, women who look like department-store ads.

Retired grocers and their cronies sit on the green benches and draw in the sand

with their walking sticks, quietly talking business, pinching snuff from silver boxes, saying, "What it comes to . . ."

His big behind flattened out over all the bench, a glass-buttoned, Flemish-bellied shop-owner enjoys his pipe, shreds of tobacco hanging from it, good black-market tobacco, don't you know?

And along the grass borders snicker punks; and, feeling sexy because of the trombones, with childish candor the recruits smell the roses and chuck children under the chin to strike up conversations with their nursemaids. . . .

(At which point, for the remaining three stanzas, Rimbaud obtrudes, and the illusion of a scene by Rousseau disappears. But for six stanzas Rimbaudian satire as robust as a Flemish genre painting has coincided detail by detail with Rousseauistic exactitude of observation. Rousseau would have been most interested in the color of the military band as a civic ornament in the Place de la Gare, Charleville, and in the deployment of solid citizens and pretty girls under the chestnut trees. Rimbaud's acid eye is guided by the precision of his sense of humor. Rousseau's eye, studiously compliant to the reality before him, would have been guided by a sense of humor radically different. But the comedy of the scene would have survived intact, if Rousseau had painted it.)

A ROUSSEAU BY FLAUBERT

Comme il faisait une chaleur de trente-trois degrés, le boulevard Bourdon se trouvait absolument désert.

Plus bas le canal Saint-Martin, fermé par les deux écluses, étalait en ligne droite son eau couleur d'encre. Il y avait au milieu un bateau plein de bois, et sur la berge deux rangs de barriques.

Au delà du canal, entre les maisons que séparent des chantiers, le grand ciel pur se découpait en plaques d'outremer, et, sous la réverbération du soleil, les façades blanches, les toits d'ardoises, les quais de granit éblouissaient. Une rumeur confuse montait au loin dans l'atmosphère tiède; et tout semblait engourdi par le désoeuvrement du dimanche et la tristesse des jours d'été.

Deux hommes parurent.

L'un venait de la Bastille, l'autre du Jardin des Plantes. Le plus grand, vêtu de toile, marchait le chapeau en arrière, le gilet déboutonné et sa cravate à la main. Le plus petit, dont le corps disparaissait dans une redingote marron, baissait la tête sous une casquette à visière pointue.

Quand ils furent arrivés au milieu du boulevard, ils s'assirent, à la même minute, sur le même banc.

Because the thermometer read 33 degrees [90 Fahrenheit], the Boulevard Bourdon was without traffic or pedestrians.

Further along, between two locks, ran the St. Martin canal as straight as a ruler and black as ink. Dead center in it, there was a barge loaded with wood, and along it, two rows of casks.

Beyond the canal, between buildings and lumberyards, the large clear sky was partitioned into squares of blue, and under the trembling hot sunlight white walls, slate roofs, and granite docks shone bright. A muffled noise came through the heavy heat, and everything seemed dull in the Sunday stillness and summer quiet.

Then two men came along.

One was walking from the Place de la Bastille, the other from the zoo. The taller one, wearing a linen suit, had pushed his hat to the back of his head, unbuttoned his collar, and was carrying his necktie in his hand. The smaller, who was encased in a red coat, wore a cap and walked with his head down.

In the middle of the boulevard, they came to a bench at the same time, and sat.

The opening paragraphs of *Bouvard et Pecuchet*. We feel both Joyce and Beckett. That would be Bloom from the direction of the Botanical Gardens, and his thoughts would be running on the cruelty (or kindness, with benefit to science) of keeping animals in cages, on the educational value of a great park with plants from all over the world. Rousseau was already painting such views of the canal, with figures and barges, with exactly the same tone of hot melancholy Sunday afternoons when these lines were written. The usefulness of knowing that Flaubert and Rousseau saw the Canal Saint-Martin with the same eyes is immense. It means that we can suspect a field of pressure points, each insignificant and of trivial importance in itself, amounting in aggregate to a matrix. One such point would be a thermometer reading rather than a rhetorical figure. Another would be (as happens again in *Ulysses*) that the setting is Paris. This assumption was well established by 1880; Zola's *Thérèse Raquin* (1867) begins by telling us that we can find the Passage du Pont-Neuf at the end of the rue Guénégaud, and that it is an alley connecting the rue Mazarine and the rue de Seine. The word Paris does not turn up for forty pages. Another would be Flaubert's careful attention to color, and then to clothing, its style and capacity to place his figures as to class. The rows of barrels get into many Rousseaux, as do the barges. The scene is flat, dull, bland. Neither Flaubert nor Rousseau feels any need to impose the picturesque (Canaletto's first concern), the metaphysical (de Chirico), the touristic (Utrillo), or any other note. Balzac would have explained the worker's Sunday in Paris to us, Camus the existential anguish of it all, Sartre the seediness. Rousseau and Flaubert simply record, and hold to a

faith, wholly new in art, that the scene has its meaning inherent in it. Flaubert worked in ironic disillusionment, Rousseau in the innocent belief that a depiction of the perfectly ordinary was deeply interesting because of the medium, painting: distiller of essences, negator of time, appreciator of charm, identifier of beauty, creator of wonder and civilized attention.

A ROUSSEAU BY APOLLINAIRE

Sur la côte du Texas
Entre Mobile et Galveston il y a
Un grand jardin tout plein de roses
Il contient aussi une villa
Qui est une grande rose

Une femme se promène souvent
Dans le jardin toute seule
Et quand je passe sur la route bordée de tilleuls
Nous nous regardons

Comme cette femme est mennonite
Ses rosiers et ses vêtements n'ont pas de boutons
Il en manque deux à mon veston
La dame et moi suivons presque le même rite

On the Texas coast between Mobile and Galveston there is a fine rose garden and in it a house that is also a rose
A woman often walks in the garden all alone and when I pass by on the country road lined with linden trees we take notice of each other
She's a Mennonite and her rose bushes and dress have no buttons and as my coat has lost two she and I are almost of the same religion

Rousseau would not see the playful simplicity as imitative of his effects, but he would appreciate the delicacy of the hint: that if this lady were to marry Apollinaire, and be a dutiful wife, he would not have buttons missing from his *veston*. Subtlety, *messieurs et dames*, is all. And the lindens and roses are correct.

FOLKLORE

In the melodramatic *Unpleasant Surprise* (Barnes Foundation) a handsome young hunter shoots a bear who is menacing a nude woman. Her clothes are draped over the limbs of a large linden tree by a lake. Has she stripped to bathe, or has the bear through some folklorish means forced her to undress? The linden ap-

pears wherever Rousseau places a wife or mistress; Marie Laurencin stands under one in the double portrait with Apollinaire, who stands under the poetic acacia. The theme is parallel to St. George and the Dragon, but would seem to have even deeper roots in French folklore.

A seasonal festival in the Pyrenees features a bear who wakes after his winter's sleep and comes into the village to claim a human bride. He is given one; there is a wedding; and the bear is shot after he has consummated the marriage. Violet Alford, the distinguished folklorist who studied animal rituals throughout Europe, seeing them as vestiges of neolithic religions, interprets this wedding and death as symbolizing the rebirth of the year at winter's end. Rousseau probably had much folklore of this sort in mind. For all his citified sophistication, Rousseau is rarely distant from folk narrative. What he was after with all his work was a buzz of interest, talk, the generation of texts. Ironically, what we got was anecdotes (a good half of them suspect) about the man, not the work. We have a debt to pay Rousseau.

ST. JEROME WITH LION

The cat of Pierre Loti. *Hippolyte on l'appelle.*
A sardine of paleozoological silver the great artist
Gave him when he sat for his portrait, aromatic
And with the *soupçon* of *huile d'olive* about it,
As was proper, whose family reached back
To Nilotic tax collectors in porcelain wigs,
To the bee gums of Beersheba, Akkadian hotels,
(A cousin removed was friend to Mr Smart the poet);
Leo Alektor kept the high gates at Mycenae.
Quite Hebraic, the family tree, rich in detail.
But we are companion to Monsieur Loti.

The cat of Pierre Loti are we. We are civilization.
Our tribe has resided beyond the borders of France.
Mr Rousseau, master in the modern manner,
Has depicted us in forests of flowers, inquisitive
As catfish, intelligent as Miss Gertrude Stein.
Under starlight we have sniffed the desert Arab;
Aztec vegetables and Perelandrian trees
Have been our precincts, and the gardens of Tchad.
But in *footballeurs* idiotic with motion
We take our delight, in Gruyère and sincerity,
Innocence, *bicyclettes*, Apollinaire, industry.

These stanzas from *Flowers and Leaves* are preceded by one describing the memorabilia-lined Victorian interior bristling with disguised erotic emblems, and followed by one of similar Ernstlike imagery (airless rooms, Pompeii under ash, industrial smog). I was suggesting that Rousseau cuts through the fin-de-siè-cle like a greenbelt through a traffic-ridden city. In the Loti portrait the smoking factory chimney is in the deep background (as in Seurat's *Bathers at Asnières,* and as distant trains traverse the horizons of some of Monet's and Renoir's most idyllic landscapes), and a tree stands between.

The French achieved an elegance and brightness of private rooms in the nine-teenth century surpassing those of Naples in the eighteenth and those of Roman villas in classical times. But of these Rousseau knew nothing. He places Joseph Brummer and Apollinaire in parks, not in the rooms where Monet or Bonnard would have painted them. Where is Pierre Loti? On a balcony overlooking facto-ries and the homes of factory workers? Standing in a field?

Space for Rousseau was the outside, never the room. Is this another reason that he disliked Matisse, who placed all his subjects in rooms (or empty exterior space which can never be taken for the out-of-doors)? Notice how many times Rousseau transplants interior furniture to the outside: a woman on a sofa in a jungle in *The Dream,* himself in a chair in a park in *Henri Rousseau as Orchestra Conductor,* Brummer in his living-room chair under trees.

BALZAC OR REMBRANDT

Novelist who changed locale and tone of weather and landscape with every novel, traveler who had been to the real jungles (Tahiti, Africa) of Rousseau's dream for-ests, newly elected member of the Academy, naval officer, Pierre Loti (exotic *nom de plume* symbolized by the red fez and Turkish cigarette) poses with superb con-fidence. The contemplative eyes are certainly Loti's, as is the moustache. A ver-satile doubleness controls all the themes in this painting. The man is (like Rous-seau) both military and artistic, Lt. Louis-Marie-Julien Viaud, age 41, of the French Navy. In fez or burnous, in tents where he can hear the growl of lions and the nicker of zebras, he is a writer of romances in which handsome smugglers and virile sailors risk their lives for a night of love.

With generosity and friendliness he shares his portrait with his cat, who is as conscious of being immortalized in paint as Loti. It is only their due, this attention of a great artist, to be followed by the world's admiration when the portrait is exhib-ited in the Louvre. Animal and human together always make a pairing of great sig-nificance in Rousseau.

And yet a journalist and minor writer, Edmond Frank, remembered years later

posing for this portrait, along with his cat, a stray from the alley that had taken up with him. Clearly what happened was that Rousseau painted Frank, and then decided that Loti was the more popular subject, and assigned the portrait to him.

Once, when Picasso was drawing caricatures in the Closerie des Lilas, he identified a face as "Balzac—or Rembrandt."

STYLE

Tradition is a genetic code. Its persistence in a culture certifies its function, however tacit that function is. We have only inadequate ideas as to why still-life flourishes more in one age than another. We do know that all persistence is evolutionary, and that evolution is critical. We can point to stages in an evolution where a sudden need for vitality becomes crucial, as when an architect changes the style of houses and public buildings, or a composer changes tone and tempo in music, or painters change the subject matter of pictures. Henri Rousseau's attention to tradition was oftentimes inadvertent, we might as well say accidental, in ways that Joyce's or Baudelaire's never was. His feeling for traditional iconography was as alert as Picasso's or Klee's, both of whom were willing to act as if they were primitive artists. When Picasso changed styles, he knew exactly what he was doing; he knew his sources and the risk he was taking. Rousseau did not: this is wonderfully useful to our knowledge of how tradition combines innovation and rules from the past to invent new forms. The styles of Racine and Milton can be accounted for with something like genetic formulae. Even a style as complex and articulate as Monet's can be charted with more success than we would have suspected at the outset. The elements of Monet's style are available to us. The elements of Rousseau's style send us off our familiar scholarly paths, and open up explorations.

L'ECOLE ROUSSEAU

The red sun discs of the jungle pictures, the cold white moon of *The Sleeping Gypsy*, the hothouse foliage, and the sense that art is a dream about reality rather than a transcription go into Max Ernst.

From the *Myself: Portrait-Landscape* Robert Delaunay took the lower left quarter (yacht with signal flags, bridge, houses, and two of the clouds, the ones resembling flying geese) for his large canvas *The City of Paris*. He put Rousseau's Wright Flyer into his *Cardiff Team*, itself an homage to Rousseau's *Joueurs de Football*. Delaunay's eclecticism of style is instructive. In *The City of Paris* he translates a Renaissance motif into Cubist idiom with the same wit and freshness as Apollinaire using traditional poetic forms for contemporary subjects. The borrowing of Rousseau demonstrates an architectural sureness: yacht and bridge occupy the same space without any crowding or muddle. But Rousseau has made a harmony

of bridge, yacht, and Eiffel Tower. Delaunay moved the red tower to the right of his composition.

Peter Blake's *Self-Portrait with Badges* (1961) is an homage to Rousseau's landscape-portrait. How the world has changed.

PRIMITIVE

Grove's *Dictionary* defined Charles Ives as a primitive composer up to the present edition. In Amsterdam around 1963 I remember seeing Edwin Romanzo Elmer's *Mourning Picture* (1890) in a show of primitive painters. I would more readily concede primitiveness to all the novels of the Brontës and the architecture of the Crystal Palace than to Ives or Elmer.

Early Balthus displays as many signs of the primitive as Rousseau; both painters were self-taught. A Martian observer might well consider Picasso, not Rousseau, our modern primitive.

Rousseau's style is a dialect, like Joel Chandler Harris's Black Georgia English, of which he and Brer Rabbit are masters, or the Scots of Burns. We cannot check grammar or diction against a rulebook. We can admire its articulateness, verve, and success and can only compare it to itself. It is therefore a privileged style, as Degas's is not, where standards set by Michelangelo and Leonardo are being kept to. The first page of *Ulysses* is meant to vie with Flaubert, just as a Cézanne is confident of holding its own against a Poussin. Rousseau, for all his subtle quotations (the leftmost fallen figure in *War*, the animals in the jungle pictures, the virgin in *The Holy Family*), is Brer Rabbit all the way. His qualities that bear comparison— the Pierre Loti with Memling's *Portrait of a Man* (Florence), the still life of coffee pot and candle with Zurbarán, the *Sleeping Gypsy* with Gérôme—are all accidental parallels.

FOURIER

The Henri Rousseau of French philosophy.

ACCURACY

Rousseau's remark to Picasso, "We are the greatest living painters, I in the modern, you in the Egyptian manner," was absolutely accurate.

TRADITION

The Gaulish attempts at Roman sculpture (as at St.-Germain-en-Laye) which came out in a style we call primitive begin a long tradition. Rousseau belongs to that tradition, at least, if to no other.

GENIUS

What, psychologically, was most useful to Rousseau was not childishness but a quality wholly mature: the ability to fool himself. In a lifetime of supposing he had achieved what most mature people achieve (as Ibsen shows us in all his plays), an inaccurate and fictional idea of themselves and their world, Rousseau certainly saw his paintings as he wanted to see them, as academically finished as Bouguereau or Rosa Bonheur. In this he was a kind of Don Quixote; and as with the Don, Rousseau wins us over to his way of seeing.

VINDICATIONS

A good case can be made for Rousseau as the best draftsman of his age. Picasso could never get style out of his drawing. Rousseau could. Things themselves, tigers, flags, canals, moons got into his paintings in styles they themselves demanded.

Primitive painters are usually realists, devoted to the literal visually and to some ideal thematically. They are true poets in that they know no ordinariness, insisting on the right of what they see to be in a painting. Shelley probably could not see a kettle, a chair, a pair of shoes.

A tree was as important a presence for Rousseau as an angel for Joan of Arc.

SEURAT

La Grande Jatte and the *Bathers at Asnières* are motifs thoroughly suited to Rousseau, and there is an uncanny resemblance of staging, distance, deployment of figures. The background of the Asnières painting is hauntingly Rousseaulike. They are equally formalistic, Rousseau and Seurat, while being at opposite poles from each other. Rousseau's surfaces are all enameled, or ceramic, or like painted wood. Seurat's surface is the Brownian movement of light.

Newtonian physics, the French ground of nature from Voltaire to Fourier (with grand moments in between: Boullée's cenotaph, libraries, stadium, all as solid as Gibraltar, or the buildings in Poussin's imaginary Rome and Athens), has its last assertion in Rousseau. Impressionist light is Einsteinian, an omnidirectional halo (as Leonardo had said), vibrant, fugitive, splendid.

Rousseau's light is polarized, inert, static. It comes from within things. His trees are self-lit.

BONHEUR

About the time Rousseau painted the *Football Players* (1906), the Baron Coubertin, founder of the modern Olympics, was lecturing on the return of grace to the

body, and rude health to schoolboys. The essence of Hellenism, he said, was *bon-heur* (which we ought to translate as *delight* or *joy* rather than *happiness*), a state of inner harmony, a sensuality of well-being. The FIFA (Fédération Internationale de Football Association) was founded in Paris in May 1904. Coubertin wanted a soccer field in the Bois de Boulogne. He was given one. It had trees in it. Coubertin said that the trees must be removed. The city fathers said that his schoolboys could play their silly game among the trees, which they were not going to cut down. That is why Rousseau's players (the game is rugby; the ball is oval) are hemmed in by trees. Chestnuts, the masculine tree. Gentlemen at play in the English manner, deep in the modern *bonheur*, details of which were flying in a machine (Rousseau is the first to paint an airplane, the Wright Flyer No. 2, exhibited at Le Mans, 1909), exploring jungles, riding to the country in the grocer Junier's cart, together with his family and dogs.

The nineteenth century had triumphed over all the ages, and was filling the world with *bonheur*. "But why has Robert broken the Tour Eiffel?" he asked on his deathbed.

Rousseau's *War* hangs in the Louvre.

1985

James Abbott McNeill Whistler (1834–1903): *Nocturne in Blue and Gold: Old Battersea Bridge*, 1872–75. Oil on canvas, 69.7 cm × 50.8 cm. The Tate Gallery, London.

STANLEY PLUMLY

Whistler's Nocturnes

Greaves—The stars are fine tonight.
Whistler—Not bad, but there are too many of them.

"An autumn evening was closing in." Like a night piece, the opening chapter of *Our Mutual Friend* offers us an image of indeterminacy, obscurity, water darkness; the shadow-life of two figures in a rowboat, like fishermen, working with the tide of the Thames, the great iron bridging of Southwark looming behind them. They are, we find out, a father and daughter, but their identity, in the abstractions of the dark, is more apparent than their business, which is the harvesting of suicides and murders risen from the bottom of the river. "How can money be a corpse's?" one of them asks. The question is rhetorical, spoken into the void, just under them. The ghoulishness of the scene, from the viewing angle, is softened, even absorbed, by the weight of the air above the darker weight of the water. The unities of color and figure against the larger forms of bridge and Victorian buildings are practically photographic, yet quietly dramatic, like a tone poem.

Whistler was no more fond of Dickens than he was of most narrative orders in the world, but he loved the River Thames, particularly in the way it seemed to gather and hold and finally swallow the last light of the day, particularly in the way it created density, atmosphere. At such an hour he loved to be rowed along its thick surface between the festival lights of Cremorne Gardens, on the north bank near where he lived, and the long fields and woods of Surrey to the south. More often than not he sketched, took notes, black and white chalk on brown paper; often, as his critics would agree, he drew in the dark, the twilight having abandoned him.

Such sketches, of necessity, looked to be little more than clues to the organization of the space—sometimes a sort of row of houses, sometimes a gantry and crane, with a boat in the water for balance, sometimes the Chinese Platform of the Gardens. Often he used the memory method of closing his eyes in order to test what he remembered seeing. "And when the evening mist clothes the riverside with poetry, as with a veil, and the poor buildings lose themselves in the dim sky, and the tall chimneys become campanili, and the warehouses are palaces in the night, and the whole city hangs in the heavens, and fairy-land is before us—then the wayfarer hastens home; the working man and the cultured one, the wise man and the one of pleasure, cease to understand, as they have ceased to see, and Nature, who, for once, has sung in tune, sings her exquisite song to the artist alone, her son and her master—her son in that he loves her, her master in that he knows her."

Purple though they may be, the words are Whistler's, part of his important *Ten O'Clock* lecture, delivered in February 1885, some years after the boat trips and the river Nocturnes were completed. The artist was, typically, in his antagonistic mode—oratorical, defensive, antibourgeois, arrogant, and right. "Industry in Art is a necessity—not a virtue—and any evidence of the same, in the production, is a blemish, not a quality; a proof, not of achievement, but of absolutely insufficient work, for work alone will efface the footsteps of work." Or: "Listen! There never was an artistic period. There never was an Art-loving nation." Or: "To say to the painter that Nature is to be taken as she is, is to say to the player that he may sit on the piano. . . . The holiday-maker rejoices in the glorious day, and the painter turns aside to shut his eyes." The lecture was yet one more try at finding an audience for an artist who had long since turned from popular realism—even in his portraits— to nature as an urban landscape.

For Whistler the nocturne was a concept as much as it was a perception, as much an idea as an image. He could take it almost anywhere and, in addition to paint, could use any number of painterly means. ("Paint should not be applied thick," he had said. "It should be like breath on the surface of a pane of glass.") Along with the better-known Nocturnes concerned with Cremorne Gardens and the bridges and buildings near them, there is *Nocturne: Trafalgar Square, Chelsea—Snow*, and there are the watercolored Amsterdam Nocturnes, plus a variety of nocturnal studies done in pastels and drypoint, and the "floating" *Nocturnes of Venice*, all etchings in a series of proof. And, of course, there is the original nocturne, *Nocturne: Blue and Gold—Valparaiso*, done in 1866, which breaks with compositional (and Occidental) realism by placing the objects (ships at harbor with lights) and the action (a distant confetti of fireworks) at the "back" of the painting, running something like a dock, monolithically, from the immediate fore-

ground up, a presence that occupies about two-thirds of the space. In all, the Nocturnes comprise a period of just under twenty years.

Much has been made of the many influences on Whistler, as a draftsman and as a painter. The influences are said, for example, to range from the use of cross-hatching and the receding dark tones of Rembrandt to the full and luminous figures in Courbet to the flat, two-dimensional purities of Japanese ukiyo-e to the one-eyed optic reality of the photographic lens. The list is long—Whistler moved in a total world of art and was, for better or worse, one of the founders of Aestheticism. So it seems inevitable that influences as different as Hiroshige and Turner ('Turner had been rowed up the Thames by the father of the brothers who served as Whistler's boatmen) should find a resolution in an artist as committed as this one—for whom art existed for its own sake. It is the power with which he understood what was possible, based on what had already been done, that came to distinguish his best work—the Nocturnes—from the security of the linear, that allowed him to discover the "interior" of his subject. Tone is often the term associated with the atmospheric Whistler ("Character! what is character? It's tone that matters!"), but it seems a precious honorific compared with the accomplishment of *Nocturne in Black and Gold: The Falling Rocket,* which Ruskin had name-called a pot of paint flung in the face of the public, and the unsurpassed beauty of the etchings of the Venetian palaces. Tone—another term for the purities and impurities of light—may have been a distillation of influences, but by the 1870s, when the Nocturnes really begin, the tonal depth of the work is transforming. Ironically, as one of the first in a series of Anglo-American artists, Whistler fit in nowhere, not in Paris with the budding Impressionists, nor in London with the dominant Pre-Raphaelites. He was outside, and an outsider; the best of him was disappearing into the work.

Asked, at the trial in his suit against Ruskin, to define a "nocturne," Whistler, monocle in place, replied simply that "I have perhaps meant rather to indicate an artistic interest alone in the work, divesting the picture from any outside anecdotal sort of interest which might have been otherwise attached to it. It is an arrangement of line, form and colour first; and I make use of any incident of it which shall bring about a symmetrical result. Among my works are some night pieces, and I have chosen the word Nocturne because it generalises and simplifies the whole set of them." He had for years been titling his art against the resources of content: if they weren't arrangements, they were harmonies, and if neither of those, they might well be symphonies. The intention, obviously, was to separate the work from its possible story-value and subjectivity, to make an object instead of announce an emotion, to subtract the immediacy of the moment from the plots of time. He was

likely less interested in analogies to music (about which he knew next to nothing) than to constructions of metaphor—he was looking for a synesthesia of color and image that would evoke. . . . But what—a correspondence? More than anything else, one critic puts it, Whistler is a compositionist. And true, even his figures in rooms become parts of those rooms, arrangements in color; while whole houses and buildings and bridges get lost in the ordered constituencies of mood and atmosphere. Forms seem to dissemble, lyrically, in front of us, as if they had become part of the air. We could argue, for example, that a painting like *Symphony in Grey: Early Morning, Thames*, a nocturnal companion, is a completely self-contained piece, completely self-referential; that, as a matter of fact, it is painted on fabric—decorative material—and that it is composed of four bars of alternating monotones—"blue" and "grey." Yet to look at this painting is to look at silence, the moment in and out of time, as Eliot put it; it is a way of looking into something, the way metaphor offers us the collateral of content, the correlative of the inner life. In spite of its cool pearl tones, it is what privacy, sotto voce, looks like.

If you compare the original Nocturne of the harbor at Valparaiso to the Thames Nocturnes of the early 1870s to the Chelsea Nocturnes at the end of the decade to the watercolor Nocturnes of Amsterdam of 1883–84 to the etchings of Venice, the degree of dissolution is amazing. It is not just that the foreground is losing to the background; rather that the monochromatic and tonal values of the ground are absorbing, advancing on those at the front—structures, if you will, are being deconstructed within the composite of the text, within the space of the moment, a blue dark dissolve. Compositionally, that is what the Nocturnes seem to be about: the subject evaporating into the object of the painting. It is no accident that the settings of the overall sequence of the Nocturnes juxtapose a harbor to a river to a sea (Bognor) to a snow-covered square to canals to the waters of Venice; it is not surprising that medium itself deconstructs from paint to watercolor wash to drypoint. Whistler wished to effect a simultaneity, a oneness, of color and composition in which a single quality of a hue would organize, harmonize, and, subtly, limit the shades around it. Naturally, the shapes, be they buildings or bridges or boats, would have to follow, as if they were only points on the scale of the order of color.

In the Valparaiso painting the ships are still relatively distinct from their shadows on the harbor surface, and shoreline and skyline are clearly delineative in the faint firelight from the rockets. In *Nocturne: Battersea Reach* and *Nocturne: Bognor*, both blue and silver renderings, the water and horizon lines are beginning to meld with the abstracting of the objects, which are like props, while the color of the water is unreflective, nearly opaque, like a gravity that is holding everything, including the sky, in place. The Chelsea Nocturnes, especially those of the Cre-

morne Gardens, resist dissipating into darkness by noticing sources of light, such as the Chinese Orchestra Platform or Ashburnum Hall; the most famous and infamous of all, the painting of the falling rocket, lights up the smoky panels of dark like a birthday. *The Falling Rocket* is interesting in the way, against the drapery of the background, the fireworks are expiring rather than exploding; again, the gravity of the black water, the Thames, pulls the scattered fire of the debris down—falling, gone. The antithesis of *Nocturne in Black and Gold: The Falling Rocket* is the snow nocturne, set in Trafalgar Square, Chelsea, 1877. The shapes are ghostly, anonymous—two winter trees stage right, one recessive in the middle in the open space between the low blocky buildings—and in their "absence" are made visible by the snow, both in the air, thick as mist, and on the ground. The snow, in fact, is the air, and is moon-bright, so much so that the emotional effect of the painting, entirely reflective, is warm, brown; in the distance the faint window lights, muted yellows and a red, suggest the warmth of home. The sky is a blue slate, wide as a wall. By the early eighties, in a painting entitled *Nocturne: Silver and Opal—Chelsea*, the forms are nearly totally lost, save for a suggestion of two pilings for the Chelsea Bridge. The brushwork has never been less disguised, the horizon line more invisible. If this is fog, you can feel its texture, you can sense at once its scary substance and insubstantiality; the bridge might appear at any moment or the magical air might swallow everything in abstraction.

It is reported that when he was working on the Nocturnes, Whistler never admitted sunlight into his studio, which seems to make only obvious sense. The Amsterdam Nocturnes, though, begin to illustrate the turn toward more intimate, interior space. There are four of them, three set on canals, one on ice. The medium, watercolor and wash, unlike the breath-on-glass application of paint, has begun to take over. By moving his "camera" closer to the dominant forms—the window-lit houses along the canals, the building behind the ice-skaters—Whistler forces the sky almost entirely out of the picture and brings the background to the fore. The only presence preventing the washed blue-brown forms of the buildings from overwhelming the whole scene is the water, which, in the clarity and calm of the night canal and on the slick surface of the ice, repeats the forms and their pumpkin lights rather ominously. Japanese ukiyo-e translates as "pictures of the floating world." Whatever influence those Edo prints had on the early Whistler had likely, by the 1880s, been long since internalized, but there is no doubt that water, as an abiding presence and value, had become indistinguishable from the dark. All along, from the Valparaiso painting on, water, with its mysterious weight and depth, had built and held the night in place. The dark, for Whistler, had become the stuff of water, a floating sheen, a mist, a fog, a snowfall, an idea of dissolve, in which the potential

reality of the form, the shape, the man-made structure, had to be close to nullified in order to be transformed. "The whole city hangs in the heavens," Whistler had said, when in fact, at nightfall, it begins to float and evaporate. This is as true of the people enjoying Cremorne Gardens (few of them as there are) as it is of the boats at the side of Chelsea Embankment—floating, evaporating. The houses along the Dutch canals become, therefore, part of the water; they seem to rise from the canals, like natural saturated substances. Like night-blooming lilies. Unlike Monet and other Impressionists, however, Whistler's ambition was not to paint the subtleties of the withdrawing of light, among other country values, but to paint graduals of "the fell of dark," the floating dark, the urban pastoral.

Whistler realized how difficult his task was. Asked, at the Ruskin trial, if he thought *The Falling Rocket* is a finished work, he responded that "It would be impossible for me to say so. I have never seen any picture of night which has been successful; and this is only one of the thousand failures which artists have made in their efforts at painting night." He was being more than a little coy, since success in the art market in London at that time depended on theme, definition, and closure of the well-tailored line. The "failure" of his Nocturnes is at the heart of their achievement, as their consistent motif and need is their "illegibility," their vulnerability. This failure is at its best, and most profound, in the drypoint etchings of Venice, of 1880. Printing, as opposed to painting and watercolor, permitted Whistler to create something impossible with paint—the chance to develop the mood and tone of a single work without altering the matrix of the basic line and arrangement of the scene. By simply varying the amount of ink and color left on the surface of the plate, he could go from twilight to "musty dusk," as Valéry calls it, to full dark. For example, in the Nocturne of the view of the entry into the Grand Canal, the sailing vessel, which is our point of focus, gradually recedes into the drawing as the degree and depth of the ink is increased. By the last of, say, four prints, the boat has become even, in perspective, with the forms of the distant city on the horizon; because slowly, in the sequence, the darkness of the water, balanced in the sky, has enclosed it, in recession.

The most beautiful of the Venice etchings is the sequence of the Palace— brown ink for a warmer, more humid nocturnal appeal, black for a cooler, stranger appeal. To avoid the calendar-art Venetian views, Whistler had chosen sites within the city, a habit he had acquired in London. Ever the *flaneur*, he decided once again to use his imagination via the memory method, making the eye more than a camera, choosing a vision over a view. It is one thing to work deep tonalities and blends with paint or wash, it is another to achieve translucency through the drypoint of the line. The Palaces is not more complicated, architecturally, than any

of the other Nocturnes: it consists of views of two buildings, the one on the left slightly in perspective, the one closer on the right facing out, like a wall on stage. An alley of the larger canal runs between them under a bridge that is tucked to the back and serves as the connection of the palaces. Half the picture is the canal, and the structures, unlike those in the Dutch Nocturnes, are actually in the water. The door arches and the windows and a balcony do more than relieve the blankness of the facades; they activate the drawing and provide negatives of lights by generating shadows, by being shadows, particularly the grillwork of the balcony. As the prints become inkier (in black), the motif of the shadows takes on dramatic, perhaps decadent, possibilities. The nature of any nocturne is to become darker, if only psychologically. By enriching the inkiness of the print, Whistler was able to manipulate the meaning of time passing, the dark coming on. In this case, the "floating" city does more than float; it appears to be suspended between two worlds. The strokes feel less drawn than cut, from up to down, and the effect, in each of the prints, is streaking, like hard rain on a window. One senses the artist's hand on the instrument. The palaces feel "lighter" than the water, into which the vertical and heavy lines of fog and mist are converging. Even the balcony, a darker interior, seems "weighted" toward the water, its shadow ready to run down the building. There is something of the black orchid here—as if the palaces themselves had created night. In the last and darkest print, a small light, like a lantern, finally comes clear, an anonymous sign of life on the bridge.

In no other work of Whistler's is the perishability of things that matter so deeply rendered. Stone is nothing, the waters of the dark are everything. *Nocturnes: Palaces* is more than an image; in Yeats's symbolist phrase, "it calls down among us certain disembodied powers." It is a sign of what is missing, a symbol of absences, of what is past and passing. It is Whistler's most spiritually open moment. All the Nocturnes, whatever the medium, are Modernist—nonrepresentational, atonal, abstract, ambiguous, self-contained, urban. And they force the artist to subordinate the self to the terms of the correlative. But more than metaphor is sustained in the Palaces: the isolation of the man, the artist, has peaked as an obsession. Not even the dark is enough, because that is merely the absence of light. If it is true "generally," to use his word, it is true here especially that Whistler needs a refraction, a natural and inevitable presence that will transform without obliterating, a presence that will allow us to see in the dark. In water he had found not only his refracting means but the meaning of the Nocturne itself—how at the moment of perfect stillness the dissolution has already begun.

1985

Winslow Homer (1836–1910): *Fisherwomen, Tynemouth*, 1881. Watercolor, 13½" × 19⅜" (34.3 cm × 49.2 cm). Honolulu Academy of Arts Purchase, 1964.

JOYCE CAROL OATES

"Life, Vigor, Fire": The Watercolors of Winslow Homer

*The life that I have chosen gives me my full hours of enjoyment
for the balance of my life. The Sun will not rise, or set, without
my notice, and thanks.*

<div align="right">Winslow Homer (1903)</div>

Winslow Homer's brilliant and innovative career as a watercolorist—he was to paint approximately six hundred eighty-five watercolors in thirty years—began in the summer of 1873 when, discouraged by unreliable sales and mixed reviews of his ambitious oil paintings, he vacationed in Gloucester, Massachusetts, and worked on a series of paintings that focused primarily on children against a seacoast background. The artist was thirty-seven years old at this turning point in his life and made his living as a free-lance illustrator for such magazines as *Harper's Weekly* ("a treadmill existence," as he called it, "a form of bondage"); he had had an early but misleading success at the age of thirty with his famous oil *Prisoners From the Front* (1866) but found, to his immense discouragement, that critics and collectors expected him to produce similar work: the chronic predicament of the artist of genius who almost at once leaves established taste behind, even as he has helped establish it. Homer's success at watercolors, however, not only allowed him to give up commercial art but freed him, for summers at least, from the concentrated labor of oil

painting, which he assumed would be the primary focus of his career. It also freed him to experiment—to conceive of his art in terms of light, color, and composition; not merely in terms of subject. The artist could not have anticipated that, in a "lesser" medium to which relative failure had driven him, he would not only create an astonishing volume of exceptional work but would, in the words of the art historian Virgil Barker, remake the craft: "He invented the handling where everything depends upon a trained spontaneity. . . . No one since has added to its technical sources, and it is even unlikely that anyone can."

Just as Winslow Homer's watercolors span many years, so too do they focus upon greatly differing subjects and take up, sometimes obsessively, greatly varying themes. They are also closely identified with specific geographical settings: Gloucester, Massachusetts; Prout's Neck, Maine; the English fishing village of Cullercoats, Northumberland; the Adirondacks and the Canadian North woods; Florida and the Caribbean. "If a man wants to be an artist," Homer said as a very young man, "he should never look at pictures." This was in fact not Homer's practice—he was too intelligent to imagine himself truly *sui generis* and superior to the historical development of his craft—but his art even at its most visionary is always in response to the physical world. The grim North Sea of England is very different from the benign and sunlit beach at Gloucester, Massachusetts, and draws forth a radically different art; images of nostalgia evoked by upstate New York seem hardly to belong to the same sensibility—the same *eye*—as those so brilliantly and seemingly effortlessly evoked by the Caribbean. Except for his experimentation with light, color, and composition, and the mastery of his brushwork, the Winslow Homer of Prout's Neck is not the Winslow Homer of the Adirondacks. "You must not paint everything you see," Homer advised a fellow artist, "you must wait, and wait patiently, until the exceptional, the wonderful effect or aspect comes." Homer's genius was to paint the exceptional as if it were somehow ordinary; to so convincingly capture the fluidity of motion of the present moment—its "life, vigor, fire," in the words of a contemporary critic—that other paintings, by other highly regarded artists, appear static by contrast. To observe the evolution of Homer's art from its earliest beginnings to its maturity is to be witness to the development of a major artist: an American painter of world stature and significance.

Winslow Homer was born in Boston in 1836, to educated and well-to-do parents; he would die in Prout's Neck, Maine, in September 1910, having lived in relative isolation for decades. At approximately the midpoint of his career he began to withdraw from society though he was never, strictly speaking, a recluse: he went on frequent hunting and fishing expeditions, insisted upon first-rate accommoda-

tions in his frequent travels, was even something of a dandy. He never married though he was said by a friend to have had "the usual number of love affairs." (In the 1870s Homer repeatedly painted studies of an attractive young red-headed woman whom he seems to have loved and, according to family legend, wanted to marry. But she disappeared from his work near the end of the decade and has never been identified. (See "Winslow Homer's Mystery Woman," by Henry Adams, in the November 1984 issue of *Art & Antiques*.) By adroitly resisting the advances of would-be acquaintances he acquired a reputation, only partly justified, for being rude and antisocial; he was in fact friendly enough when he chose to be, and always remained on intimate terms with his family. Like most artists he lived more and more intensely in his art as he aged, and though he suffered periods of discouragement over poor or erratic sales there is no evidence that he ever suffered a moment's self-doubt. His extraordinary painterly genius remained with him to the very end: his last painting, an oil titled *Driftwood* (1909), painted after he had had a stroke, is a masterly Impressionist seascape.

As a boy Homer exhibited a precocious talent for drawing and painting but he seems to have had no formal instruction apart from that given him by his mother, the gifted amateur watercolorist Henrietta Benson Homer. His work as a free-lance illustrator provided him with an apprenticeship in his craft: such early watercolors as *Fresh Eggs* and *Rural Courtship* have the look of magazine illustrations executed by a first-rate professional. There is a delight here in closely observed detail; colors are bright and fresh; the overall impression is affable, anecdotal, warmly nostalgic. Homer began his watercolor career at a time when post–Civil War America was rapidly changing, hence the avid interest in sentimental genre art depicting "typical" Americans in "typical" activities—the most popular being mass-produced, of course, by the printmakers Currier and Ives. Homer found that he could execute and sell such watercolors easily (he got about $75 apiece for them); yet his professional facility was not to interfere with his instinct for experimentation.

Homer's watercolors differed significantly from those painted by the majority of his American contemporaries, who worked diligently, and often prettily, in the prevailing English style. Indeed, the medium of watercolor itself was not taken very seriously at this time, being largely the province of amateurs, for whom the rigor of oils was too demanding. Homer's first exhibits drew praise from critics, who thought him original and striking; but he was also faulted for what was perceived to be his crudeness and sketchiness—his conspicuous "lack of finish." The thirty-two-year-old Henry James, reviewing an exhibit of 1875, could not have been more ambivalent in his response to Homer's work:

He is almost barbarously simple, and, to our eye, he is horribly ugly; but there is nevertheless something one likes about him. What is it? For ourselves, it is not his subjects. We frankly confess that we detest his subjects—his barren plank fences . . . his flat-breasted maidens, suggestive of a dish of rural doughnuts and pie. . . . He has chosen the least pictorial features of the least pictorial range of scenery and civilization; he has resolutely treated them as if they *were* pictorial, as if they were every inch as good as Capri or Tangiers; and, to reward his audacity, he has incontestably succeeded.

It may well have been that Homer himself was impatient with his American subjects, or, in any case, with his mode of depicting them. In 1881 he went to live for twenty months in the fishing village of Cullercoats, Northumberland; he was in his mid-forties, no longer young, and ready for a complete break with his past. The paintings that derive from that period of isolation and intense work are like nothing he had ever done before, and represent a break too with the genteel tradition of American nature art. This is not the "English" England but the more primitive England of Shakespeare's Lear, Brontë's Heathcliff, Hardy's Tess. Homer's realistic rendering of the hard-working fisherfolk of Cullercoats—the women in particular—gives these paintings a dramatic urgency totally alien to his earlier work. His women are closely observed individuals, yet they are also monumental, heroic, mythic: they bear virtually no resemblance to women of the sort commonly depicted by Homer's American contemporaries. In *Fisherwoman, Tynemouth* a young woman strides along the beach, wind-whipped and unflinching, a study in blues and browns, seemingly one with her element; the painting is a small masterpiece of design and execution. *Watching the Tempest* and *The Wreck of the Iron Crown* are yet more ambitious compositions, remarkable for the artist's success in capturing the wildness of a storm-tossed sea and the helplessness of human beings in confronting it. This is not the Romantic vision of a nature sublime and unknowable but bound up in some mystical way with man's own emotions; it is dramatically different from the pantheism suggested by the work of Homer's contemporaries George Inness, Frederic Church, Albert Bierstadt, and the Hudson River school of painters generally. The man who would one day stun and offend critics no less than potential customers by his unjudging depiction of acts of human violence—a hunter slashing a deer's throat, for instance—had found his subject and theme by way of the impersonal violence of the North Sea; in his later work even human figures were to be eliminated in the artist's obsessive contemplation of the forms and forces of nature.

After the Cullercoats series Winslow Homer's reputation was established

though sales of his work were, as always, erratic and unpredictable. He returned to Prout's Neck, Maine, where he was to live from 1884 onward, concentrating on marine paintings—watercolors and oils; he visited the Caribbean and Florida, where the dazzling sunshine had the effect of liberating his palette, and inspiring him to open-air painting of a particularly lyric sort. If the quintessential watercolor bears a relationship to any literary form it is surely to the lyric poem: a work which, in Robert Frost's words, rides on its own melting, like a piece of ice on a hot stove. The transparent luminosities and compositional brilliance of such works as *Shark Fishing* (1884–85), *The Gulf Stream* (watercolor: 1889), and *After the Tornado* (1898) are extraordinary. Out of wholly realistic material, charged with intense but thoroughly muted emotion, the artist renders an art that suggests abstraction—the very reverse of "genre" or narrative painting. In this sun-flooded space we contemplate a fractured world of planes, angles, gradations of light, in which the human figure is but an element in design. Homer had long been conscious of the phenomenon of light and had experimented with its possibilities for years, like his Impressionist contemporaries Monet, Pissarro, and Sisley; he wrote: "You have the sky overhead giving one light; then the reflected light from whatever reflects; then the direct light of the sun; so that, in the blending and suffusing of these several illuminations, there is no such thing as a line to be seen anywhere." The elegaic *Rowing Home* (1890) might be said to be a study in the withdrawal of light—a muted evening sun presides over the subdued and seemingly melancholy action of rowers on a lake or an inlet in the North woods; faint grays and blues wash transparently together; the human figures bleed into the stillness of impending night. In this beautiful tone-poem there are no lines or outlines, only shadowy, smudged silhouettes, on the verge of dissolution.

Along with his marine studies, it is Homer's Adirondacks and North woods paintings which most admirers know, and upon which his popular reputation rests. Certainly these are dazzling works—bold, eye-stopping, executed with the bravura of a master. So exquisite is Homer's brushwork in the large Adirondack series, so absolute his confidence in his art, the "impression" one forms in contemplating such works of the early 1890s as *Adirondack Guide, Adirondack Lake, Old Friends*, and *The End of the Hunt* is that they are, despite their incalculable complexity, simple compositions. So too with the remarkable *Shooting the Rapids*, where a sense of vertiginous motion is conveyed by the most economic means, as two canoers plunge through tumultuous white water, gripping their oars tightly. White paper breaks through transparent washes to suggest the dim reflections of the sky; all colors are muted—browns, blues, greens, black. Here as elsewhere Homer succeeds wonderfully in communicating the fluidity of the present moment,

the experience of physical action, as few other painters have done. Set beside his seemingly effortless watercolors the experimental work of certain avant-garde artists who similarly attempted "movement"—the Italian Futurists, for instance—seems merely studied and artificial. It is only Homer's occasional predilection for frank sentiment, or sentimentality, and for the emotional tug of narrative, in such paintings as *Old Friends* and *The End of the Hunt*, that suggests his background in magazine illustration, and his kinship, however oblique, with American genre artists of the nineteenth century.

But Winslow Homer was—and is—an artist to transcend all categories. It might even be argued that, had he worked only in watercolor, he would still be considered one of America's most original artists.

1987

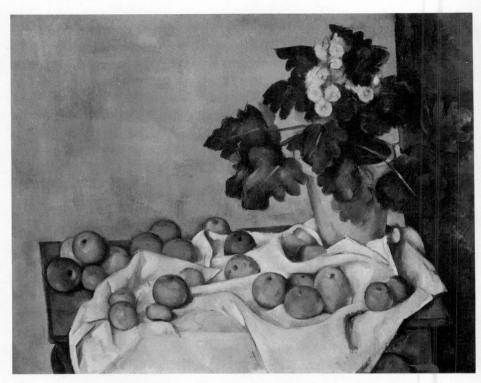

Paul Cézanne (1839–1906): *Still Life: Apples and a Pot of Primroses*, 1890–94. Oil on canvas, 28¾" × 36⅜" (73 cm × 92.4 cm). The Metropolitan Museum of Art, Bequest of Sam A. Lewisohn, 1951. 51.112.1.

RAINER MARIA RILKE

The Cézanne Inscape

These extraordinary letters, here first translated into English, show to what degree
the eye of one artist can penetrate to the essence of another art. The most distin-
guished of modern German poets, Rainer Maria Rilke, was born when Paul Cé-
zanne had already been painting nearly a decade. It was more than thirty years later
that he encountered Cézanne in the memorial retrospective held at the Salon d'Au-
tomne in Paris in 1907, the year after the painter's death. Rilke was himself a mature
artist with several volumes already published. Yet another distinguished poet, Ge-
rard Manley Hopkins, had already given a name to the unique pattern that distin-
guishes each art—music, poetry, painting—its "inscape." Hopkins's idea was that
a poem's sound is as integral to its sense as a painting's color to its design or music's
melody to its form. For Cézanne, who gave landscape a new meaning in painting,
the verbal play of "inscape" seems especially apt; it also defines Rilke's winged em-
pathy with the other arts. His letters of enthusiastic discovery, written to his
sculptress-wife, Clara, tell that he found in Cézanne's pictures, visited day after
day, "all existing things incorruptibly assembled according to their color content."
Also commenting here on Manet, van Gogh, Picasso, and Rodin, Rilke emerges as
a unique artist who interprets, in prose and verse, the inscapes of others as well as his
own.

Jane Bannard Greene

29 rue Cassette, Paris VI^e
October 7, 1907

I was at the Salon d'Automne again this morning. Met Meier-Graefe again at the Cézannes. . . . Count Kessler was there, too, and he spoke to me at length with sincere warmth about the *Book of Pictures* which he and Hofmannsthal had read aloud to one another. All this took place in the Cézanne room where the strong pictures immediately take hold of one. You know how I always find the people walking about at exhibitions so much more interesting than the paintings. This is also true of this Salon d'Automne with the exception of the Cézanne room. There all the reality is on his side, in that thick, quilted blue of his, in his red and his shadowless green and the reddish black of his wine bottles. How humble all the objects are in his paintings. The apples are all cooking apples and the wine bottles belong in old, round, sagging coat pockets. . . .

Paris
October 9, 1907

. . . Today I wanted to tell you a little about Cézanne. Insofar as work was concerned, he maintained that he had lived like a Bohemian until his fortieth year. Only then, in his acquaintance with Pissarro, did the taste for work open up to him. But then so much so, that he did nothing but work for the thirty latter years of his life. Without joy really it seems, in continual fury, at variance with every single one of his works, none of which seemed to him to attain what he considered the most indispensable thing. *"La réalisation,"* he called it, and he found it in the Venetians whom he used to see and see again in the Louvre and had unconditionally acknowledged. The convincing quality, the becoming a thing, the reality heightened into the indestructible through his own experience of the object, it was that which seemed to him the aim of his innermost work; old, sick, every evening exhausted to the point of faintness by the regular daily work (so much so that he would often go to bed at six, as it was growing dark, after an insensibly eaten supper); ill-tempered, distrustful, laughed at every time on the way to his studio, jeered at, mistreated,—but observing Sunday, hearing Mass and vespers like a child, and very politely asking his housekeeper, Madame Brémond, for somewhat better fare—: he still hoped from day to day, perhaps, to reach the successful achievement he felt to be the only essential thing. In so doing (if one may believe the reporter of all these facts, a not very congenial painter who went along for a while with everybody), he had increased the difficulty of his work in the most obstinate way. In the case of landscapes or still-life, conscientiously persevering before the

subject, he nevertheless made it his own by extremely complicated detours. Starting with the darkest coloring, he covered its depth with a layer of color which he carried a little beyond that and so on and on, extending color upon color, he gradually came to another contrasting pictorial element, with which he then proceeded similarly from a new center. I think that in his case the two procedures, of the observant and sure taking over and of the appropriation and personal use of what he took over, strove against each other, perhaps as a result of becoming conscious; that they began to speak at the same time, as it were, interrupted each other continually, constantly fell out. And the old man bore their dissension, ran up and down in his studio, which had bad light because the builder didn't deem it necessary to listen to the eccentric old man, whom they had agreed not to take seriously in Aix. He walked back and forth in his studio, where the green apples lay about, or in despair seated himself in the garden and sat. And before him lay the little city, unsuspecting, with its cathedral; the city for respectable and modest citizens, while he, as his father, who was a hatmaker, had foreseen, had become different; a Bohemian, as his father saw it and as he himself believed. This father, knowing that Bohemians live and die in misery, had taken it upon himself to work for his son, had become a kind of small banker to whom ("because he was honest," as Cézanne said) people brought their money, and Cézanne owed it to his providential care that he had enough later to be able to paint in peace. Perhaps he went to the funeral of this father; his mother he loved too, but when she was buried, he was not there. He was *"sur le motif,"* as he expressed it. Work was already so important to him then and tolerated no exception, not even that which his piety and simplicity must certainly have recommended to him.

In Paris he gradually became even better known. But for such progress as he did not make (which others made and into the bargain *how*—), he had only distrust; too clearly there remained in his memory what a misunderstood picture of his destiny and of his intent Zola (who knew him from youth and was his compatriot) had sketched of him in *Oeuvre*. Since then, he was *closed* to writing of all sorts: *"travailler sans le souci de personne et devenir fort*—," he screamed at a visitor. But in the midst of eating he stood up, when this person told about Frenhofer, the painter whom Balzac, with incredible foresight of coming developments, invented in his short story of the *Chef d'Oeuvre inconnu* (about which I once told you), and whom he has go down to destruction over an impossible task, through the discovery that there are actually no contours but rather many vibrating transitions—, learning this, the old man stands up from the table in spite of Madame Brémond, who certainly did not favor such irregularities, and, voiceless with excitement, keeps pointing his finger distinctly toward himself and showing himself, himself, him-

self, painful as that may have been. It was not Zola who understood what the point was; Balzac had sensed long ahead that, in painting, something so tremendous can suddenly present itself, which no one can handle.

But the next day he nevertheless began again with his struggle for mastery; by six o'clock every morning he got up, went through the city to his studio and stayed there until ten; then he came back by the same way to eat, ate and was on his way again, often half an hour beyond his studio, *"sur le motif"* in a valley before which the mountain of Sainte Victoire with all its thousands of tasks rose up indescribably. There he would sit then for hours, occupied with finding and taking in *plans* (of which, remarkably enough, he keeps speaking in exactly the same words as Rodin). He often reminds one of Rodin anyway in his expressions. As when he complains about how much his old city is being destroyed and disfigured. Only that where Rodin's great, self-confident equilibrium leads to an objective statement, fury overcomes this sick, solitary old man. Evenings on the way home he gets angry at some change, arrives in a rage and, when he notices how much the anger is exhausting him, promises himself: I will stay at home; work, nothing but work.

From such alterations for the worse in little Aix he then deduces in horror how things must be going elsewhere. Once when present conditions were under discussion, industry and the like, he broke out "with terrible eyes": *"Ça va mal. . . . C'est effrayant, la vie!"*

Outside, something vaguely terrifying in process of growth; a little closer, indifference and scorn, and then suddenly this old man in his work, who no longer paints his nudes from anything but old drawings he made forty years ago in Paris, knowing that Aix would allow him no model. "At my age," he said, "I could get at best a fifty-year-old, and I know that not even such a person is to be found in Aix." So he paints from his old drawings. And lays his apples down on bedspreads that Madame Brémond certainly misses one day, and puts his wine bottles among them and whatever he happens to find. And (like van Gogh) makes his "saints" out of things like that; and compels them, *compels* them to be beautiful, to mean the whole world and all happiness and all glory, and doesn't know whether he has brought them to doing that for him. And sits in the garden like an old dog, the dog of this work which calls him again and beats him and lets him go hungry. And yet with it all clings to this incomprehensible master, who only on Sunday lets him return to God, as to his first owner, for a while.—And outside people are saying: "Cézanne," and gentlemen in Paris are writing his name with emphasis and proud at being well informed—.

I wanted to tell you all this; it is related to so much about us and to ourselves in a hundred places.

Outside it is raining copiously, as usual. Farewell . . . tomorrow I will speak again of myself. But I have done so today too.

Paris
October 10, 1907

. . . Meanwhile I am still going to the Cézanne room. After yesterday's letter you may have some small idea of what it is like. Today again I spent two hours in front of certain pictures. This is somehow useful to me, I feel. I wonder whether you would find it revealing. I don't know how to say it simply. Actually all of Cézanne's paintings can be seen in two or three well-chosen examples, and somewhere else, at Cassirer's perhaps, we could surely have got as far in understanding him as I have now. But everything takes a long, long time. When I remember how strange and disconcerting the first things seemed to me when I looked at them and saw them before me associated with a name I had never heard before. And then nothing for a long time, and suddenly one has the right eyes. . . . If you could be here for a day, I would almost rather take you with me to the *Déjeuner sur l'herbe*, to the female nude sitting in the green mirror of the leafy wood which is everywhere Manet, fashioned with an indescribable means of expression that suddenly, after trial and error, appeared, and there succeeded. All the methods he used to achieve it have been consumed, dissolved in the success. It seems as though he had used none at all. Yesterday I spent a long time in front of it. But each time the miracle is valid only for the one person, only for the saints to whom it happens. In spite of this, Cézanne had to begin all over again from the very bottom. . . . Farewell until next time.

Paris
October 15, 1907

. . . and now, just think, added to everything else, Rodin drawings. They were expected at the Salon d'Automne. A page in the catalogue lists them in full, but the room originally reserved for them has long been filled with bad stuff. And suddenly today on the big boulevards I read that they are at Bernheim-jeune, more than one hundred and fifty of them. As you can imagine, I gave up everything and went to Bernheim. There indeed were the drawings, many that I knew, that I had helped to frame in the cheap, white-gold frames that were ordered in such prodigious quantity at the time. That I knew. Yes, but did I know them? How much seemed different to me than it did before. (Is it Cézanne? Is it the passage of time?) What I wrote about them two months ago shifted back to the limits of validity. It was valid somewhere still; but as always when I make the mistake of writing about art, it was

valid as a provisional, personal insight rather than as a fact, objectively ascertained from looking at the pictures before me. Their interpretation and interpretability disturbed me, confined me, just as before they seemed to open up all sorts of vistas. I would like to have had them without any comment, more discrete, more factual, left to themselves. I admired several in a new way, rejected others that seemed to shift color in the reflected light of the interpretation, until I came to some that I did not know. Scattered among the others I discovered perhaps fifteen sheets, all from the time when Rodin followed the dancers of King Sisowath on their travels, to prolong his enjoyment and increase his appreciation. Remember, we read of it at the time? There they were, the little, gracile dancers like metamorphosed gazelles, the two long slender arms as though drawn in a single piece through the shoulders, through the slender-masive torso (that has all the slenderness of Buddha figures) drawn as though in a single, long-hammered piece out to the wrists where the hands made their appearance like actors, mobile and independent in their perfor-mance. And what hands! Buddha hands that know how to sleep, that, when every-thing is over, lie down flat, finger to finger, resting there for centuries at the edge of the lap, lying palm upwards or standing up stiffly from the wrist commanding in-finite silence. Those same hands awake, just think. Those fingers spread, opened out ray-like or curved in toward one another like a Jericho rose. Those fingers ec-static and happy or frightened, at the very end of the long arms, dancing *them*. And the whole body used to keep this intense dance in balance in the air, in its own at-mosphere, in the gold of an oriental setting. Again in an almost contrived way he managed to take advantage of every accident. A thin, brown tracing paper which when it is taken up forms tiny, many-sided folds reminiscent of Persian script. And the color tones, enamel-smooth pink, intense blue as in the most precious mini-atures, and yet, as always in his drawings, very primitive. Flowers, one thinks, pages of a herbarium in which the most spontaneous gesture of a flower is pre-served and defined with even greater precision by drying. Dried flowers. Of course, just after the thought had come to me, I read somewhere in his vigorous handwrit-ing: "*Fleurs Humaines.*" It is almost a pity that he doesn't leave it to us to think it through. It is quite obvious. And yet once again it was moving to me to find that I had immediately understood him so exactly, as often before. Goodnight. Until tomorrow. . . .

Paris
October 17, 1907

. . . rain and more rain, all day yesterday, and just now it is beginning again. If you look straight ahead, you would say it was going to snow. But last night I was awak-

ened by moonlight in a corner over my bookshelves, a patch of light that did not shine, but covered the place where it fell with its aluminum white. And the room was filled to every corner with cold night. I could tell lying there that it was under the wardrobe too, under the chest of drawers and around the objects with no intervening space, around the brass candlesticks which looked very cold. But a bright morning. A broad east wind that swept over the city in full force, finding it so spacious. In the opposite direction, to the west, blown, driven out by the wind, archipelagos of clouds, island groups, gray as the neck and breast feathers of water birds in a cold, faint-blue ocean, serene and remote. And beneath all this, close to the ground, the Place de la Concorde and the trees of the Champs-Elysées, shadowy, black simplified to green under the westerly clouds. On the right, bright houses, the sun beating on them, and away in the background, in a dove-gray haze, more houses locked in planes with quarry-like, rectilinear surfaces. And suddenly, one approaches the obelisk (where there is always a little ancient, blond heat flickering round the granite, and in the hollows of the hieroglyphics the old Egyptian shadow-blue, lingering in the ever recurrent owl, dried up as in colored shells). There the wonderful avenue flows toward one with a scarcely perceptible drop, swift and rich like a river that ages ago by its own violence cut out the gate in the rock walls of the Arc de Triomphe back at the Etoile. And it all lies there with the generosity of a natural landscape and flings out space. And here and there, flags reach up higher and higher on the roofs, stretch, flap their wings as though they were about to take flight. This is how it looked today on my way to see the Rodin drawings.

First Mr. Bernheim showed me some van Goghs in the storeroom. I have already written you about the *Night Café*, though there is still much more to say about its wakefulness that is ingeniously evoked with wine-red, yellow lamplight, deep and very shallow green. Then a park, or rather a path through a city park in Arles, with black people on benches right and left, a blue newspaper reader in the foreground and a violet woman in the background, under and between the green of the trees and bushes that are executed with bold strokes. The figure of a man against a background which looks as though it were made of woven reeds (yellow and greenish yellow), but which becomes simplified to a unified brightness when one moves away from it. An elderly man with a clipped, black-white mustache, equally short hair, sunken cheeks under a broad skull, all in black-white, pink, moist dark blue and opaque bluish-white up to the big brown eyes. And finally one of those landscapes such as he always thrust aside and yet kept on painting: setting sun, yellow and orange-red, surrounded by its glow composed of round, yellow daubs. Full of rebellious blue, blue, blue, on the other hand, is the curving slope

of the hill, separated by a strip of soothing vibrations (a river?) from the transparent dark antique gold of the dusk in which is visible, in the slanting lower third of the foreground, a field and a huddle of upright sheaves. Then again the Rodins.

But now rain, rain, as loud and plentiful as in the country, its sound unbroken by any other noises. The round wall bordering the convent is covered with moss and has patches of quite luminous green such as I have never seen before. Farewell for this time. . . .

Paris
October 22, 1907

. . . Today the Salon closes. And already, as I return home from it for the last time, I would like to go to see a violet, a green or certain blue tones I feel I ought to have seen better, more unforgettably. Already, although I have stood in front of it so often, attentively and stubbornly, the great color scheme of the woman in the red armchair has become as hard for me to reproduce in my memory as a number with a great many figures. And yet I stamped it on my mind, digit by digit. Emotionally, my awareness of its existence has become an exaltation that I feel even in my sleep. My blood describes it to me, but the words with which to say it pass by somewhere outside and refuse to be called in. Did I write you about it?—A low armchair, all upholstered in red has been placed in front of an earth-green wall on which, re-curring at infrequent intervals, is a cobalt-blue pattern (a cross with an open cen-ter). The plump, rounded back curves and slopes down forward to the arms (which are closed like the coat sleeves of an armless man). The left arm, and the tassel full of vermilion suspended from it, no longer have the wall behind them, but a wide, low border stripe of greenish blue to which they object loudly. Seated in this red armchair, which is a personality in itself, is a woman, her hands in the lap of a dress with broad, vertical stripes. The dress is very lightly indicated by little scattered splotches of greenish-yellow and yellowish-green up to the edge of the bluish-green jacket which is held together by a blue silk bow shimmering with green lights. The close proximity of all these colors is used in the brightness of the face to produce a simple modeling. Even the brown of the hair that curves around the temples and the satiny brown of the eyes are compelled to protest against their sur-roundings. It is as though every place were aware of every other place. Each par-ticipates so actively; its adaptation or rebellion is so important; each in its way is concerned with the balance and contributes to it. For if it is called a red armchair (and it is the first and final red armchair in all painting) this is only because it con-tains within it a skillfully computed color sum which, whatever the individual colors may be, strengthens and confirms the red. To achieve this intensity of

expression the painting around the light portrait is very strong, giving somewhat the effect of a coat of wax. And yet the color does not overbalance the subject which seems to be so perfectly translated into its pictorial equivalents that the bourgeois reality, although it is so successfully conveyed, loses all heaviness in its ultimate existence as picture. As I wrote you before, it has all become an affair of the colors among themselves. Each one asserts itself against the others, emphasizes itself, thinks only of itself. As various juices are secreted in the mouth of a dog at the approach of certain things—affinitive ones that merely assimilate, and corrective ones that are meant to neutralize—so within each color are concentrations or dilutions with the help of which it survives the contact with another color. Apart from this glandular activity within the color intensity, the biggest role is played by reflections. (The presence of these in nature has always surprised me, finding the red of sunset in water as the permanent tone in the crude green of waterlily leaves.) Weaker local colors abandon themselves entirely and are content to reflect what is strongest in their vicinity. The interior of the picture vibrates with this give-and-take of manifold, reciprocal influence. It rises, falls back into itself and not a single place is static. Only this for today. . . . You see how hard it is when one tries to get very close to the facts.

Paris
October 23, 1907

. . . I could not help wondering last evening whether my attempt to describe the woman in the red armchair had given you any clear idea of it. I am not sure that I even got the value relations. More than ever, words seemed to me excluded, and yet it must be possible to compel them to serve this purpose. If only a picture like that can be looked at as nature, then it should be possible to express it somehow as an existing object. For a moment it seemed easier to me to talk about the *Self-portrait*. It reveals itself more quickly. It does not extend through the entire palette. It seems to maintain itself at the center of the palette between yellow-red, ocher, lacquer red and gentian blue, and in the coat and hair to reach to the depths of a moist violet-brown that contrasts with a wall of gray and pale copper. On closer examination, however, the inner presence of bright greens and succulent blues is discernible even in this picture. They bring out the reddish tones and define the light ones. Here, however, the subject itself can be captured more readily, and the words that feel so unhappy when they try to give the facts of painting would be only too happy—when confronted with a representation with which their province begins—to recover themselves and describe what is there. There is the right profile of a man, turned a quarter to the front, looking. The thick, dark hair is shoved to-

gether at the back of the head and is placed above the ears in such a fashion that the entire contour of the skull is exposed. It is drawn with consummate sureness, hard and yet round, down the forehead in one piece, and the firmness is still maintained even where, resolved into form and plane, it is only the last of a thousand outlines. At the corners of the eyebrows the strong structure of the skull (that is actuated from within) is again emphasized. But from there the face is suspended, thrust forward and down, as though vamped like a shoe onto the chin with its closely cropped beard. It is as though every feature were hung from it individually. There is an incredible intensity about it, and at the same time, reduced to the most primitive terms, that expression of blank astonishment in which children and country people can lose themselves—except that here the unseeing imbecility of the absorption is replaced by an animal alertness that maintains a continuous, objective vigilance in the unblinking eyes. And the great and incorruptible objectivity of this gaze is borne out in an almost touching way by the fact that he himself, without in any way interpreting or taking a superior attitude toward his expression, reproduced it with such humble adherence to the fact, with the credulity and detached interest of a dog that looks at itself in the mirror and thinks: there is another dog.

Farewell . . . for now. Perhaps from all this you can get a slight glimpse of the old man to whom apply the words that he himself wrote of Pissarro: "*humble et colossal.*" Today is the anniversary of his death. . . .

On the Prague-Breslau train
afternoon, November 4, (1907)

. . . Will you believe that I came to Prague to see Cézannes? . . . Outside in the Manes-pavilion, where at one time there was a Rodin exhibition, there was (as I luckily found out in time) an exposition of modern paintings. The best and most remarkable were: Monticelli, Monet good, Pissarro represented by a few pictures, 3 things of Daumier. And 4 Cézannes. (Also several each of van Gogh, Gauguin, Emile Bernard.) But Cézanne. A big portrait, a seated man (M. Valabrègue) with a lot of black against a lead-black background. The face and the closed hands, resting below on his knees, excited to orange, stated strongly and unequivocally. A still-life which also is concerned with black. A long loaf of white bread in natural yellow on a smooth, black table, a white cloth, a thick wineglass on its base, two eggs, two onions, a tin milk container and, at an angle with the bread, a black knife. And here, even more than in the portrait, the black treated as color, not as contrast, and recognized as color in everything: in the cloth, where it is spread over the white, introduced into the glass, subduing the white of the eggs and weighing down the yellow of the onions to old gold. (Just as, without having actually seen it,

I had suspected that he would use black.) Beside it a still-life with a blue cloth. Between its bourgeois cotton blue and the wall that is covered with slightly cloudy blueness a lovely big gray-glazed ginger jar explaining itself to the right and left. An earth-green bottle of yellow Curaçao, and farther on a pottery vase, the upper two-thirds of which is covered with green glaze. On the other side, in the blue cloth, a porcelain plate, its color determined by the blue, filled with apples, some of which have rolled out. The rolling of their red into the blue appears to be an action deriving from the color processes of the picture, just as the link between two Rodin statues springs from their plastic affinity. And finally, another landscape, blue air, blue sea, red roofs, speaking to one another against green and very animated in their inner conversation, full of communication with one another. . . .

1959

Translated from the German by Jane Bannard Greene
(Letter of October 12 with M. D. Herter Norton)

Paul Cézanne (1839–1906): *Mont Sainte-Victoire*, 1886–87. Oil on canvas, 23½″ × 28½″ (59.6 cm. × 72.3 cm.). The Phillips Collection, Washington, D.C.

WILLIAM S. WILSON

Cézanne's Rapport

So much, in that dim suburban childhood, was disappointing—"We'll see that later, on the way back," they said, but the way back would lie in some other direction, or I was tired and fussy, so I didn't get to see it, then or later—but eventually, in my early teens, I could wait for *The Book of the Month Club News* for the perplexed pleasures of the paintings reproduced on its cover. I kept thinking that I wanted to pass for a middle-class kid, but when one of my buddies in school commented to the guys that the pictures in my house weren't always hanging on the same walls in the same rooms, an offense I still don't understand, I could see that I wouldn't make it, and remembering the gray steel engravings in their dining rooms—the Death of Wellington, the Burial of Napoleon, or vice versa—and so many averted gazes—I realized that I didn't want to make it, seeing clearly when I was sixteen and read Geoffrey Gorer's book on the American character that I didn't want to have one, though a clever lad would be able to pass, and I did for most purposes.

When I came home from college, to a house in which concepts were defined and justified, I found one self-evidently true concept reigning in the house, by then a ten-acre "farm" north of Baltimore: Cézanne's space. With some improbability, against a background of station wagons, swimming pool, and organic gardening, the visual thinking of a French painter who had been dead for about fifty years emerged to affect the texture of our daily lives. My father withdrew into the ironies of a man serving a life sentence, and he would, speaking of the latest "modern" painting, comment on the "spatial desperation" of the artist, a criticism more accurate than most. My mother had the faith of an uneducated, or self-educated,

woman—where had she learned that faith if not from the outline of her anxie-
ties?—in what could be taught. First she studied painting and art history by cor-
respondence—Peter Selz was a teacher, such was her good luck with the U.S.
mails—and she listened to the lessons friends brought home from summers in
Provincetown where they studied with Hans Hofmann. She read and studied and
looked and painted—Roger Fry, Erle Loran, Sheldon Cheney were indeed house-
hold names—and she returned to household surfaces to recompose her life in har-
mony with Cézanne's space as she understood it.

I watched as people who had been close to her withdrew, or were overlooked,
and as people at a distance (Ray Johnson in New York, and mail art) were brought
near, as she focused past the foreground of domestic cares onto a background of re-
mote art which seemed to be coming ever closer. We lived, in that house among
rolling Maryland hills, with an eight-mile view across a valley, on intimate terms
with Paul Cézanne. The key word was *planes*, and my mother couldn't dig a flow-
erbed without planting the lighter colors in the back—the yellows would advance
visually—and the darker colors in the front—the blues would appear to recede—
and since within this advancing and receding, colors pulling back and pushing for-
ward, a white would jump off the plane—"jump right out and hit you in the eye"—
white had to be eliminated, though whites had once been favored because they
could be seen from the terrace glowing on in the twilight long after reds and blues
had submerged in the encroaching darkness, as bats skimmed drinks of water from
the swimming pool. She let the gardens go to greens; Cézanne had written, as we
did not know then but might have deduced, "green being one of the gayest colors
which is the most soothing to the eyes." I don't know if that woman—younger then
than I am now—understood the lessons of Cézanne, but she tried, and I was learn-
ing over her shoulder, awakening to a revelation. In that household, to let the eye
wander out of the picture-field, as it might do if misled by a stray diagonal, or to
violate the picture plane (a color advancing too far "popped out," a color receding
too far "made a hole"), were offenses that hurt the eyes, and the ignorant bourgeois
American scene, with holes in its picture planes from which other things were pop-
ping out, offered more visual insults than could be borne. Cézanne wanted to see
without theorizing, usually, but to us he was a theory. *The* theory.

Twenty-five years later, and a little more casually, *plane* remains the axiomatic
metaphor of my thinking about art. I read a novel and see that the author has shifted
or violated planes, that is, has changed the plane of focus; errors in point of view,
in my vocabulary, are violations of the focal plane, as when a writer suddenly goes
beyond the speech into the thoughts of a character, onto a mental plane. With a
sudden change of diction in a poem, I feel my focus thrown onto another plane of

language. The meaning of a work of art seems to me to emerge from the relations among planes—stable or unstable, open or closed, systematic or unsystematic—and I see Cézanne as constructing a "stable open system" of planes in complex relations, like something kindled that continues in operation. I am still looking for the correct word for the relations among planes in a Cézanne, in a landscape, in a poem.

Looking at an actual landscape, I adjust or correct my focus, with many successive changes in focus as the depth of the visual field alters. I feel these changes of focus, different eye-awareness, but not much mention is made of them in art criticism, unless by Ruskin. They belong to raw, wary, predatory and arboreal binocular vision, as if I were swinging from branch to branch in pursuit of prey. But a painting as a physical object is flat, and so it is within a single focal plane—illusory near and illusory far are on one plane. Gazing at the painting (which is an eye-awareness entirely unlike gazing at a landscape, for the landscape requires more focus on focusing, feeling the efficacy of the eye), I can enjoy some respite from the binocular vision which would enable me to catch something in a tree. Looking at a painting is a truancy, or liberation, from animal (biological) need, and even from good taste, for in those suburbs we received cutting looks if we were seen to be staring (why? because staring is predatory?), unless we were dragged to a museum on a school trip and required to look. We didn't believe at first that we were free to look even at naked people in pictures, though we'd better not stare at the people in the museum. The freedom to look—freedom of movement for the eyes—is the opposite of the necessity to look at everything that is part of the hunting-gathering of necessities. Painting is a liberal art.

While deep space is the space of events in time—something can happen in such space—the deep space represented in Cézanne's paintings is not the space of historical events; he has altered that space, bringing the distant nearer, and pushing the near back. As we look towards Mont Sainte-Victoire it is brought towards us, but Cézanne doesn't show the cross that had been erected on it. Anything might happen in historical space, but Cézanne did not want that; he wanted painting to be about what was happening, when what was happening was an experience of successive spontaneous visual sensations which include a feeling of earlier and later, of before and after, along with *now*. Looking at a landscape by Cézanne, it is as though in that space we would go a few yards to the left, some yards back, some more yards upward, and several yards *later*. Even a painting by Poussin looks more like a single instant—the slowly painted version of an instantaneous event—than a painting by Cézanne, whose shadows rarely tell the time of day: "As early as ten o'clock in the morning he would stop painting: 'The daylight is beginning to fade,'

he would say." Rewald, in a tender essay, describes the late afternoon light, "an un-forgettable hour of harmony and peace. Those who have wandered over the coun-tryside of Aix in the footsteps of the artist call it 'the hour of Cézanne.'"

Cézanne's adjustments of emotional perspectives are visible in his letters, as in this one sentence he links earlier and later in a complex exchange with near and far: "I am too remote from you, through my age and the knowledge which you acquire everyday; nevertheless, I commend myself to you and your kind remembrance so that the links which bind me to this old native soil, so vibrant, so austere, reflecting the light so as to make one screw up one's eyes and filling with magic the receptacle of our sensations, do not snap and detach me, so to speak, from the earth whence I have imbibed so much even without knowing it" (July 21, 1896). "Je suis trop dis-tant de vous et par l'âge et par les connaissances que vous acquérez chaque jour; néanmoins, je viens me recommander à vous et à votre bon souvenir pour que les chaînons qui me rattachent à ce vieux sol natal si vibrant, si âpre et réverbérant la lumière à faire clignoter les paupières et ensorceler le réceptacle des sensations, ne viennent point à se briser et me détacher pour ainsi dire de la terre où j'ai ressenti, même à mon insu." Elsewhere he asks Joachim Gasquet to send him the magazine which, in a doubling of perspective, ". . . would remind me of my distant land and of your lovable youth." Cézanne senses emotional alterations in distances of time and space: "I clasp your hands from rather a long distance, while waiting to clasp from nearer," he writes to Numa Coste in 1869, conventionally enough, but Cé-zanne chose his conventions. And then to his son after Pissarro's death: "Give my regards to Madame Pissarro—how distant everything already is and yet how close"—"comme tout est déjà lointain de pourtant si rapproche." We need words to describe these reciprocal modifications of near and far, of earlier and later, but also of near and later, of far and now.

John Rewald published an edition of Cézanne's letters in French (1937), in En-glish (1941), and there we find the extraordinary thought, "I started a water-colour in the style of those I did at Fontainebleau, it seems more harmonious to me, it is all a question of getting as much affinity as possible." So that is it: as much affinity as possible. We could rethink Cézanne with the concept *affinity*, or look again at the anecdotes, as in a story of affinity regained: ". . . Cézanne, as his old friend had foreseen, became more sociable. His conversation, of astonishing erudition, kin-dled by the enthusiasm of the listener, who provided the repartee, was a splendid and enriching enchantment. In order to put us all at ease, my father-in-law, during the short pauses, evoked picturesque recollections with him. Cézanne smiled, a sad and distant smile. . ." Cézanne's *affinity*.

Rewald published a marvelous enlarged and revised edition in 1976. Structur-

alism had flourished since the first edition, studying the relations of relations, and the new translation brings Cézanne into the intellectual foreground: ". . . it is all a question of putting in as much inter-relation as possible." *Interrelation*, like *affinity*, is illuminatingly true, and after all Poincaré wrote that mathematicians study not objects but the relations among objects, and Braque had said, "I don't paint things, but their relations," and Matisse: "I don't paint things but the differences between things." But *interrelations*. I can say from experience thinking with the word that it slips out of focus, and won't differentiate relations within a Cézanne from relations within a Braque. Time, I finally thought, to look at Cézanne's French, even if I inevitably Americanize it. But still, the useful concept: Cézanne's *interrelation*.

Cézanne wrote, ". . . le tout est de mettre le plus de rapport possible." *Rapport* is correctly translated *affinity* or *interrelation*, but *rapport* is the word, and Liliane Brion-Guerry, or her translator John Shepley, preserves it in translating her essay in the distinguished catalogue *Cézanne: The Late Work*: "Compare Cézanne's letter to his son of August 14, 1906, one of the last before his death: '. . . it [a watercolor] seemed to me more harmonious, the main thing is to put as much rapport into it as possible.'" So we might take Cézanne at his word, even as we put an English on it: Cézanne's *rapport*.

In that same catalogue Rewald writes that for Cézanne, "There was no real rapport with many of his other sitters, such as the peasants painted in those years." But *rapport* defines precisely the feelings contained in the portraits, so non-intrusive, so without comment on the character of the sitter. The affinity or interrelation with the sitter can be described as *stubborn rapport*. If we focus on *rapport*, we can throw some of the other terms applied to Cézanne out of focus. Richard Shiff, with uncharacteristic vulgarity, writes that "Cézanne was, after all, not only suspicious and paranoid . . . ," and Clement Greenberg had written that Cézanne was ". . . a forerunner in his paranoia." I don't see anything to do with such trivializations of the noble and glorious except to use them as an opaque plane from which to deflect light onto Cézanne, so no, Cézanne was not paranoid, he sounds distrustful because he was so trusting, so trustworthy, as when he writes to Paul, ". . . tu sais mieux que moi ce que je dois penser de la situation, c'est donc toujours à toi de diriger nos affaires." "You know better than I do what I should think of the position, so it is up to you to direct our affairs."

Cézanne's suspicions are the working suspicions of a painter who is trying to make an art of trustworthy appearances. He might have written that the whole point is to have as many trustworthy affinities, or reliable interrelations, as possible. By *rapport* Cézanne means an interrelation or affinity that can be trusted, he

means an emotional perspective that adjusts and readjusts planes into harmonies with each other, he does not mean any feeling of melting into, swallowing up, or being absorbed emotionally. As I wrote in 1969, "The best that a painter can do is to make the picture plane coincide with the focal plane of his faith, his values, and his energy" ("Operational Images," *Aspects of a New Realism*, Milwaukee). The picture plane is not physical, it is not paint; the picture plane is a visual focal plane that coincides, or should coincide, with a metaphorical focal plane of beliefs and commitments. Cézanne knew that he had only his *sensations* as information about existence, and that he had to trust his sensations, and he had to be honest about them and limit their implications to keep them trustworthy. His visual sensations are a report on his rapport with the world, and his paintings render that rapport, not an extreme of either selfless objectivity or expressionist self-display. Compared with Cézanne, too many artists of his period, and of ours, are like actors who comment on the parts they perform as they perform them. Cézanne in his mature work *detheatricalizes* painting. His visual probing with his sensations constructs an observable plane which he discovers as he invents it (Richard Shiff's helpful colloquialism is that Cézanne "makes a find"). When the parts of the painting are in rapport, the painting is in rapport with nature, not by copying nature but, as Cézanne said again and again, by being a harmony parallel with nature. Cézanne tries, and this is why he becomes one of the most primitive of painters, *to draw with his sensations*. Sensations in his complex vocabulary are sense data and more, they are immediate mediations between self and nature; they are Cézanne's original rapport.

Cézanne has been the subject of some breathtaking remarks: "I could have finished Cézanne's paintings," Henri Rousseau said, bringing rational thought to a halt as he narrows the distance between himself and Cézanne. And then Picasso: "What forces our interest is Cézanne's anxiety. That's Cézanne's lesson." I am momentarily blinded by Picasso, who is a bit of a bully visually. His dazzling remark forces me to see Picasso's own anxieties, and I feel my argument—*that Cézanne's rapport is Cézanne's reality*—overpowered. Yet what is Cézanne's anxiety but the fear that appearances are not trustworthy, yet are all we have? His anxiety is not fear without an object, it is fear that objects do not exist strongly enough to be seen again, to be seen the same way twice, or to be re-discovered, an anxiety that can be illuminated by a quotation from Freud in which his own anxiety speaks: "Thus the first and immediate aim of the process of testing reality is not to discover an object in real perception corresponding to what is imagined, but to *re-discover* such an object, to convince oneself that it is still there" ("Negation"). Cézanne knew that painting is a theory of knowledge, of what can be known and of how it can be

known, and he knew that he could not paint the world as it looked when he was not looking at it, that he could paint only his own sensations, and he had the problem of trying to paint nothing that was not there while painting sensations which had no authority except himself. He wanted to join the world as it is, visually, without consolations or sentiments, without myths or metaphors, but he knew that to join it is to change it. He tried to paint without illusions or unearned inferences: "In *La Peau de chagrin* Balzac describes a 'tablecloth white as a layer of newly fallen snow, upon which the place-settings rise symmetrically, crowned with blond rolls.' 'All through youth,' said Cézanne, 'I wanted to paint that, that tablecloth of new snow. . . . Now I know that one must will only to paint the place-settings rising symmetrically and the blond rolls. If I paint "crowned" I've had it, you under-stand? But if I really balance and shade my place-settings and rolls as they are in nature, then you can be sure that the crowns, the snow, and all the excitement will be there too.' "

Cézanne's rapport enables him to work toward solutions of three problems be-setting artists in his era, whether or not ours. First, the identity of the self. Cé-zanne, in one mood, describes himself, "Not master of myself, a man who does not exist" (April 30, 1896). Later in that paragraph, ". . . were it not that I am deeply in love with the landscape of my country, I should not be here." He exists as the love of his birthplace; *to be is to be in rapport*. Elsewhere he says, "The land-scape thinks itself in me," and he might have added without contradiction, "and without my knowing it."

Next, the forms, even the shapes. Cézanne must invent his forms, he does not or cannot inherit them like a standard size of stretcher. His objection to Gauguin and to van Gogh is their cloisonné outline; he wrote against it to Emile Bernard, apparently without knowing that Bernard claimed to have invented it, as ". . . a fault that must be fought at all costs." Since forms had to be invented, but could not be formulas, they would be difficult to complete. Cézanne's choice of classic sub-jects—landscape, still life, portrait—shows us by contrast with the art of the mu-seums that he had few a priori or pre-potent forms to impose on visual events. No certainty of self, then, and no trustworthy forms, and refusing to accept false con-tainments, and false continuities, he had to depend on the rapportage of his visual sensations to confirm his self and to build up forms as he tried to draw in paint with his sensations. A painting by Cézanne is a field of rapports. Perhaps Renoir saw that: "He cannot put two touches of color on to a canvas without its being already an achievement."

Next, the problem of nature, or the source or correlate of the sensations. Cé-zanne is aware that he has only his sensations (emotionally charged sense data).

His sensations, the visual display, might or might not be the display of something out there, objective and external. In a conversation with Joachim Gasquet, whom for these purposes I trust, Cézanne said, trying to focus on a plane under phenomenal appearances, "What is there underneath? Maybe nothing. Maybe everything. Everything, you understand." With the phrase "Maybe everything" Cézanne leaps across the gap, the abyss between subject and object, with the thought that phenomena have an objective counterpart in nature. The thought is a hope, which of course engenders anxiety, that the self exists and can invent true forms that suggest an objective source of sensations. Cézanne's rapport is with something real, and it is itself something real; our interest is forced, but not by Cézanne's anxiety, which is to be used merely as a template to guide our delineation of Cézanne's rapport.

I am a pragmatist of space. The way I interpret the virtual, represented, illusory space in a painting is to ask myself what I would do in that space, and how I would feel doing it; virtual space entails virtual actions. I hope, as I pursue my own *rapports*, that Michael Polanyi means something close to this when he writes, "Art does not inform us about its subject, but makes us live in it, as its maker first lived in it." One would not live in, or act in, the space of a Turner as one would live or act in the space of a Constable. One would feel differently doing the deeds implied in the space of a Claude from the way one would feel doing the deeds implied in the space of a Poussin. Any space is a set of implications for actions, and actions are accompanied by feelings. I feel, in the space of Pissarro, an unhesitating generosity, the space of largesse, of liberal movement. I think of the space of Matisse, who bought Cézanne's *Three Bathers* in 1899, but who would himself paint in behalf of feelings different from those of Cézanne, as he paints many a vista with a *joie de vivre*, in which one would act with more verve and feel more vivaciousness than in the more somber views of Cézanne. Matisse asked that the painting, when he gave it to the city of Paris, be given plenty of space and light: "It is rich in color and surface and only when it is seen at a distance is it possible to appreciate the sweep of its lines and the exceptional sobriety of its relationships." I hope that Matisse means something close to what I mean when I say that the feeling of the actions that one would perform dwelling in that space would be feelings of sober rapport. In fact, Matisse's French reads, "Elle est savoureuse de couleur et de métier and par le recul elle met en évidence la puissance de l'élan de ses lignes et la sobriété exceptionelle de ses rapports."

The style in which a painting is to be read is the style in which existence is to be read. How do the parts of the painting interrelate? The way parts of a work of art act on each other is how the parts of an event should act on each other; or is an image

of how they do interact. For Cézanne, the correct relation among parts of a work of art, the feeling with which the parts should interact, as in the "harmonic sequence of planes" Fry describes, is rapport, and so the lesson is that the significant events in life are those which are structured with rapport. The murder and the orgy in his early work were too little and too much. And of course Cézanne notes a failure of rapport, as when he points out to a traveling companion, "What a lovely motif!" and the companion responds, "The lines are too well balanced," an academic response that appalls Cézanne, who always felt that he lacked equilibrium (see the letter of May 11, 1886), but who had discarded the usual props of stability, and who would not accept an easy balance as a true rapport.

Sooner or later in studies of Cézanne the author surrenders. In an essay translated by Roger Fry, Maurice Denis wrote, "I have never heard an admirer of Cézanne give me a clear and precise reason for his admiration"; and then Virginia Woolf describes Roger Fry lecturing: "He was pointing to a late work by Cézanne and he was baffled. He shook his head; his stick rested on the floor. It went, he said, far beyond any analysis of which he was capable. And so instead of saying, 'Next slide,' he bowed, and the audience emptied itself into Langham Place." I know the feeling. I can't describe or account for the intensity of the jolts I was receiving from Cézanne's late work in the Museum of Modern Art; I felt, looking at the views of Mont Sainte-Victoire, as if I were seeing the feeling I longed to see and to feel, seeing the space in which life could be lived amidst continual rebirths of feeling, the space of Cézanne's heroic rapport.

1985

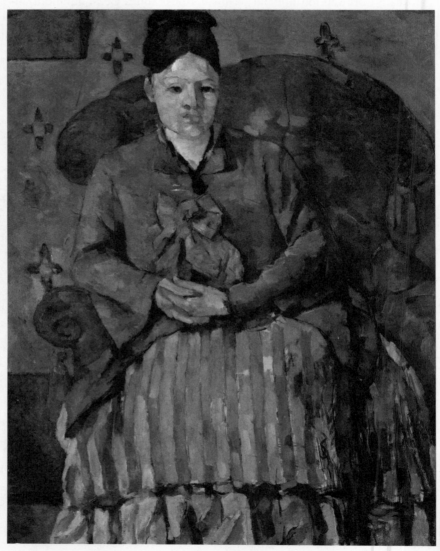

Paul Cézanne (1839–1906): *Madame Cézanne in a Red Armchair*, 1877. Oil on canvas, 28½″ × 22″ (72.5 cm × 56.0 cm). Bequest of Robert Treat Paine, 2nd. Courtesy, Museum of Fine Arts, Boston. 44.776.

D. H. LAWRENCE

Cézanne

The actual fact is that in Cézanne modern French art made its first tiny step back to real substance, to objective substance, if we may call it so. Van Gogh's earth was still subjective earth, himself projected into the earth. But Cézanne's apples are a real attempt to let the apple exist in its own separate entity, without transfusing it with personal emotion. Cézanne's great effort was, as it were, to shove the apple away from him, and let it live of itself. It seems a small thing to do: yet it is the first real sign that man has made for several thousands of years that he is willing to admit that matter *actually* exists. . . .

Cézanne felt it in paint, when he felt for the apple. Suddenly he felt the tyranny of mind, the white, worn-out arrogance of the spirit, the mental consciousness, the enclosed ego in its sky-blue heaven self-painted. He felt the sky-blue prison. And a great conflict started inside him. He was dominated by his old mental consciousness, but he wanted terribly to escape the domination. . . .

If he wanted to paint people intuitively and instinctively, he couldn't do it. His mental concepts shoved in front, and these he *wouldn't* paint—mere representations of what the *mind* accepts, not what the intuitions gather—and they, his mental concepts, wouldn't let him paint from intuition: they shoved in between all the time, so he painted his conflict and his failure, and the result is almost ridiculous.

Woman he was not allowed to know by intuition: his mental self, his ego, that bloodless fiend, forbade him. Man, other men, he was likewise not allowed to know—except by a few, few touches. The earth likewise he was not allowed to know: his landscapes are mostly acts of rebellion against the mental concept of

landscape. After a fight tooth-and-nail for forty years, he did succeed in knowing an apple, fully; and, not quite as fully, a jug or two. That was all he achieved.

It seems little, and he died embittered. But it is the first step that counts, and Cézanne's apple is a great deal, more than Plato's Idea. Cézanne's apple rolled the stone from the mouth of the tomb, and if poor Cézanne couldn't unwind himself from his cerements and mental winding-sheet, but had to lie still in the tomb, till he died, still he gave us a chance.

. . . Our instincts and intuitions are dead, we live wound round with the winding-sheet of abstraction. And the touch of anything solid hurts us. . . .

So that Cézanne's apple hurts. It made people shout with pain. And it was not till his followers had turned him again into an abstraction that he was ever accepted. Then the critics stepped forth and abstracted his good apple into Significant Form, and henceforth Cézanne was saved. Saved for democracy. Put safely in the tomb again, and the stone rolled back. The resurrection was postponed once more. . . .

The most interesting figure in modern art, and the only really interesting figure, is Cézanne: and that, not so much because of his achievement as because of his struggle. . . .

Cézanne was naïve to a degree, but not a fool. He was rather insignificant, and grandeur impressed him terribly. Yet still stronger in him was the little flame of life where he *felt* things to be true. He didn't betray himself in order to get success, because he couldn't: to his nature it was impossible: he was too pure to be able to betray his own small real flame for immediate rewards. Perhaps that is the best one can say of a man, and it puts Cézanne, small and insignificant as he is, among the heroes. He would *not* abandon his own vital imagination.

. . . I find scientists, just like artists, asserting things they are *mentally* sure of, in fact cocksure, but about which they are much too egoistic and ranting to be *intuitively, instinctively* sure. When I find a man, or a woman, intuitively and instinctively sure of anything, I am all respect. But for scientific or artistic braggarts how can one have respect? The intrusion of the egoistic element is a sure proof of intuitive uncertainty. No man who is sure by instinct and intuition *brags*, though he may fight tooth and nail for his beliefs.

Which brings us back to Cézanne, why he couldn't draw, and why he couldn't paint baroque masterpieces. It is just because he was real, and could only believe in his own expression when it expressed a moment of wholeness or completeness of consciousness in himself. He could not prostitute one part of himself to the other. He *could* not masturbate, in paint or words. And that is saying a very great deal, today; today, the great day of the masturbating consciousness, when the mind

prostitutes the sensitive responsive body, and just forces the reactions. The masturbating consciousness produces all kinds of novelties, which thrill for the moment, then go very dead. It cannot produce a single genuinely new utterance.

What we have to thank Cézanne for is not his humility, but for his proud, high spirit that refused to accept the glib utterances of his facile mental self. He wasn't poor-spirited enough to be facile—nor humble enough to be satisfied with visual and emotional clichés. Thrilling as the baroque masters were to him in themselves, he realized that as soon as he reproduced them he produced nothing but cliché. . . .

Cézanne's early history as a painter is a history of his fight with his own cliché. His consciousness wanted a new realization. And his ready-made mind offered him all the time a ready-made expression. And Cézanne, far too inwardly proud and haughty to accept the ready-made clichés that came from his mental consciousness, stocked with memories, and which appeared mocking at him on his canvas, spent most of his time smashing his own forms to bits. To a true artist, and to the living imagination, the cliché is the deadly enemy. Cézanne had a bitter fight with it. He hammered it to pieces a thousand times. And still it reappeared.

Now again we can see why Cézanne's drawing was so bad. It was bad because it represented a smashed, mauled cliché, terribly knocked about. If Cézanne had been willing to accept his own baroque cliché, his drawing would have been perfectly conventionally "all right," and not a critic would have had a word to say about it. But when his drawing was conventionally all right, to Cézanne himself it was mockingly all wrong. It was cliché. So he flew at it and knocked all the shape and stuffing out of it, and when it was so mauled that it was all wrong, and he was exhausted with it, he let it go; bitterly, because it still was not what he wanted. And here comes in the comic element in Cézanne's pictures. His rage with the cliché made him distort the cliché sometimes into parody, as we see in pictures like *The Pasha* and *La Femme*. "You *will* be cliché, will you?" he gnashes. "Then *be* it!" And he shoves it in a frenzy of exasperation over into parody. And the sheer exasperation makes the parody still funny; but the laugh is a little on the wrong side of the face.

This smashing of the cliché lasted a long way into Cézanne's life: indeed, it went with him to the end. The way he worked over and over his forms was his nervous manner of laying the ghost of his cliché, burying it. Then when it disappeared perhaps from his forms themselves, it lingered in his composition, and he had to fight with the edges of his forms and contours, to bury the ghost there. Only his colour he knew was not cliché. He left it to his disciples to make it so.

In his very best pictures, the best of the still-life compositions, which seem to

me Cézanne's greatest achievement, the fight with the cliché is still going on. But it was in the still-life pictures he learned his final method of *avoiding* the cliché: just leaving gaps through which it fell into nothingness. So he makes his landscape succeed.

In his art, all his life long, Cézanne was tangled in a twofold activity. He wanted to express something, and before he could do it he had to fight the hydra-headed cliché, whose last head he could never lop off. The fight with the cliché is the most obvious thing in his pictures. The dust of battle rises thick, and the splinters fly wildly. And it is this dust of battle and flying of splinters which his imitators still so fervently imitate. If you give a Chinese dressmaker a dress to copy, and the dress happens to have a darned rent in it, the dressmaker carefully tears a rent in the new dress, and darns it in exact replica. And this seems to be the chief occupation of Cézanne's disciples, in every land. They absorb themselves reproducing imitation mistakes. He let off various explosions in order to blow up the stronghold of the cliché, and his followers make grand firework imitations of the explosions, without the faintest inkling of the true attack. They do, indeed, make an onslaught on representation, true-to-life representation: because the explosion in Cézanne's pictures blew them up. But I am convinced that what Cézanne himself wanted *was* representation. He *wanted* true-to-life representation. Only he wanted it *more* true to life. And once you have got photography, it is a very, very difficult thing to get representation *more* true-to-life: which it has to be.

Cézanne was a realist, and he wanted to be true to life. But he would not be content with the optical cliché. With the impressionists, purely optical vision perfected itself and fell *at once* into cliché, with a startling rapidity. Cézanne saw this. Artists like Courbet and Daumier were not purely optical, but the other element in these two painters, the intellectual element, was cliché. To the optical vision they added the concept of force-pressure, almost like an hydraulic brake, and this force-pressure concept is mechanical, a cliché, though still popular. And Daumier added mental satire, and Courbet added a touch of a sort of socialism: both cliché and unimaginative.

Cézanne wanted something that was neither optical nor mechanical nor intellectual. And to introduce into our world of vision something which is neither optical nor mechanical nor intellectual-psychological requires a real revolution. It was a revolution Cézanne began, but which nobody, apparently, has been able to carry on.

He wanted to touch the world of substance once more with the intuitive touch, to be aware of it with the intuitive awareness, and to express it in intuitive terms.

That is, he wished to displace our present mode of mental-visual consciousness, the consciousness of mental concepts, and substitute a mode of consciousness that was predominantly intuitive, the awareness of touch. In the past the primitives painted intuitively, but *in the direction* of our present mental-visual, conceptual form of consciousness. They were working away from their own intuition. Mankind has never been able to trust the intuitive consciousness, and the decision to accept that trust marks a very great revolution in the course of human development.

Without knowing it, Cézanne, the timid little conventional man sheltering behind his wife and sister and the Jesuit father, was a pure revolutionary. When he said to his models: "Be an apple! Be an apple!" he was uttering the foreword to the fall not only of Jesuits and the Christian idealists altogether, but to the collapse of our whole way of consciousness, and the substitution of another way. If the human being is going to be primarily an apple, as for Cézanne it was, then you are going to have a new world of men: a world which has very little to say, men that can sit still and just be physically there, and be truly non-moral. That was what Cézanne meant with his: "Be an apple!" He knew perfectly well that the moment the model began to intrude her personality and her "mind," it would be cliché and moral, and he would have to paint cliché. The only part of her that was not banal, known *ad nauseam*, living cliché, the only part of her that was not living cliché was her appleyness. Her body, even her very sex, was known nauseously: *connu, connu!* the endless chance of known cause-and-effect, the infinite web of the hated cliché which nets us all down in utter boredom. He knew it all, he hated it all, he refused it all, this timid and "humble" little man. He knew, as an artist, that the only bit of a woman which nowadays escapes being ready-made and ready-known cliché is the appley part of her. Oh, be an apple, and leave out all your thoughts, all your feelings, all your mind and all your personality, which we know all about and find boring beyond endurance. Leave it all out—and be an apple! It is the appleyness of the portrait of Cézanne's wife that makes it so permanently interesting: the appleyness, which carries with it also the feeling of knowing the other side as well, the side you don't see, the hidden side of the moon. For the intuitive apperception of the apple is so *tangibly* aware of the apple that it is aware of it *all around*, not only just of the front. The eye sees only fronts, and the mind, on the whole, is satisfied with fronts. But intuition needs all-aroundness, and instinct needs insideness. The true imagination is for ever curving round to the other side, to the back of presented appearance.

So to my feeling the portraits of Madame Cézanne, particularly the portrait in

the red dress, are more interesting than the portrait of M. Geffroy, or the portraits of the housekeeper or the gardener. In the same way the *Card-Players* with two figures please me more than those with four.

But we have to remember, in his figure-paintings, that while he was painting the appleyness he was also deliberately painting *out* the so-called humanness, the personality, the "likeness," the physical cliché. He had deliberately to paint it out, deliberately to make the hands and face rudimentary, and so on, because if he had painted them in fully they would have been cliché. He *never* got over the cliché denominator, the intrusion and interference of the ready-made concept, when it came to people, to men and women. Especially to women he could only give a cliché response—and that maddened him. Try as he might, women remained a known, ready-made cliché object to him, and he *could not* break through the concept obsession to get at the intuitive awareness of her. Except with his wife—and in his wife he did at least know the appleyness. But with his housekeeper he failed somewhat. She was a bit cliché, especially the face. So really is M. Geffroy.

With men Cézanne often dodged it by insisting on the clothes, those stiff cloth jackets bent into thick folds, those hats, those blouses, those curtains. Some of the *Card-Players*, the big ones with four figures, seem just a trifle banal, so much occupied with painted stuff, painted clothing, and the humanness a bit cliché. Nor good colour, nor clever composition, nor "planes" of colour, nor anything else will save an emotional cliché from being an emotional cliché, though they may, of course, garnish it and make it more interesting.

Where Cézanne did sometimes escape the cliché altogether and really give a complete intuitive interpretation of actual objects is in some of the still-life compositions. To me these good still-life scenes are purely representative and quite true to life. Here Cézanne did what he wanted to do: he made the things quite real, he didn't deliberately leave anything out, and yet he gave us a triumphant and rich intuitive vision of a few apples and kitchen pots. For once his intuitive consciousness triumphed, and broke into utterance. And here he is inimitable. His imitators imitate his accessories of tablecloths folded like tin, etc.—the unreal parts of his pictures—but they don't imitate the pots and apples, because they can't. It's the real appleyness, and you can't imitate it. Every man must create it new and different out of himself: new and different. The moment it looks "like" Cézanne, it is nothing.

But at the same time Cézanne was triumphing with the apple and appleyness he was still fighting with the cliché. When he makes Madame Cézanne most still, most appley, he starts making the universe slip uneasily about her. It was part of his desire: to make the human form, the *life* form, come to rest. Not static—on the contrary. Mobile but come to rest. And at the same time he set the unmoving

material world into motion. Walls twitch and slide, chairs bend or rear up a little, cloths curl like burning paper. Cézanne did this partly to satisfy his intuitive feeling that nothing is really *statically* at rest—a feeling he seems to have had strongly— as when he watched the lemons shrivel or go mildewed, in his still-life group, which he left lying there so long so that he *could* see that gradual flux of change: and partly to fight the cliché, which says that the inanimate world *is* static, and that walls *are* still. In his fight with the cliché he denied that walls are still and chairs are static. In his intuitive self he *felt* for their changes.

And these two activities of his consciousness occupy his later landscapes. In the best landscapes we are fascinated by the mysterious *shiftiness* of the scene under our eyes; it shifts about as we watch it. And we realize, with a sort of transport, how intuitively *true* this is of landscape. It is *not* still. It has its own weird anima, and to our wide-eyed perception it changes like a living animal under our gaze. This is a quality that Cézanne sometimes got marvellously.

Then again, in other pictures he seems to be saying: Landscape is not like this and not like this and not like this and not . . . etc.—and every *not* is a little blank space in the canvas, defined by the remains of an assertion. Sometimes Cézanne builds up a landscape essentially out of omissions. He puts fringes on the compli-cated vacuum of the cliché, so to speak, and offers us that. It is interesting in a *re-pudiative* fashion, but it is not the new think. The appleyness, the intuition has gone. We have only a mental repudiation. This occupies many of the later pic-tures: and ecstasizes the critics.

And Cézanne was bitter. He had never, as far as his *life* went, broken through the horrible glass screen of the mental concepts, to the actual *touch* of life. In his art he had touched the apple, and that was a great deal. He had intuitively known the apple and intuitively brought it forth on the tree of his life, in paint. But when it came to anything beyond the apple, to landscape, to people, and above all to nude woman, the cliché had triumphed over him. The cliché had triumphed over him, and he was bitter, misanthropic. How not to be misanthropic when men and women are just clichés to you, and you hate the cliché? Most people, of course, love the cliché—because most people *are* the cliché. Still, for all that, there is per-haps more appleyness in man, and even in nude woman, than Cézanne was able to get at. The cliché obtruded, so he just abstracted away from it. Those last water-colour landscapes are just abstractions from the cliché. They are blanks, with a few pearly coloured sort of edges. The blank is vacuum, which was Cézanne's last word against the cliché. It is a vacuum, and the edges are there to assert the vacuity.

And the very fact that we can reconstruct almost instantly a whole landscape from the few indications Cézanne gives, shows what a cliché the landscape is, how

it exists already, ready-made, in our minds, how it exists in a pigeon-hole of the consciousness, so to speak, and you need only be given its number to be able to get it out, complete. Cézanne's last water-colour landscapes, made up of a few touches on blank paper, are a satire on landscape altogether. *They leave so much to the imagination!*—that immortal cant phrase, which means they give you the clue to a cliché and the cliché comes. That's what the cliché exists for. And that sort of imagination is just a rag-bag of memory stored with thousands and thousands of old and really worthless sketches, images, etc., clichés.

We can see what a fight it means, the escape from the domination of the ready-made mental concept, the mental consciousness stuffed full of clichés that intervene like a complete screen between us and life. It means a long, long fight, that will probably last for ever. But Cézanne did get as far as the apple. I can think of nobody else who has done anything.

1929

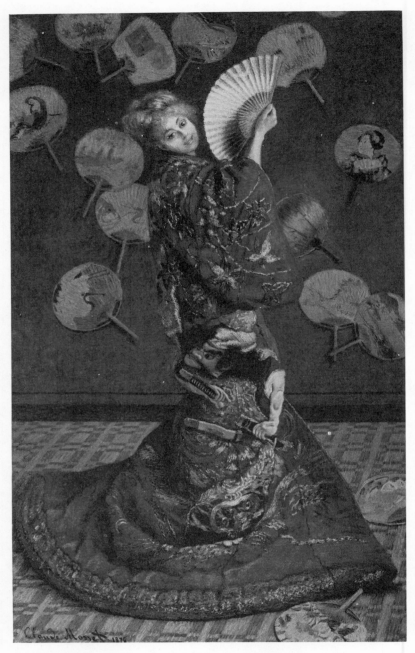

Oscar Claude Monet (1840–1926): *La Japonaise (Camille Monet in Japanese Costume)*, 1876. Oil on canvas, 91¼″ × 56″ (231.6 cm × 142.3 cm). 1951 Purchase Fund. Courtesy, Museum of Fine Arts, Boston. 44.776.

MICHEL BUTOR

Claude Monet
or The World Upside Down

FLEETING

Fidelity to nature is the crux of Impressionist strategy against the Salon or the Academy, but consider Monet's paradoxical inflection of it. When Courbet or the early Manet tell us they paint objects or people as they are, they are implying we can verify what they have done; for them the model must have a certain stability, must hold still so that the painter can compare it point by point with the representation of it he has just made, and the spectator after him: so a calm scene is required, a quiet landscape, a still life, a ceremony, a moment of leisure. Painting out of doors or with a palette knife alters nothing in these fundamental *données*; we may now verify the exactitude of the nuance, as we once did that of the detail. But Monet, with his insistence on the fleeting, explodes the old notion of fidelity. Traditional verification becomes impossible—denied not only to the spectator but to the painter himself. Already the colors he has put on the canvas no longer correspond to those he sees. The design of the reflection has obviously changed.

So not Cézanne's famous "What an eye!" should be said about Monet, but "What a memory!" If what he painted for us really corresponds to a fleeting moment, we must conclude he painted it without having it before his eyes. His construction is as "grand" as that of the Franche-Comté landscapes Courbet was reconstituting in his studio: but while Courbet's reconstitutions, like Cézanne's later on, are attached to something permanent, something available to the spectator,

Monet's are attached to an object which, by definition, has disappeared forever. The only verification still available to us is the encounter in nature, say on a walk, with an *effect* of the same kind, differing in the same way from habitual vision. Monet's instantaneity, far from being passivity, requires on the contrary an extraordinary power of generalization, of abstraction.

Nineteenth-century *realist* landscape would tell us: "Here is nature not as painters ordinarily represent it but as you yourselves see it." Neither Courbet nor Corot asked us to look at things differently, but Monet announces: "Here is nature as you don't usually see it, as I myself don't usually see it, but as you can see it—not necessarily this particular effect but, in my wake, others which resemble it. The vision I offer you is superior to the one we put up with; my painting will change reality for you."

So he must discover subjects in which there is an obvious instability, subjects whose dynamic enables them to intervene in the spectator's vision.

Compare his landscapes to Sisley's. The latter adopts everything in the early Monet which can be taken as a continuation of Corot, but the instability I have just alluded to remains foreign to Sisley, in whose art everything is calm. In the dark apartments of Paris and London, he opens windows onto a countryside, or a suburb, peaceful, airy, luminous, where time keeps flowing, spreading. . . . We feel nothing has moved between the moment Sisley set up his easel and the moment he finished the painting. In *l'Inondation de Port-Marly* he spreads before our eyes the surface of dead-calm water which reflects the light, heightens the colors: the reflections playing upon it are there only to make us feel that the substance represented is water; in themselves they are of no interest. Conversely, in Monet, the reflection, with its ceaselessly evanescent design, will often be the center of the composition.

PORTRAIT DE MME GAUDIBERT *(Musée du Jeu de Paume, Paris)*

So there will be something provocative about Monet's art, compared to Corot's or Sisley's. Whereas they open a window and let fresh air into the comfortable but increasingly confined bourgeois world of the end of the nineteenth century, helping it resist asphyxiation though without changing it, Monet effects a profound transformation of perception itself which little by little overturns that world altogether.

With Monet, we no longer look at nature, or the out-of-doors, from some calm interior vantage, *chez soi*; instead it is that out-of-doors which begins to invade the room where the painting hangs. When Monet scours the countryside "like a hunter," what he is looking for is not something that will paint well but, as he will say time and again in his letters, something "impossible to paint," something

which would allow him to give his final surface that dynamic instability which is the essence of his art.

One of the simplest means would seem to be to paint a human being or an animal in motion, as Degas and Lautrec will do. But Monet soon abandons this method. Within his frame immobilized being remains immobile; he suggests that something is moving on the other side of the painting's window-pane, but he does not make the painting itself move. Monet comes closer to his goal when he can capture an immobility about to come to an end, for then the immobility of the canvas is justified: a movement will be born from it.

At the Musée du Jeu de Paume in Paris, we can see side by side two very important paintings which are virtually contemporary: Monet's *Portrait de Mme Gaudibert* and Manet's *Le Balcon*. Here Monet is still his elder's disciple, but a detail common to the two canvases already suggests a fundamental difference. In *Le Balcon*, Jenny Claus is putting on her gloves; so is Mme Gaudibert: they are almost at the same point. But in *Le Balcon*, there is all the time in the world. We feel that Berthe Morisot, in the foreground, could sit there for hours, while behind her, in the shadows, the servants slowly pass back and forth. Jenny Claus moves her hands calmly—the moment is a broad, spreading one which the painter expands still further, for it is this leisure which is his subject. In contrast, Mme Gaudibert is all nerves, as if her pose itself—she is seen in *profil perdu*—were annoying her; being unable to see her portraitist must have exasperated her during the sittings; she is just waiting for a sign from him to turn around, to escape at last. Her tall figure is entirely immobilized in a forward tension, toward the spectator. And her dress will swirl around her then, rustling. . . .

LA RIVIÈRE *(Art Institute of Chicago)*

In the *Portrait de Mme Gaudibert*, whatever is not the subject herself remains motionless. How to bring the whole surface to life, so that the entire content of the picture invades the room where it hangs? Monet will seek out forms which force us to reorganize our perception. The simplest scheme, characteristic of his art, very frequent in his work and absent from that of his friends, is inversion, the act of turning an object upside down.

When we see a house with its roof underneath, we still think of it with its roof on top, and consequently we make this figure move: we keep putting it right side up, our eyes keep showing it to us upside down. If *everything* is inverted, then the painting is wrong side up, and all we have to do is turn it around; if movement is to persist, we must combine inverted figures with normal ones.

La Rivière masterfully solves this problem for the first time.

A young woman, doubtless Camille Monet, is sitting in the grass on a river-bank, in the shade of a tree. A boat is moored to her right; on the other side of the water, some bright houses. A Corot, we might say. But the woman's face is a single blur, without detail, without individualization, so as not to attract our attention. What does attract our attention is the reflection, under the tree, of the houses we do not see, hidden as they are by the foliage, inverted houses just as bright and distinct as those seen directly, though their outline is faintly disrupted by ripples from the boat.

The woman's figure is the symmetrical center here: on her right the roofs of the houses are on top; on her left they are inverted. This arrangement forces us to reconstruct, behind the foliage, the normal outline of the reflected houses; to inscribe on the water's now broken surface to the right a reflection of the houses to the right which would be their perfect inversion. The entire canvas is stirred to life by these pairings.

IMPRESSION, SOLEIL LEVANT (Musée Marmottan, Paris)

In La Rivière, certain parts of the painting give us precise information about what is happening in another part, about something hidden or momentarily interrupted. When the sheet of water permitting the inversion gently breaks up the shapes into broad fragments, the real object represented will be, in a sense, the key to the riddle posed by the reflection: we no longer perceive that reflection as another object but as a decomposing version of its original. We keep reassembling and dispersing the fragments of the image. It is we who restore the water's movement.

As is quite clear in the famous Impression, soleil levant, to which the Impressionist group owes its name. The red circle in the upper part is there to tell us that the complex striping in the lower part is the sun, which we certainly would not suspect if we were to cut the painting in two. The upper half is really a title for the lower.

Once the identification is made, the whole surface comes to life in waves, the original circle dissolving and reappearing according to a definite rhythm.

Further, the vertical length of the reflection makes the light come toward us, brings it closer, bathes us in its glow.

The name Monet gave this canvas is its necessary complement: it emphasizes its composition while adding a new element. Indeed, it has already been remarked that if we consider the painting without the title, we cannot tell if the time of day represented is morning or evening; the phrase "rising sun" gives the red circle an ascending movement in relation to the sky's sphere, emphasizing this advent of the light.

RÉGATES À ARGENTEUIL *(Musée du Jeu de Paume, Paris)*

Take the 1872 *Régates:* if we isolate the lower right quarter and invert it, we get a picture of remarkable chromatic intensity coupled with violent and emotional drawing—a Fauve painting. All the elements which compose it and which might be somewhat obscure are elucidated by the upper half which explains: this is a boat, this is a house, etc. The reflection provokes an analysis of what is enumerated above.

It is as though Monet were telling us: you can't see this red, this green, beautiful as they are in their pure state—but look: they're in this house and you, too, can draw them out. . . .

Impossible to interpret the reflected part as the simple notation of what the painter had before his eyes. Among the millions of figurations a camera might have produced, we cannot even suppose that Monet might have chosen one; he has *constructed* a figuration stirred by a certain rhythm, one that we can imagine obeys that of the liquid surface from which he takes his inspiration (though nothing can guarantee this for us), starting from real objects, a figuration which teaches us something about those objects.

The semantic relation between top and bottom functions, evidently, in both directions:

1) the top names the bottom: this cluster of brush strokes, which looks like nothing in particular, suddenly becomes a tree, a house, a boat;

2) the bottom reveals the top: this boat, this house which you suppose so dull secretly contain these chromatic harmonies, these elemental shapes, these expressive possibilities.

Here the top corresponds to the recognizable, to the reality we are used to; the bottom, the part which brings these houses and boats toward us, corresponds to the painter's activity. The water becomes a metaphor for painting. The broad brush strokes by which these reflections are rendered vigorously assert both substance and tool. The liquid surface gives us an example in nature of that activity which the painter's labor imparts to this second surface, this canvas we hang in our apartments and then in our museums.

MADAME MONET EN COSTUME JAPONAIS *(Boston Museum of Fine Arts)*

The canvas is a surface whose volume the eye will seek out, will develop. In the course of those *hunts* of his, Monet will search for those surfaces which already give an impression of volume; he will become their pupil.

A *voluminous surface*—that is the key to this singular painting, in which Monet himself, at the end of his life, hesitated to recognize his hand.

We know that the *Portrait de Camille en Robe Verte*—scarcely a portrait, for the face is almost entirely avoided—had been one of the artist's first great successes. He wanted, he remarks, to make a red pendant for it, and he was further tempted by the gift of a bolt of silk decorated with elaborate embroidery representing a furious samurai drawing his sword. Whence this strange composition, this dancer with her head thrown back, fanning herself in front of a wall decorated with a spatter of round fans.

The face, that of Monet's wife, is treated very lightly, barely indicated; the work's focus is obviously the samurai's head grimacing on her buttock, whose volume is much more emphatically marked; in this region of the canvas we have a real *trompe-l'oeil*. Such a figuration might inspire a psychoanalyst; for us it is enough to cite the structural ambiguity set up by these two faces: the real one and the false one more "present" than the real.

The earliest critics, by their very incomprehension (as often happens), sensed a characteristic element: the fans scattered on the rear wall cluster around the woman in a lively dance of their own, as if they were suspended in air and caught up in her gesticulation. Except for the floorboard lines, no element of perspective; the distance to the rear wall remains very vague, and since the details of the round fans are treated more minutely than the woman's face, they tend to advance almost to the same level as the samurai's head.

Soon we can find a double *trompe-l'oeil* in Monet's canvases: one, common to all painting, the *trompe-l'oeil* of the space which the work forces us to imagine, landscape or interior; and another which will give a volume to the painted surface itself, will make it into an embroidery as astonishing as that of the Japanese gown.

It has often been remarked that during an entire period Monet's paintings have a woolly look. It is within this first voluminosity, noticeable long before the other —as if it were some sumptuous carpet—that the second, the figurative voluminosity will originate, will gather strength; the figurative volume will escape from the surface volume, then return to it, take refuge within it. Just as there is a pulsion on the surface between the right-side-up and the inverted figures, there is a perpendicular pulsion between the apparent volume of the canvas and the volume of its subject.

WESTMINSTER BRIDGE *(Collection of Lord Astor of Hever)*

Such a movement in depth, which will give Monet's work its aggressiveness in relation to the space where it is hung, is made possible only by discarding classical perspective.

For when a specific staging has given each element its exact distance, the space represented becomes so much more powerful than the surface of the canvas with its irregularities, its real or apparent thickness, that this surface will be utterly forgotten. The spectator's perception will then settle into a definitive interpretation. Resting his elbows, so to speak, on the guard-rail of the frame, he lets his imagination soar into the distance arranged for him—he will escape down Ruysdael's paths, float over Claude's Arcadias.

Monet cuts short all such escapes.

Generally he does so by choosing as his subject a plane parallel to that of the picture, for example a steep riverbank (Argenteuil, Vétheuil, Carrières-Saint-Denis, etc.) seen from across the water. Horizontal in nature, the plane of this water, since it represents the very activity of painting which brings the distant object toward us, will always seem to be righting itself toward the picture's vertical.

In such an arrangement, the problems of classical perspective, if the roof lines and angles are attenuated, do not even come up. But occasionally Monet wants to introduce into the painting lines which are perpendicular to it and normally run toward a vanishing point, lines which might suspend all interpretations in a permanently fixed distance, thereby depriving the work of its forward thrust, its provocative dynamics. Ruysdael, Claude, even Corot acknowledge this perspective; it is essential to their endeavor. With Monet, what counts most is the aggressive return of a certain abandoned, unacknowledged reality, the invasion of the 1900 urban interior by what it hides, denies, keeps back.

Whenever a classical-type perspective tends to form in the exemplary image Monet has discovered, he manages to neutralize it. In one of his first views of London, Lord Astor of Hever's *Westminster Bridge*, the Abbey extends parallel to the canvas as in the famous later series, but the quay on the right forms a perspective cluster of lines which might produce an irrevocable deepening. Monet compensates for this by the construction of black horizontal and vertical pilings whose presence is clearly much stronger and which draws attention to itself, and by creating, on the pretext of some floating logs whose real image would be constantly changing, a veritable counter-cluster which restores the entire composition to its perspective instability.

LA SEINE À BOUGIVAL *(Currier Gallery of Art, Manchester, New Hampshire)*
LE BASSIN D'ARGENTEUIL *(Musée du Jeu de Paume, Paris)*

In Hobbema's *Middleharnis Lane* (National Gallery, London), a double row of slender trees emphasizes the perspective until their movement toward the vanishing point becomes dizzying. We are swept away by this appeal; prisoners of this

void, we wait until the fascination wears off a bit so that we ourselves can leave—make our escape. Such rows of trees perpendicular to the picture occur in several of Monet's works, but the effect they produce is quite different: light falls parallel to the plane of the canvas, in which the trees carve out slices of sunlight and shadow. They look like stakes marking off a depth layered in bright and dark zones, and the vertical planes they define become more important than the trees themselves.

It is the façades of Vétheuil and Argenteuil which are now rendered transparent and endlessly reflected. In the rhythm of these pale and dark curtains we recognize the rhythm of the liquid surfaces which allowed us to question the reality of things. The metaphorical water, the *painting* of the lower half of the 1872 *Régates*, begins to permeate the whole work.

Monet counters the empty, dizzying space of the Dutch painters with a full space which pours out onto the spectator. It is as though the surface were continually emitting a white wave, then a black wave. . . .

LES DÉBARDEURS *(Durand-Ruel Collection, Paris)*

The activity of these parallel vertical planes receives a matchless interpretation in this unique painting from the Durand-Ruel Collection. Here the barges and the quays perpendicular to the painting should produce a powerful perspective movement toward the vanishing point, but such movement is countered by the bridge in the upper part and especially by all the narrow intersecting gangplanks on which the stevedores come and go, their fantastic hats giving this scene a kind of Oriental picturesqueness.

The different parallel planes into which the space is layered no longer consist of sunlight and shadow only, but of movement in one direction or the other, and of weight or lightness as well. The shadow is petrified into coal; the rhythm of the waves emitted by the canvas is no longer that of the river's current or of the tree-lined avenue, but the rhythm of an effort and its relaxation; it is the actual rhythm of a laborious task which obtrudes upon the spectator.

Here nature's aggressiveness, of which the city-dweller is to be reminded, is identified with the demands of the laborer, whose movements are likely to circumvent the rich man. The initial exoticism—the golden color, the hats—merely emphasizes the violence of this obtrusion.

LE PONT DE CHEMIN DE FER À ARGENTEUIL *(Musée du Jeu de Paume, Paris)*

In a Dutch painting, the void created by perspective emphasized the plenitude of objects or merchandise which the owner displayed in his cellars and his rooms; in

the greatest masters, this void made a mockery of things, urging us to live another life, to abandon what was no more than *vanity*. But in Monet, the space proposed must offer itself as fullness, must introduce an upheaval into the gathered objects, corrode them, destroy or transform them. Then the air will no longer be exquisitely calm and silent, the air which fills the free space of the canvas will assume such a presence that it is the room we are in which will seem empty, overcrowded as it is.

Whence the fundamental role of the wind; it is the means by which the intervals between the objects represented no longer constitute voids but instead centers of pressure and activity. The wind blows in Ruysdael too, but it sweeps us toward other shores, it is an *invitation au voyage*; in Monet, the wind will blow toward us, will sustain that emanation of the surface, will push away the objects nearby.

The billowing of a dress, the flutter of a scarf, the tightly held handle of a resisting parasol, the curve of sails will be so many indicators endowing space with a tension. To which may be added noise.

Le Pont du Chemin de Fer à Argenteuil unites the water's broken surface, the rhythm of light and dark planes produced by the pilings, the dynamic streak of the train vanishing with its imagined noise, and the opposing streak of its smoke which the victorious wind sweeps back toward us.

A little later, the first *series*, that of the Gare Saint-Lazare, adds entirely different developments to the theme of trains, their noise, their smoke—adds the rhythm of their arrivals and departures, of the crowds they bring and remove, of the pulsation they give to the city's life. These too will be a metaphor for that communication which painting establishes between the city and the unrecognized countryside, between the bourgeois interiors and the landscape of the city unrecognized by its inhabitants.

LA RUE MONTORGUEIL PAVOISÉE *(Musée de Rouen)*

Other noises besides those of trains—shouts, for example—can be indicated by a kind of script. Monet made this experiment only once, I think. The street's void is filled with flags and with the wind that is fluttering them. Among all these tricolor flames and scrupulously countered by the general movement unfolds a banner with the motto VIVE LA FRANCE. At first we do not notice it—often it must be pointed out before the spectator sees it at all. But suddenly it strikes the eye like a shout in the ear. Once our attention is caught by this slogan, we find it is echoed in gold letters on the white of one of the nearest flags. Thus the shout comes toward us and vanishes.

LA DÉBÂCLE *(Gulbenkian Collection, Lisbon)*

The emanation the canvas produces, with its expressions—wave, wind, noise—will lead Monet to seek out not only voluminous surfaces but surfaces *becoming* voluminous, surfaces which are themselves emanations.

Water, however stirred, insofar as it is treated only in terms of its reflections, remains necessarily smooth. Ice is a first mode of its thickening. The river will be covered by a rough crust; but then it no longer reflects anything, it is petrified.

Between these extremes of the mirror without any volume whatever, pure reflection without refraction, and the rough ice in which images no longer form, unfolds the entire metaphor of painting, from which comes the theme of *La Débâcle*, that moment when the river's thick surface, its crust, breaks up, causing the trees on the bank to appear in inverted fragments.

But since I have spoken of a double *trompe-l'oeil*, since the canvas preserves a certain apparent thickness, even after the emanation of what it represents, in order for the metaphor to be complete, the "crust" pole of *La Débâcle* must already be presented as making something visible, as having its own power of emanation or transparency.

Now water, regarded as substance, possesses these characteristics: it has an actual transparency which can be shown by weeds within it, like the purplish lianas of *En Canot sur l'Epte* (in the São Paulo museum); and if the wind stirs it sufficiently, it will produce, on the primary surface, the appearance of drops, foam, mist, all of which phenomena will be accompanied by odors and noises we will recall precisely to the degree that the painter has managed to preserve the dynamics of these voluminous surfaces. Sometimes the water's emanation will become a fog invading the entire canvas and, as we know so well, bringing objects closer together, as in the various great London series.

LES COQUELICOTS *(Musée du Jeu de Paume, Paris)*
CHAMP DE COQUELICOTS PRÈS DE GIVERNY *(Boston Museum of Fine Arts)*

As early as the Jeu de Paume *Coquelicots* we find a characteristic example of this voluminous *and* dynamic surface: the tall grass is stirred by the wind which the two women's fluttering scarves so clearly indicate. How does Monet manage to free the red spots from their fixity?—how does he keep them from seeming to be painted on the ground?

By a discrepancy of scale: considered at close range, these corollas which grow smaller and closer together as they recede from us are much too large compared to

the heads of the women and children. It is this double distance which allows the surface to be double, the flowers to stir toward us, outward at the tips of their slender stems.

Later on this discrepancy will become one of Monet's favorite methods: the characteristic detail of the substance considerably enlarged in relation to the surface it defines. For example, a comparison of the Metropolitan's *Falaise d'Etretat* with Mr. Seitz's photograph of the same site reveals the enormous enlargement the painter has made of the chalk striae. In the same way, grass will have giant stems, straw in its ricks the diameter of little logs.

Division of tone sometimes allows Monet to achieve a dynamic analysis of the voluminous surface. Thus in Boston's *Champ de Coquelicots* the red and green spots which at a distance melt into dark brown are not in the least imitative of the shapes of flowers and their leaves, but because we must interpret the red as that of the petals and the green as that of the background against which they stand out, we have the impression of seeing red in front of green. Since these are complementary colors, and hence extremely active in relation to each other, clashing at close range, merging at a distance into a third very different color, the link between these two planes, or more precisely between this red superficies and its own green depth, will be experienced as a veritable growth.

LA CATHÉDRALE DE ROUEN *(Musée du Jeu de Paume,*
Boston Museum of Fine Arts, etc.)

That disappearance of "drawing" which we noticed in the Boston *Coquelicots* ultimately gives the canvas an authentic power of repulsion. The brush strokes of the young Monet, so remarkable, so lively, so varied, will give way for a time to a kind of roughened substance in which all his individuality vanishes. Monet never carried this further than in the Rouen cathedral series.

The principle of the *series* is the development in an indefinite number of canvases of the duplication we have encountered in the *Régates* and in many other works. Each member in the series can play for any of the others the role which the upper part of the canvas there played for the lower, the reciprocal animation of surfaces thereby reaching its maximum.

In the cathedral series, almost all the canvases sight the façade obliquely, and though some show it from the front, these do not form a separate group. This is because the obliquity in the majority is already countered by the absolute unity of substance, by the fact that what is close to us, according to the composition decided on, involves no more detail than what is far away.

At close range, "drawing" and brush strokes dissolve to such a degree that we can no longer even discern the limit between stone and sky, between a dark zone and a pale one. We have the impression of standing in front of plaster, or cement, in front of the shell of a building being constructed or demolished, exposed, naked, indecent, before being clothed by all the woodwork, the hangings, the wallpaper habitual to the period, or after they have been torn away.

The surface of the canvas here denounces the surface of the wall on which it is hung and which in most cases it helps to mask.

Now it is out of what we might call this insolent substance that a monument is constructed before the eyes of the fortunate owner, a monument he is meant to consider quite superior to the building he inhabits.

What first attracted Monet to the façade of Rouen cathedral is its remarkable density—its bulges and hollows—but what keeps him there is the fact that these optical characteristics sustain a meaning in which everything the cathedral represents is involved.

It is a sacred object which invades the profane apartment, which repulses and judges it. The cathedral is cut in such a way as to leap out of the frame at the top and on the right, extending indefinitely; and in the oblique versions, a kind of swinging of shutters occurs, for the obliquity vanishes as soon as we approach, only to reappear when we back away.

We know we can rediscover the plasterlike mural substance—which is no longer a *represented* substance, which is an entirely different kind of *trompe-l'oeil*, which is the substance of the denatured painting—if we visit the cathedral itself and get close enough to it; between this known object, the cathedral, with its masonry substance which we can remember, and this denatured painting, this housepainter's painting which echoes it, will be located (and contained) all the usual intermediaries. At a certain distance, the impression of *painting* returns, a little farther back, or a little later, the substance of the general surface of the façade, its hollowed and bulging aspect, a texture quite different from the one we are accustomed to in building-stone; and from this latter substance will emanate all kinds of imaginary substance, from it the gold will stream, the silver gush, the sky will fall.

Monet attributes to the architect of the Rouen façade an intention comparable to his own; he too has achieved a surface by whose mediation a revelation is produced, a surface which in the profane as in the most religious sense will make the heavens flow into the very heart of the city, flow, founder, roar—those heavens which then stand revealed in gold, in lightning, in darkness, in ice.

LES NYMPHÉAS *(Orangerie, Paris)*

It is to an intention of this kind that *Les Nymphéas* corresponds, that monument to peace created in the midst of war. Far from capturing a chance effect met with on some walk or *hunt*, Monet deliberately altered the course of the Epte to form a small pond. Work *"sur le motif"* is still very apparent in the first paintings of the series, those of 1898, but there is no longer a trace of it in the decoration of the Orangerie.

At the time, Monet was going almost blind, suffering from a double cataract and from difficulties in the perception of color. In several astonishing canvases painted just before his operation, the tints are entirely *invented*. Even after recovering the use of his eyes, he could no longer trust them; working at times with numbered tubes, he was to rely more on what he knew of the pigments than on his *impressions*.

The Orangerie's *Nymphéas* is an altogether constructed work; the real pond is no longer there as a model (or as an alibi), but as a *master*. Listen to the painter:

> If I remained insensitive to the subtleties and modulations of color seen at close range, nonetheless my eyes did not deceive me when I stepped back and considered the subject in large masses, and this was my point of departure for new compositions. A modest point of departure, to tell the truth, for I mistrusted myself and wanted to leave nothing to chance. Slowly I tested my powers in countless rough sketches which at first convinced me that the study of natural light was permanently forbidden, but reassured me, too, by proving that if my color-diversions and landscapes were no longer my specialty, I still saw as clearly as ever when it came to bright tones isolated in a mass of dark ones.
>
> How could I turn this to good advantage?
>
> Gradually my intentions took shape. Since the age of sixty I had always meant to devote myself to a sort of "synthesis" in each of the categories of subjects which in turn had attracted me; I planned to return in one painting or on some occasions in two to my earlier impressions and sensations. Now I had given this up, for I would have had to travel far and wide, review one by one all the stages of my life as a painter and examine my emotions of long ago. I decided while I was doing my rough sketches that a series of general impressions, recorded at the time when my eyesight had the best chance of being exact, would have an interest. I waited until the idea had taken flesh, and the arrangement and composition of the subjects had of their own accord gradually etched themselves in my brain, and on the day when I felt I had enough trumps in my hand to try my chances with real hope of success I resolved to act, and I did.

Cosa mentale.

It does not occur to Monet to stand in front of his pond in order to reproduce his already conceived composition—he calls in a contractor to build him a new studio:

> blind walls with no opening except the door; glass panes in two-thirds of the roof . . .

The war halts the construction of this cell, but the painter achieves its equivalent in his old studio by having wheeled easels made which allow him to surround himself entirely with his work-in-progress.

The water of the *Nymphéas* will save his sight. However remote he had been, all his life, from classical Fable, he was to rediscover it here in his title, spelled out hundreds of times over by the flowers; they are the divinities of the springs to whom he prays.

No longer able to trust himself sufficiently with color, he marks out the different elements of the canvas by a whole vocabulary of brush strokes. In this respect, the *Nymphéas* is indeed a recapitulation of his entire *oeuvre*, but on a monumental scale. He works with calculated contrasts of tones whose properties he has already tested, all the details which might escape him now having to function as *fleeting effects* subordinated to the general composition.

Great hairy filaments of reeds and waterside rushes, woolly verticals of tree trunks in the second room; tiny vertical filaments of willow branches; surfaces clogged with inverted clouds, longer or shorter, more or less animated horizontals of the water's surface; great enveloping flourishes for the lily pads with brilliant splotches for their flowers.

The raising of the horizon, already so marked in the past, is now absolute—the sky or the distance appear only in their inversion, and the surface of the water tips up toward the vertical all around us, inspiring dreams of flying or diving.

The trees in the second room repel us by the obvious unreality of their woolly substance—they are said to be painted "like a stage set," that is, like something which should be viewed from far away, from farther away than is possible here—while the water's surface imperturbably advances toward us from a distance impossible to specify, the perspective groupings occurring among the flowers remaining unstable, if only because of the curve of the wall; and balancing this repulsion is the enveloping welcome of the entire elliptical liquid extent, gathering us in on all sides, making those trees shift behind us in an incessant movement.

So we fall gently into the sky, and the waters of the sky stream over us.

Monet has kept only a few indications of ordinary landscape; the waters take

them, stir them to life, discover in them thousands of properties, but all this can happen only because there is already something which defines the canvas as a voluminous mirror, germinating and blossoming, because there are the water lilies, starting from which everything becomes legible.

In the real pond at Giverny, the world's aspect would be reflected even if the flowers had not been there; but in the work, the figuration appears only by means of their presence. They are the nymphs of the springs which come into the city's very heart to make us turn upside down.

1976

Translated from the French by Joan Templeton and Richard Howard

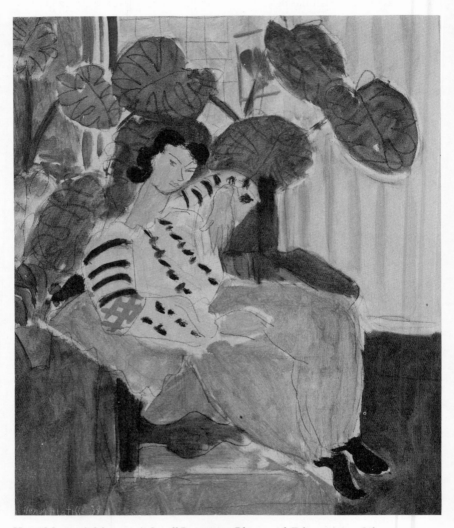

Henri Matisse (1869–1954): *Small Rumanian Blouse with Foliage*, 1937. Oil on canvas, 18⅛″ × 15″ (46.1 cm × 38.1 cm). The Baltimore Museum of Art: The Cone Collection, formed by Dr. Claribel Cone and Miss Etta Cone of Baltimore, Maryland. BMA 1950.262.

Matisse

One was quite certain that for a long part of his being one being living he had been trying to be certain that he was wrong in doing what he was doing and then when he could not come to be certain that he had been wrong in doing what he had been doing, when he had completely convinced himself that he would not come to be certain that he had been wrong in doing what he had been doing he was really certain then that he was a great one and he certainly was a great one. Certainly every one could be certain of this thing that this one is a great one.

Some said of him, when anybody believed in him they did not then believe in any other one. Certainly some said this of him.

He certainly very clearly expressed something. Some said that he did not clearly express anything. Some were certain that he expressed something very clearly and some of such of them said that he would have been a greater one if he had not been one so clearly expressing what he was expressing. Some said he was not clearly expressing what he was expressing and some of such of them said that the greatness of struggling which was not clear expression made of him one being a completely great one.

Some said of him that he was greatly expressing something struggling. Some said of him that he was not greatly expressing something struggling.

He certainly was clearly expressing something, certainly sometime any one might come to know that of him. Very many did come to know it of him that he was clearly expressing what he was expressing. He was a great one. Any one might come to know that of him. Very many did come to know that of him. Some who came to know that of him, that he was a great one, that he was clearly expressing

something, came then to be certain that he was not greatly expressing something being struggling. Certainly he was expressing something being struggling. Any one could be certain that he was expressing something being struggling. Some were certain that he was greatly expressing this thing. Some were certain that he was not greatly expressing this thing. Every one could come to be certain that he was a great man. Any one could come to be certain that he was clearly expressing something.

Some certainly were wanting to be needing to be doing what he was doing, that is clearly expressing something. Certainly they were willing to be wanting to be a great one. They were, that is some of them, were not wanting to be needing expressing anything being struggling. And certainly he was one not greatly expressing something being struggling, he was a great one, he was clearly expressing something. Some were wanting to be doing what he was doing, that is clearly expressing something. Very many were doing what he was doing, not greatly expressing something being struggling. Very many were wanting to be doing what he was doing were not wanting to be expressing anything being struggling.

There were very many wanting to be doing what he was doing that is to be one clearly expressing something. He was certainly a great man, any one could be really certain of this thing, every one could be certain of this thing. There were very many who were wanting to be ones doing what he was doing that is to be ones clearly expressing something and then very many of them were not wanting to be being ones doing that thing, that is clearly expressing something, they wanted to be ones expressing something being struggling, something being going to be some other thing, something being going to be something some one sometime would be clearly expressing and that would be something that would be a thing then that would then be greatly expressing some other thing than that thing, certainly very many were then not wanting to be doing what this one was doing clearly expressing something and some of them had been ones wanting to be doing that thing wanting to be ones clearly expressing something. Some were wanting to be ones doing what this one was doing wanted to be ones clearly expressing something. Some of such of them were ones certainly clearly expressing something, that was in them a thing not really interesting then any other one. Some of such of them went on being all their living ones wanting to be clearly expressing something and some of them were clearly expressing something.

This one was one very many were knowing some and very many were glad to meet him, very many sometimes listened to him, some listened to him very often, there were some who listened to him, and he talked then and he told them then that certainly he had been one suffering and he was then being one trying to be certain

that he was wrong in doing what he was doing and he had come then to be certain that he never would be certain that he was doing what it was wrong for him to be doing then and he was suffering then and he was certain that he would be one doing what he was doing and he was certain that he should be one doing what he was doing and he was certain that he would always be one suffering and this then made him certain this, that he would always be one being suffering, this made him certain that he was expressing something being struggling and certainly very many were quite certain that he was greatly expressing something being struggling. This one was knowing some who were listening to him and he was telling very often about being one suffering and this was not a dreary thing to any one hearing that then, it was not a saddening thing to any one hearing it again and again, to some it was quite an interesting thing hearing it again and again, to some it was an exciting thing hearing it again and again, some knowing this one and being certain that this one was a great man and was one clearly expressing something were ones hearing this one telling about being one being living were hearing this one telling this thing again and again. Some who were ones knowing this one and were ones certain that this one was one who was clearly telling something, was a great man, were not listening very often to this one telling again and again about being one being living. Certainly some who were certain that this one was a great man and one clearly expressing something and greatly expressing something being struggling were listening to this one telling about being living telling about this again and again and again. Certainly very many knowing this one and being certain that this one was a great man and that this one was clearly telling something were not listening to this one telling about being living, were not listening to this one telling this again and again.

This one was certainly a great man, this one was certainly clearly expressing something. Some were certain that this one was clearly expressing something being struggling, some were certain that this one was not greatly expressing something being struggling.

Very many were not listening again and again to this one telling about being one being living. Some were listening again and again to this one telling about this one being one being in living.

Some were certainly wanting to be doing what this one was doing that is were wanting to be ones clearly expressing something. Some of such of them did not go on in being ones wanting to be doing what this one was doing that is in being ones clearly expressing something. Some went on being ones wanting to be doing what this one was doing that is, being ones clearly expressing something. Certainly this one was one who was a great man. Any one could be certain of this thing. Every one

would come to be certain of this thing. This one was one certainly clearly express-
ing something. Any one could come to be certain of this thing. Every one would
come to be certain of this thing. This one was one, some were quite certain, one
greatly expressing something being struggling. This one was one, some were quite
certain, one not greatly expressing something being struggling.

1912

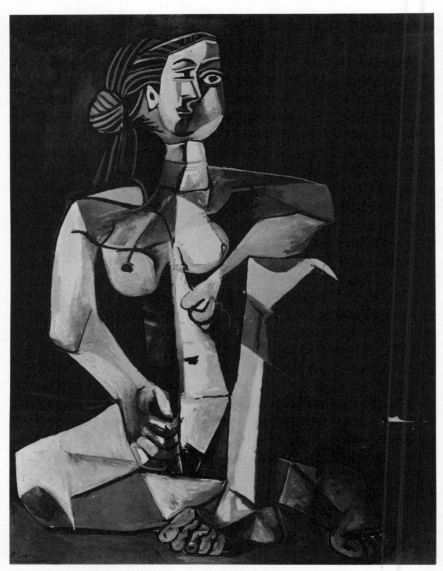

Pablo Picasso: *Seated Woman*, 1953. Oil on canvas, 51¼″ × 37¾″ (130. 2 cm × 95.9 cm). The Saint Louis Art Museum. Gift of Joseph Pulitzer, Jr.

An Eye on Picasso

For the last fifty years (if one is to take as his point of departure *Les Demoiselles d'A-vignon*) Picasso has used his brush like a sword, disemboweling an eye to plaster it over the ear, lopping off a breast in order to turn it behind an arm, scoring the nostrils of his ladies until they took on the violent necessities of those twin holes of life and death, the vagina and the anus. Up and down the world of appearances he has marched, sacking and pillaging and tearing and slashing, a modern-day Cortés conquering an empire of appearances. It is possible that there has never been a painter who will leave the intimate objects of the world so altered by the swath of his work. The institutional world, the monumental world, the world of skyscrapers and glass-walled banks, of public gardens and functional architecture belong (at their best) to Mondrian, the Bauhaus, and Corbusier. Picasso's conquests range through the constellation of small objects, through ash trays and lamps and crockery and textile designs and the oncoming tendency of women's fashions (swollen bellies, padded hips, lopsided breasts), through green eye make-up and silver nail polish, Greenwich Village jewelry and custom-made peasant shoes with laces on a diagonal, through homosexual haircuts, the coiffures of East Side poodles, and the chromium swaths and steel crimps of the American automobile.

But of course these influences are the superficial victories which come to mind, the sensuous fertilization of those objects and creatures which lend themselves to the sensuous. More profound is a conquest of form so complete that all modern painting including the relative emancipation from form of such artists as Hofmann and Pollock derive from his Napoleonic marches. He is the first painter to bridge the animate and the inanimate, to recover the infantile eye which cannot

distinguish between a pitcher and a bird, a face and a plant, or indeed a penis and a nose, a toe and a breast. Tearing through all obsidian flats of surface, the gargantuan anomalies of his figures return us to the mysteries of form. Picasso is the monomaniac of form, showing us a figure which is the proliferation of the breast, the eye as breast, the nose as breast, the chin, and the head, the shoulders, knees, belly, and toes as a harem garden of breasts—or equally a cornucopia of fecal forms, of genitalia, of buttocks, or conversely—for this is the other half of the demonstration—he will reconstruct the topologies of our flesh in geometric cells, until a triangle or a rhomboid will prove his case. Here is a face, he says to us, I have given it the form of the letter W, I have placed a triangle for one eye, ignored the nose, compounded a prism of triangles for the mouth, made facets of the neck, and drawn angles for the breasts, and yet it is a person, this one breathes, she has character, a most refractory and stubborn character, but she is there, a lady of triangles, and if the triangle is equal to conveying the mystery of the human figure, then the triangle is a mystery as well, Q.E.D.

For he is also saying that exploration is circular, it moves along the route of the association, and so any exploration of reality must travel not from object to object but from relation to relation. In this sense he is the modern creator of the visual symbol, the father of all advertising art. The symbol is the flag of the empires he has cut out for himself, the symbol is the visual presentation of a nonvisual chain of relations. Picasso's guitar is hips, a waist, and the breast; it is a torso, it is woman; it is an hourglass; it is time; it is sound; it is two opposed waves ∞; it is the curve of two lovers in the act, it is the act, it is creation.

But of course it is none of these things unless we give to it the links of consciousness, unless we choose to adopt the guitar as a symbol for some all but unperceived relations of sex and time and sound and creation, and in doing so we have done no more than disembowel a Picassan eye, collide infinities against one another in order to leave the corpse of a psychopathic joke, since it is undoubtedly the enthusiasms of the moment rather than an intrinsic and continuing relation which has been attached to the symbol.

So the painter as warrior is conversely an infant, never too long alienated from that other universe out of which he was born—conquistador, warrior, lover, wrestler, the artist as infant is forever learning and relapsing, distinguishing the eye from the ear only to sink back into that ocean of equivalents where an open mouth and a windowpane are interchangeable, and light and sound collide at the edge of the skin.

1959

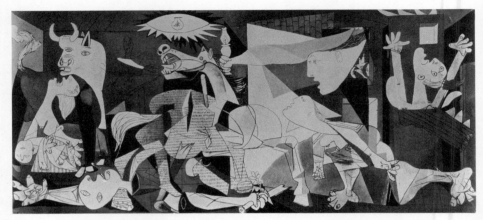

Pablo Picasso: *Guernica*, 1937. Oil on canvas, 11′5½″ × 25′5¾″. The Prado Museum, Madrid. Photo: Giraudon/Art Resource, New York. SPADEM/ARS.

Picasso

Picasso—but you know it better than I: on this page and at this moment, your name quite simply in its rightful place—as it is now.

For Picasso, in the dawn of this century, raised his standard *urbi* and *orbi* (*urbi* was Paris, the balcony in Montmartre, *orbi* our entire world). It is surely his name that will remain throughout the centuries as the flag of ours.

This is also why, at the commencement of this text, I have had to plant this name like an oriflamme at the head of a pike, of an intellectual offensive in which, when my eyes received the revelation of this phenomenon in 1920 or thereabouts, I was at best a persevering sapper. The world was effectively seized at that time. Today, however, it is some thirty years since the regular progression of Time's revolving sidewalks promoted me to the surface and its works. Of necessity my first gesture, at the top left of the first white page on my work table, has been to firmly draw from top to bottom that vertical line which mimics the planting in earth of a pikestaff. Forming immediately at its head is the brief flag of the second stroke, which is to float held taut by the wind over the summits of the conqueror, the victorious invader sweeping all before him, at times for the fun of it. He has outdone Genghis Khan in circling the world many times, always returning (in order to immediately start out again) to his point of departure, France, to check the gallop of his mount. This pennon also flies tautly from its staff, from left to right.

At that time the "starting-post" of my text was driven into the ground, marked in an even more signal manner than by the aforesaid pennon of the initial letter, was immediately redoubled below by the starting line itself—and then magically tricolored by the three syllables of the name: those three pure syllables, "pure" de-

scribing syllables of one vowel only, vowels colored here by values (i, a, o) as boldly diverse as can be.

And so the point of departure of the text was, from the point *of view* of the writing as such, decided. The most important thing was done. There was nothing more than to wait for the starter's resonant signal, for the writing to be under way. But there was no waiting. Meaning was instantaneous in the cerebellum of the three colored syllables: immediately the go-ahead was given, the series of signals begun.

What could be more piercing, more percussive, than the rapid-fire sounding of these three syllables? They ring out, well heard and understood, like the sharp call of that trumpet, the Catalonian *tenora*, which gives the Sardana its flavor.

But let's return here, in time as in space. Let's evoke instead another phenomenon of sound, perceived very often at Mougins as well as where I live, by reason of the proximity of the Italian border. Our three colored syllables are blared out by its means even better than by the *tenora*, and much more categorically. I speak of those three horn blasts let out by impatient young motorists of which it's said, in one of those catalogues which we all receive quite regularly: "Of a tonality deep yet shrill, powerful, they signal far ahead your arrival at the intersection; strident, so as to dominate your surroundings and be heard even by the big trucks. Their instantaneous resonant intensity startles and asserts your presence on the road. They are as loud as the law permits." Let us say, of the proboscidian sirens of Picasso, most often under a harlequin's tricorne, that they constantly infringe the regulations, exceed the limit every time.

Very far from having said all about the *one first word* imposed on me by a force (or person) stronger than myself, I will nonetheless stop here. I take it that I have sufficiently alerted the very great majority of my readers whose eyes opened on the world later than mine. A world very much altered, besides, by the chain reaction set off by Picasso, the unprecedented echo for those who were contemporaries of the event, the effect of a radical, stupefying, dynamic, atomizing and galvanizing break with the past of the meteor, the phenomenon in question.

If, to resume from the beginning our gallop, we should ask what that mysterious authority is that rules us *both*, here is what I would say to Picasso:

To have been able, after so much and so many, to write of you, if it was more than I could not do in only one way: by the act of your name immediately driven, planted in the mind of the reader by the telecommand of my right hand—it was that thus, one more time (and doubtless you better than anyone understand it, since thus—have you not told us?—Painting signed itself), that power much

stronger than myself was manifested of Writing, the immortal Deity that makes me do its will, that does with me as it will.

We are each of us at the power of an Immortal who, having conceived us (in the mortal breast of our mother) in the act of love with that other mortal, our father (we know it well, do we not, that man and the immortal have loved each other. To Don José Ruiz, as to my father, we have known well, even before receiving it as they gave it to us, the *alternative*), will one day take us from our mother's lap—at whichever period of our childhood suits it—to make us come into the world. Yes, but what world if not that which is meet for its children—that mythic world interposed between gods and men where, doomed like these last to die, we find ourselves endowed with a Divine Power which we are enjoined to employ constantly in a series of prodigious labors, in the service of the fabulous memory where we will live since we are destined there, yet which, throughout our mortal lives, is as strong as it is disquieting, disquieting as it is puissant. Of this inquietude, we know from Paulhan himself how Braque answered him one day when goaded on the subject of Picasso. "*He* refuses himself nothing. He paints in every style. What talent, what boldness!" And Braque: "What saves him is that he's troubled. The only vicious horses are those who don't sweat, as any jockey knows." Apropos of this inquietude, look at the expression of the eyes in nearly all the photographs taken of Picasso as he stands by a recent masterpiece.

When I speak of prodigious labors, of course, the present one to which *hic et nunc*, I address myself, is one of them—and will, by that fact, appear *ugly* to you. But apropos of the *ugly* (and of Picasso), here are two quotations. Here's the first (from an extremely amusing and remarkable lampoon by Dali, in that it bears witness to the relative proximity in loftiness of view of the two geniuses, but at the same time to a certain slight inferiority of one—by "slight" you will doubtless have understood which—to the other): "What an anarchist Picasso is. Having half poniarded Bouguereau, he gave him the *puntilla* and at a single blow achieved modern art, making it uglier by himself in one day than all others combined in several years. . . . Thank you, Pablo! . . . In a matter of weeks you have attained the limits and the ultimate consequences of the abominable. And this, as Nietzsche would have wished, by leaving your blood on everything. There remains nothing for us but to turn our eyes once more to Raphael" [*sic*].

But here, just as candid but infinitely more touching and serious, is the second quotation, a statement by Picasso himself as reported by Gertrude Stein:

"He who creates a thing is forced to make it ugly. In the effort of creation one fights, and the result invariably is a certain ugliness. Those who follow, with time

and distance for judgement, will do better" (a marvellous modesty here, or a significative mistake in Gertrude Stein's transcription) "and will please more, because they do not have to fight, they know what they are doing, where they are going, the thing having already been created"

To these two quotations, let us add this statement of Braque's about his first "glued papers" (collages):

"How could I make a mistake? I didn't know what I wanted." And again: "I have always been compelled by something stronger than myself. I have taken what came to hand."

As a second and last example of the imbrication of our work, each treading in the other's footsteps, here is what I wrote one day, also about another painter friend (Fautrier):

"We know nothing or very little of the processes of Nature, directing the artistic operation. We nonetheless observe. . . ."

Cf. Picasso, quoted by Brassaï: "Doubtless there will one day exist a science . . . which will seek to penetrate further into man through the creative man. I often think of that science, and am resolved to leave posterity with as complete a documentation as possible. . . . That is why I date all that I do."

To speak thus is to show as much modesty as courage, as much lucidity as ambition. It is in fact to show oneself rather a "materialist," to conceive of oneself simply as an organism like another, a "phenomenon" of Nature, like another, to proclaim, accept and wish oneself as such.

And, no doubt, this admission, this clear view of our dependence is our one chance of surpassing this condition, of bypassing it. I am thus able to imagine Picasso as a sort of Sisyphus, but one capable of pushing his rock so that it doesn't fall back, of pushing it to the top where the other horizon is revealed and the rock rolls down the other side, the Hero rid of it rejoicing, upright on the highest peak of the world, in his victory. Doubtless this is what Picasso understood when, towards the summer of 1906, already exercised by and so to speak "big" with the *Demoiselles d'Avignon*, he exclaimed, in an equally dramatic renewal of the legendary "Eureka!":

"A tenor that reached a higher pitch than that inscribed on the wall: 'Me!' "

The wall already written is, evidently, all of nature such as ancient culture allowed us to see it. It is all the museums of all human cultures—not only the universal art museum and library but all the museums of man, all the archaeological collections, all the museums of natural history, all the zoos, all that which Picasso, who has read and seen it all, has shown himself *solely* able to digest, to reproduce and re-create to his own taste, with no trace of the university or erudition, for his

"Bon Plaisir," in the "Gai Savoir" of Nietzsche or, finally, in what I call the "Ob-joy": i.e., the orgasm achieved by any system of signs which has, by a mad redou-bling of the textual grasp, reached its Seventh Heaven, the *certain point* at which it signifies purely itself. That is the summit, attained each time he has passionately desired it, by Picasso.

Here, somewhat in the manner of a collage, also to break the *temporal* monotony of a text written, in some sense, from one end to the other, on the same day and then (despite certain essays in detail, in the sentence, in retro-narration) on the whole quasi-melodic, arabescoid, as if the pen had left neither my hand nor the note-book, it seems to me good—despite all the risks that this entails for my present "honor"—to cut out, from a rough draft written in 1945–47 at one sitting, unin-terruptedly, with enthusiasm, without the slightest remorse, with brusque jumps of tension, with airholes, imbecilities, grossnesses, improprieties, "whatever you want, it's there," to cut-out, then, entire passages and to rearrange them, *changing nothing*, interspersing them with paragraphs written by my hand and in my ink to-day.

Only, if there is such a one, the particularly alert reader will detect, all too easily, the texts of one and the other period. But I hope that the uninitiated majority will find here only some of my own pleasure, despite a certain shame at times and a de-sire perhaps for self-punishment? I hope simply that neither one nor the other reader will find himself, at any time, ready to give up this text with a curse.

Here (it starts from here).

The air is pure, the road wide, the sun floods the sky. In a brand-new town, the mul-ticolored laundry rumples and snaps in the rising wind. Each object revives and proclaims its positive virtue.

Automobiles, small fry aviation, bodies of wood or iron take the road, take the air.

Steel and copper, horns and sirens resonate. It is morning in the twentieth cen-tury.

At this moment, a great flag is unfurled on which, in pure and dazzling colors, a simple emblem that is question and answer has taken shape.

And everything begins to move forward.

Man has appeared.

It is a painting by Picasso.

Everything is there: the prehistoric, the ancient, the old, the baroque, the classical, the romantic. All the reasons for man are present.

The world is complete. All is new, rejuvenated.

It is civilization.

It is youth.

Picasso, Stravinsky, James Joyce: they are of the twentieth century. By them the twentieth century appeared, owing everything to previous centuries, owing nothing to anyone.

In the twentieth century, the mirrors burst in pieces.

Blinding lights in the streets. Ragtime and cocktails.

There was no shade except that brought by negroes. A beautiful shadow, that of the melancholy depths of the negro race (negro art, negro spirituals). Very quickly, in fact, this what I shall call a beautiful destruction in broad daylight turned baroque. Melody, the melodic line, the melodic worm reappeared. Sorrow reinstated the scene: subjectivity.

But Picasso, who takes all into account, is thus one of the most brilliant proofs of man's power.

So much money that it was funny. Insolent good fortune. Picasso thumbed his nose at the Fine Arts, Fortune and Fame. Triumph of our coterie.

The hatefulness, then, of seeing merchants in power went for nothing.

But since he is the perfect type of the gangster, he lives like an Andalusian peasant. His family, his Spanish clientele. Vulgar pigeons, chiens de luxe flying and running about his apartment.

Each painting by Picasso is a new flag for the intellectual offensive. We'd decided not to let ourselves be romanced any longer by the sempiternal song which our eyes and established tradition sang to us: teach us about nature. To mix things up. As in a kaleidoscope or cocktail shaker. To do by fits and starts, by fooling around, what we could to change things.

Analogy of the paintings of Picasso and the trituration of language (of languages) and logical time by Joyce.

Suppose for an instant that Picasso stopped producing, I noted a few weeks ago. Where would we be?

It would be like a window closed forever. Like an ended session of diversities. Like a circus leaving town. Like a kaleidoscope abandoned in a corner, which no longer works.

Everything would be still once more. Without interest or surprise. Colors would slowly fade, forms erode, collapse, wear away.

We would await the new magician who would put everything in motion again. But we would await in vain.

It is our good luck to live in a time in which one man, the greatest scene-shifter imaginable, modifies appearance at each moment. With a flick of his thumb he makes the universe vary.

At intervals, we open our eyes. All is changed. Not destroyed: arranged otherwise. And each time we enter this new world with a new enthusiasm. A new morning. As fresh, juvenile, indubitable as yesterday's. As deserving of our joy and our energy, of our joy in living, of our breath.

It must also be said: he is the best man (and the worst demon) there is: his particular, differential quality is to bring together in himself *all* the possible and conceivable qualities and of course (if one wishes) all the defects, transformed in him, so perfect are they, into qualities (negative). *All the qualities* and then one: that of possessing them all. For a phenomenon like Picasso, quantity and quality are no longer incompatible. I have never, myself, had anything from him other than his friendship: a kind of tender, fierce familiarity—and have had from him only proofs of his generosity, his affectionate spontaneity. When he failed me (as the phrase is) five or six times, how could I hold it against him, since it was out of kindness for others? For instance, for Eluard, who blanched ("He turned green," our colorist informed me over the phone) when he learned that Picasso had sent Resnais' assistant to me because he wished for *me* to write the narration of his film on *Guernica*. Picasso had phoned me about it two or three days earlier, the assistant had come and we had begun work. Then this second call: "You understand, I could not do it to him. I'd forgotten his poem! We will do something else together." Another time it was Sabartes who must have turned color when, in connection with a volume of reproductions about whose preface Reverdy had made difficulties which the publisher found ridiculous, Picasso immediately designated me. Mourlot and I came to an agreement, but Sabartes . . . but of course, Sabartes, his factotum since they were young, who saw him every day: how could he not understand?

I might mention several other incidents of this genre, one quite recent. But I have known many such lucid and generous impulses in him.

It is known that he excelled in such gestures. As Racan wrote of Malherbe, what he said carried, all his acts were decisive and even, in a way, magical. I will record only two here: a word, a gesture the first time he met me and then kept me with him several hours. I had heard that he'd read my little book *The Parti Pris of Things*, published in Paris in 1942, with sufficient interest to desire to know me. But I did not return to Paris until after the Liberation (just after: the end of 1944). I asked Paul (Eluard) at the time to introduce us. It was at the Grenier des Grands Augustins. As soon as he looked at me (inadequate: from the first split-second-glance) he exclaimed in the liveliest, warmest way: "But we belong to the same family! I have cousins who resemble you trait for trait." Nothing better calculated to break the ice, as one says: but among cousins (Mediterranean) there was no ice to break: melted at the first glance of recognition. It was like a father recognizing his twenty-year-old son among a thousand others (I was then forty-five) after twenty years of separation. From that time I had only those marks of affection, spontaneous and sometimes biased, that I have spoken of.

Picasso kept us there, and we all went downstairs to eat at the old "Catalan." The three of us sat at a table near the door, facing the zinc bar. Others were there: Dora Maar, Nusch, Fenosa, Cocteau and someone else: G. Hugnet (perhaps). Cocteau: not at all brilliant then but humble, contrite, effaced, withered, sinister-looking. He had a good deal to be forgiven for, his "resistance" against the "Occupation" not having been, it was said, particularly intransigent. Before long I had a very bad headache. When I said so, Picasso immediately left the people sitting on either side of him (Nusch and Dora Maar), made me take an aspirin at the bar and walked me outside, saying that some fresh air would do me good. But the air was more cold than fresh. He immediately changed his mind, went back inside the little restaurant, got his own hat from the coatstand, came out and put it on me like a crown.

Believe this if you like—the aspirin had certainly not had time to act (with me it takes nearly fifteen minutes)—but wearing the old hat of the old artisan, in two minutes I was cured, my migraine instantly dissipated. Picasso himself laughed. We rejoined our abandoned table companions, who hadn't stopped talking. No more anecdotes.

All those, innumerable, who speak, write, sing or paint without creating and into whose timid (?—but I know what I mean) jabbering it requires much good will— and spare time—to enter; all the explicators, the propositioners, the critics, the analyzers, the men of hypotheses, the story tellers (except for a few), the reviewers, novelists, journalists—and I almost forgot the poets—all those who propose to themselves and us their thought, i.e., nothing, a progress of larvae in the ooze, an

inconsistent marsh, lyric poets or other fantasists, surrealists, intimists or others, all those who praise silence in many words, who take an airing towards the exit from the world, crayon in hand, they will all come one day, of course, to reproach the creator for creating. They will reproach him for his assurance, his pride, his insolence, his incontinence, his flippancy, his virtuosity, his tours de force of cards or strings, his equilibrium on the tightrope, his authority: they will reproach him for his defiance of pontiffs and the Creator—with a capital C—himself, for his masterful boxing of the Creation's ears (who turned all colors and saw stars)—and if they are obliged in fact to consider him finally as God himself, they will reproach him then for not being only God, for having needed to create things, for not having known to content himself with primeval nothingness. It is as Groethuysen made Master Eckhart say:

> So great was its love (of the soul for God, placing no difference between) that it suffered to see him God and wished to see him super-God. Jealous of things, it wanted God for itself, the God of the soul and not that which had placed the world between them. My distress is great, said the soul. Nothing was created . . . and you uttered the world. . . . I was the creature then, you the creator. And you loved me. But sometimes I said: if he loves me why has he created me and given me a name as if I were this soul and not another? Why is he the God of a world in which I must coexist with all things, and why am I in this world, I who was a soul before any world? And the soul answered: You are God, you are spirit, you are that of which it is said: it is, and I suffered to see you God, I wanted to see you nothing. The stone is stone, the bird is bird: what are you other than the bird and the stone, being a thing? . . . Then you created the world, but it was useless creating worlds and worlds. Will you ever be other than yourself, the God of creatures, of your creatures which make you God and from whom you implore love, revealing yourself to them so that they will say: I love you. . . . The soul wished to be no more. It sought its death and the annihilation of all things.
>
> The soul perceived that through love of God it could love God no longer, that God had been its great temptation. But deep within itself it preserved its nothingness, which no creature nor even God had penetrated. There, *it was alone* [my emphasis] and *everything become image was swallowed up in it*. There it was poor, and deprived of everything: and all was simple and one.

This is without doubt a fine page, a trifle long perhaps. So many words in praise of silence! Truly, a perfection (in its genre). I would like to have quoted all of it.

We, however, have no desire for things to become images. We aren't jealous of them. We have freed ourselves from any inferiority complex vis-à-vis the things of the world, since we may create other things. On the contrary, we love them, they ravish us, we thank them for bringing us out of our nothingness. We see ourselves as one of them. But on the other hand, as equals of the so-called God who created them all. God is a materialist because he wished to create things (and not im-ages)—and we are materialists too. We know the joy of diversity, if we refuse the mystic joy of unity born of fear, of trembling before death.

If we do know disquiet, it is the disquiet of creation, of work, of the creative power. It is that of unwillingness to let escape the possibility of creating again and again a new thing. It is that of a plethora of choices.

From it we adhere to our successive desires, born of very strong emotions, no doubt, born themselves most often of an encounter. But the desire for expression according to our vision of the object (being or thing) is immediately thwarted by the commandments or caprices of our method itself: drawing, painting, writing: all grows complicated, and we are led to some unexpected result (obtained sometimes in the accomplishment of another project undertaken at the same time) in which we nonetheless recognize with certainty the jubilation of our language itself.

Thanks to his exceptional gift of revealing at the first glance what is the simplest, noblest and most moving of the human eternal, in each human figure, face and attitude, of the animal eternal in each animal, of the eternal jug-ness in such and such a jug, Picasso achieves a sort of *abstraction embedded in our nervous system* which in him only is pathetic and appealing, in Braque only serene, and which is absent everywhere except in these two titans. There is, in every painting of Picasso, something like a grand fable, a depth of landscape, be this only the air and light (or shadow), that is worthy of a universal mythology.

This is so even in his cubist period. There is always a sort of narrative or genre scene or noble likeness which touches us in our moral being. In Braque there is, between the ordinary and the fatal, the same praiseworthy equilibrium as in Chardin.

In every painting by Picasso there is a ballet, a pantomime, an Elizabethan the-atrical scene.

But it is of immobility, of the mute, or rather, like writing itself, of mobility pre-pared for, i.e., to begin without guidance, whenever you please, at the chosen in-stant, according to the rhythm which suits us.

These are what we call *tableaux vivants*. But significant of feelings of an intensity, a mechanical precision and unprecedented aggressiveness, where everything starts up as when you aim for the bull's eye in a shooting gallery: there is a capital punishment, a drama automatic and deadly.

Merely rough sketches, perhaps, or simple schemata at times, but so successful that they are much closer to perfection than any perfection of labor and patience. No drudgery. Happy creation. Happy creations. Not to be, but to bes.

The plural infinitive.

"To err is human." And not only human, but divine. Witness these fumblings of Creation, these monsters, these innumerable sacrificed possibilities. . . . To live, to be, to create is to err.

Aside from immobility, nothingness (which we challenge, defy and detest) there is nothing but errors. Long live errors, then. The most serious, the most divine men are those who carry their errors to the extreme. Those whose pendulum has the deepest and widest swing. What is intelligence, imagination, the ability to hypothesize, genius (scientific and artistic), if not this?

It is simply a question of not giving as *truth* (of not making oneself so ridiculous) that which is nicely and usefully error. Definitively valuable as such. And should one be aware of its value that, certainly, is not ridiculous. It is rightful pride.

Nevertheless, there are valuable, positive errors, and others which are hardly so (or not at all).

What is necessary for them to be so? Firstly, that they go far, are well constituted, and that they carry all the weight of previous outmoded errors (or truths): that the pendulum be heavy with all this.

That is what Apollinaire meant when he said that Picasso is the heir, the inheritor of all the great artists. Yes: nothing of what the past has given us is absent in Picasso. He takes it all with him, in his movement (the "Life" of which Apollinaire speaks), and in an unexpected direction. He enlarges the sphere of knowledge. He has greatly extended the domain of art. . . .

Errare humanum est. . . . Amplitude and intensity. Picasso directs his swing at the four cardinal points.

And it's known that the pendulum, beyond a certain ("reasonable") amplitude in its movement, wobbles, strikes and startles the onlooker in very unexpected places, goes through magnificent arcs, torsions and deformations.

What is also necessary is that there be installed on the swing *someone* or *some-*

thing. Everyone knows that to send off an empty swing lacks interest. It is the reality of the exterior world that we send off on our swing. We photograph the object in its utmost amplitudes.

Errare humanum est . . . Divinum atque . . . and perhaps we should define the world as the errors of God. *Positive* errors and not (merely) defects. Variety.

Don Juanism, or feminine dissatisfaction (of the frigid woman)? Not at all. The ostentation of defects, thus transformed into qualities. End of the collage.

Since it was Picasso's wish to send up his last firework, the last *bouquet* of his work at Avignon in 1973, close to the station where in 1914 he left for the front with Braque (and Derain), it is with the period properly called heroic which ended then, of his work in conjunction with Braque, that I wish to conclude. Labors of Hercules. Cf. the heroism of Cézanne, cf. Mallarmé. "We were very close and concentrated then," Braque has said. Braque: rejected by the Salon d'Automne in 1908. As late as 1913, Picasso caused people to cancel their subscriptions to Apollinaire's *Soirées de Paris*, where some of his cubist drawings had been reproduced. "Cézanne was for us then like a mother who protects her children." (Picasso).

No trickery, no conclusion.

Reader, you have just heard, as you will have been able to, this *Toccata, variations and fugue without end to the Glory and on the Name of Picasso*, which I have had to cut short on August 7, 1973, at three p.m., for the needs of publication.

1976

Translated from the French by Lane Dunlop

Georges Braque: *Musical Forms (Fête and Journ)*, 1913. Oil, pencil and charcoal on canvas, 36¼″ × 23½″. Philadelphia Museum of Art, Louise and Walter Arensburg Collection.

EUGENIO MONTALE

A Visit to Braque

An "accelerated course" in French taste for tourists who are still in need of it ought to begin, in my opinion, with a visit to the *marché aux puces* and end with a visit to the studio of Georges Braque. On the one hand the odds and ends, coffee pots, cast-off rags, the secondhand goods, in short, produced by several centuries of a unified and centralized culture; on the other, the same objects interpenetrated and flattened out in compositions that have little to do with the well-known genre of the *nature morte*, although they deserve the name much more legitimately than, for example, those by Chardin or Cézanne, which are so much more alive.

Braque's work presents itself as a conglomeration, a *torrone* of old and exquisite objects. If the term "crepuscularism" had been invented in France instead of Italy, one could say that crepuscular poetry (the world under glass) had found its classical expression in France, in the work of Georges Braque.

Among the artists over seventy who still maintain the high prestige of French painting, Braque is the one whose reputation is most secure, who has the least to fear from the passing of time. A poll of the man in the street throughout the world would reveal that Picasso is much better known, but if one really examined the opinions expressed one would easily see that Picasso has as many detractors as admirers, while there is almost no one who knows Braque's work and does not express admiration or deference.

And French criticism lacks the proper terms of comparison in discussing him: as in the case of Corot, the name most frequently invoked is that of Mozart. Braque, it would seem, is not only *the painter*, the true painter, of the cubist team, but also the greatest expression of French genius in the last fifty years. It is to his cau-

tious and prudent instinct (as well as to the much less cautious instincts of Picasso, Matisse, and Rouault) that we owe—or are supposed to owe—that modern French painting, that new beauty "in the face of which even the painting of Renaissance Italy pales." (I quote verbatim from Jean Paulhan.)

These are not the views of isolated critics, but common opinions, widely held and widely accepted. Even those who continue to mistrust the spoiler Picasso and the other holy fathers of his generation bend the knee before Braque. And even those who admit that the Maestro's last works represent a standing-still or an *embourgeoisement* hasten to concede that for Braque everything is permitted, and that a Braque nodding is worth a whole generation of other painters awake.

But to see Braque, to talk with him or at least listen to him talk? In Paris, everyone was agreed that this was an impossible enterprise. Only old friends and a few important dealers, trailing several millions of dollars behind them, could cross the threshold of his studio. Everyone else was supposedly turned away by the immortal Marietta, a *femme de chambre* who will live in history like Proust's Céleste. In the last few weeks, besides, Braque had been especially busy painting certain *plafonds*, cartoons intended for the ceiling of a room in the Louvre, which because of them will become a place of pilgrimage no less visited than the one in the Orangerie which houses the *Nymphéas* of Claude Monet.

I had already given up the audacious notion of a visit to Braque when one day Stanislas Fumet, a Catholic critic as well as a hagiographer of the Maestro, came to my hotel and said to me in broken tones, "Good news. I have overcome Marietta's resistance. We can go." "When?" "*Dépêchez-vous.* Immediately. A taxi, let's not waste time. Later could be too late."

The rue du Douanier, which flanks the Parc Montsouris, is a modern street, one of the few in Paris where the residents can paddle around in a lovely tile bath and go up in elevators that do not present mortal dangers. The well-proportioned houses by the architect Perret are of brick, and they blend well with the mother-of-pearl light of the Ile-de-France. Stanislas Fumet (round-bearded with bangs, halfway in between Giorgio Morandi and Fra Melitone[*]) was agitated. He got out first, rang the doorbell of a small house, bowed to the sullen old woman who came to let him in, took her hands and held them a long time in his own, introduced me as a decent person who would not unduly disturb the *Patron*, and pushed me up an extraordinarily spic-and-span spiral staircase which led directly into the large many-windowed studio where the Maestro was awaiting us.

Braque! A tall, handsome, white-haired old man, wearing a jacket of blue cloth and olive-colored velvet trousers, with felt slippers on his feet. His eyes are blue and

[*]Comic character in Verdi's *La forza del destino*.

penetrating, his face massive but also chiseled. He wears a silk scarf around his neck and his glasses hang on his chest, attached to a cord.

One's first impression is that he carries his ninety years marvelously, but the facts belie this erroneous impression. Georges Braque, in fact, is barely seventy-one years old, for he was born at Argenteuil, that city of caulkers and painters, in 1882. There, as a boy, he saw Claude Monet at work and his fate was sealed: abandoning his studies at the *lycée* he dedicated himself then and there to painting. "Not so bad," his father thought. "He can paint houses, apartments."

Although cubism was already knocking at the gates by the time Braque was twenty, his first attempts at copying Raphael (in the Louvre) or at imitating Renoir had discouraged the young painter, who soon found himself herded into the most curious team of painters our time has known.

Misfortune never struck this sedentary man who has traveled little and whose biographers note only one important event: the serious wound he sustained in combat as a second lieutenant of artillery at Neuville-Saint-Vaast in May 1915. He healed miraculously, then returned to civilian life and painting, and had his first success. Nineteen nineteen marks the triumph of cubism, but by then the *Patron* was already bored with it, he had already, as he says, *"foutu le camp."*

He presents himself (in conversation at least) as a typical non-conformist and there is nothing eccentric in his talk. *Braque* in French means madcap, hare-brained, as well as French pointer, but few men are less deserving of the name than he. Prudence, economy, good management, horror of risk ooze from every pore of his squarish face; a *bourgeois* is talking, a great French *bourgeois*, not a foreigner or a *parvenu*; he talks like a man for whom the figures will always add up. The critics say that in the (ideal) Picasso-Braque couple, Braque would have been the woman, the receptive being, the sharper, the stabilizing and conservative force. But this is a metaphor for saying covertly that Braque is less daring but a better painter: an opinion faintly whispered yet never openly expressed by French critics.

Braque talked at length: of himself, of Normandy, where he lives six months of the year, of Italy, which he knows as far south as Naples. He remembers Modigliani, from the time when the young man from Livorno received five francs and a bottle of rum a day from his patron. He also recalls Soffici, who used to complain about a miserly old aunt. Marinetti always struck him as mad; among the Futurists, he was interested in Balla. Medardo Rosso? A fine talent but a *sale caractère*. No one in Paris remembers him any more.

De Chirico's first pictures were very odd, but more literary than pictorial. He knows nothing about the other Italians. (Stanislas Fumet turns out to be better in-

formed; as a former Jew and a Catholic he reveals an intellectual curiosity lacking in other French literary men.)

Braque now shows us photographs of the frescoes he has painted for the Louvre: great black birds fluttering on a deep blue background. These are oil cartoons of colossal proportions. "One can't be Raphael any more," he mumbles, lighting the end of a rather evil-smelling Gauloise. "But then," he adds, "it was impossible to do Renoir over again; each era has its own recipe." Then he talks some more about his Norman *atelier* in Varengeville; about Dieppe, which he advises me to visit out of season, when fishermen from all over the world gather there; about his wife (who does not appear); about Marietta (who does, menacingly, from behind a screen).

Braque talks splendidly, like a great gentleman farmer. In Italy, only Count Sforza* talked as well, though with a more aristocratic accent. He speaks and perhaps listens to himself with some self-satisfaction, and takes a look at the works that surround him: manikins with lobsters, carafes with guitars, high reliefs on medals, a vase of flowers, a small seascape that might be by an Italian *chiarista*. He is weighed down by years and glory, he knows he has become a national monument and shows he is happy but also a bit bored by it all. And I listen and look at those great painted tarts of his, that universe which to the critics is the poem of the discontinuous but which here on the contrary seems strangely caramelized, fused in one casting and then cut up into slices; a world served on a tray like a *gâteau*, an entirely mental and peaceable world unpenetrated either by faith or despair.

I look . . . but Marietta has reappeared and made a sign. Stanislas draws her aside (a *pourboire?*), takes her in his arms, then pushes me toward the door. Braque relights the Gauloise, which he does not smoke. The light of sunset sets the trees of the Parc Montsouris on fire, dissolves them into one gigantic honey-colored Braque. The same thing happened in Florence on leaving the Villa Loeser: everything around seemed strangely Cézannian. And this sensation, more than anything else, contributed to my feeling that this time I had truly encountered someone of uncommon stature; one of those of whom it will one day be a pleasure to say, "I knew him." Be he genius or talent, such is the impression left by the boy, now in his seventies, who saw the greatest masters of French impressionism working *en plein air*.

*Carlo, Conte Sforza (1872–1952). Italian foreign minister 1920–1921 and 1947–1951. An opponent of Mussolini, he spent the war years in the United States.

1953

Translated from the Italian by Jonathan Galassi

Edward Hopper: *Nighthawks*, 1942. Oil on canvas, 76. 2 cm × 144 cm Friends of American
Art Collection, 1942. 51. ©1988 The Art Institute of Chicago. All Rights Reserved.

MARK STRAND

Hopper:
The Loneliness Factor

It is often remarked that many of Edward Hopper's paintings engender feelings of loneliness. It is also assumed that such feelings are in response to narrative elements in the paintings, but in fact they are in response to certain repeated structural motifs. We often feel left behind, even abandoned, while something else in the painting, usually a road or tracks, continues. We feel caught in a wake that offers no possibility of catching up to whatever has departed. Likewise, if we have the impulse to linger, allowing ourselves to be taken into the painting's reduced ambience, we are resisted by a force within the painting that closes us out. It is this being left behind or left out that gives rise to our experience of alienation. And if there are figures in the paintings who suggest loneliness, they do so because they represent our situation as viewers. What we see in them is our own stillness in relation to powerful resistant forces in the painting. It is not the figures themselves, no matter how we wish to characterize the look on their faces, that establish the element of loneliness. It is something else, something in the formal disposition of the painting that does it, certain geometrical imperatives having to do with missing or sealed-off vanishing points. For example, the loneliness of *Nighthawks* (1942) does not depend on the few people gathered together in an all-night diner. What guarantee, after all, do we have that a few people gathered at night are lonely? Or, for that matter, why should it be assumed that a figure alone in a painting is lonely unless—as I've said—the viewer finds in it some confirmation of his own situation? In *Nighthawks* loneliness depends on the dominant form of an isosceles trapezoid. The

trapezoid moves from the right-hand side of the painting and stops two-thirds the way across. It alone establishes the emphatic directional pull of the painting to a vanishing point that cannot be witnessed but must be imagined, for the simple reason that it is not situated on the canvas but beyond it in an unreal and unrealizable place from which the viewer is forever excluded. The long sides of the trapezoid slant towards each other, but never join, leaving him midway in their trajectory. It is this element of passage that is constantly emphasized by Hopper, contributing to the general condition of loneliness in his work. *Dawn in Pennsylvania*, painted the same year as *Nighthawks*, is structured the same way except that we look "out" instead of "in." The dominant isosceles trapezoid, the periodic posting of verticals that frame and give momentary respite from the strong horizontal movement are in identical positions and of the same size. *Approaching the City* (1946), also composed around an isosceles trapezoid, provides the most unsettling example of the nonexistent vanishing point. The trapezoid is a bleak, featureless wall of concrete that gradually darkens as it heads underground. There are no verticals to slow its disappearance as it is hurried along by the foreground tracks. Above and behind the wall are some buildings whose windows suggest vertical movement, but these, along with two truncated smoke stacks that run through a patch of half-clouded sky, hardly relieve the picture's atmosphere of gloom, its determination to disappear into itself even before a geometrical vanishing point can be indicated. It is a work that invites the viewer in only to bury him. It is the most remorseless and sinister of Hopper's paintings.

Other well-known Hoppers that point to a resolution or ultimate stability which is beyond the picture plane and, consequently, not within the picture's power to satisfy, seem almost benign when compared to *Approaching the City*. *Drug Store* (1927) and *Seven A.M.* (1948), whose trapezoidal storefronts are less acute and less extended, are, geometrically at least, mirror images of each other. They do not present the issue of psychological closure in so extreme a way. In *Drug Store* there is a mollifying frontality about the illuminated plate glass; and in *Seven A.M.* a counter-trapezoid, formed by light entering the store window, dissolves into the shadowy but relatively safe interior.

Hopper has another means of isolating the viewer from the resolution of strong geometrical structures within the canvas. He frequently establishes a vanishing point inside the picture plane only to hide it, making it unreachable. In an early painting, *Stairway* (1925), we look down some stairs through an open door to an impenetrable clump of trees. Everything in the painting points to wilderness, a mass of dark trees that effectively prevents us from seeing anything. All that the painting's geometry prepares us for is darkly denied us. In *Chair Car* (1965) a progression of yellow blocks of light on the train-car floor, flanked by windows and

chairs, leads to the end of the car, which in this picture seems unusually large. The high ceiling and closed door have the effect of immobilizing the painting, freezing it in an absolute present. If the people here are traveling, they are not going far. There is nothing outside the windows, nothing but the light that enters the car establishing the painting's air of immobility. Another painting that uses the same device is *Automat* (1927). A woman, near a door and in front of a plate-glass window, sits alone at a round table. The plate glass reflects only the twin receding rows of ceiling lights; reflects nothing else of the automat's interior, and allows nothing of the street to be seen. The painting suggests many things, but most obviously that if the glass is to be believed the scene takes place in limbo and the seated woman is an illusion, not least because Hopper has invented her.

These are only a few examples of how the loneliness factor in Hopper operates in ways that are strictly formal. There are many more works in which isosceles trapezoids and occluded vanishing points work their depressing magic. But some paintings that are generally assumed to project loneliness in fact project another form of refusal. The viewer feels excluded from the scene in the painting, but feels, at the same time, no desire to enter. Two of the best known are *House by the Railroad* (1925) and *Early Sunday Morning* (1930). *House by the Railroad*, which seems so forthright in its frontality, is deeply mysterious. The harsh sunlight on the house walls is not conventionally descriptive. It illuminates secrecy without penetrating it. The house is really a tomb, a monument to the idea of enclosure, a stately emblem of withholding. It is like an elaborate coffin in sunlight; it shines with finality, and has no door. In its starkness it promises so little that its air of absolute denial cannot be taken personally and can only be trivialized by attempts to associate it with lonelinesss. True, it stands alone, but does so with rigid, disdainful insularity. The trapezoidal element is more than compensated for by the house's verticality and its strong position in the center of the painting. *Early Sunday Morning* also suffers from the misapplication of the term "loneliness." Though it is a scene devoid of people, the viewer is not made to feel isolated from anything, surely not from any suggested terminus or vanishing point. The absence of slanting trapezoids lends the painting a calming air. Though the street may be extended infinitely on either side, the viewer is made to feel that he is in the center, the true center, somewhere between the fire hydrant and the barber pole, that if the painting were to spread out it would offer only a repetition of the order he is already familiar with. There is no actual or implied progression in the shaded or open windows, none in the dark doorways and store fronts. The painting is utterly frontal. It is a quiet, peaceful scene that would inspire loneliness only in those who derive comfort from being able to shop seven days a week.

1985

José de Creeft: *Emerveillement*, 1941. Serpentine, H. 18⅜″ (46.7 cm). The Metropolitan Museum of Art, M. K. Jessup Fund, 1941. 41.184.

EUDORA WELTY

José de Creeft

In its way it is typical of José de Creeft and his *taille directe* that, when asked to name someone to write an article about him, he named me. I had been invited to do work at Yaddo the same summer he had been, and my designation was "writer." This is outside de Creeft's world—both words (except as purely functional or graceful, as in exchange, and then it does not matter from which language any consecutive ones spring up) and words about himself. De Creeft does not talk about himself, or his life—though talking, the pleasure, is a delight to him. He works, and in every way that signifies anything to him, his work is his life. Most biographical facts in this little article come out of *Current Biography* and the notes to exhibitions of his work.

The formalities of life, the conventions of education, were shed from the first by de Creeft. He evidently ran through them like a boy through a shower of rain. It is wholly probable that instinct has always led him surely by the hand, and warned him never to assume such burdens of thought and habit as would only have to be shaken off before he could go freely in his own right way of working. He was born in 1884 of Catalan parents, with some Flemish ancestry, in Guadalajara, Spain, "the Valley of the Stones." (His sculptor friend, Alexander Calder, has suggested that "he must have carved his way out.") He probably first opened his eyes in the outer world upon stones, and perhaps he saw from even a child's glance some spirit in them which he had a desire, that some might call atavistic, to release. He didn't like school. The family was poor. He became an apprentice in a bronze foundry when he was twelve, and by the time he was fourteen, with the family living in Madrid, he had an idea that he would be a sculptor. He lived, almost literally, in the

Prado, that being the best teacher available to him then. He was recommended by the Minister of Art and put to apprenticeship under the kind of old, dogmatic, fussy, spiteful teacher who seems destined to confront eager spirits and turn them lightning-like to mischief. Bound to such a one, who forced learning by the copy-this-cast method, he found the random hands and feet of plaster, the shrouded, uncompleted, ridiculous statues, the tipsy scaffoldings fine props for playing impish tricks, and with a final comment of a foot let fall within an inch of the master's bending body from the top of an old statue where he perched, de Creeft departed from formal learning for good.

He met a painter almost right away, set up a studio with him, and when the painter won the Prix de Rome and went off, de Creeft gaily made a date to meet him in Paris in three years, though his pockets were turned-out empty at the time. As a matter of fact the date was kept, for by that time de Creeft was living in a rather famous studio on the Left Bank, the other inhabitants of it being Juan Gris and Picasso. Here he labored in a stoneyard as a craftsman, where he learned a great deal of practical things, and had his first actual art training at the Académie Julien. The World War brought poverty to him, and he made a thin living as a caricaturist and sometimes as a house painter, but once the armistice was signed there was great demand for statues for war memorials. He was given a commission for an eighteen-foot granite statue of a poilu for Puy-du-Dome. He carved this statue directly, and has never worked in any other way since that day. He knew without question that this direct method was the true way for him.

After living the long-haired years of the twenties in Paris, the dazzling and bedazzled art groups and cliques may have grown a little too much for de Creeft. At any rate, in 1925 he entered, in the newly founded Salon des Tuileries, the life-sized Picador made of stove-pipe, a wondrous and hilarious compilation, which looked too much like a comment on the rest of the salon to give people comfort. By 1926 he was in Majorca, in a garden, making all the fountains and big and little seasonal and animal statues that came into his head—a famous and rich estate had given him carte blanche to decorate the grounds with his work. With the money from this, he sailed for America, with three tons of sculpture on the same boat.

It was in Seattle that he had his first American showing. The director of the museum there, Richard Fuller, had an Oriental collection, and when he looked at the work of this Spanish sculptor, he saw something in it that held his same admiration. Then, East, the Ferargil Galleries took up de Creeft's work. But illness intervened, caused by the Majorcan stone dust, and it was not until 1936 that he was able to work and exhibit again. This was at the Georgette Passedoit Gallery which since then has given annual exhibitions of his work.

So great is de Creeft's energy and imagination that a year always brings a whole new room-full of work—which would take the ordinary sculptor about a lifetime to bring the hard way out of metal and stone, granting that he could. De Creeft also teaches regularly at the New School for Social Research, and has time to paint an occasional watercolor show. His studio on Greene Street is a work room. It opens off the sidewalk and is about the same size as a country store, and as tightly packed with ungainly and mysterious things piled, crowded, standing, hanging, crated and uncrated. Furthermore, de Creeft likes cats. The studio has been called "cat-haunted." It has upper quarters with a ladder disappearing upward, for de Creeft lives there.

The simplicity (it is really abstract concentration) with which he sees his work problems, he sees daily life with too. He needs a nail, he has none, so he makes one—it takes time, of course, but this is part of his work, whereas leaving his work for the wild jungles of the dime store is outer distraction and would not occur to him as allowable during the intense concentration and meditation of his labor. Early hard times gave him the knowledge of how to make nearly every small needed thing, which was luck in one way. He never goes far away from his work, for it is his life.

If I were describing de Creeft's appearance, I would think first of all that it is fully eloquent. His face (lined, tanned, with light eyes) in animation is mobile and alight, in repose meditative. His hands look both gentle and strong, above all, vital. Their power seems quite visible. You can imagine them easily in the tirelessness and the delicateness and the energy of his hard work. There is no bluntness in the fingers, no heaviness from the tons of matter that have been held in them. His talk (made up of Spanish, French, and English with onomatopoeic words and some spectacular pauses and frequent delighted laughter) carries a pantomime as agile and explicit and sometimes, for his and your amusement, as exaggerated as an acrobat's or dancer's. Once when I saw Massine (whom in some way, not too literal, he resembles) dancing the Gay Peruvian in *"Gaité Parisienne,"* his unbounded high spirits reminded me of de Creeft at Yaddo before lunchtime—indeed, de Creeft says his energies are too exuberant in the morning for him to fully control and concentrate his direction of work; he waits until they have been expended somewhat. At Saratoga Springs he would leap on a bicycle of English racer design, and, wearing a striped sweatshirt, brief shorts, and a cap on backwards, he would tear off, waving to everybody—actually to spot stones lying on the hillsides that he might dream of some day carrying off. The most wonderful of these stones, he would say regretfully, were parts of gateways, or holding up some house. He coveted them from his bicycle. Materials used by de Creeft have been things found in

a field as well as things acquired at great cost and sacrifice. Material is important to him for its own sake in a very deep sense; fundamentally it directs what he does with it. It has taught him the great craftsmanship which is implicit in his work—it is an inspirer itself, a piece out of the earth, with the whole of life implicit in it, and its earthy shape, grain, color, weight, warmth, and the undefinable qualities, which he, by study, calls forth, are brought into full spirit and life by his physical work upon it. He therefore never has seen an uninteresting stone in a field or bit of drift-wood on a beach.

In the spontaneity of conversation, the way de Creeft begins some tale and tells it with words agilely plucked from any and all languages, with his wiry gesture, forms it, as it were, and then with delicacy and humor suddenly abandons it at just a certain moment to let it stand before you. You can understand that he is a creator even in his freest moments—that every act, every little joke even (which he seems to be performing under his nickname, Pepe), is a using of the material of the moment and a bringing it to form.

De Creeft is a kind man, he listens to others with the patience of a tried under-standing (how often he responds, *"Est possible!"*) and from him—though he can be logically brief and ironical—comes the unmistakable spark that shows real interest in other people and invites their best ideas. He seems seldom surprised: he is the one who surprises others. With artists able to understand talk of work and its meaning, and with pupils learning from him, de Creeft must certainly be at his most eloquent and at his most explicit. I would guess this instruction to sound quite simple, essential, and yet, as always, four-dimensional, with that other, bolstering dimension of expression which is his conception (and certainly the right one) of communication.

He loves every small life. He would watch the fat Yaddo squirrels with what I can only call a very Spanish amusement, slightly imitative. He was always hoping a telegraph boy would walk in the great hall with some news about the condition of his mother cat, who was expecting kittens in New York. He seemed the kind of man who could feel rather far from daily things and would miss being sure of them, though he had luxurious isolation for his work. He did no sculpturing that summer. He had arthritis somewhat in his hands. Then, too, it is possible that he had an apprehension that the appeal of such institutions as Yaddo, however well meant, is to the artist's vanity, and de Creeft had no vanity to receive it. He did some rapid red and yellow watercolors in his studio there, frieze-like, imaginary, bacchanalian-looking figures, though he did not paint much of the dark and park-like landscape around him. Looking at it he nodded, "Is for oils."

He also occupied himself with a whole colony of two- and three-inch-high clay

figures which he brought with him. A marvelous and sympathetic sense of the absurd in man could account for the playful but astonishing and keen distortions in these figures, which are a kind of thinking in clay. A godlike affection as well as a devastating devil-glance has perpetrated these. Caricature can be the sign of the whole of tolerance—and limitless delight in the unending possibilities of form. And the absurd is often the last gate before the most unexplored fields of the imagination—where any undreamed of beauty might be.

The extreme variety of de Creeft's work has never ceased to astonish people. Sometimes colossal and elephantine, it has been called Asiatic. Much of it has a subtle, flowing, smiling energy like the sculpture of India. Again it will have the galloping, mocking quality that comes straight from Spain. *Semite Head* is more like an Assyrian seasonal god. There is one common factor in each piece—something lives. In *Maturity*, English stone turns as ripe as a plum and yet is still stone— a warm life comes out of it. His working on garden images and fountains might be thought symbolic in de Creeft's life—for out of his stone he has always seen and released forces of nature, and jets of living life. He is not so much imposing a dauntless will on the rock as giving to the rock his creative labor and his imagination, and allowing it to release a form. Creation is, in its practising sense, taking one thing and making another thing out of it—which yet shows its origin and gives to that origin greater glory. Its greatest strength would seem to imply the most intimate as well as the most abstract (in that it is humble and the self disappears into work) way of using material—the *taille directe*. By *taille directe*, de Creeft's imagination, abundant and profound, generous, daring, ardent, yet always coherent, above all utilizes the material at his hand. This is almost to say that the material is making the sculpture as he, simultaneously, is learning and working from it. If this is extreme, I believe it could be said that it is not far from de Creeft's belief. His is a noble conception of work, which fills the sculptor with dignity, and endlessly leads him to experiment.

Another variety exists in de Creeft's work—variety in mood. *Group of Women*, in English limestone, whose embracing figures make a cluster of ripe swelling curves, is as delicious to the sight as a Hindu carving, with a lulling, joyous quality. And *Cloud*, of similar composition, is complete abstraction. *Seguidillas—Spanish Gypsy Dance* is a sculptural examination of what happens in four beats of gypsy music. De Creeft knows not only the majestic moods of the spirit, exemplified most purely, perhaps, in *Himalaya*, but the gentle, passing moods, the humorous, the gay, and the mood of the child. This is because de Creeft knows the timelessness of the most momentary, the most fragile aspects of the human being and the human form, when they are seen in the illumination of the spirit. If only de Creeft

would work a playful expression, a *moue*, into pink quartz for eternity, it would be perfect proof of his delight in life itself, his evaluation of its most fleeting moments. All of life is as real and enduring as basic rock—nothing in life can be lost—and the most playful moments, equally with the most serious, endure and have their place.

In all truly great works of art we find ourselves looking at many faces upon it; many ideas out of other times and countries crowd upon us, as when we look in the vastest pools, a world of reflections strikes our eyes. This need not be the same as thinking the pool is "influenced" by what is seen in its depths. Mayan and Oriental things are seen in de Creeft's work—in the fruitful curves and fullness and subtlety and twining of forms—likewise an ascetic beauty, a purity and loftiness that speak out of work like *Himalaya*. But does it not all spring out of one profundity? Profundity does not know how to be influenced, for in its own being is its own secret of learning. Time alone is its influence.

1944

Giorgio Morandi: *Still Life with Coffeepot*, 1933. Etching, 11¹¹/₁₆″ × 15⅜″. Collection, The Museum of Modern Art, New York. Mrs. Bertram Smith Fund.

CHARLES WRIGHT

Giorgio Morandi

Morandi's drawings, toward the end of his life, resemble the poems of certain masters of style: each line tends to be a statement, self-sufficient, self-contained, where no elaboration is needed: the entire weight of their lives seems flicked off in a phrase, an observation. Eugenio Montale comes to mind. Morandi's late line is always on the point of disappearing, of not *seeming* to be there. And it takes so few of them to get the structure right. Again Montale. Or the spider and her web. Or the various camouflages of other creatures: the praying mantis who looks like a day lily stalk, the shadow of the water bug that floats refracted and huge on the stream's bottom, the insect above all but invisible.

The famous bottles and compote dishes begin to be drawn back into the paper, becoming larger the more they dissemble. It's almost as though they are drawn on the air, that masterly, and in that instant starting to be borne away, the statement having been made, the design now lodged in the memory, tactile and unremovable. Redemptive on the unredemptive air. These are Platonic drawings, their form and architecture already seen and palpable, their decisive indications and linear notations traveling like impulses down the arm and out through the pencil. This is no longer an art of discovery but one of affirmation: the voyage of discovery is ours now. He knows what's there. Like Dante's, his vision is actual because he sees it. These drawings, especially from the 1950s and early 1960s, are maps, trail markings, sand sketches from an absolute.

There's a blue pencil drawing from 1958—several bottles, a couple of canisters (tin boxes) and what appear to be two epergnes—that stands in well, I think, for this process. And a landscape from 1960 consisting of a house, a palm tree, the sugges-

tion of a second house and possibly a third with some intervening trees or shrub-
bery, apparently all on a slight hillside, which does for his landscapes what the blue
drawing does for his mystical still lifes. In both, the windows into the invisible are
lit; in both, what is not there is at least as powerful and tactile as what is. It is an art
in transition, between here and there. If great art tends toward the condition of the
primitive, as I believe it does, and toward the mysteries, as I believe it does, then
the late drawings tend toward the same condition. They are full of wonder and sin-
gularity, lifelines to the unseen.

1985

Joan Miró: *The Farm*, 1921–22. Oil on panel, 48¼″ × 55¼″. National Gallery of Art, Washington, D.C., Courtesy of Mrs. Ernest Hemingway.

Joan Miró

When I first knew Miró he had very little money and very little to eat and he worked all day every day for nine months painting a very large and wonderful picture called *The Farm*. He did not want to sell this picture nor even to have it away from him. No one could look at it and not know it had been painted by a great painter and when you are painting things that people must take on trust it is good to have something around that has taken as long to make as it takes a woman to make a child (a woman who isn't a woman can usually write her autobiography in a third of that time) and that shows even fools that you are a great painter in terms that they understand.

After Miró had painted *The Farm* and after James Joyce had written *Ulysses* they had a right to expect people to trust the further things they did even when the people did not understand them and they have both kept on working very hard.

If you have painted *The Farm* or if you have written *Ulysses*, and then keep on working very hard afterwards, you do not need an Alice B. Toklas.

Finally everyone had to sell everything and if Miró was to have a dealer he had to let *The Farm* go with the other pictures. But Shipman, who found him the dealer, made the dealer put a price on it and agree to sell it to him. This was probably the only good business move that Shipman ever did in his life. But doing a good business move must have made him uncomfortable because he came to me the same day and said, "Hem, you should have *The Farm*. I do not love anything as much as you care for that picture and you ought to have it."

I argued against this explaining to him that it was not only how much I cared about it. There was the value to consider.

"It is going to be worth much more than we will ever have, Evan. You have no idea what it will be worth," I told him.

"I don't care about that," he said. "If it's money I'll shoot you dice for it. Let the dice decide about the money. You'll never sell it anyway."

"I have no right to shoot. You're shooting against yourself."

"Let the dice decide the money," Shipman insisted. "If I lose it will be mine. Let the dice show."

So we rolled dice and I won and made the first payment. We agreed to pay five thousand francs for *The Farm* and that was four thousand two hundred and fifty francs more than I had ever paid for a picture. The picture naturally stayed with the dealer.

When it was time to make the last payment the dealer came around and was very pleased because there was no money in the house or in the bank. If we did not pay the money that day he kept the picture. Dos Passos, Shipman and I finally borrowed the money around various bars and restaurants, got the picture and brought it home in a taxi. The dealer felt very bad because he had already been offered four times what we were paying. But we explained to him as it is so often explained to you in France, that business is business.

In the open taxi the wind caught the big canvas as though it were a sail and we made the taxi driver crawl along. At home we hung it and everyone looked at it and was very happy. I would not trade it for any picture in the world. Miró came in and looked at it and said, "I am very content that you have *The Farm*."

When I see him now he says, "I am always content, *tu sais*, that you have *The Farm*." It has in it all that you feel about Spain when you are there and all that you feel when you are away and cannot go there. No one else has been able to paint these two very opposing things. Although Juan Gris painted how it is when you know that you will never go there. Picasso is very different. Picasso is a business man. So were some of the greatest painters that ever lived. But this is too long now and the thing to do is look at the picture: not write about it.

1934

Gregorio Valdes: *Church of St. Mary Rosario*. Courtesy Alice Methfessel.
Photo credit: Rosina Fleming 1988.

Gregorio Valdes

The first painting I saw by Gregorio Valdes was in the window of a barbershop on Duval Street, the main street of Key West. The shop is in a block of cheap liquor stores, shoeshine parlors and poolrooms, all under a long wooden awning shading the sidewalk. The picture leaned against a cardboard advertisement for Eagle Whiskey, among other window decorations of red-and-green crepe-paper rosettes and streamers left over from Christmas and the announcement of an operetta at the Cuban school—all covered with dust and fly spots and littered with termites' wings.

It was a view, a real View, of a straight road diminishing to a point through green fields, and a row of straight Royal Palms on either side, so carefully painted that one could count seven trees in each row. In the middle of the road was the tiny figure of a man on a donkey, and far away on the right the white speck of a thatched Cuban cabin that seemed to have the same mysterious properties of perspective as the little dog in Rousseau's *The Cariole of M. Juniot*. The sky was blue at the top, then white, then beautiful blush pink, the pink of a hot, mosquito-filled tropical evening. As I went back and forth in front of the barbershop on my way to the restaurant, this picture charmed me, and at last I went in and bought it for three dollars. My landlady had been trained to do "oils" at the Convent.—The house was filled with copies of *The Roman Girl at the Well*, *Horses in a Thunderstorm*, etc. —She was disgusted and said she would paint the same picture for me, "for fifteen cents."

The barber told me I could see more Valdes pictures in the window of a little cigar factory on Duval Street, one of the few left in Key West. There were six or seven pictures: an ugly *Last Supper* in blue and yellow, a *Guardian Angel* pushing two

children along a path at the edge of a cliff, a study of flowers—all copies, and also copies of local postcards. I liked one picture of a homestead in Cuba in the same green fields, with two of the favorite Royal Palms and a banana tree, a chair on the porch, a woman, a donkey, a big white flower, and a Pan-American airplane in the blue sky. A friend bought this one, and then I decided to call on Gregorio.

He lived at 1221 Duval Street, as it said on all his pictures, but he had a "studio" around the corner in a decayed, unrentable little house. There was a palette nailed to one of the posts of the verandah with G. *Valdes, Sign Painter* on it. Inside there were three rooms with holes in the floors and weeds growing up through the holes. Gregorio had covered two sections of the walls with postcards and pictures from the newspapers. One section was animals: baby animals in zoos and wild animals in Africa. The other section was mostly reproductions of Madonnas and other religious subjects from the rotogravures. In one room there was a small plaster Virgin with some half-melted yellow wax roses in a tumbler in front of her. He also had an old cot there, and a row of plants in tin cans. One of these was Sweet Basil, which I was invited to smell every time I came to call.

Gregorio was very small, thin and sickly, with a childish face and tired brown eyes—in fact, he looked a little like the *Self-Portrait* of El Greco. He spoke very little English but was so polite that if I took someone with me who spoke Spanish he would almost ignore the Spanish and always answer in English, anyway, which made explanations and even compliments very difficult. He had been born in Key West, but his wife was from Cuba, and Spanish was the household language, as it is in most Key West Cuban families.

I commissioned him to paint a large picture of the house I was living in. When I came to take him to see it he was dressed in new clothes: a new straw hat, a new striped shirt, buttoned up but without a necktie, his old trousers, but a pair of new black-and-white Cuban shoes, elaborately Gothic in design, and with such pointed toes that they must have been very uncomfortable. I gave him an enlarged photograph of the house to paint from and also asked to have more flowers put in, a monkey that lived next door, a parrot, and a certain type of palm tree, called the Traveler's Palm. There is only one of these in Key West, so Gregorio went and made a careful drawing of it to go by. He showed me the drawing later, with the measurements and colors written in along the side, and apologized because the tree really had seven branches on one side and six on the other, but in the painting he had given both sides seven to make it more symmetrical. He put in flowers in profusion, and the parrot, on the perch on the verandah, and painted the monkey, larger than life-size, climbing the trunk of the palm tree.

When he delivered this picture there was no one at home, so he left it on the ver-

andah leaning against the wall. As I came home that evening I saw it there from a long way off down the street—a fair-sized copy of the house, in green and white, leaning against its green-and-white prototype. In the gray twilight they seemed to blur together and I had feeling that if I came closer I would be able to see another miniature copy of the house leaning on the porch of the painted house, and so on—like the Old Dutch Cleanser advertisements. A few days later when I had hung the picture I asked Gregorio to a vernissage party, and in spite of language difficulties we all had a very nice time. We drank sherry, and from time to time Gregorio would announce, "More wine."

He had never seemed very well, but this winter when I returned to Key West he seemed much more delicate than before. After Christmas I found him at work in his studio only once. He had several commissions for pictures and was very happy. He had changed the little palette that said *Sign Painter* for a much larger one saying *Artist Painter*. But the next time I went to see him he was at the house on Duval Street and one of his daughters told me he was "seek" and in bed. Gregorio came out as she said it, however, pulling on his trousers and apologizing for not having any new pictures to show, but he looked very ill.

His house was a real Cuban house, very bare, very clean, with a bicycle standing in the narrow front hall. The living room had a doorway draped with green chenille Christmas fringe, and six straight chairs around a little table in the middle bearing a bunch of artificial flowers. The bareness of a Cuban house, and the apparent remoteness of every object in it from every other object, gives one the same sensation as the bareness and remoteness of Gregorio's best pictures. The only decorations I remember seeing in the house were the crochet and embroidery work being done by one of the daughters, which was always on the table in the living room, and a few photographs—of Gregorio when he had played the trombone in a band as a young man, a wedding party, etc., and a marriage certificate, hanging on the walls. Also in the hall there was a wonderful clock. The case was a plaster statue, painted bronze, of President Roosevelt manipulating a ship's wheel. On the face there was a picture of a barkeeper shaking cocktails, and the little tin shaker actually shook up and down with the ticking of the clock. I think this must have been won at one of the bingo tents that are opened at Key West every winter.

Gregorio grew steadily worse during the spring. His own doctor happened to be in Cuba and he refused to have any other come to see him. His daughters said that when they begged him to have a doctor he told them that if one came he would "throw him away."

A friend and I went to see him about the first of May. It was the first time he had failed to get up to see us and we realized that he was dangerously sick. The family

took us to a little room next to the kitchen, about six feet wide, where he lay on a low cot-bed. The room was only large enough to hold the bed, a wardrobe, a little stand, and a slop-jar, and the rented house was in such a bad state of repair that light came up through the big holes in the floor. Gregorio, terribly emaciated, lay in bed wearing a blue shirt; his head was on a flat pillow, and just above him a little holy picture was tacked to the wall. He looked like one of those Mexican retablo paintings of miraculous cures, only in his case we were afraid no miraculous cure was possible.

That day we bought one of the few pictures he had on hand—a still life of Key West fruits such as a coconut, a mango, sapodillos, a watermelon, and a sugar apple, all stiffly arranged against a blue background. In this picture the paint had cracked slightly, and examining it I discovered one eccentricity of Gregorio's painting. The blue background extended all the way to the tabletop and where the paint had cracked the blue showed through the fruit. Apparently he had felt that since the wall was back of the fruit he should paint it there, before he could go on and paint the fruit in front of it.

The next day we discovered in the Sunday *New York Times* that he had a group of fifteen paintings on exhibition at the Artists' Gallery in New York. We cut out the notice and took it to his house, but he was so sick he could only lie in bed holding out his thin arms and saying "Excuse, excuse." We were relieved, however, when the family told us that he had at last consented to have another doctor come to see him.

On the evening of the ninth of May we were extremely shocked when a Cuban friend we met on the street told us that "Gregorio died at five o'clock." We drove to the house right away. Several people were standing on the verandah in the dark, talking in low voices. One young man came up and said to us, "The old man die at five o'clock." He did not mean to be disrespectful but his English was poor and he said "old man" instead of "father."

The funeral took place the next afternoon. Only relatives and close friends attend the service of a Cuban funeral and only men go to the cemetery, so there were a great many cars drawn up in front of the house filled with the waiting men. Very quickly the coffin was carried out, covered with the pale, loose Rock Roses that the Valdeses grow for sale in their back yard. Afterwards we were invited in, "to see the children."

Gregorio was so small and had such a detached manner that it was always surprising to think of him as a patriarch. He had five daughters and two sons: Jennie, Gregorio, Florencio, Anna Louisa, Carmela, Adela, and Estella. Two of the daughters are married and he had three grandchildren, two boys and a girl.

I had been afraid that when I brought him the clipping from the *Times* he had been too sick to understand it, but the youngest daughter told me that he had looked at it a great deal and had kept telling them all that he was "going to get the first prize for painting in New York."

She told me several other anecdotes about her father—how when the battle-ships came into Key West harbor during the war he had made a large-scale model of one of them, exact in every detail, and had used it as an ice-cream cart, to peddle Cuban ices through the streets. It attracted the attention of a tourist from the North and he bought it, "for eighty dollars." She said that when the carnivals came to town he would sit up all night by the light of an oil lamp, making little pinwheels to sell. He used to spend many nights at his studio, too, when he wanted to finish a sign or a picture, getting a little sleep on the cot there.

He had learned to paint when he and his wife were "sweethearts," she said, from an old man they call a name that sounds like "Musi"—no one knows how to spell it or remembers his real name. This old man lived in a house belonging to the Valdeses, but he was too poor to pay rent and so he gave Gregorio painting lessons instead.

Gregorio had worked in the cigar factories, been a sign painter, an ice-cream peddler, and for a short time a photographer, in the effort to support his large family. He made several trips to Cuba and twenty years ago worked for a while in the cigar factories in Tampa, returning to Key West because his wife liked it better. While in Tampa he painted signs as well, and also the sides of delivery wagons. There are some of his signs in Key West—a large one for the Sociedad de Cuba and one for a grocery store, especially, have certain of the qualities of his pictures. Just down the street from his house, opposite the Sociedad de Cuba, there used to be a little café for the workers in a nearby cigar factory, the Forget-Me-Not Café, *Café no me Olvidades*. Ten years ago or so Gregorio painted a picture of it on the wall of the café itself, with the blue sky, the telephone pole and wires, and the name, all very exact. Mr. Rafael Rodríguez, the former owner, who showed it to us, seemed to feel rather badly because since the cigar factory and the café have both disappeared, the color of the doors and window frames has been changed from blue to orange, making Gregorio's picture no longer as perfect as it was.

This story is told by Mr. Edwin Denby in his article on Valdes for the Artists' Gallery exhibition: "When he was a young man he lived with an uncle. One day when that uncle was at work, Valdes took down the towel rack that hung next to the wash-basin and put up instead a painting of the rack with the towel on it. When the uncle came back at five, he went to the basin, bent over and washed his face hard; and still bent over he reached up for the towel. But he couldn't get hold. With the

water streaming into his eyes, he squinted up at it, saw it and clawed at it, but the towel wouldn't come off the wall. 'Me laugh plenty, plenty,' Valdes said. . . ."

This classical ideal of verisimilitude did not always succeed so well, fortunately. Gregorio was not a great painter at all, and although he certainly belongs to the class of painters we call "primitive," sometimes he was not even a good "primitive." His pictures are of uneven quality. They are almost all copies of photographs or of reproductions of other pictures. Usually when he copied from such reproductions he succeeded in nothing more than the worst sort of "calendar" painting, and again when he copied, particularly from a photograph, and particularly from a photograph of something he knew and liked, such as palm trees, he managed to make just the right changes in perspective and coloring to give it a peculiar and captivating freshness, flatness, and remoteness. But Gregorio himself did not see any difference between what we think of as his good pictures and his poor pictures, and his painting a good one or a bad one seems to have been entirely a matter of luck.

There are some people whom we envy not because they are rich or handsome or successful, although they may be any or all of these, but because everything they are and do seems to be all of a piece, so that even if they wanted to they could not be or do otherwise. A particular feature of their characters may stand out as more praiseworthy in itself than others—that is almost beside the point. Ancient heroes often have to do penance for and expiate crimes they have committed all unwittingly, and in the same way it seems that some people receive certain "gifts" merely by remaining unwittingly in an undemocratic state of grace. It is a supposition that leaves painting like Gregorio's a partial mystery. But surely anything that is impossible for others to achieve by effort, that is dangerous to imitate, and yet, like natural virtue, must be both admired and imitated, always remains mysterious.

Anyway, who could fail to enjoy and admire those secretive palm trees in their pink skies, the Traveler's Palm, like "the fan-filamented antenna of a certain gigantic moth . . ." or the picture of the church in Cuba copied from a liquor advertisement and labeled with so literal a translation from the Spanish, "Church of St. Mary Rosario 300 Years Constructed in Cuba."

1939

Alfeo Faggi (1885–1966): Busts of Artist's Wife. Bronze, 17″. The Metropolitan
Museum of Art, Bequest of Virginia Alekian Mouradian, 1971. 1971.57.

Is the Real Actual?
[Alfeo Faggi]

The preoccupation today is with the actual. The work therefore of Alfeo Faggi* exhibited last year and with important additions this year at the Bourgeois Gallery, is especially for the thinker, presenting as it does solidly and in a variety, a complete contrast to the fifty-fathom deep materialism of the hour. Spiritual imagination as is apparent, is especially potent in interpreting subjects which are spiritual, seeming to derive feeling from the subject rather than to have to bring feeling to it as in the theme which is palpable and easily comprehensible; therefore as could be expected, in the recent exhibition, the more purely philosophic and intellectual concepts—the *Ka* and the *Dante*—make the most powerful impression; and although one would not naturally classify the *Robert Jones* with the *Dante*, it is entirely congruous that the same mind that could reach the heights and depths of spirituality which would produce the *Dante*, could marginally produce that which is so highly aesthetic as the *Jones*; a thing so illusory in its effect of poetic distillation as the mask of *Noguchi*; a portrait so distinguished as that of Robert Frost; so pliant as the *Eve* with its early-in-the-morning atmosphere, recalling Spenser's swans:

> even the gentle streame, the which them bare,
> Seem'd foule to them, and bade his billows spare
> To wet their silken feathers.

*Reproductions of Mr. Faggi's sculptures have appeared in *The Dial* for March, 1921 (*Madonna, Yoné Noguchi*, and *Pietà*) and in April, 1922 (*Dante*).

The astutely chosen medium in which each study is executed, bears out what one feels, in the sensitive development of the subject in hand—the smooth dark surface of the *Tagore* like a ripe olive, the bone-white, weathered aspect of the *Frost*, the misty waxlike bloom on the *Eve* as on bayberries or iris stalks, there is a creative unity; complementary curves and repeated motive of lines or angles in hands or drapery—which instantly mark the subjects as being one man's work; there is moreover as in the work of any disciplined mind, an absence of stentorian insistence on the work's right to attention—the scorn of self-extenuation as in the case of *Dante, Socrates,* and *Christ.* Remembering C. H. Herford's comment upon Sir Thomas Browne's contemporary, Alexander Ross, one hesitates to appraise work—even to praise it—the inspiration of which is spiritual. Herford says: "The formidable Alexander Ross in his *Medicus Medicatus,* drove his heavy bludgeon this way and that through the tenuous fabric of the *Religio* without damaging a whit its spiritual substance 'for it was as the air invulnerable.'" Corrupted by the conventions of the banal and the bizarre, under contract to compass every novelty, there are many critics or so-called artists qualified to judge of such work only in so far as they are able to discriminate between Hepplewhite and Sheraton. The most hasty, however, the most errant, will feel in Mr. Faggi's *Ka* as in all his work, the controlled emotion, the mental poise which suggests the Absolute—a superiority to fetishism and triviality, a transcendence, an inscrutable dignity—a swordlike mastery in the lips, which suggests the martyr secure in having found the key to mystery, a reserve which recalls Dante as pictured by Croce, "absorbed and consumed by his secret, unwilling that vulgar and gossiping folk should cast their eyes upon it: 'and he smiling looked at them and said nothing.'" Face to face with such sincere expressions, one suspects that in the vulgarity and peremptoriness of one's passions, either in praise or blame, one may be as St. Augustine says he was prior to his conversion, "like a dog snapping at flies." A reverence for mystery is not a vague, invertebrate thing. The realm of the spirit is the only realm in which experience is able to corroborate the fact that the real can be also the actual. Such work as Mr. Faggi's is a refutation of the petulant patronage which for instance assigns Plato to adolescents—which remarks: "How Plato hated a fact!"

To grasp the nature of the phenomenon which *Dante* represents, is perhaps impossible to many of us since one cannot discern forces by which one is not oneself unconsciously animated. As Symons has remarked, "We find the greatest difficulty in believing that Socrates was sincere, that Dante was sincere." One feels that even with a profound critical interest in Dante, Boccaccio could not, as Symons says, comprehend a nature more metaphysical than his own. However, those who have studied biographical conjecture and the historical certainties of Dante's life,

will be grateful to Mr. Faggi for his synthesis of what is the feeling or at least the apprehension of so many. In this robustly compact bronze like some colossal gold ingot stood erect, obviously intended to represent a man but not brutishly male, with the look of the athlete made lean, with the action in repose of the spiritual potentate, one sees the man as one has imagined him, the student of "philosophy, theology, astrology, arithmetic, and geometry, turning over many curious books, watching and sweating in his studies," with a view of the world founded as Croce says, on faith, judgment, and bound by a strong will, commanding like a wall of solid water, the incredulity of minds egotistical and as shallow as a fish-wafer—too idle to think. In the intellectuality, the distilled impersonal spiritual force of Mr. Faggi's *Dante,* one recalls Giotto's superiority to interest in masculinity of femininity *per se*; the inadvertent muscularity and angelic grace of his male figures— the faces of his madonnas and female saints, like the faces of stalwart boys. In the shoulders compact like a bulldog's, in the nostrils built for expansion under physical stress sunk under long imposed restraint, the horizontal eyebrows, raised cheekbones of the ascetic, the iron skull, the substantial character of the face as of an iron crow, the mobile expression of the mouth—not incompatible with the gaiety of which Croce and other authorities are convinced—the cap like war, set from the face as if to indicate hope; the collar, round like an ecclesiastic's, the wakeful reserve of the lowered eyes—we have "the ardor, admiration and fury" of the politician, the distilled supersensory sentience of the seer—the man who was "the product of a nation of scholars and doctors who were artists." In the animating force of this bronze in its setting of physical power, is embodied the spiritual axiom that Dante has come to be.

1922

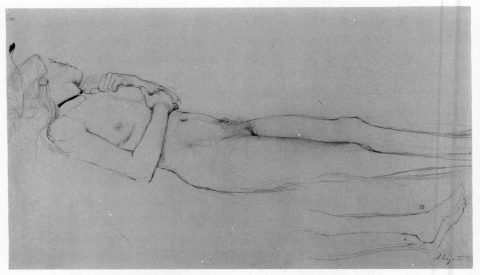

Andrew Wyeth: *Black Velvet (study) #2768*, 1972. Pencil, 18″ × 23¾″.
© 1987 Leonard E. B. Andrews.

JOHN UPDIKE

Heavily Hyped Helga
[Andrew Wyeth]

One must approach the Helga exhibition determined to forgive it its hype. Subway riders in Boston, months before the show arrived, were tantalized by a poster saying, "To the world, she has become a sensation. To Wyeth, she was just the girl next door."

What does one do with the girl next door? Why, one falls in love with her and, if one is an artist of a certain stripe, paints and draws her, mostly in the nude, more than 200 times over a period of 15 years, amassing a collection that is then bought by a millionaire collector (Leonard E. B. Andrews, publisher of such pivotal newsletters as *The National Bankruptcy Report* and *The Swine Flu Claim & Litigation Reporter*) with a handshake and the mural-scale remark, "Mr. Wyeth, congratulations, you have created a national treasure, and I want to protect it and show it to the American people. I want the collection." In confirmation of Mr. Andrews's generous estimate, a portrait of Helga adorned simultaneous covers of *Time* and *Newsweek*, and a show mounted at the National Gallery, with a best-selling catalog introduced by the gallery's deputy director, John Wilmerding, began a continental circuit to museums in Boston, Houston, Los Angeles, San Francisco, and Detroit.

The nub of the stir that the Helga collection has made is the innuendo, not exactly suppressed by Betsy Wyeth's blaming it all on "Love," that its hitherto unexhibited riches recorded a secret love affair. Not only is Helga Testorf, a Chadd's Ford neighbor of the Wyeths, often nude, but she is frequently painted dozing in a rumpled bed, in a little whitewashed room like that of an olde-tyme motel, or

with a black riband around her neck in deliberate echo of the loose lady in Manet's *Olympia*.

That global excitement could be generated by the dim possibility that an aging artist had slept with his middle-aged model (Wyeth was 53 when the sequence began in 1971, and Helga was 53 when it ended in 1985) testifies, I suppose, to the lowered sexual expectations of the AIDS era; those of us who were young in the '50s sympathetically remember how a little (a glimpse of Hedy Lamarr's breasts in *Ecstasy*; Brigitte Bardot's bottom in the middle distance of *And God Created Woman*) can be made to go a long way. Idle speculation about the artist and his model predates the tale of Pygmalion and Galatea; the Victorians worried a good deal about the erotic potential of the studio, and Thomas Eakins's painting of the artist William Rush extending a courteous hand to his naked model as she descends from the draped platform is rich with anxiety—his, hers, and ours. But in fact none of the Helga paintings, intensely worked and radiantly real as some are, is quite the sunburst of female glory unveiled by Wyeth's 1969 *Virgin*, of the then 15-year-old Siri Erikson.

Helga, with her thick braids, heavy features, and sour expression, is somewhat plain, which quickens our titillated suspicions. If she isn't a beauty, why are her clothes off? The Helga pictures also show her, like a Playmate of the Month, engaged in healthy outdoor activities—walking in a loden coat, brooding amid the sticks and dead leaves of Wyeth's customary wintry landscape. The exhibit—set up as if sub rosa in some galleries emptied of their usual Chinese art, while the Boston museum's premier exhibition space, the Gund Gallery, has been given over to a retrospective of the chastely mechanistic Charles Sheeler—has been arranged rather like a striptease, with the penciled head studies and the muffled loden-coat watercolors yielding around a corner to rooms of nudity. Helga's body, first seen when she is 38 and last when she is over 50, is a remarkably firm one, and in many of its representations might be that of a young girl. And perhaps that sufficiently explains her charm for the artist.

The mood of the portraits is elusive. Often deadpan Helga is not so much there as her hair is there, braided or free-flowing or cut in a pageboy, each glowing filament laid on, in the more finished works, in painstaking tempera or drybrush—a miracle of eyesight if not of mimesis. "What's drybrush?" art-viewers kept asking each other the day I viewed the show. It is a technique whereby a watercolor brush is squeezed almost dry to produce a fine, opaque line. Wilmerding's introduction relates how Wyeth was captivated by this technique in the work of Albrecht Dürer, and Helga in *Sheepskin* does look eerily Düreresque—flattened and enameled and darkened as if by centuries. But Dürer's virtually microscopic rendering of a hare's

coat, or of the grasses in a piece of turf, has about it the Renaissance exhilaration of recovering the physical world: not for a thousand years had things seemed so interesting in themselves; never, before Dürer and Leonardo, had reality been so exactly captured in drawing. With a late-20th-century artist such as Wyeth, such close and avid rendering of hair, fur, thready sweaters, and eyelashes—in hyperfinished, minutely mottled paintings like *Braids* and *The Prussian* even the skin looks reconstructed, squamous cell by squamous cell—amounts to a knowing defiance, one underlined by the broad and scrubby contrasting sections that seem to say, "I can be abstract too!" The catalog chapters are headed by remarks that, however extracted from Wyeth, seem here a bit self-serving and apologetic. "I honestly consider myself an abstractionist. . . . My people, my objects, breathe in a different way; there's another core—an excitement that's definitely abstract." The slashes of daylight behind the figure in *Drawn Shade* could have come from a Franz Kline, and two of his finest reclining nudes (*Black Velvet*, supine, and *Nudes*, prone) float in a pure mess of dark brown brush strokes.

Of course, dashingly rough rendering toward the edges is an old magazine illustrator's trick, and it is Wyeth's ties, filial and sentimental, to the tradition of commercial illustration that incite such vehement scorn among aesthetic arbiters like Hilton Kramer, Henry Geldzahler, and, more politely, Robert Hughes. In the heyday of abstract expressionism, the scorn was simple gallery politics; but resistance to Wyeth remains curiously stiff in an art world that has no trouble making room for photorealists like Richard Estes and Phillip Pearlstein and graduates of commercial art like Wayne Thiebaud, Andy Warhol, and, for that matter, Edward Hopper. We resent broody poses in Wyeth and accept them from Hopper, perhaps because there is a glamorizing touch in a Wyeth painting like *In the Orchard* and none in a Hopper like *Morning Sun*, or because broodiness feels more excusable in Hopper's urban than in Wyeth's rural settings. Nevertheless, the two men are close—close in their loyalty to American landscape and in their interest in the dramatics of light—and posterity may wonder how one could be so "in" and the other so "out."

At the exhibition, my own pleasure did diminish whenever I felt Wyeth was trying to tell me a story, as with the tricky little illumined spillage through the window above the sleeping nude in *Overflow* (she is dreaming of overflow? she has just been overflowed into?), or when he was using light theatrically (*Night Shadow*; *Sun Shield*), or when he dressed Helga up in costumes like a doll (*Peasant Dress*; *Crown of Flowers*). Wyeth has, I think, an intense and individual enough relation to his visual material not to need to toy with it. A painting like *Farm Road*, for instance, with its massive, shining back of Helga's braided head bluntly centered in a scratchy brown monotone beneath a tilted horizon and a fused clump of pines,

wins an expressionistic strangeness not from any anecdotal overtones but from the absorbed way it is painted. Here, and elsewhere, something has been released by Helga's turning her back. The liveliest portraits in the show, the ones that least effortfully deliver a sense of spirit in a face, are a few of Helga's preadolescent daughter; the girl has an elfin skewed look the artist deftly captures, relieved of his chronic subject's enigmatic gravity.

The show mounts less than half of Andrews's national treasure, yet even so it seems somewhat thin and repetitious; my fellow viewers, having been satisfied as to what drybrush is, politely stooped toward each fragmentary sketch like salesmen dutifully knocking on a row of unopening doors. Yet the high points do represent, it seems to me, an expansion of Wyeth's artistic ambition, and should expand his reputation beyond that of a dryly meticulous renderer of dead grasses, barn walls, and withered country characters.

My personal method for locating high points is a simple one: the covetousness test. Would I want to own it and see it daily? A number of the pencil sketches met that test—the entire *Asleep* sequence and the studies for *Overflow*, *Black Velvet*, and *Barracoon* have a cumulative power as Helga driftingly turns this way and that. The pose (or fact) of sleep somehow lifts these nude studies beyond both academic and erotic anxiousness and irradiates their physical intimacy with auras from the realm of Blake and Jung. We sense here what Wyeth means when he says, "I enter in a very focused way and then I go through it." Of the other pencil works, the very first sketch of Helga, in profile, has an unforced nobility, and in those posed with the dog Nell the dog's company lends her face an unusual expression of amusement. Here, and in Nos. 116 and 129 of the sleeping model, the sometimes staid linear precision is animated by a visible scribbling, an energy in the pencil.

Of the more or less finished paintings, *Black Velvet* seemed to me a triumph: a long nude, white as lightning, floats in black space, an American Venus with something touchingly gawky in her beautifully rendered big bare feet, bent elbow, and clenched hands. That is what Winslow Homer's maidens would have looked like beneath their calico. Looser in rendering, yet more plausibly afloat on an inflated plastic raft, in what seems a very muddy pond, is a nude in the saucy bottoms-up position of a Boucher; this, and the larger and more finished watercolor titled *From the Back*, possess what is often absent from Wyeth's showpieces—a sense of massiness, of sculptural shadow, and of potential motion. *From the Back* catches a rough-hewn goddess as she swingingly strides into a darkness that swallows her arm. Both these, and the perhaps slightly too monumental *Lovers*, were done in

1981, and display an unfussy confidence with the nude, and an underlying humor, that Wyeth achieved over his instinctive dryness.

The finished *On Her Knees* (an erotically charged pose that he has used several times elsewhere) seems to me to suffer from this dryness, a studied chalky glamour, but in the same series the headless, breastless, armless abdomen, with its honestly thick waist and tangled pubic hair thrusting flamelike above a phallic shadow, confronts us—affronts us, even—with iconic directness. And the painting *Barracoon* (a word for slave barracks suggested by Betsy Wyeth, and also produced in a version where the sleeping woman has been colored black) is as lovely as its pose is perennial, as delicate as an Ingres slave and more subtle, in its hippy rhythm, than the often-reproduced reclining nude by John Trumbull.

The nudes are what make the show sensational, and also what make it worthwhile. They significantly add to a central, indeed primeval, genre rather undernourished in America, where the menace and the sadness of naked flesh have impressed artists as much as its grandeur and allure. When all the hype has faded, and Leonard Andrews has got his (to cite the rumored purchase price) ten million dollars' worth of exposure, Wyeth's 15 years of friendly interest in Helga should leave a treasurable residue.

1987

David Smith: *Hudson River Landscape,* 1951. Welded steel, 49½″ × 75″ × 16¾″ (125.5 cm × 190.5 cm × 47 cm). Collection of Whitney Museum of American Art. Purchase 54.14.

FRANK O'HARA

David Smith

Smith was a very strong individualist and a very strong moral force in American art. He was considered by many to be the finest sculptor North America has produced; his death in 1965 in an automobile accident, as had Jackson Pollock's earlier, assumed for many a symbolic as well as tragic significance. A great and vital force, who like Pollock had given inspiration and esthetic confidence to many other artists, was suddenly gratuitously removed from American art. Unlike Pollock, Smith died at the height of his productivity. In 1962, thanks to the accommodations of the Italian steel producing company Italsider, S.p.A., and the workmen in its factory at Voltri, he had created twenty-six sculptures in thirty days, ranging in importance from superb to no less than significant. This same prodigal approach to sculptural ideas long fermenting within him continued when he returned from Italy, though naturally the same incredible pace was not maintained without the resources placed at his disposal by Italsider and the Italian government. But renewed freshness and vigor had come from this experience, and after the showing of the works at the Festival of Two Worlds in Spoleto, he returned to America to commence work on bronzes, on small painted steel pieces (the Men-and series), on the heroic stainless steel series called Cubi, on three huge *Wagons*, inspired by one he had made in the Voltri factory, and on the Voltri-Bolton series, homages to the experiences and materials he had found so inspiring during his work in Italy. A week or so before he died, in the midst of preparations for an exhibition of the *Cubis* at the Los Angeles County Museum, he spoke of plans for one or two more "gate-type" *Cubis*, a twenty-foot-high stainless steel *Tower* (its

parts already laid out in a preliminary stage on the terrace of his workshop), and a *Zig* "as big as a locomotive engine."

This intense productivity was not, however, a late development in his career. Through the last twenty-five years of his life, the home, studio, and workshop at Bolton Landing, in the beautiful mountains above Lake George in northern New York State (near Canada), had gradually filled with sculptures which spilled out onto the hill on which the house was situated. In the early days he had begun to place sculptures outdoors in the fields for lack of indoor storage space and in order to study them in an unconfined and uncluttered area. Later he built cement pedestals in the fields where sculptures became a permanent feature, constantly replaced by newer work. With the hundreds of sculptures and paintings, and some three thousand drawings done in his solitude at night or when the weather prevented his working on sculptures, Bolton Landing became an extraordinary one-man museum. Since Smith did not begin to sell significantly until relatively late in his career, and because of his desire to retain certain key works of each period for his two young daughters, the collection at Bolton Landing comprised a nearly complete survey of every aspect of his gifts and interests, as well as many intriguing diversions of his talents. Approaching it, one was struck by these brilliant and sophisticated stainless steel or painted structures, poised against the rugged hills and mountains, the lake in the distance, and the clouds, an assertion of civilized values not nearly so surprising in the confines of a gallery or museum, where, conversely, these same sculptures took on an aspect of rugged individualism and often an almost brutally forthright power. This was also true of Smith the man. At a party or a *vernissage* in New York he appeared a great, hulking, plain-spoken art-worker out of Whitman or Dreiser, neither impressed nor particularly amused by metropolitan "lightweight" manners, somewhat of a bull in a china shop; at his home in Bolton Landing, with the same "plain" manner, he prepared delicious meals himself, , offered excellent wines and cigars, and spoke of his love of Renaissance music (particularly Giovanni Gabrieli) and Mozart and the writings of James Joyce, of his interest in the musical ideas of John Cage, in the dancing and choreography of Merce Cunningham, in the poetry of Dylan Thomas and William Carlos Williams, in the work of younger artists, particularly, as I remember, the sculptors John Chamberlain, Mark di Suvero, and Anthony Caro, and the painter Kenneth Noland, who had influenced his conception of the Circle series. On walks he might discuss Egyptian and Sumerian art (his Zig series was inspired by the latter and, I believe, also the Cubi series), local politics (he had run for public office in Bolton Landing, but not been elected), the cult of Marilyn Monroe (with which he was in complete and enthusiastic sympathy), what you yourself had been work-

ing on recently and the difficulties involved. His compressed time-sense and his attention to both scholarly and immediate experiences is best expressed in his own words:

> The stream of time and the flow of art make it plain that no matter what the sculptor's declaration of individual vision he cannot conceive outside his time. His art conception takes place in dialectic order. The flow of art, the time of man, still places him within his own period, out of which he cannot fly, and within which all other men exist. For no object he has seen, no fantasy he envisions, no world he knows, is outside that of other men. No man has seen what another has not, or lacks the components and power to assemble. It is impossible to produce an imperceptible work. . . .
>
> Practically, the law of gravity is involved, but the sculptor is no longer limited to marble, the monolithic concept, and classic fragments. His conception is as free as the painter's. His wealth of response is as great as his draughtsmanship. Plastically he is more related to pagan cultures with directives from Cubism and Constructivism. *

As an affirmation of his contemporaneity, Smith found it only natural to range freely from Mesopotamia to Paris, from the Lascaux caves to the most recent painting exhibition of his friend Helen Frankenthaler, on each of which he had equally passionate opinions and insights.

Smith was born in the Midwest in 1906. (Knowing that I was brought up in mountainous New England, he once told me that no one not born in the "flatlands" of the Midwest could appreciate the thrill that the mountains of Bolton Landing had for him or just how inspiring to him that space was.) He spent his youth in Decatur, Indiana, where "everyone in town was an inventor. There must have been fifteen makes of automobiles in Decatur, Indiana; two blocks from where I lived there were guys building automobiles in an old barn. Invention was the fertile thing then. . . ."† He himself took an early interest in drawing and making signs and cartoons. He attempted to study art, but found the available curricula unsatisfactory.

At the age of nineteen he took a job in an automobile plant in South Bend, Indiana, thus beginning the development of skills which would later serve him as a sculptor and even direct his impulses toward technical innovation in steel sculpture, though at the time his inclination was growing toward being a painter.

* "Who is the artist? How does he act?" *Numero*, no. 3, May-June 1953, p. 21.
† "The Secret Letter, An Interview with David Smith," June 1964. Thomas B. Hess. In *David Smith*, New York, Marlborough-Gerson Gallery, October 1964.

A year later, after a brief stay in Washington, D. C., he moved to New York City, where he had the good fortune to meet the painter Dorothy Dehner, who was to be his first wife and who is now also a distinguished sculptor. Miss Dehner persuaded him to attend classes at the Art Students League. Once established as a student at the League, Smith encountered further good fortune in meeting the Czech abstractionist Jan Matulka, then teaching at the League, who introduced him to the works of Picasso, Mondrian, Kandinsky, Malevich, and Lissitzky—since the general tenor of art instruction in America at the time was provincial and traditionalist, this encounter was of great importance. Shortly after, he became acquainted with painters who were to have a major role in the development of modern American art: John Graham and Jean Xceron, both liaisons with the avant-garde movements in Paris, and the New York–based painters, Stuart Davis, Arshile Gorky, and Willem de Kooning. All devoured the reproductions in *Cahiers d'art* and the texts in *transition*, thus turning away from the main impulses of American artistic thought of the period, saving that of the American expatriates.

Of this period, Smith wrote later: "One did not feel disowned—only ignored and much alone, with a vague pressure from authority that art couldn't be made here. It was a time for temporary expatriates, not that they made art more in France, but that they talked it. . . . Their concept was no more *avant* than ours, but they were under its shadow there and we were in the windy openness here. Ideas were sought as the end, but the result often registered in purely performance. Being far away, depending upon *Cahiers d'art* and the return of patriots, often left us trying for the details instead of the whole. I remember watching a painter, Gorky, work over an area edge probably a hundred times to reach an infinite without changing the rest of the picture, based on Graham's recount of the import in Paris on the 'edge of paint.' We all grasped on everything new, and despite the atmosphere of New York, worked on everything but our own identities."

Smith was then a painter twenty-four years old. In the next year, 1931, he began to attach materials and then objects to the surface of his paintings, then constructed painted wooden objects. By 1932 he had begun making welded steel structures under the influence of reproductions of the works of Gargallo, Picasso, and Gonzalez, and the Russian Constructivists, retaining nevertheless his close relation to the flat surface of painting, the desire to incorporate color in his emerging sculptural ethos, and a consuming interest in Cubist aesthetics. "While my technical liberation came from Picasso's friend and countryman Gonzalez, my aesthetics were more influenced by Kandinsky, Mondrian, and Cubism. My student period was only involved with painting. The painting developed into raised levels from the canvas. Gradually the canvas became the base and the painting was a

sculpture. I have never recognized any separation except one element of dimension. The first painting of cave man was both carved line and colour, a natural reaction and a total statement . . . I do not recognize the limits where painting ends and sculpture begins." This conviction continues into the painting of the late *Zigs*, and has everything to do with the burnishing of the stainless steel surfaces of the Plane and Cubi series, and the deliberate rusting of the *Voltri-Boltons*.

In addition to the influence of Cubism and Constructivism on Smith's work, the influence of Surrealism cannot be underestimated. Unlike many other American artists, Smith seems to have gotten no romantic aura from Surrealism and no social or intellectual glamour: rather, he took its ideas as a development out of Freud, a serious rather than fanciful one, and in the late thirties he utilized the Surrealist vocabulary of forms (he was somewhat influenced at the time by Giacometti, Laurens, and Lipchitz) more as a means of social protest prompted by the years of the U.S. financial depression and the imminence of war than as an expression of any personal subconscious revelation. There are no frivolities and no self-indulgences in the works of this period, as there were in so many other American Surrealist-inspired works: though not his most significant works, the *Medals for Dishonor* are extraordinary technically, and most of Smith's other sculptures of the period carry an indictment of war and Fascism which is marred in its expressive conviction only by a kind of plastic self-consciousness. While one does not doubt the sincerity of the sentiment, for the only time in Smith's career, one doubts the sculpture itself, in which his high purpose seems lowered to that of propaganda, a realization he himself reached later. He went on instead to the exploration of his own identity and the discovery of his own imagery, perhaps here for the first time approaching the original impulse of Surrealism, but by exploring the vocabularies of all the contemporary styles compatible with his aims. As the American critic Hilton Kramer wrote:

> . . . as an artist he came into the inheritance of all the modernist impulses of European art simultaneously and without having to commit himself to one over another. Moreover, he came to this inheritance under the pressure of an extreme historical moment, when the structure of society seemed as much in question as the conventional forms of native American art. There is an analogue in Smith's refusal to chose one branch of modernism over another—to become purely a Cubist *or* a Surrealist *or* a Constructivist—with the anarchism of his social views. He chose to use whatever was useful to him. . . .
>
> One must add that such a freedom of choice was possible because European modernism itself had become fragmented and split into isolated

impulses by the early thirties. Henceforth each artist was on his own in
making whatever connections he could between the shattered fragments
of the modern movement, and projecting out of them a new aesthetic
possibility. . . .

In effect, he restored the Constructivist idea to the Cubist tradition,
which had spawned it in the first place, and then threw in the Surreal-
ism of his own generation for good measure. Once this synthesis was
achieved, Smith moved freely in and out of figurative and non-figurative
modes; heads, figures, landscapes, animal images, mythical and Surre-
alist fantasies, the symbolic anecdote and the purely formalistic concep-
tion were all available to his medium. *

This freedom, however, was not so simply won at first, and Smith in the thirties was
obviously casting about for the particular qualities and significant values available
to him in the modes which attracted his enthusiasm, and for the means to incor-
porate these modes in a single, organic vision of his own originating. He had his
partisans as a young artist beginning to show publicly with increasing frequency,
but like de Kooning, Gorky, and Pollock, he had few, and they were largely con-
tained within the world of artists and a few astute collectors and critics. Restless in
his ambition and in his intellectual curiosity, he was frequently accused of eclec-
ticism, always a curious and confusing accusation when leveled at a young artist.

Because of this free-ranging exploration of form, style, and medium (his first
sculpture was made in the Virgin Islands out of coral) and because of later devel-
opments in his own work and that of others, his three "eclectic" heads of 1933, the
Agricola Head, Chain Head, and *Saw Head,* may now be seen as works of marked
originality and intelligence without any aura of hesitant experimentation; made
from steel and "found" steel parts, welded and painted, they establish clearly and
quickly a discourse between Smith and his own environment and show how the
formal innovations of Gonzalez and his Spanish environment encouraged
Smith's self-searching dialogue with modern art. From the start, Smith took the
clue from the Spaniards to lead him toward the full utilization of his factory-skills
as an American metalworker, especially in the aesthetic use of steel, glorifying
rather than disguising its practicality and durability as a material of heavy industry.
By incorporating found iron and steel parts from farm implements, and factory-
ordered steel parts such as I-beams and concave discs in his work, Smith utilized
his American milieu in much the same way that Spanish metal sculptors from
Gargallo to Chillida and Chirino have utilized the traditional Spanish forging and
wrought-iron techniques in developing their styles. Indeed, for all the technical

*Hilton Kramer, "The Sculpture of David Smith," *Arts,* v. 34, No. 5, February 1960, pp. 22–41.

delicacy and complexity of his symbolism in the late forties and the fifties, the "drawing-in-air" of such works as *Agricola IX*, *Parallel 42*, and *O Drawing*, and the surcharged symbolic form-combinations of *Home of the Welder*, *Portrait of the Eagle's Keeper*, and *Pillar of Sunday*, Smith took genuine delight in the progress of industrial technology and the new techniques it made available to him for his work. This delight, however, did not spread to reproductive methods; perhaps because of his early experience as a painter, Smith insisted adamantly that each piece be unique, finished by the artist's hand. Working in bronze, he preferred the lost wax process and created the patina himself; in other media, no matter how much assistance he needed in the progress of the large works, the final painting or burnishing was his own. Like the self-made man, he had the self-taught artist's pride in personal completion of each event: "Modern tools and method permit the expression of complete self-identity from start to finish. His [the contemporary sculptor's] work can show who he is, what he stands for, in many different ways and with all the fluency he desires, for every step is his own. His identity, pattern, and goal are shown in a qualitative unity, an integration stated in a manner not open to mind or hand before. . . . This is, I believe, a specifically mid-twentieth-century privilege, as long as he knows the tools and materials of his time."

Another aspect of our century's privilege for Smith appears in the free play of subconscious imagery he seems to have taken for granted. The human form can be found in many abstract guises, even in works as geometrically abstract as the Cubi and Plane series, and anatomical references (to brain, heart, viscera, etc.) appear in many of the early works such as *Head as Still Life*, *Blackburn—Song of an Irish Blacksmith*, and the odalisque-like *Leda*.

The last works of David Smith bring to startling new fruition a number of plastic ideas he had pursued with enormous variation over the years. The Voltri-Bolton series brings to a new height of inventiveness the combination of found and manufactured forms with his created ones, and presents a clearer vision than ever before of the possibilities of these materials. The Cubi series presents the stainless steel volumes balancing one on another, signalling like semaphores, climbing into the air with the seeming effortlessness and spontaneity of a masterful drawing, while retaining the sobriety of their daring defiance of gravity, a concept the meaning of which Smith had pondered often during his career both as challenge and limitation. And in the Zig series Smith reached the peak of his effort to create monumental painted sculptures in which color becomes an organic resonance of the forms, to make sculptures which *must be* painted for their full realization. They are among his most unique accomplishments, majestic in their scale and authority, revelatory in the aspects of plane, line, and volume, which the colors enforce,

outspoken in the originality and virility which they proclaim as prime values in art, yet unpretentious in the simplicity and eagerness of their expression.

A suitable epitaph for this great artist might be the words he spoke of himself a year before his death in an interview with the critic Thomas B. Hess: "You know who I am and what I stand for. I have no allegiance, but I stand, and I know what challenge is, and I challenge everything and everybody. And I think that is what every artist has to do. The minute you show a work, you challenge every other artist. And you have to work very hard, especially here. We don't have the introduction that European artists have. We're challenging the world. . . . I'm going to work to the best of my ability to the day I die, challenging what's given to me."*

*"The Secret Letter," Thomas B. Hess.

1975

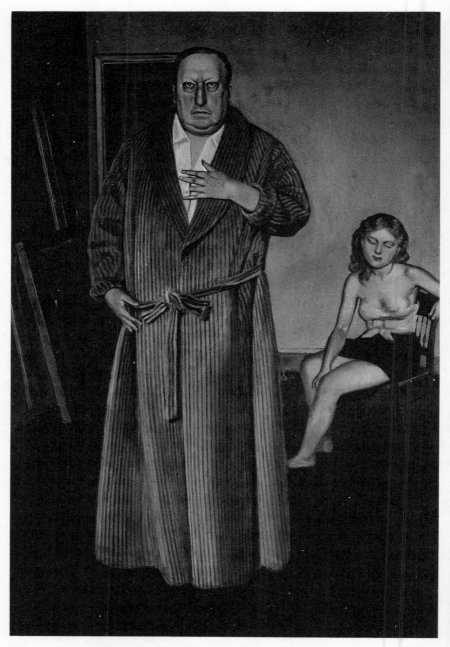

Balthus (Balthusz Klossowski de Rola): *André Derain*, 1936. Oil on wood, 44⅜″ × 28½″. Collection, The Museum of Modern Art, New York. Acquired through the Lillie P. Bliss Bequest.

ALBERT CAMUS

Balthus

Patient and clairvoyant swimmer that he is, the artist makes his way up strange streams to forgotten headwaters. A footprint in the sand, long-since extinct fires, the indistinct cry of an invisible lookout, these are the promises upon which he nourishes himself. His whole effort consists in not allowing himself to be carried away by the current. Before getting lost at the rivermouth, he wishes first to discover the source and the promised land. This holds for the painter, whose will it is to extricate the world from night and stay forever what is already on the point of vanishing. At each dawn, the creation starts afresh. Landscapes, faces, and objects take wing, fade from the memory, or annul one another. That is why the landscapist and the subject painter isolate in time and space that which would otherwise and normally blend into infinite perspectives or disappear under the impact of rival values. Theirs is a process of fixation. And the real painters are those who, like the great Italians, give the impression that a fixation *has just been produced*, as if their projective mechanism had unexpectedly come to a full stop. All the figures in great paintings induce in us the belief that they have just been immobilized and that, by a miracle of art, they continue among the living while ceasing on the other hand to be perishable.

I know of no better example of this process than the portrait of Derain by Balthus, which may be seen at the Museum of Modern Art in New York. The style of a painter is nothing other than a certain way of yoking the natural and the impossible, of presenting what is ever in process of becoming and presenting it in a moment of time that will never end.

Balthus has a style—something more and more rare. And his manner is peculiar to itself. It seems to me that one could define it satisfactorily by saying that his painting emerges from its native bounds in proportion as it is more realist. For Balthus knows that there is no such thing as solitary creation and that to correct reality it is necessary to utilize reality instead of turning one's back on her as is done by so many of our contemporaries. He knows that it is easier to shock than scandalize. Nature is not ugly, she is an object of beauty. If she is unsatisfactory, that is owing to the fact that she is incessantly in movement, both in her creatures and settings. One must therefore compass nature, not deny her. One must select, not destroy. Balthus selects his model at its most accessible point and simultaneously fixes the emotion and the scene with such precision that we are left with the impression of contemplating, as through glass, figures that a kind of enchantment has petrified, not forever, but for the fifth fraction of a second, after which movement will resume—the difference being that the fifth of a second still endures at this moment of writing. And we then perceive that nature, when viewed in such a moment of silence and immobility, is stranger than the strange monsters that take birth in the imagination of men. It is indeed reality, the most familiar kind of reality, with which we are confronted. But we learn, thanks to Balthus the interpreter and translator, that until now we had not really seen it, that lurking amidst our apartments, familiars, and streets were disquieting faces against which we had closed our eyes. We especially learn that the most quotidian reality may have the distant and unwonted air, the sonorous sweetness, the muffled mystery of lost paradises.

It is indeed in this direction that Balthus' talent lies, namely: at the very onset of the already dying day to re-create the un-intermittent day—that day about which he has chosen in his own way to say that it alone is real, that it is the paradise of childhood, green in Balthus as it is in Baudelaire. The theme of the little girl who figures in many of his canvases is very revealing in this respect. Some of the illustrations that Balthus has made for *Wuthering Heights* would not be inappropriate to *Le Grand Meaulnes*. Balthus has understood that one of the keys to this novel in which love calves its howl in an adult rage is the memory of the childlike loves of Cathy and Heathcliff and the terrible nostalgia that these two creatures have carried along with them up to the moment of their final separation. They are literally consumed by nostalgia; and this emotion, which people imagine to be so distinguished, then reveals its true face, the very face of human misery, so blinded and wasted by its exhausting effort to ascend to the source of joy and innocence.

1949

Translated from the French by Jean Stewart

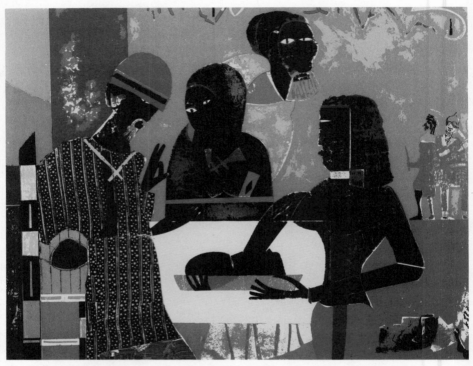

Romare Howard Bearden: *Prevalence of Ritual*, 1974. Color lithograph on paper, 36″ × 29½″. Hirshhorn Museum and Sculpture Garden, Smithsonian Institution, The Joseph H. Hirshhorn Bequest, 1981. 86. 274. 5.

The Art of
Romare Bearden

*I regard the weakening of the importance given to objects as the
capital transformation of Western art. In painting, it is clear
that a painting of Picasso's is less and less a "canvas," and more
and more the mark of some discovery, a stake left to indicate the
place through which a restless genius has passed. . . .*

André Malraux

This series of collages and projections by Romare Bearden represents a triumph of
a special order. Springing from a dedicated painter's unending efforts to master the
techniques of illusion and revelation which are so important to the craft of paint-
ing, they are also the result of Bearden's search for fresh methods to explore the
plastic possibilities of Negro American experience. What is special about Bear-
den's achievement is, it seems to me, the manner in which he has made his dual
explorations serve one another, the way in which his technique has been used to
discover and transfigure its object. For in keeping with the special nature of his
search and by the self-imposed "rules of the game," it was necessary that the meth-
ods arrived at be such as would allow him to express the tragic predicament of his
people without violating his passionate dedication to art as a fundamental and
transcendent agency for confronting and revealing the world.

To have done this successfully is not only to have added a dimension to the tech-
nical resourcefulness of art, but to have modified our way of experiencing reality.
It is also to have had a most successful encounter with a troublesome social anach-

ronism which, while finding its existence in areas lying beyond the special province of the artist, has nevertheless caused great confusion among many painters of Bearden's social background. I say *social*, for although Bearden is by self-affirmation no less than by public identification a Negro American, the quality of his *artistic* culture can by no means be conveyed by that term. Nor does it help to apply the designation "black" (even more amorphous for conveying a sense of cultural complexity), and since such terms tell us little about the unique individuality of the artist or anyone else, it is well to have them out in the open where they can cause the least confusion.

What, then, do I mean by anachronism? I refer to that imbalance in American society which leads to a distorted perception of social reality, to a stubborn blindness to the creative possibilities of cultural diversity, to the prevalence of negative myths, racial stereotypes, and dangerous illusions about art, humanity, and society. Arising from an initial failure of social justice, this anachronism divides social groups along lines that are no longer tenable while fostering hostility, anxiety, and fear; and in the area to which we now address ourselves it has had the damaging effect of alienating many Negro artists from the traditions, techniques, and theories indigenous to the arts through which they aspire to achieve themselves.

Thus, in the field of culture, where their freedom of self-definition is at a maximum and where the techniques of artistic self-expression are most abundantly available, they are so fascinated by the power of their anachronistic social imbalance as to limit their efforts to describing its manifold dimensions and its apparent invincibility against change. Indeed, they take it as a major theme and focus for their attention, they allow it to dominate their thinking about themselves, their people, their country, and their art. And while many are convinced that simply to recognize social imbalance is enough to put it to riot, few achieve anything like artistic mastery, and most fail miserably through a single-minded effort to "tell it like it is."

Sadly, however, the problem for the plastic artist is not one of "telling" at all, but of *revealing* that which has been concealed by time, by custom, and by our trained incapacity to perceive the truth. Thus it is a matter of destroying moribund images of reality and creating the new. Further, for the true artist, working from the top of his times and out of a conscious concern with the most challenging possibilities of his form, the unassimilated and anachronistic—whether in the shape of motif, technique or image—is abhorrent, an evidence of conceptual and/or technical failure, of challenges unmet. And although he may ignore the anachronistic through a preoccupation with other pressing details, he can never be satisfied simply by placing it within a frame. For once there, it becomes the symbol of all that is

not art and mockery of his powers of creation. So at his best he struggles to banish the anachronistic element from his canvas by converting it into an element of style, a device of his personal vision.

For as Bearden demonstrated here so powerfully, it is of the true artist's nature and mode of action to dominate all the world and time through technique and vision. His mission is to bring a new visual order into the world, and through his art he seeks to reset society's clock by imposing upon it his own method of defining the times. The urge to do this determines the form and character of his social responsibility, it spurs his restless exploration for plastic possibilities, and it accounts to a large extent for his creative aggressiveness.

But it is here precisely that the aspiring Negro painter so often falters. Trained by the circumstances of his social predicament to a habit (no matter how reluctant) of accommodation, such an attitude toward the world seems quite quixotic. He is, he feels, only one man, and the conditions which thwart his freedom are of such enormous dimensions as to appear unconquerable by purely plastic means—even at the hands of the most highly trained, gifted, and arrogant artist.

"Turn Picasso into a Negro and *then* let me see how far he can go," he will tell you, because he feels an irremediable conflict between his identity as a member of an embattled social minority and his freedom as an artist. He cannot avoid—nor should he wish to avoid—his group identity, but he flounders before the question of how his group's experience might be given statement through the categories of a nonverbal form of art which has been consciously exploring its own unique possibilities for many decades before he appeared on the scene; a self-assertive and irreverent art which abandoned long ago the task of mere representation to photography and the role of storytelling to the masters of the comic strip and the cinema. Nor can he draw upon his folk tradition for a simple answer. For here, beginning with the Bible and proceeding all the way through the spirituals and blues, novel, poem, and the dance, Negro Americans have depended upon the element of narrative for both entertainment and group identification. Further, it has been those who have offered an answer to the question—ever crucial in the lives of a repressed minority—of who and what they are in the most simplified and graphic terms who have won their highest praise and admiration. And unfortunately, there seems to be (the African past notwithstanding) no specifically Negro American tradition of plastic design to offer him support.

How then, he asks himself, does even an artist steeped in the most advanced lore of his craft and most passionately concerned with solving the more advanced problems of painting as *painting* address himself to the perplexing question of bringing his art to bear upon the task (never so urgent as now) of defining Negro American

identity, of pressing its claims for recognition and for justice? He feels, in brief, a near-unresolvable conflict between his urge to leave his mark upon the world through art and his ties to his group and its claims upon him.

Fortunately for them and for us, Romare Bearden has faced these questions for himself, and since he is an artist whose social consciousness is no less intense than his dedication to art, his example is of utmost importance for all who are concerned with grasping something of the complex interrelations between race, culture, and the individual artist as they exist in the United States. Bearden is aware that for Negro Americans these are times of eloquent protest and intense struggle, times of rejection and redefinition—but he also knows that all this does little to make the question of the relation of the Negro artist to painting any less difficult. And if the cries in the street are to find effective statement on canvas, they must undergo a metamorphosis. For in painting, Bearden has recently observed, there is little room for the lachrymose, for self-pity or raw complaint; and if they are to find a place in painting, this can only be accomplished by infusing them with the freshest sensibility of the times as it finds existence in the elements of painting.

During the late thirties when I first became aware of Bearden's work, he was painting scenes of the Depression in a style strongly influenced by the Mexican muralists. This work was powerful, the scenes grim and brooding, and through his depiction of unemployed workingmen in Harlem he was able, while evoking the Southern past, to move beyond the usual protest painting of that period to reveal something of the universal elements of an abiding human condition. By striving to depict the times, by reducing scene, character, and atmosphere to a style, he caught something of both the universality of Harlem life and the "harlemness" of the national human predicament.

I recall that later, under the dual influences of Hemingway and the poetic tragedy of Federico García Lorca, Bearden created a voluminous series of drawings and paintings inspired by Lorca's *Lament for Ignacio Sánchez Mejías.* He had become interested in myth and ritual as potent forms for ordering human experience, and it would seem that by stepping back from the immediacy of the Harlem experience—which he knew both from boyhood and as a social worker—he was freed to give expression to the essentially poetic side of his vision. The products of that period were marked by a palette which, in contrast with the somber colors of the earlier work and despite the tragic theme with its underlying allusions to Christian rite and mystery, was brightly sensual. And despite their having been consciously influenced by the compositional patterns of the Italian primitives, and the Dutch masters, these works were also resolutely abstract.

It was as though Bearden had decided that in order to possess his world *artistically*, he had to confront it *not* through propaganda or sentimentality, but through the finest techniques and traditions of painting. He sought to re-create his Harlem in the light of his painter's vision, and thus he avoided the defeats suffered by many of the aspiring painters of that period who seemed to have felt that they had only to reproduce, out of a mood of protest and despair, the scenes and surfaces of Harlem in order to win artistic mastery and accomplish social transfiguration.

It would seem that for many Negro painters even the *possibility* of translating Negro American experience into the modes and conventions of modern painting went unrecognized. This was, in part, the result of an agonizing fixation upon the racial mysteries and social realities dramatized by color, facial structure, and the texture of Negro skin and hair. And again, many aspiring artists clung with protective compulsiveness to the myth of the Negro American's total alienation from the larger American culture—a culture which he helped to create in the areas of music and literature, and where in the area of painting he has appeared from the earliest days of the nation as a symbolic figure—and allowed the realities of their social and political situation to determine their conception of their role and freedom as artists.

To accept this form of the myth was to accept its twin variants, one of which holds that there is a pure mainstream of American culture which is "unpolluted" by any trace of Negro American style or idiom, and the other (propagated currently by the exponents of *Negritude*) which holds that Western art is basically racist, and thus anything more than a cursory knowledge of its techniques and history is to the Negro artist irrelevant. In other words, the Negro American who aspired to the title "Artist" was too often restricted by sociological notions of racial separatism, and these appear not only to have restricted his use of artistic freedom, but to have limited his curiosity as to the abundant resources made available to him by those restless and assertive agencies of the artistic imagination which we call technique and conscious culture.

Indeed, it has been said that these disturbing works of Bearden's (which literally erupted during a tranquil period of abstract painting) began quite innocently as a demonstration to a group of Negro painters. He was suggesting some of the possibilities through which commonplace materials could be forced to undergo a creative metamorphosis when manipulated by some of the nonrepresentational techniques available to the resourceful craftsman. The step from collage to projection followed naturally, since Bearden had used it during the early forties as a means of studying the works of such early masters as Giotto and de Hooch. That he went on

to become fascinated with the possibilities lying in such "found" materials is both an important illustrative instance for younger painters and a source for our delight and wonder.

Bearden knows that regardless of the individual painter's personal history, taste, or point of view, he must, nevertheless, pay his materials the respect of approaching them through a highly conscious awareness of the resources and limitations of the form to which he has dedicated his creative energies. One suspects also that as an artist possessing a marked gift for pedagogy, he has sought here to reveal a world long hidden by the clichés of sociology and rendered cloudy by the distortions of newsprint and the false continuity imposed upon our conception of Negro life by television and much documentary photography. Therefore, as he delights us with the magic of design and teaches us the ambiguity of vision, Bearden insists that we *see* and that we see in depth and by the fresh light of the creative vision. Bearden knows that the true complexity of the slum dweller and the tenant farmer requires a release from the prison of our media-dulled perception and a reassembling in forms which would convey something of the depth and wonder of the Negro American's stubborn humanity.

Being aware that the true artist destroys the accepted world by way of revealing the unseen, and creating that which is new and uniquely his own, Bearden has used cubist techniques to his own ingenious effect. His mask-faced Harlemites and tenant farmers set in their mysteriously familiar but emphatically abstract scenes are nevertheless resonant of artistic and social history. Without compromising their integrity as elements in plastic compositions his figures are expressive of a complex reality lying beyond their frames. While functioning as integral elements of design, they serve simultaneously as signs and symbols of a humanity that has struggled to survive the decimating and fragmentizing effects of American social processes. Here faces which draw upon the abstract character of African sculpture for their composition are made to focus our attention upon the far from abstract reality of a people. Here abstract interiors are presented in which concrete life is acted out under repressive conditions. Here, too, the poetry of the blues is projected through synthetic forms which, visually, are in themselves tragicomic and eloquently poetic. A harsh poetry this, but poetry nevertheless; with the nostalgic imagery of the blues conceived as visual form, image, pattern, and symbol—including the familiar trains (evoking partings and reconciliations) and the conjure women (who appear in these works with the ubiquity of the witches who haunt the drawing of Goya) who evoke the abiding mystery of the enigmatic women who people the blues. And here, too, are renderings of those rituals of rebirth and

dying, of baptism and sorcery which give ceremonial continuity to the Negro American community.

By imposing his vision upon scenes familiar to us all, Bearden reveals much of the universally human which they conceal. Through his creative assemblage he makes complex comments upon history, upon society, and upon the nature of art. Indeed, his Harlem becomes a place inhabited by people who have in fact been *resurrected*, re-created by art, a place composed of visual puns and artistic allusions and where the sacred and profane, reality and dream are ambiguously mingled. And resurrected with them in the guise of fragmented ancestral figures and forgotten gods (really masks of the instincts, hopes, emotions, aspirations and dreams) are those powers that now surge in our land with a potentially destructive force which springs from the very fact of their having for so long gone unrecognized, unseen.

Bearden doesn't impose these powers upon us by explicit comment, but his ability to make the unseen manifest allows us some insight into the forces which now clash and rage as Negro Americans seek self-definition in the slums of our cities. There is a beauty here, a harsh beauty that asserts itself out of the horrible fragmentation which Bearden's subjects and their environment have undergone. But, as I have said, there is no preaching; these forces have been brought to eye by formal art. These works take us from Harlem through the South of tenant farms and northward-bound trains to tribal Africa; our mode of conveyance consists of every device which has claimed Bearden's artistic attention, from the oversimplified and scanty images of Negroes that appear in our ads and photo-journalism, to the discoveries of the School of Paris and the Bauhaus. He has used the discoveries of Giotto and Pieter de Hooch no less than those of Juan Gris, Picasso, Schwitters, and Mondrian (who was no less fascinated by the visual possibilities of jazz than by the compositional rhythms of the early Dutch masters), and has discovered his own uses for the metaphysical richness of African sculptural forms. In brief, Bearden has used (and most playfully) all of his artistic knowledge and skill to create a curve of plastic vision which reveals to us something of the mysterious complexity of those who dwell in our urban slums. But his is the eye of a painter, not that of a sociologist, and here the elegant architectural details which exist in a setting of gracious but neglected streets and the buildings in which the hopeful and the hopeless live cheek by jowl, where failed human wrecks and the confidently expectant explorers of the frontiers of human possibility are crowded together as incongruously as the explosive details in a Bearden canvas—all this comes across plastically and with a freshness of impact that is impossible for sociological cliché or raw protest.

Where any number of painters have tried to project the "prose" of Harlem—a task performed more successfully by photographers—Bearden has concentrated upon releasing its poetry, its abiding rituals and ceremonies of affirmation—creating a surreal poetry compounded of vitality and powerlessness, destructive impulse, and the all-pervading and enduring faith in their own style of American humanity. Through his faith in the powers of art to reveal the unseen through the seen, his collages have transcended their immaculateness as plastic constructions. Or to put it another way, Bearden's meaning is identical with his method. His combination of technique is in itself eloquent of the sharp breaks, leaps in consciousness, distortions, paradoxes, reversals, telescoping of time, and surreal blending of styles, values, hopes, and dreams which characterize much of Negro American history. Through an act of creative will, he has blended strange visual harmonies out of the shrill, indigenous dichotomies of American life, and in doing so, reflected the irrepressible thrust of a people to endure and keep its intimate sense of its own identity.

Bearden seems to have told himself that in order to possess the meaning of his Southern childhood and Northern upbringing, that in order to keep his memories, dreams, and values whole, he would have to re-create them, humanize them by reducing them to artistic style. Thus, in the poetic sense, these works give plastic expression to a vision in which the socially grotesque conceals a tragic beauty, and they embody Bearden's interrogation of the empirical values of a society that mocks its own ideals through a blindness induced by its myth of race. All this, ironically, by a man who visually at least (he is light-skinned and perhaps more Russian than "black" in appearance) need never have been restricted to the social limitations imposed upon easily identified Negroes. Bearden's art is therefore not only an affirmation of his own freedom and responsibility as an individual and artist, it is an affirmation of the irrelevance of the notion of race as a limiting force in the arts. These are works of a man possessing a rare lucidity of vision.

1968

Wayne Thiebaud: *San Francisco Intersection*, 1977. Graphite drawing, 30″×22″. Private collection.

LEONARD MICHAELS

Thiebaud's City

It's a bright day in San Francisco, but nobody is out walking, cars and trucks go without drivers, and a police cruiser sits at the curb, abandoned in the empty streets that radiate from an intersection below. They swoop and stand straight up. The police cruiser sits illegally parked, front wheels not cut against the curb as required by law in San Francisco, but nobody is present to see, to object, to enforce laws. The viewer of the drawing is alone, his privacy guaranteed, his conscience liberated. He may indulge himself, see everything unviolated by any other consciousness. The emptiness is pure, like the emptiness of prairies, not urban vacancy. Were anyone present in the drawing, walking or driving, the exuberant adventure of these streets wouldn't seem so nakedly apparent. The police cruiser—municipal eye—casts a shadow, an expression of its blindness.

In some of his portraits, Thiebaud also eliminates the pressures of others seeing. He waits for the mind, or the conscious self, to fall away from the features, revealing a blank stillness. Faces look out from it, but don't see. A strange, scientific innocence emerges, reminiscent of surrealists who thingify people and discover animacy in things. Among writers this modern vision also obtains. Kafka applies it to himself in an ecstasy of annihilation:

> A picture of my existence . . . would portray a useless stake covered with snow and frost, fixed loosely and slantwise in the ground in a deeply plowed field on the edge of a great plain on a dark winter's night.

Useless, powerless, blinded by snow yet able to see that he is invisible and nothing against the energy of the deeply plowed and useful field, greatness of the plain, cold

and dark of the night. In a similar way, Thiebaud's streets live tremendously while people exist only by implication, like the invisible drivers of a child's toy trucks and cars. All the potential consciousness inherent in other people is eliminated, or surrendered to the viewer's privacy; but, confronted by these empty spectacular streets, he may feel his own absence from them, too. The effect is a mysterious all-seeing loneliness, a bit scary as well as sensuously exhilarating. The effect is well known to painters, poets, novelists, and children, but there is no word for it in English. It is natural seeing in a moment unconstrained by any communal formula, any ideas, any other mind or eye. Wallace Stevens writes about it incessantly. "One must have a mind of winter," he says, and one must become nothing in order to behold the "Nothing that is not there and the nothing that is."

In England it is said one lives "in" a street. Americans say one lives "on" a street, as a town is built on a river, beside-and-separate-from the flow. The English preposition keeps the idea of street as a way, a flow of traffic "in" which one lives, as if there were no strict boundary between the privacy of homes and the public place. Thiebaud's streets are also ways, but they are full of force and direction, a wildness shooting through real estate. Seeing his streets for the first time, if you know San Francisco, is shocking. You realize that you'd never truly seen the city before.

In contrast, consider New York's streets, how nothing they contain isn't qualified by others seeing it. In those streets, there is an oppressive intimacy and utter impersonality at once. Everything you see is already seen by millions upon millions of others, and whatever is, is as others see it. Though not exactly old, New York feels ancient, European, deeply known as well as knowing. Its streets mean sidewalks, no fancy intuitions, just concrete beaten dead by the passage of peoples. Below them live other populations, cryptozoic societies teeming in darkness. In Thiebaud's city nothing is cryptic. Broad daylight reigns, an exultation of supreme visibility. His San Francisco is stark, bright, barbaric, original, unique.

1988

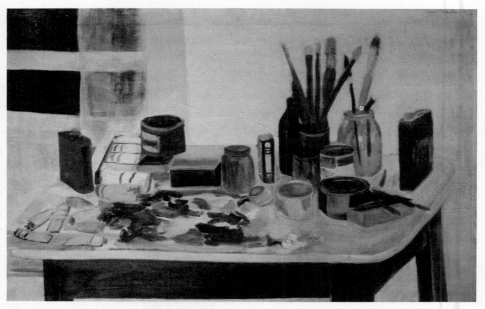

Jane Freilicher: *The Painting Table*, 1954. Oil on canvas, 26″ × 40″. Collection of John Ashbery. Photo courtesy of Fischbach Gallery, New York.

On Jane Freilicher

I first met Jane Freilicher one afternoon in the early summer of 1949. I had recently graduated from Harvard and had somewhat reluctantly decided to move to New York, having been simultaneously rejected by the graduate school of English at Harvard and accepted by Columbia. Kenneth Koch, who had graduated the year before me, had been urging me to come and live in New York. He was at the time visiting his parents in Cincinnati, and told me I could stay in his loft (loft?) till he got back; his upstairs neighbor Jane would give me the keys. Accordingly I found myself ringing the bell of an unprepossessing three-story building on Third Avenue at Sixteenth Street. Overhead the El went crashing by; I later found that one of Kenneth's distractions was to don a rubber gorilla mask and gaze out his window at the passing trains.

After a considerable length of time the door was opened by a pretty and somewhat preoccupied dark-haired girl, who showed me to Kenneth's quarters on the second floor. I remembered that Kenneth had said that Jane was the wittiest person he had ever met, and found this odd; she seemed too serious to be clever, though of course one needn't preclude the other. I don't remember anything else about our first meeting; perhaps it was that same day or a few days later that Jane invited me into her apartment on the floor above and I noticed a few small paintings lying around. Noticed is perhaps too strong a word; I was only marginally aware of them though I found that they did stick in my memory. As I recall, they were landscapes with occasional figures in them; their mood was slightly expressionist though there were areas filled with somewhat arbitrary geometrical patterns. Probably she told me she had done them while studying with Hans Hofmann, but it wouldn't have

mattered since I hadn't heard of him or any other member of the New York School at that time. My course in twentieth-century art at Harvard had stopped with Max Ernst. (For academic purposes it was okay to be a surrealist as long as the period of surrealism could be seen as being in the past, and things haven't changed much since.)

Despite or because of our common trait of shyness, Jane and I soon became friends and I met other friends of hers and Kenneth's, most of whom turned out to be painters and to have had some connection with Hofmann. (This is not the place to wonder why the poets Koch, O'Hara, Schuyler, Guest and myself gravitated toward painters; probably it was merely because the particular painters we knew happened to be more fun than the poets, though I don't think there were very many poets in those days.) There was Nell Blaine, whom the others seemed in awe of and who differed from them in championing a kind of geometric abstraction inflected by Léger and Hélion, both of whom had spent part of the war years in New York. There were Larry Rivers, Robert de Niro and Al Kresch, who painted in a loose figurative style that echoed Bonnard and Matisse but with an edge of frenzy or anxiety that meant New York; I found their work particularly exciting. And there was Jane, whose paintings of the time I still don't remember very clearly beyond the fact that they seemed to accommodate both geometry and expressionist surges, and they struck me at first as tentative, a quality I have since come to admire and consider one of her strengths, having concluded that most good things are tentative, or should be if they aren't.

At any rate, Jane's work was shortly to change drastically, as was mine and that of the other people I knew. I hadn't realized it, but my arrival in New York coincided with the cresting of the "heroic" period of abstract expressionism, as it was later to be known, and somehow we all seemed to benefit from this strong moment even if we paid little attention to it and seemed to be going our separate ways. We were in awe of de Kooning, Pollock, Rothko and Motherwell and not too sure of exactly what they were doing. But there were other things to attend to: concerts of John Cage's music, Merce Cunningham's dances, the Living Theatre, but also talking and going to movies and getting ripped and hanging out and then discussing it all over the phone: I could see all of this entering into Jane's work and Larry's and my own. And then there were the big shows at the Museum of Modern Art, whose permanent collection alone was stimulation enough for one's everyday needs. I had come down from Cambridge to catch the historic Bonnard show in the spring of 1948, unaware of how it was already affecting a generation of young painters who would be my friends, especially Larry Rivers who turned from playing jazz to painting at that moment of his life. And soon there would be equally breathtaking

shows of Munch, Soutine and Matisse, in each of whom—regardless of the differences that separate them—one finds a visceral sensual message sharpened by a shrill music or perfume emanating from the paint, that seemed to affect my painter friends like catnip. Soutine, in particular, who seems to have gone back to being a secondary modern master after the heady revelation of his MOMA show in 1950, but whose time will undoubtedly come again, was full of possibilities both for painters and poets. The fact that the sky could come crashing joyously into the grass, that trees could dance upside down and houses roll over like cats eager to have their tummies scratched, was something I hadn't realized before, and I began pushing my poems around and standing words on end. It seemed to fire Jane with a new and earthy reverence toward the classic painting she had admired from a distance, perhaps, before. Thus she repainted Watteau's *Le Mezzetin* with an angry, loaded brush, obliterating the musician's features and squishing the grove behind him into a seething whirlpool, yet the result is noble, joyful, generous: qualities that subsist today in her painting, though the context is calmer now than it was then. The one thing lacking in our privileged little world (privileged because it was a kind of balcony overlooking the interestingly chaotic events happening in the bigger worlds outside) was the arrival of Frank O'Hara to kind of cobble everything together and tell us what we and they were doing. This happened in 1951, but before that Jane had gone out to visit him in Ann Arbor and painted a memorable portrait of him, in which abstract expressionism certainly inspired the wild brushwork rolling around like so many loose cannon, but which never loses sight of the fact that it is a portrait, and an eerily exact one at that.

After the early period of absorbing influences from the art and other things going on around one comes a period of consolidation when one locks the door in order to sort out what one has and to make of it what one can. It's not a question— at least I hope it isn't—of shutting oneself off from further influences: these do arrive, and sometimes, although rarely, can outweigh the earlier ones. It's rather a question of conserving and using what one has acquired. The period of analytical cubism and its successor, synthetic cubism, is a neat model for this process, and there will always be those who prefer the crude energy of the early phase to the more sedate and reflective realizations of the latter. Although I have a slight preference for the latter, I know that I would hate to be deprived of either. I feel that my own progress as a writer began with my half-consciously imitating the work that struck me when I was young and new; later on came a doubting phase in which I was examining things and taking them apart without being able to put them back together to my liking. I am still trying to do that; meanwhile, the steps I've outlined recur in a different order over a long period or within a short one. This far longer time is that

of being on one's own, of having "graduated," and having to live with the pleasures and perils of independence.

In the case of Jane Freilicher one can see similar patterns. After the rough ecstasy of the Watteau copy or a frenetic Japanese landscape she once did from a postcard, came a phase in the mid-fifties when she seemed to be wryly copying what she saw, as though inviting the spectator to share her discovery of how impossible it is really to get anything down, get anything right: examples might be the painting done after a photograph by Nadar of a Second-Empire *horizontale* (vertical for the purposes of the photograph) with sausage curls; or a still life whose main subject is a folded Persian rug precisely delineated with no attempt to hide the fact of the hard work involved. Her realism is far from the "magic" kind that tries to conceal the effort behind its making and pretends to have sprung full-blown onto the canvas. Such miracles are after all minor. Both suave *facture* and heavily worked-over passages clash profitably here, as they do in life, and they continue to do so in her painting, though more subtly today than then. That is what I meant by "tentative." Nothing is ever taken for granted; the paintings do not look as if they took themselves for granted, and they remind us that we shouldn't take ourselves for granted either. Each is like a separate and valuable life coming into being.

I was an amateur painter long enough to realize that the main temptation when painting from a model is to generalize. No one is ever going to believe the color of that orange, one says to oneself, therefore I'll make it more the color that oranges "really" are. The model isn't looking like herself today—we'll have to do something about that. Or another person is seated on the grass in such a way that you would swear that the tree branch fifty feet behind him is coming out of his ear. So lesser artists correct nature in a misguided attempt at heightened realism, forgetting that the real is not only what one sees but also a result of how one sees it—inattentively, inaccurately perhaps, but nevertheless that is how it is coming through to us and to deny this is to kill the life of the picture. It seems that Jane's long career has been one attempt to correct this misguided, even blasphemous, state of affairs; to let things, finally, be.

One of my favorite pictures from this period of slightly rumpled realism—which, in my opinion, though perhaps not in hers, reflects a quiet reaction against expressionism, impressionism and realism all at once—a kind of "Okay but let's see what else there is" attitude—is a still life I own, of a metal kitchen table that she once used as a palette. It was perhaps done in a tiny cold-water flat in the East Village that was her studio in the mid-fifties. The walls were (and are in the picture) an unglamorous off-white, and there was little that was eye-catching in the apartment beyond some Persian-print bedspreads, potted plants and cut flowers, which suffice to animate the pictures of that period with luscious but low-keyed arabesques

that wouldn't be out of place in Matisse's Nice hotel room paintings of the twenties. (One of Jane's most beautiful works and one of the most magical paintings I know is a picture of a vase of iris on a windowsill at night, with the fuming smokestacks of a Con Ed plant in the background, proving that *luxe, calme* and *volupté* are where you find them.) Perhaps I chose the painting-table still life because of my own fondness for a polyphony of clashing styles, from highbred to demotic—in a given poem, musical composition (the "post-modern eclecticism"—unfortunate term—of David del Tredici and Robin Holloway, for instance) or picture. *The Painting Table* is a congeries of conflicting pictorial grammars. There is a gold paint can rendered with a mellow realism that suggests Dutch still life painting, but in the background there is a reddish coffee can (Savarin?) that is crudely scumbled in, whose rim is an arbitrarily squeezed ellipse—one understands that this wasn't the shape of the can, but that the painter decided on a whim that it would be this way for the purposes of the picture. Other objects on the table are painted with varying degrees of realism, some of them—the flattened tubes of paint and the blobs of pigment—hardly realistic at all. There is even a kind of humor in the way the pigment is painted. What better way than to just squeeze it out of the tube onto the flat surface of the canvas, the way it is in fact lying on the surface of the table, reality "standing in" for itself? But she doesn't leave it entirely at that, there are places where she paints the image of the pigment too, so that one can't be exactly sure where reality leaves off and illusion begins. The tabletop slants up, the way tabletops are known to do in art since Cézanne—but this seems not the result of any expressionist urge to set things on edge but rather an acknowledgment that things sometimes look this way in the twentieth century, just as the gold tin can is allowed to have its way and be classical, since that is apparently what it wants. The tall, narrow blue can of turpentine accommodates itself politely to this exaggerated perspective, but the other objects aren't sure they want to go along, and take all kinds of positions in connivance with and against each other. The surrounding room is barely indicated except for the white wall and a partly open window giving on flat blackness. (Is it that these objects have come to life at night, like toys in some *boutique fantasque*?) The result is a little anthology of ways of seeing, feeling and painting, with no suggestion that any one way is better than another. What *is* better than anything is the renewed realization that all kinds of things can and must exist side by side at any given moment, and that that is what life and creating are all about.

One would expect that a painter who could give the assorted objects found on a tabletop at a given moment their due would not go out of her way to arrange things so as to make some point, and one would be right. It's always possible to tell whether a still life has been posed, even those that are meant to look chaotic and arbitrary,

just as one can tell a *plein air* landscape from one composed in the studio. The artists of the world can be divided into two groups: those who organize and premeditate, and those who accept the tentative, the whatever happens along. And though neither method is inherently superior, and one must always proceed by cases, I probably prefer more works of art that fall in the latter category. Not surprisingly, Jane Freilicher has never gone very far from home ("Wherever that may be," as Elizabeth Bishop reminds us) in search of things to paint. During the past twenty years she has divided the year between New York and a summer home in Water Mill, Long Island, and most of her paintings have been of views from her studio windows in both places, or of still lifes, self-portraits or portraits of friends. In 1975, as one of a group of artists commissioned by the Department of the Interior to paint the American scene for a show commemorating the Bicentennial, she was offered a trip to any American site she wished to paint, but settled for the landscape outside her window—a suitably American decision in the circumstances, for hasn't our popular music told us that "That bird with feathers of blue / Is waiting for you / Back in your own backyard"? Not that there is anything rigid or doctrinaire, either, in her choice. As must be obvious by now, such qualities are entirely absent from her work, but neither is there any implication that her surroundings are a bill of goods that has been paid for and must therefore make its presence known on canvas: she is capable of including a cat copied from Gainsborough in an otherwise straightforward inventory of the studio's contents on a particular day—a shaggy bouquet of flowers with window, landscape and sky.

She has become one of those artists like Chardin, Cézanne or Giacometti who, unlike Delacroix or Gaugin, find everything that they need close at hand, and for whom the excitement of their craft comes not from the exotic costumes that reality wears in different parts of the world, but in the slight disparities in the sybilline replies uttered by a fixed set of referents: the cat, the blue pitcher, the zinnias, the jumble of rooftops or stretch of grass beyond the window. Yet how enormously, disconcertingly varied these answers can be. And how confusingly different replies to the same question ("What do I see?") would be if one lost sight of the fact that each is a major piece in the puzzle, that the only single answer is the accumulation of all of them, with provision made for those still to come. We should never lose sight of what Robert Graves, in his most famous line of poetry, tells us: "There is one story and one story only." But it is even more important to remember that it is minute variations in the telling that make this situation bearable and finally infinitely rich, richer than the anxious inventions of Scheherazade. Luckily we have artists of Jane Freilicher's stature to remind us.

1986

CYRIL CONNOLLY

Surrealism

1.

Looking back upon Surrealism—for, although the movement is still active in Paris under its vigorous leader, the momentum decreases, the fissions multiply—we cannot fail to become more and more impressed by the spectacle of what was without question the greatest artistic commotion of the twentieth century and one of the few enlargements of sensibility in the last thirty years which stand to the credit of humanity.

There is a tendency to discuss Surrealism and Cubism as if one proceeds out of the other, but in fact there is no similarity. Cubism was a way of painting which a group of painters imposed on themselves, Surrealism a philosophy of life put forward by a band of poets. The first was essentially a method of breaking up the object and putting it together again according to concepts of pictorial structure, a phase of the greatest importance in the development of such painters as Picasso, Braque, Marcoussis and Gris, but affecting literature only through Apollinaire, and life hardly at all. The second was the attempt of a highly organized group to change life altogether, to make a new kind of man. *"Le surréalisme n'est pas une école littéraire ou critique. C'est un état d'esprit. A notre époque, seule l'imagination peut rendre aux hommes menacés le sentiment d'être libres."* ("Surrealism is neither a literary school nor a method of criticism. It is a state of mind. In our time, only the imagination can give back to mankind in peril the idea of liberty"—invitation to the international Surrealist exhibition in Amsterdam.) So in discussing Surrealism it is necessary to forget terms like Cubist, Fauve, Abstract, Post-Impressionist—which

belong to painting, as Symbolist belongs to poetry—and to think of Surrealism as a new interpretation of life, as the name of one of the last and fiercest explosions in our human consciousness which has been detonating since Heraclitus and Galileo. This last combustion, whose effects we are still experiencing, was brought about by a few young poets dreaming of what man ought to be. As Aragon wrote, "It's a question of arriving at a new declaration of the rights of man."

2.

Why a group? "Here's the essential thing. A group is the beginning of everything. The isolated individual can do nothing, reach nowhere. A properly directed group can do a great deal and has a good chance of getting results which one man would never be in a position to obtain. You don't realize your own situation. You are all in prison. All you want, if you are in your right mind, is to escape. But how can we escape? We must break through the walls, dig a tunnel. One man can accomplish nothing. But suppose there are ten or twenty and that they all take their turn, by combining together they can finish the tunnel and escape. Besides, no one can escape from the prison without the help of those who have got out already." (Gurdjev, quoted by Ouspensky, quoted by the Surrealists.)

3.

In the beginning was the word. The word was "Dada." The darkest moments of European wars are strangely propitious to new movements in art. There is an awareness of absolutes, a closing-in on the self; like those pine cones which germinate only in forest fires, the rarest talents are liberated by the deepest despair. Zurich, Swiss capital of German humanism, was the scene in 1916–17 of a strange incubation. Here, while the battle of Verdun was raging, James Joyce was quietly working on *Ulysses*, here collected the war-weary and war-desperate, displaced neutrals or refugees from conscription like the German war-poet Hugo Ball, who opened in 1916 the Cabaret Voltaire. In it congregated Richard Huelsenbeck, another German poet in exile; Jean Arp, Alsatian poet, sculptor and painter; Tristan Tzara, young Rumanian poet. The fear of extinction which dominated the group led to a concerted attempt to render ridiculous the powers which were destroying the world they knew. Choosing the word "Dada" haphazard from a dictionary (according to the legend), they baptized their revolt against futility in terms of futility.

The movement had no positive quality but an exhibitionism of the Absurd; being against "art" ("Art is rubbish" wrote Jacques Vaché in 1918), its only medium was nonsense—the use of nonsense in public to discredit all forms of sense. This nihilism suited the angry despair of German intellectuals in defeat, and Dada groups soon formed in Berlin, Hanover and Cologne, contributing Baader, Baar-

geld, Kurt Schwitters, Max Ernst and many others. Meanwhile a similar trend had come into the open in New York where Marcel Duchamp from Paris, Picabia from Barcelona and Man Ray, in their prophetic discontent, had published the review *291*. After the war all these bands converged on Paris. The greater the ability, the deeper the disgustability—only thus can we explain the presence of such pure artists as Ernst, Arp and Schwitters or the three painters from America in this troupe of destructive harlequins.

In Paris, Tzara and Baargeld, with their sublime Dadaist effrontery, immediately triumphed; art and life were rejected as impostures equally vile. The first to rally round the invaders from the East was a handful of very young poets, just released from their war-service: André Breton, a hospital interne, and Louis Aragon, a law student; Paul Eluard, Philippe Soupault, Benjamin Péret. (Breton himself had been greatly influenced by an isolated and undeclared Dadaist, Jacques Vaché, who had just committed suicide.) In 1919 this disillusioned group had founded the magazine *Littérature*, in 1920 Breton and Soupault collaborated on *Les Champs Magnétiques* and Max Ernst gave an exhibition in Paris of his first collages, with Breton's introduction. All sought inspiration in three isolated and unfortunate geniuses of the nineteenth century, poets with a contempt for humanity and a deep hatred of "literature": Lautréamont, Rimbaud and Jarry. Both the Dadaists and the young French band, however, revered the poet of the avant-garde and interpreter of Cubism whose death was so recent, Apollinaire.

At first the combination seemed to work smoothly, giving birth to books, magazines, pictures and, above all, to scandal-making public meetings, until towards the end of 1921 a quarrel of capital importance broke out between Breton and Tzara. Breton was fundamentally a poet who wished to facilitate the germination of new beauty from those lofty arts which the necessary whirlwind of Dada had uprooted. Tzara was the destructive showman. "The true Dadaist is against Dada"— this terrible and logical axiom of Tzara would in the end render all action impossible. The absurd cannot engender even absurdity without some order creeping in. In Dada the pendulum of European vitality had reached the extreme point of its arc, the impetus of defeat and despair had exhausted itself, and as Communism was now replacing nihilism, capitalism beginning its recovery, Mussolini marching on Rome, insulin and the tomb of Tutankhamen being discovered, so Breton's party won. Dada abdicated and Surrealism was born.

4.

Surrealism—out of respect to Apollinaire the word was borrowed from his last play-title—means the reality which lies beyond what we call real. As a former medical student who had treated the shell-shocked, Breton was familiar with

Freud and, after the revelation of automatic writing which occasioned his first book with Soupault, it was clear to him that the reality beyond reality (Nerval's "supernaturalism") was the subconscious mind, the universal truth that underlies all poetry, all imagery, all desire and which Lautréamont and Rimbaud had drawn on inexhaustibly, the truth in reach of all that reason is bribed to deny. The German Dada movement however was inclined to Bolshevism and was as susceptible to Marx as were the Surrealists to Freud. The revolutionary element in Surrealism was therefore twofold, it was a revolt of the psyche, against the authority of reason, it was also an appeal to reason to liberate man from his oppressors—family, church, fatherland, boss. It embraced both Freud and Hegel, the promenade which the iron pot in the fable forces on the uneasy earthenware vessel had already begun.

The early years of the group, before the inner tensions became intolerable, can only be described as magical. The youthful Surrealists possessed talent, courage and charm: they had also experienced a revelation, a glimpse of a dream-dazzled world: "The marvelous is always beautiful, anything that is marvelous is beautiful; indeed nothing but the marvelous is beautiful," wrote Breton. They lived only for these mystic glimpses and for each other; while the group held together, and was strong enough to pulverize its enemies, excommunication from it was a kind of torture. Meeting in large cafés on Montmartre or in the now-demolished Passage de l'Opéra, drinking Mandarin-curaçaos, whiling the afternoons away applauding at films in the wrong places, they would pass the evening in conversation, composition, confession or love, being driven on by an apostolic intoxication of liberty. To a conventional young Englishman they represented the very arcana of Paris, the spirit of insurrection arising from its most sacred flaking quarters, the dark and shabby corners which they loved—Buttes Chaumont, Musée Grévin, Rue de la Lune—alight with their revolutionary intelligence and gaiety. I remember seeing them all one summer evening in the fun fair of Luna Park, in the blue suits and white knitted ties they affected, gathering like a band of gibbons around "La Femme Tronc," a legless, armless wonder with a charming face who was seated on a marble pedestal, signing a photograph of herself for them with a pen held in her teeth. The brotherhood seemed to have long given up all recognized means of livelihood and to exist only for the ecstasy of the mystical experience—"eager to discover the formula and the place."

5.

In this early period the poets dominated the scene. Breton, Aragon, Eluard, Péret, Desnos, Char, Soupault and Crevel—they formed a central committee. Ernst,

Miró, Tanguy, Arp, Man Ray, Picabia were honored but not the framers of policy. Books like Breton's *Nadja* or Aragon's *Paysan de Paris* or the poems of Eluard and Péret with their affirmations of the dream and hatred of humanism seemed the supreme expression of the movement. But the painters were steadily gaining in authority. They could reach a wider public and, by the nature of their work, they were less involved in political purges. They were allowed to make a reasonable income from their pictures in a manner which was not permitted to those who sought a living from their articles. As Breton wrote: "Surrealism requires from its participators that they should observe the utmost purity of mind and life . . . and is less ready than ever to accept departures from this purity which are justified by the obscure and revolting pretext that 'one must live.'"

The dissensions within the movement sprang from three causes, the attempted Freud-Marx synthesis, the Dada legacy and the economic problem. Although automatic writing had been accepted as the principal literary method of Surrealism, as the secret weapon by which reason was to be overthrown and the poetry of super-reality placed within reach of all, the new vision had certain inconveniences: it became impossible to earn a living by one's books and thus some of the weaker vessels were driven into journalism, for which they were publicly excommunicated. Nor was it a weapon of much efficacy in the class struggle and one or two persistent dreamers, like Desnos and Artaud, were viciously expelled as a-political. As under Dada, the revolution came first and words were only to be used "to wring the neck of literature."

While a team of scientific researchers can devote themselves quietly to their pursuit, the Surrealists had inherited from Dada a taste for public manifestation. The group-spirit evolved according to the laws which govern groups: manifestoes, excommunications, public penitences, secret betrayals; it was avid for notoriety and sensation and to miss a meeting was to court disaster. The Surrealists were too dynamic to consider the overthrowing of reason by the unconscious as separate from the destruction of bourgeois capitalism (the society which reason had created), they refused to be called parlor revolutionaries whose activities were merely aesthetic, and therefore they handed themselves over to the Communist Party as Marxist shock troops to be employed as it thought best. The automatic writing of the poets was frequently combined with a vicious polemical style, with "humor" (in the sense of a macabre, cannibal-sadistic gaiety) as the common factor of both. *Un Cadavre*, a pamphlet deriding the obsequies of Anatole France (1924), is the first of the "jokes in bad taste" with which the group achieved notoriety in the name of integrity. The swing to Communism left several Surrealists behind when Breton—unable to accept the disciplines of a party-line—veered back towards Trot-

skyism and the formation of an independent aesthetic and revolutionary move-
ment.

Around 1931, the widely advertised defection of Aragon to the Communists
and the entry into film-making of Dali altered the balance of power. The visual arts
and the exhibitions connected with them attracted far more attention to the move-
ment than Breton's search for his precise political position or automatic writing as
"the communism of genius." Dali's eventual marriage to Gala, ex-wife of the poet
Eluard, seemed a symbolic consecration of the new emphasis.

6.

The master of Surrealist painting was Max Ernst. This great self-taught artist, with
his bold eclectic imagination, passed effortlessly from Dada in Cologne into the
Freudian Surrealist pantheon. The doctrines of Breton seemed especially created
for him. His collages, arrangements of cut-out nineteenth-century illustrations to
provoke disquieting, ironical and erotic suggestions were, like so much Surrealist
art, essentially literary. They adapted the fantastic children's world of half a cen-
tury before to the sophisticated wonder-seeker. *La femme cent têtes* (1929) and
Rêve d'une petite fille (1930) are somewhat monotonous, but the *Semaine de Bonté*
or, rather, the *Seven Elements* as it was subtitled, is one of the masterpieces of the
movement, a reassembling of lion-headed or bird-faced supermen and their pas-
sionate consorts with their adventures "by flood and field" into a sequence new,
beautiful and disturbing—a tragic-strip from the Minotaur's nursery. The roman-
tic nineteenth century was the epoch wherein the Surrealists felt most at home,
and Germany the place; in the master from Cologne they possessed a magician
who could create around some familiar feature, like Paris' statue of the *Lion de Bel-
fort*, a new mythology of poetry, bloodshed, unrest and nostalgia.

The three great forerunners of Surrealist painting stood in a very different re-
lation. Chirico, whose early work presents a closed world of the imagination, al-
ready perfect and passing away, a dream of urban apprehension, a haunted inner
city of squares and statues, of freight trains and grief-stricken colonnades in the last
second before the explosion, this once most Surrealist of all painters, before the
fact, had begun to trick and evade, copying ineffectually his old paintings (accord-
ing to Breton) and falsifying the dates. He had seen the vision but was unworthy and
soon was drifting into the paranoiac false classicism of Mussolini. Chagall re-
mained a little too Oriental, his imagination was like a peasant's fairy story, mar-
velous, certainly, but without the tragic intelligence of the Surrealists. Picasso,
though for a time thoroughly Surrealist, had also been undeniably Cubist and
would soon become what else? This giant fish, after reflecting a moment's glory on

the Surrealist anglers, would break the net. It was not painters who were Surrealist for whom they were looking, but Surrealists who were painters.

Two more Simon Pures were found in Tanguy and Miró. Tanguy's world was another closed private garden, an allotment of poisonous plants from remoter planets, landscapes of which it would be impossible to say that life doesn't exist in them or to prove that it does. Like many Surrealists, he was obsessed by perspective and, somewhat constricted in his handling of paint, original only in the content of his dream. His world is static, as if he had secret access to an inexhaustible supply of Mars salad and Venus weed. Miró, unlike the others, is essentially a pattern-maker, an artist in whom an exquisite gaiety seems to be always pouring out in an ever-changing kaleidoscope of shape and color; he combines the impeccable taste of abstract painters with an irrepressible Catalan warmth and audacity. His pottery is the most beautiful of Surrealist "objects," his bird-happy colors, the yellows and blues of serenity, pervade all his work.

Arp, the Dadaist wood-cutter, though for long associated with the Surrealist movement, has strong affinities with abstract art. The group's most typical sculptor is rather the earlier Giacometti, whose imagination supplied a note of austerity welcome among the Surrealist flamboyance. His archaic personages are so etiolated by internal conflict as to seem more or less than human, his constructions appear heroic embodiments of frustration, the desire for perfection contrives to bring all his work to a ferocious standstill. His counterpart in painting is undoubtedly Masson, another rugged militant of the arts who has tried to interpret nature with a deep intuition of her violence; through the insect world, whose cruelty is too extreme to leave room for fear or hate, through the giant body whose mountain udders and pubic forests we mortals inhabit, to the cloudy clash of planetary wear-and-tear which we dimly envisage.

7.

In Masson and Giacometti Surrealism has discovered two of its most original artists with a revolutionary attitude to their mediums. It is they who supply it with some of the emotional discipline and intellectual tension which were the glory of Cubism and which are lacking in the fretful doodling or weary Pre-Raphaelism of many Surrealist painters. On the other side: perspective-haunted, oil-bound conservative, even academic in their treatment, though startling in their choice of subject-matter and bold in imagination, are such typical Surrealist painters as Dali, Magritte, Delvaux, Pierre Roy and Leonor Fini.

Magritte, a very early Surrealist, remains a completely literary painter who startles us by the force and universality of his dream symbols, but who gives us little pic-

torial quality. With Dali we reach the core of the problem: Dali and Aragon, the two geniuses of the movement, alas were also its two evil geniuses, the right and left deviationists, the one leading on towards salons and *succès de scandale*, Hollywood and shiny-papered fashion magazines, the other into Marxist polemic "the boring pamphlet and the public meeting," until each reached his respective goal, an interview with the Pope, and the editorship of a Communist daily. Dali and his fellow-Spaniard Buñuel were responsible for two famous Surrealist films, *L'Age d'Or* (in which Max Ernst appeared) and *Un chien Andalou*. Man Ray, whose photography can raise the dead, also contributed *Les Mystères du Château de Dé*, a film built round the ultra-modern villa of the Vicomte de Noailles above Hyères, for this family were the Medici and chief patrons of the movement at the end of the golden age.

In the silent film Surrealism had found an almost perfect medium; Man Ray, the painter and photographer who "drew in light," as Picasso described his work, made three films of increasing lyrical quality before the crisis of the *L'Age d'Or*; Dali's *Andalusian Dog*, in spite of some superfluous sadism, has a crystalline intensity that reveals unexplored regions of pure cinema, it becomes something far more moving than even the scenario leads one to expect. *The Golden Age* is less concentrated and suffers from an awareness of the new talking films, which the Surrealists didn't have the funds to produce. It contains more shocking material; erotic, blasphemous or anti-social (i.e., kicking the blind) than any picture ever made, but in spite of being a dithyrambic ode to physical passion it is too disjointed and amateurish to qualify as great. It is a collection of incidents based on the theme of the world well lost for love, orchestrated by the Marquis de Sade. After the scandal which it caused, the cinematic expression of Dali's celebrated paranoia was compelled to filter down through the Marx brothers, reappearing in a much-watered form in his famous Hollywood dream-sequence for *Spellbound*.

The Surrealist object was also removed by Dali from the region of pure sculpture where Giacometti and Arp were confining it and took on a more ephemeral form, as in the lady's bust enlivened with ants and a necklace of corncobs; with Millet's *Angelus* on a loaf of bread as an inkstand-headdress, which appeared, increasingly mildewed, at several international exhibitions before the famous fur tea-set of Meret Oppenheim took away the spotlight.

Although in theory the Surrealist object was in reach of anyone who chose to put it together, even as poetry was available to all who could hold a pen when half-asleep, it was still the painters who produced the best: the fur-lined tea-set, for instance, is not ridiculous but alarming, for there is something more horrible than one would expect about drinking from a fur-lined cup, tea and cup having a deeply

buried Freudian content which the fur brings up to the surface. Dali's red satin sofa, shaped like two closed lips, is another uneasy-chair. The suggestiveness of so much Surrealist art, based on liberating the unconscious, takes effect only on the repressed and so it is among the guilty, puritanical and bottled-up society of Anglo-Saxony that these luxurious objects find new victims. The ascendency of what Breton called Dali's "master impulse" in 1931–36, brings Surrealism nearer to the big money and the fashionable crowd. Dali's genius, so dazzling in conception, so reactionary in technique, so original yet so meretricious, is baffling even now. His most recent exhibition in Paris contains some spectacular draftsmanship, painting which seems like a triumph of color photography, and evidence of that inflation of the ego which brings this academic psychopath from the cove of Cadaqués near to Chirico, who signs his recent pictures "Pintor Maximus"—a conjuror dazzled by his own skill.

8.

The later thirties were the period of success abroad and dissension within. International exhibitions flourished and Surrealism was launched in Prague, London, New York and Tenerife, but in 1935 the charming René Crevel, *"le plus beau des surréalistes,"* and also their most intelligible prose-writer, killed himself, *"dégoûté de tout"*; Breton's political position grew closer to Trotsky's; manifestoes multiply; and the frog-march along the razor's edge perceptibly quickens. The war caught the Surrealists without a clear policy; their hatred of 1914–18 had brought them together, their bewilderment in 1939 now led to their dispersal. They remained for a while in Vichy-France designing their Tarot pack of cards, and then gradually sought asylum in Mexico or the United States. Hating Hitler, they were threatened by Pétain; international, they detested a nationalist war; artists, they were also pacifists; revolutionaries, they yet lacked a political organization. When Jean Cocteau (the counterfeit Surrealist and private enemy of the movement) was told by a young poet that he was joining the Resistance, he replied "You are making a mistake; life is too serious for that"—which may be described as the Surrealists' final attitude.

Their arrival in America may be likened in its consequences to that of the Byzantine scholars in Italy after the fall of Constantinople. From that moment "the Surrealists" were disbanded but surrealism began to sow itself spontaneously. Dali in Hollywood, Breton and Masson in New York, Péret in Mexico, Ernst in Arizona were its wandering apostles—the inevitable luxury magazine, a gelded *Minotaur*, appeared as *Triple* V; the Daliesque objects spread to fun-fairs and shop-windows; *Dyn* edited by Paalen appeared in Mexico City; Wifredo Lam, Matta and Gorky and the Caribbean poet Aimé Césaire were acclaimed by Breton. When the exiles

returned to Paris, where reason had been re-enthroned by Sartre, they had left behind what was the worst in Surrealism—a flourishing commercial formula beloved of window-dressers or a façade for rich complex lightweights, for few, alas, were the disciples who had understood the astonishing galaxy of ideas which Breton had all his life so harmoniously assembled and so passionately, if obscurely, expounded—his home-made revolution: *"Changez la vie!"*

9.

For we cannot bid farewell to Surrealism without a formal tribute to its founder. This much-loved, much-hated and therefore enigmatic figure has accomplished far more than Apollinaire; he formed and led his group of writers and artists instead of merely interpreting them; his distinguished bull-like appearance, as of a serious Oscar Wilde, with some of Wilde's dignity and benevolence and none of his vulgarity, reflects a strange mixture of qualities, the ability to lead, inspire, deceive and threaten, to criticize and create, to love and command both jealous rivals and the envious young. His own writing, with its seventeenth-century fullness, at its best in *Nadja* or in the straightforward criticism of *Les Pas Perdus* rather than when married to the welling, inexhaustible fountain of Eluard's poetry, achieves (as in his description of the peak of Tenerife) an extraordinary vigor. Condemned by the logic of the times to lead his flock along the arête between militant Marxism and introverted lunacy, this reason-hating intellectual brought safely over as many as he could. Besides Eluard, Aragon, Péret, Crevel, Hugnet and Gracq, one must admire his influence on many ex-Surrealists, such as Paulhan, Pongé, Prévert, Queneau and Leiris, who are well-known today. His passion for art not only gave painters the feeling that their ideas were important, but inclined him towards those who were truly original rather than to the fashionable antiquarians, while he was quick to discover the Surrealist content of much primitive and popular art.

Without the Surrealist movement, "surrealism" might still have come into being; the unconscious would have found other aesthetic interpreters, but under Breton's guidance the synthesis between Freud and Marx was attempted many years in advance, as a parachuted battalion can attack an objective weeks ahead of schedule. A share of the faults of totalitarian leaders was not lacking, but seldom has one man's intellectual honesty, courage and passion for beauty enriched us more. Always with the Surrealists, in spite of their lapses into vulgarity and spiteful pettiness, one is conscious of the dedicated life; of the whole conception of bourgeois living being utterly rejected for the sake of a mystical idea—*le merveilleux*: "Neither a school nor a clique, much more than an attitude, Surrealism is, in the most complete and aggressive sense of the term, an adventure," proclaims a man-

ifesto of May 1951, an adventure which has not recoiled from madness and suicide in the search for inspiration, for the vision which is not always compatible with art, which may destroy art and literature and sometimes life itself. If Surrealism is to perish, it will be because the world we live in renders ineffectual the private rebellion of the individual and because the symbols and battlecries of the Unconscious—Sade, Ubu, Maldoror, Oedipus—awake no answering revolt in a generation which finds its predicament too serious even for Surrealism!

They were, perhaps, the last Romantics. Despite the shapeless obscurity of so much of their writing, despite their rejection of the advances made by Impressionism, Fauvism and Cubism for "the rehabilitation of academic art under a new literary disguise" (as critic Clement Greenberg has written), the world of literature and art would be—and, in fact, is—the flatter and feebler without them. They have restored to man, love-child of fatality and chance, the belief in his destiny, they have given woman back her pride and her magic, they have handed the imagery of the unconscious over to poetry and returned freedom of subject to painting, imprisoned by its own rules. To the question "what does that picture represent?," the Surrealists make answer: "the person who did it."

<div align="right">1951</div>

Against Abstract Expressionism

A Devil's Advocate opposes, as logically and forcibly as he can, the canonization of a new saint. What he says is dark, and serves the light. The devil himself, if one can believe Goethe, is only a sort of devil's advocate. Here I wish to act as one for abstract expressionism.

Continued long enough, a quantitative change becomes qualitative. The latest tradition of painting, abstract expressionism, seems to me revolutionary. It is not, I think, what it is sometimes called: the purified essence of that earlier tradition which has found a temporary conclusion in painters like Bonnard, Picasso, Matisse, Klee, Kokoschka. It is the specialized, intensive exploitation of one part of such painting, and the rejection of other parts and of the whole.

Earlier painting is a kind of metaphor: the world of the painting itself, of the oil-and-canvas objects and their oil-and-canvas relations, is one that stands for—that has come into being because of—the world of flesh-and-blood objects and their flesh-and-blood relations, the "very world, which is the world / Of all of us,—the place where, in the end, / We find our happiness or not at all." The relation between the representing and the represented world sometimes is a direct, mimetic one; but often it is an indirect, farfetched, surprising relation, so that it is the difference between the subject and the painting of it that is insisted upon, and is a principal source of our pleasure. In the metaphors of painting, as in those of poetry, we are awed or dazed to find things superficially so unlike, fundamentally so like; superficially so like, fundamentally so unlike. Solemn things are painted

gaily; overwhelmingly expressive things—the Flagellation, for instance—painted inexpressively; Vollard is painted like an apple, and an apple like the Fall; the female is made male or sexless (as in Michelangelo's *Night*), and a dreaming, acquiescent femininity is made to transfigure a body factually masculine (as in so many of the nude youths on the ceiling of the Sistine Chapel). Between the object and its representation there is an immense distance: within this distance much of painting lives.

All this sums itself up for me in one image. In Georges de La Tour's *St. Sebastian Mourned by St. Irene* there is, in the middle of a dark passage, a light one: four parallel cylinders diagonally intersected by four parallel cylinders; they look like a certain sort of wooden fence, as a certain sort of cubist painter would have painted it; they are the hands, put together in prayer, of one of St. Irene's companions. As one looks at what has been put into—withheld from—the hands, one is conscious of a mixture of emotion and empathy and contemplation; one is moved, and is unmoved, and is something else one has no name for, that transcends either affect or affectlessness. The hands are truly like hands, yet they are almost more truly unlike hands; they resemble (as so much of art resembles) the symptomatic gestures of psychoanalysis, half the expression of a wish and half the defense against the wish. But these parallel cylinders of La Tour's—these hands at once oil-and-canvas and flesh-and-blood; at once dynamic processes in the virtual space of the painting, and spiritual gestures in the "very world" in which men are martyred, are mourned, and paint the mourning and the martyrdom—these parallel cylinders are only, in an abstract expressionist painting, four parallel cylinders: they are what they are.

You may say, more cruelly: "If they are part of such a painting, by what miracle have they remained either cylindrical or parallel? In this world bursting with action and accident—the world, that is, of abstract expressionism—are they anything more than four homologous strokes of the paintbrush, inclinations of the paint bucket; the memory of four gestures, and of the four convulsions of the Unconscious that accompanied them? . . . We need not ask—they are what they are: four oil-and-canvas processes in an oil-and-canvas continuum; and if, greatly daring, we venture beyond this world of the painting itself, we end only in the painter himself. A universe has been narrowed into what lies at each end of a paintbrush."

But ordinarily such painting—a specialized, puritanical reduction of earlier painting—is presented to us as its final evolution, what it always ought to have been and therefore "really" was. When we are told (or, worse still, shown) that painting "really" is "nothing but" this, we are being given one of those definitions which explain out of existence what they appear to define, and put a simpler entity in its

place. If this is all that painting is, why, what painting was was hardly painting. Everyone has met some of the rigorously minded people who carry this process of reasoning to its conclusion, and value Piero della Francesca and Goya and Cézanne only in so far as their paintings are, in adulterated essence, the paintings of Jackson Pollock. Similarly, a few centuries ago, one of those mannerist paintings in which a Virgin's face is setting after having swallowed alum must have seemed, to a contemporary, what a Donatello Virgin was "really" intended to be, "essentially" was.

The painting before abstract expressionism might be compared to projective geometry: a large three-dimensional world of objects and their relations, of lives, emotions, significances, is represented by a small cross section of the rays from this world, as they intersect a plane. Everything in the cross section has two different kinds of relations: a direct relation to the other things in the cross section, and an indirect—so to speak, transcendental—relation to what it represents in the larger world. And there are also in the small world of the picture process many absences or impossible presences, things which ought to be there but are not, things which could not possibly be there but are. The painter changes and distorts, simplifies or elaborates the cross section; and the things in the larger world resist, and are changed by, everything he does, just as what he has done is changed by their resistance. Earlier painters, from Giotto to Picasso, have dealt with two worlds and the relations between the two: their painting is a heterogeneous, partly indirect, many-leveled, extraordinarily complicated process. Abstract expressionism has kept one part of this process, but has rejected as completely as it could the other part and all the relations that depend on the existence of this other part; it has substituted for a heterogeneous, polyphonic process a homogeneous, homophonic process. One sees in abstract expressionism the terrible aesthetic disadvantages of directness and consistency. Perhaps painting can do without the necessity of imitation; can it do without the possibility of distortion?

As I considered some of the phrases that have been applied to abstract expressionism—revolutionary; highly non-communicative; non-representational; un-critical; personal; maximizing randomness; without connection with literature and the other arts; spontaneous; exploiting chance or unintended effects; based on gesture; seeking a direct connection with the Unconscious; affirming the individual; rejecting the external world; emphasizing action and the process of making the picture—it occurred to me that each of them applied to the work of a painter about whom I had just been reading. She had been painting only a little while, yet most of her paintings have already found buyers, and her friends hope, soon, to use the money to purchase a husband for the painter. She is a chimpanzee at the Baltimore

Zoo. Why should I have said to myself, as I did say: "I am living in the first age that has ever bought a chimpanzee's paintings"? It would not have occurred to me to buy her pictures—it would not have occurred to me even to get her to paint them; yet in the case of action painting, is it anything but unreasoning prejudice which demands that the painter be a man? Hath not an ape hands? Hath not an animal an Unconscious, and quite a lot less Ego and Superego to interfere with its operations?

I reminded myself of this as, one Saturday, I watched on Channel 9 a chimpanzee painting; I did not even say to myself, "I am living in the first age that has ever televised a chimpanzee painting." I watched him (since he was dressed in a jumper, and named Jeff, I judged that he was a male) dispassionately. His painting, I confess, did not interest me; I had seen it too many times before. But the way in which he painted it! He was, truly, magistral. He did not look at his model once; indeed, he hardly looked even at the canvas. Sometimes his brush ran out of paint and he went on with the dry brush—they had to remind him that the palette was there. He was the most active, the most truly sincere, painter that I have ever seen; and yet, what did it all produce?—nothing but that same old abstract expressionist painting. . . .

I am joking. But I hope it is possible to say of this joke what Goethe said of Lichtenberg's: "Under each of his jokes there is a problem." There is an immense distance between my poor chimpanzee's dutiful, joyful paintings and those of Jackson Pollock. The elegance, force, and command of Pollock's best paintings are apparent at a glance—are, indeed, far more quickly and obviously apparent than the qualities of a painter like Chardin. But there is an immense distance, too, between Pollock's paintings and Picasso's; and this is not entirely the result of a difference of native genius. If Picasso had limited himself to painting the pictures of Jackson Pollock—limited himself, that is, to the part of his own work that might be called abstract expressionism—could he have been as great a painter as he is? I ask this as a typical, general question; if I spoke particularly I should of course say: If Picasso limited himself in anything he would not be Picasso: he loves the world so much he wants to steal it and eat it. Pollock's anger at things is greater than Picasso's, but his appetite for them is small; is neurotically restricted. Much of the world— much, too, of the complication and contradiction, the size and depth of the essential process of earlier painting—is inaccessible to Pollock. It has been made inaccessible by the provincialism that is one of the marks of our age.

As I go about the world I see things (people; their looks and feelings and thoughts; the things their thoughts have made, and the things that neither they nor their thoughts had anything to do with making: the whole range of the world) that, I cannot help feeling, Piero della Francesca or Brueghel or Goya or Cézanne

would paint if they were here now—could not resist painting. Then I say to my wife, sadly: "What a pity we didn't live in an age when painters were still interested in the world!" This is an exaggeration, of course; even in the recent past many painters have looked at the things of this world and seen them as marvelously as we could wish. But ordinarily, except for photographers and illustrators—and they aren't at all the same—the things of our world go unseen, unsung. All that the poet must do, Rilke said, is praise: to look at what is, and to see that it is good, and to make out of it what is at once the same and better, is to praise. Doesn't the world need the painter's praise any more?

Malraux, drunk with our age, can say about Cézanne: "It is not the mountain he wants to realize but the picture." All that Cézanne said and did was not enough to make Malraux understand what no earlier age could have failed to understand: that to Cézanne the realization of the picture necessarily involved the realization of the mountain. And whether we like it or not, notice it or not, the mountain is still there to be realized. Man and the world are all that they ever were—their attractions are, in the end, irresistible; the painter will not hold out against them long.

1957

OCTAVIO PAZ

Three Notes on Painting

1. PRIMITIVES AND BARBARIANS

The poem or sculpture of primitive man is the swollen seed, the superabundance of forms: a focal point of different times, the point of intersection of all spatial trajectories. I wonder whether the famous sculpture of Coatlicue in the Mexican National Museum, an enormous block of stone covered with signs and symbols, might not be described as primitive despite the fact that it belongs to a very definite historical period. On second thought: it is a barbarous work, like many others left us by the Aztecs. It is barbarous because it does not possess the unity of the primitive artifact, which puts the contradictions of reality before us in the form of an instantaneous totality, as in the pygmy poem; and barbarous because it has no notion of the pause, of the empty space, of the transition between one state and another. What distinguishes classic art from primitive art is the intuition of time not as an instant but as succession, symbolized in the line that encloses a form without imprisoning it: Gupta or Renaissance painting, Egyptian or Huastec statuary, Greek or Teotihuacán architecture. Coatlicue is more an idea turned to stone than a palpable form. If we look on it as a discourse in stone, at once a hymn and a theology, its rigor may seem admirable. It strikes us as a cluster of meanings, its symbolic richness dazzles us, and its sheer geometrical proportions, which have a certain grandeur all their own, may awe us or horrify us—a basic function of a sacred presence. As a religious image, Coatlicue humbles us. But if we really study it, rather than simply thinking about it, we change our minds. It is not a creation; it is a construction. Its various elements and attributes never fuse into a form. This mass is

the result of a process of superposition; more than a powerful accumulation of sep-
arate elements, it is a juxtaposition. Neither a seed nor a plant: neither primitive
nor classical. And not Baroque either. The Baroque is art reflecting itself, line that
caresses itself or tears itself apart, a sort of narcissism of forms. A volute, a spiral,
mirrors reflecting each other, the Baroque is a temporal art: sensuality and medi-
tation, an art that feeds the illusions of the disillusioned. A dense jumble of forms,
Coatlicue is the work of semicivilized barbarians: it attempts to say everything, and
is not aware that the best way to express certain things is to say nothing about them.
It scorns the expressive value of silence: the smile of archaic Greek art, the empty
spaces of Teotihuacán. As rigid as a concept, it is totally unaware of ambiguity, al-
lusion, indirect expression.

Coatlicue is a work of bloodthirsty theologians: pedantry and cruelty. In this
sense it is wholly modern. Today, too, we construct hybrid objects which, like
Coatlicue, are mere juxtapositions of elements and forms. This trend, which has
carried the day in New York and is now spreading all over the globe, has a twofold
origin: the collage and the Dada object. But the collage was meant to be a fusion of
heterogeneous materials and forms: a metaphor, a poetic image; and the Dada ob-
ject was an attempt to destroy the idea of physical objects as useful tools and the idea
of works of art as valuable things. By regarding the object as something that destroys
itself, Dada made the useless the antivalue par excellence and thus attacked not
only the object but the market. Today, the successors of Dada deify the object: their
art is the consecration of the artifact. The art galleries and the museums of modern
art are the chapels of the new cult and their god goes by the name of the product:
something that is bought, used, and thrown away. By the workings of the laws of
the marketplace, justice is done, and artistic products suffer the same fate as other
commercial objects: a wearing out that has no dignity whatsoever. Coatlicue does
not wear out. It is not an object but a concept in stone, an awesome idea of an awe-
some divinity. I realize that it is barbarous; but I also appreciate its power. Its rich-
ness strikes me as uneven and almost formless, but it is a genuine richness. It is a
goddess, a great goddess.

Can we escape barbarism? There are two sorts of barbarians: the barbarian who
knows he is one (a Vandal, an Aztec) and therefore seeks to borrow a civilized life-
style; and the civilized man who knows that the "end of a world" is at hand and does
his utmost to escape by plunging into the dark waters of savagery. The savage does
not know that he is a savage; barbarism is a feeling of shame at being a savage or a
nostalgia for a state of savagery. Either way, its underlying cause is inauthenticity.

A truly modern art would be one that would reveal the hollowness rather than
mask it. Not the object-that-is-a-mask, but the frankly truthful work, opening out

like a fan. Was not the aim of Cubism and, more radically, the goal of Kandinsky the revelation of essence? For the primitive, the function of the mask is to reveal and conceal a terrible, contradictory reality: the seed that is life and death, fall and resurrection in a fathomless *now*. Today the mask hides nothing. In our time it may be impossible for the artist to invoke presence. But another way, cleared for him by Mallarmé, is still open to him: manifesting absence, incarnating emptiness.

2. NATURE, ABSTRACTION, TIME

"From the imitation of nature to its destruction": this might well be the title of a history of Western art. The most vital of modern artists, Picasso, may also have been the wisest: if we cannot escape nature, as a number of his successors and his contemporaries have vainly endeavored to do, we can at least disfigure it, destroy it. Basically, this is a new homage to nature. Nothing pleases nature more, Sade said, than the crimes whereby we attempt to violate her. In her eyes creation and destruction are one and the same. Wrath, pleasure, sickness, or death wreak changes in the human being no less terrible (or comic) than the mutilations, the deformations, the furious stylizations that Picasso delights in.

Nature has no history, but its forms are the living embodiment of all the styles of the past, present, and future. I have seen the birth, the full flowering, and the decline of the Gothic style in rocks in the valley of Kabul. In a pond covered with green scum—full of little stones, aquatic plants, frogs, tiny monsters—I recognized both the temple sculpture of the Bayon at Angkor and one of the periods of Max Ernst. The form and plan of the buildings of Teotihuacán are a replica of the Valley of Mexico, but this landscape is also a prefiguration of Sung painting. The microscope reveals that the formula of the Tibetan *tankas* is already hidden in certain cells. The telescope shows me that Tamayo is not only a poet but also an astronomer. White clouds are the quarries of the Greeks and the Arabs. I am bemused by *plata encantada*, obsidian covered with a vitreous, opalescent white substance: Monet and his followers. There is no escaping the fact: nature is better at abstract art than at figurative art.

Modern abstract painting has taken one of two forms: a search for essences (Kandinsky, Mondrian), or the naturalism of Anglo-American abstract expressionists. [*] The founders of the school wanted to get away from nature, to create a world of

[*] I don't like the term expressionism applied to abstract painting: there is a contradiction between expressionism and abstraction. The term "abstract painting" is no less misleading. As Benjamin Péret has pointed out, art is always concrete.

pure forms or reduce all forms to their essence. In this sense, the first abstract paint-
ers could be called *idealists*. Americans have not taken their inspiration from na-
ture, but they have decided to work in the same way as nature. The act or the ges-
ture of painting is more or less the ritual double of the natural phenomenon.
Painting is *like* the action of sun, water, salt, fire, or time on things. To a certain
degree abstract painting and natural phenomena are an *accident*: the sudden, un-
foreseen intersection of two or more series of events. Many times the result is strik-
ing: these paintings are fragments of living matter, chunks sliced out of the cosmos
or heated to a seething boil. Nonetheless, it is an incomplete art, as can be seen in
Pollock, one of the most powerful of these artists. His great canvases have no be-
ginning or end; despite their huge dimensions and the energy with which they are
painted, they seem to be giant chunks of matter rather than complete worlds. This
kind of painting does not assuage our thirst for totality. Fragments and stammer-
ings: a powerful urge to express, rather than a total expression.

Whether idealist or naturalist, abstract painting is a timeless art. Essence and
nature lie outside the flow of human time: natural elements and the Idea have no
date. I prefer the other current in modern art that endeavors to capture the meaning
of change. Figuration, disfiguration, metamorphosis, a temporal art: Picasso at
one end of the scale, Klee at the other, the great Surrealists in the middle. We owe
to idealist abstract art some of the purest and most perfect creations of the first half
of this century. The naturalist or expressionist tendency has left us great and in-
tense works, tragic and, at times, hybrid art. It is the result of the contradiction be-
tween the natural phenomenon (pure objectivity) and human activity (subjectiv-
ity, intentionality). A mixture, a conflict, or a fusion of two different orders of
reality: the living material of the painting (energy and inertia) and the romantic
subjectivism of the painter. A heroic painting, but also a theatrical painting: part
daring feat, part dramatic gesture. Temporal art, for its part, is a vision of the instant
that envelops presence in its flame and consumes it: an art of presence even though
it hacks it to pieces, as in Picasso's work. Presence is not only what we see: André
Breton speaks of the "inner model," meaning that ghost that haunts our nights,
that secret presence that is proof of the otherness of the world. Giacometti has said
that the one thing he wants to do is to *really* paint or sculpture a face some day.
Braque does not search for the essence of the object: he spreads it out over the trans-
parent river of time. The empty hours of de Chirico with not a single person in
sight. Klee's lines, colors, arrows, circles: a poem of movement and metamorpho-
sis. Presence is the cipher of the world, the cipher of being. It is also the scar, the
trace of the temporal wound: it is the instant, instants. It is meaning pointing to the
object designated, an object desired and never quite attained.

The search for meaning or its destruction (it makes no difference which: there is no way of escaping meaning) is central to both tendencies. The only meaningless art in our time is realism: and not only because its products are so mediocre, but also because it persists in reproducing a natural and social reality that has lost all meaning. Temporal art resolutely confronts this loss of meaning, and therefore it is an art of imagination par excellence. In this respect, the Dadaist movement was an example (and an inimitable one, despite its recent imitations in New York). Dada not only took the absence of meaning and absurdity as its province, but made lack of meaning its most effective instrument of intellectual demolition. Surrealism sought meaning in the magnetic excitement of the instant: love, inspiration. The key word was *encounter*. What is left of all this? A few canvases, a few poems: a branch of living time. That is enough. Meaning lies elsewhere: always just a few steps farther on.

Modern art oscillates between presence and its destruction, between meaning and the meaningless. But we thirst for a *complete art*. Are there any examples?

3. FIGURE AND PRESENCE

Dada torpedoed the speculative pretensions of Cubist painting and the Surrealists countered the object-idea of Juan Gris, Villon, or Delaunay with an inner vision that destroyed its consistency as a *thing* and its coherence as a *system* of intellectual coordinates. Cubism had been an analysis of the object and an attempt to put it before us in its totality; both as analysis and as synthesis, it was a criticism of *appearance*. Surrealism transmuted the object, and suddenly a canvas became an *apparition*: a new figuration, a real transfiguration. This process is being repeated today. Abstract painting had rejected aesthetic reality along with every other reality— whether in the form of appearances or in the form of apparitions. Pop Art is the unexpected return of figurative art, a hostile and brutal reappearance of reality, such as we see it every day in our cities, before it is passed through the filter of analysis. Both Surrealism and Pop Art represent a reaction against the absolutism of pictorial speculation, in the form of a return to spontaneous, concrete vision. Fantasy, humor, provocation, hallucinatory realism. The differences between the two movements are as great as the similarities, however. We might even say that the resemblance is merely an outward one; it is not so much a fundamental similarity as a historical and formal coincidence; they are one extreme of the modern sensibility, which continually oscillates between love of the general and passion for the individual, between reflection and intuition. But Pop Art is not a total rebellion as Dada was, nor is it a movement of systematic subversion in the manner of Surrealism, with a program and an inner discipline. It is an individual attitude; a re-

sponse to reality rather than a criticism of it. Its twin and its enemy, Op Art, is not even an attitude: it is literally a point of view, a procedure. It is really a more or less independent branch of the abstractionist tendency, as is clear in the works of one of the best representatives of the school: Vasarely.

The Pop artist accepts the world of things we live in and is accepted by the society that possesses and uses these things. Neither rejection nor separation: integration. Unlike Dada and Surrealism, Pop Art from the beginning was a tributary of the industrial current, a small stream feeding into the system of circulation of objects. Its products are not defiant challenges of the museum or rejections of the consumers' aesthetic that characterizes our time: they are consumer products. Far from being a criticism of the marketplace, this art is one of its manifestations. Its works are often ingenuous sublimations of the show windows and counter displays of the big department stores. Nonetheless, Pop Art is a healthy trend because it is a return to an immediate vision of reality, and, in its most intense expressions, a return to a vision of immediate reality. How can we fail to see the poetry of modern life, as defined by Apollinaire, in certain of Rauschenberg's works, for instance? The world of the streets, machines, lights, crowds—a world in which each color is an exclamation and each form a sign pointing to contrary meanings. Pop Art has reinvented the figure, and this figure is that of our cities and our obsessions. At times it has gone further and turned this mythology into a blank space and a question: the art of Jasper Johns is that of the object become a Saint Sebastian. A truly metaphysical art in the great tradition of de Chirico, yet deeply American. But Johns is an exception—a more rigorous imagination beyond both the easy charms and the mindless brutality of most of Pop Art. . . . What these artists have restored to us is a figure, not presence itself: a mannequin rather than a true apparition. The modern world is man, or his ghost, wandering among things and gadgets. In the work of these young people, I miss something that Pound saw in a Paris métro station and expressed in two lines:

> The apparition of these faces in the crowd;
> Petals on a wet, black bough.

1973

Translated from the Spanish by Helen R. Lane

WILLA CATHER

On Various Minor Painters

PORTRAITS AND LANDSCAPES

The Haydon Art Club, named for the English painter Benjamin Robert Haydon (1786–1846), was organized by a group of Lincoln social, civic, and cultural leaders in May 1888, and held its first exhibition (consisting of a single picture) during the Christmas holidays of that year. The 1894 exhibition, held at Grant Memorial Hall on the University campus, was the largest of the club's early years. It included 609 items—200 oil paintings, 145 water colors, and 264 "ceramics, curios and statuettes." More than a hundred of the paintings were on loan from the annual exhibition of the Chicago Art Institute, one of the most important showings of American impressionists up to this time. The leading exponent of the school was Theodore Robinson (1852–1896), recently returned from eight years of study in France and the recipient of many medals for his work. Frank Weston Benson (1862–1951), an instructor in the Boston School of Fine Arts since 1889, had won a medal at the Chicago World's Fair of 1893 and later was to do the murals for the Congressional Library in Washington, D.C. Among other artists whose work Willa Cather singled out for comment are: Carl Newman (1868–19??), a minor Pennsylvania painter who slipped into obscurity during the 1920s; Charles Corwin (1857–1938), a Chicago artist, student of Duveneck; Richard Lorenz (1858–1915), a German-born*

*When the Haydon Art Club was reorganized in 1900, it was renamed the Nebraska Art Association. Since 1963 its distinguished collection has been housed in the Sheldon Memorial Art Gallery on the University of Nebraska campus. Information about the Haydon Art Club is derived from a souvenir booklet issued by the Nebraska Art Association on its seventy-fifth anniversary in 1963.

*artist living in Milwaukee, best known for his genre paintings; and Thomas Noble
(1835–1907), a Kentucky-born painter of American subjects. The only local artist
whose work is mentioned is Flavia Canfield, wife of Chancellor James H. Canfield.*

As one enters the inner sanctum of the Haydon Art Club's midwinter exhibit three
pictures strike the eye at once. They are not hung near together, but in some way
they appear at the same instant and command attention. They are Carl Newman's
two woman's portraits and Benson's girl in the firelight. They are wonderful
women, all three of them, and it is worth going to a good deal of trouble to see them
at their best.

After you have seen them at all hours and in all lights, you decide that the best
time to call on them is in the evening, just after the lights are turned on and before
everyone else in town has come to admire them at the top of their voices. Three
women so ecstatically beautiful are best seen in solitude, unsurrounded by a hun-
dred other women rather less lovely and much less silent. It is a privilege and a
blessing to be alone with three such divine femininities for half an hour, for they
are made beautiful and are not constantly doing and saying things to spoil it all.
They have the silence which is golden and repose which is priceless.

Newman's two women are wonderfully alike in general contour. They are more
than the same type. They were perhaps done from the same model. Both of them
are very different from Benson's girl by the pine fire, different not only in treatment
and execution, but in type and character. The first thing one notices in Benson's
figure is the shoulders, in Newman's the bust. That means more than it says.

Newman's woman is of a cruder stock than Benson's, her ancestors were not so
good. She has warmer sympathies, but her intelligence is not so keen. She has
more strength, perhaps, but not so much energy as the woman in the firelight. She
has a liberal share of muscle and adipose tissue, while the other is all nerves. Both
Newman's women are rather large, rather too generously built. Benson's girl is all
lightness and poise. There is a century of refined ancestry between her and New-
man's women. Newman's women are loosely built; their flesh is beautiful, but not
especially firm, and their clothes fit them loosely. Benson's girl is all concentra-
tion.

What a girl she is anyway! What simplicity and elegance. How the slenderness
of the waist, the poise of the head, the carriage, the firmness of the flesh, even the
severe elegance of the dress with its little cloud of wonderfully painted illusion
about the breast combine to suggest that innate aristocratic refinement which
should be the outcome of wealth and culture.

There is another portrait by Newman which, although it has not so much imagination as his two female portraits, looks wonderfully real. It is a convincing piece of work. It is owned by Stanley Hurlbut. If it is Mr. Hurlbut's portrait he is a gentleman one would like to know. He looks like a man of taste, whom ugly things would pain. He seems a bit of a critic and connoisseur, a man of opinions, whom intelligence gives the right to be opinionated.

The most attractive landscape in the collection is certainly Theodore Robinson's "Scene on the Delaware and Hudson Canal." That picture is full of air and sunlight, its abundance of clear atmosphere gives it a bracing, exhilarating effect. One instinctively takes a deep breath as one stands before it. Better sky effects are not often seen. The sky actually arches and recedes. The horizon seems incalculably far away. The clouds are such as might float and the thinner ones have a suggestion of rapid motion. It is plainly a morning picture, a few hours later than the misty time that Corot loved to paint, done when the sun is well up in the sky, and the world is high and dry and the life and work of the world has begun again.

In sharp contrast to this wonderfully airy picture of Robinson's is Charles Corwin's "St. Joe, Michigan," which looks as if the atmosphere has been exhausted with an air pump. It has the dead, lifeless effect of a scene worked upon tapestry.

Richard Lorenz's "In The West," is at once strong and disappointing. The worst thing about it is the title. It is a western subject and a western man placed it in an unwestern atmosphere. The position of the man, his bronzed, rugged face, his sun-browned beard, the way his hair grows, or rather does not grow on his head, that arm and hat and buckskin glove leave little to be desired. But for all that the picture is not western. The impressionists say it is "keyed too low." Whatever that may mean the lights are certainly at fault and the color is too tame. The sunlight is gentle, not the fierce, white, hot sunlight of the West. Sunlight on the plains is almost like sunlight of the northern seas; it is a glaring, irritating, shelterless light that makes the atmosphere throb and pulsate with heat.

Turning to the western wall again there is Thomas Noble's sermon, "Idle Capital," an "unprotected furnace in Alabama." Though it is perhaps the most correctly and skilfully drawn of the collection it is an irritating and unpleasant picture. It tells the story too plainly and too well, and it was done too much for the story's sake. It is a picture that ought to delight Hamlin Garland. The secret of the jarring effect is that like too many novels and pictures of the hour it was not done with an artistic motive. That furnace was not painted because it was beautiful or touching, but because it was a stern, ugly lesson in political economy. In the spectator it appeals to the matter of fact, not the artistic sense. There is no artistic merit in paint-

ing a subject merely because it has a sermon in it. A run on the bank has sermon enough, but it is not an exalted thing to paint it. Some people have tried to make political economy out of Millet's picture, but there is none there. There is only the poor pathos of labor and poverty. Millet painted for the sake of the people who suffered, never vexing himself about the cause of it. There is no humanness in "Idle Capital." The earth and air about Millet's laborers is filled with a sad poesy which is the painter's own. There is no poetic medium between you and that furnace of rusted iron. It would fascinate a mechanic and repel a poet.

In literature and painting there is no such thing as sacrificing art for truth. Perfect art is truth, truer than any science, even political economy. It is unfortunate that the economic sciences cannot keep to their place, but insist upon overrunning and coarsening everything else. We shall be hearing economic symphonies and sonatas next.

In the outer court of the exhibit there are several pictures of Mrs. F. A. C. Canfield that are well worth noticing. "A Tennis Player" is an easy, wholesome picture and is good to look upon. The composition in "A Duet" is unusually good. The portrait work in "The Morning Prayer" is good, though it seems to suffer somewhat from an overrefining of the features. In spite of a few minor flaws the most striking canvas among them is the picture of the two Salvation Army women called "Soldiers." It is a picture that will stand close acquaintance, and it is sad without being painful. There is a good deal of expression worked into the faces. The picture is sympathetic without being prosy and tells a story without obtruding it.

As to the impressionism in general, it is natural enough. The treating of phases and moods and incidents becomes more popular in every art. It should not occasion any very bitter warfare with the more conservative school. While Mr. Benson's "Firelight" does not at all put Rubens and Rembrandt to shame it is an excellent picture in its way. If a picture is good, it does not denote whether it is done with a pin point or a palette knife, whether it must be seen through the big end or the small end of an opera glass. If a man gives good work to the world he should at least be allowed the privilege of choosing his own method. Beauty is not so plentiful that we can afford to object to stepping back a dozen paces to catch it.

[*Journal*, January 6, 1895, p. 13.]

JOE JEFFERSON, THE PAINTER

Willa Cather had a great deal of admiration for the dean of American actors. The exhibition of his paintings, reported here, was not a sentimental tribute to a popular favorite, for Jefferson was recognized as a serious artist. One of his paintings had

been in the original collection of Pittsburgh's Carnegie Institute Gallery, and when
he was elected to the American Academy of Arts and Letters in 1905, it was as much
in recognition of his painting as of his work in the theatre.

An exhibit of fifty-four of Joseph Jefferson's oil paintings at the principal art store of
the city kept the veteran actor in the city nearly two weeks. I met him dining at the
Raleigh with some friends one evening and got him to talk of his pictures. If en-
thusiasm and good humor alone could keep a man young, this gentleman would
be younger than either of his sons. Talking to him is a good deal like talking to a boy
with a Santa Claus mask on, you have to keep reminding yourself of the discrep-
ancy between the man and the mask. "You see I come honestly by having two
strings to my bow," he said. "My ancestors were painters and players, sometimes
one, sometimes the other, about evenly divided. I can't remember the time when
I didn't want to be both. But painting required leisure and comparative financial
security; so I didn't get at that so early. I had to hustle when I was a youngster, and I
was fairly successful as an actor before I even got started at my brushes, otherwise,
who knows? I might have been the founder of a religion, like Whistler, instead of
a poor play-actor at whom people clap their hands. I suppose it would never do at
all for me to say that I would rather be a painter than an actor, for the public insists
that a man shall be entirely loyal to his *premier amour*. Indeed, I have always con-
cealed my work with colors, rather than vaunted it, and one of the articles of the
Philistine's creed is that a man cannot excel in two things. So outwardly I have been
devoted to one art and have carried on a lifelong liaison with another. It is only be-
hind the shelter of my grey hairs that I dare to brazenly exhibit my pictures."

I could not forbear asking the gentleman how the limitations of the stage
seemed to a man fortunate enough to be master of the mediums of two arts.

"Of course, the painter does his work under more fortunate conditions, but I am
always the man to say a good word for the buskin. I've worn it on sunny roads and
stormy, and I've never been tempted to quit it. It is the most difficult of all the arts,
because it is not necessary to do your best to succeed. Its conditions are the hardest
and most irksome for a sensitive soul to endure, and yet they have a sorcery all their
own, and one becomes wedded to them and can't get on without them. We're a
good deal like the tramp who loves the misery of sleeping out of doors. I shall be
very content to die an actor."

While the pictures were on exhibition here, Francis Wilson bought one of the
largest, "The King of the Forest," an immense oak on the White Mountains. Sol
Smith Russell purchased a Florida scene, and several more were sold to nonprofes-

sional people. Individual pictures by Jefferson may be seen almost anywhere, but a collection of them speaks more strongly than any single picture could do. It was the excellence of the painting that most surprised one, the way in which the paint-er's medium responds to him, the sureness of his execution. There are none of those affectations of the bizarre so often seen in the painters who are forever talking about "strengthening their style." This is downright good painting, a sound tech-nical skill, modestly used, and responding to the fancy of a poet. The collection was made up exclusively of landscapes, and, with the exception of a few Australian scenes, of American landscapes. One of the most striking canvases was a study of the Everglades, in sepia and Chinese white, with no other color discernible, with broken trees and grey mosses, and snakey creepers over everything. It is very dif-ferent from the tender green woods which Mr. Jefferson usually paints, and for an effect of density of shadow, of still, dead light and decaying wilderness, it is cer-tainly a piece of work which any painter might be proud of. "After Trout" and "For-est and Streams" are two brook studies, and the latter picture is especially poetic, being entirely submerged in that peculiar yellow shade of green, the green of high noon and early spring in which Jefferson delights as Inness did in the colder and bluer tint. In both these pictures, and in many others in this exhibit, the willow trees were treated with peculiar feeling and tenderness, the color so completely in character, the lines of the trunk through the yellow green of the slender leaves so truly those of the willow and of no other tree.

It is an interesting thing to watch, that feeling of certain painters for certain trees. With Corot it was always the wide-topped elm, the most exquisite tree of all for shape and line; with Sisley it was the silver poplar, the whole tree permeated and riddled with light like a lattice. Certainly these men must have played when they were little under their peculiar trees, and got on a personal footing with them, so to speak, got the individuality of the tree established in their inner consciousness. Somehow or other Jefferson has got all the glad message of the willows in the spring, all their freshness and wetness and gay yellow, and their appeal to every man to be a boy again and to cut his pole and bait his hook and hunt for a warm spot along the bank where the current is not too swift.

But "Moonrise" and "The Tug Boat" are good examples of the strongest tech-nical merit of Mr. Jefferson's work, his handling of skies. In "The Tug Boat" the tug has just made fast to the vessel, and is saving her steam. There is no action of any kind in the picture, and a light, fog-like cloud hangs over the water, but where the mist is thin the cold, clear blue night sky of the winter time shows bright behind it, with its stars glittering and bright. It is as blue and as cold as some of Fritz Thau-

low's* wonderful night skies, and looks at you through an atmosphere of still, piercing cold.

In "Moonrise" the painting of the sky is more conventional, but the sentiment of the piece is exquisite. The storm clouds coming over the Adirondacks, yellow-brown and full of motion, is perhaps the most remarkable work in the collection.

"A Smoky City" is a long, somber picture of the Chicago lake front, full of dull greys and reds. It is chiefly artistic through what it omits, and its avoidance of vulgar realism, so easy to turn to in handling such a subject, and so effective with the crowd. The grey of the slimy lake water, the soft colors of the smoke, the effect of height and murkiness are present, but beyond that I don't believe a Chicago merchant would know his town any more than a London cockney would recognize Whistler's picture of St. James, and that is the best I can say for it.

"A Street Scene in St. Augustine" is one of the most attractive of the pictures; a languid sunset sky, with the fiercest of its color burned out, a pale evening star, an old house of the architecture of another time and another country, a Negro and his cart. Why should this be a true work of art? "Because," said W. E. Curtis, "Rip Van Winkle is a poem."†

Of what a beautiful life are these pictures the record, these studies in nature made here and there for nature's sake, made in his resting time, deep in the woods or far in the country, where "Nobody works for money and nobody works for fame." As Jules Dupré‡ said of Jefferson, "He soaks up the poetry in nature like a sponge, only to go home and squeeze it out upon his palette." What invaluable memories this collection of paintings must recall, what a veritable Arcadian youth, that has never grown grey, what a lifelong love affair with the grass and trees and flowers, what comradeship with free winds and running water, what a deathless passion for beauty. Yet Mr. Jefferson belongs to a profession whose votaries spend their whole lives in the midst of crowded cities, who regard those precincts beyond the reach of bellboys and elevators and fizzing soda bottles, with a vague horror, much as the Romans regarded Britain, as a country of wilderness and savagery. So many of these people have become mere machines operated by steam and electricity and stimulated by complex drinks. Yet out of this world of false perspectives and all manner of tricks and shams, where the trees and flowers are mimicked, where the

*Fritz Thaulow (1847–1906), Norwegian painter, who had one painting in the original Carnegie Gallery collection.

†W. E. Curtis (1850–1911), journalist on the Chicago *Record* (1887–1901) and author of *Relics of Columbus* (1883).

‡Jules Dupré (1811–1889), French landscape painter, who had three paintings in the original Carnegie Gallery collection.

brooks are wretched things of glass and the very sun is basely counterfeited, comes this old wanderer with the breath of the fields in him. And yet people ask why he is a better actor than the men of the younger generation!

THE CHICAGO ART INSTITUTE

William Chase is another painter whom the people love and whom the Young Art Student affects to hold in scorn because he has the tricks of pleasing color, and because his pictures convey no lofty message. Mr. Chase is not, indeed, a poet; much less is he a seer. He is an admirable colorist, and he believes that there is a sort of divinity in color itself. He has at least marvellous facility and craft, and it ill becomes young folk with large ideals and scant technique to belittle him. Technique is the base of every art, and the noblest sentiment may be shipwrecked in that perilous voyage from the brain to the hand. Pretty little girls daintily posed and painted with exquisite refinement of color have as good a right to exist in the catholic kingdom of art as the pale, primeval shades of Puvis de Chavannes.

It is not unlikely that the Chicago Art Institute, with its splendid collection of casts and pictures, has done more for the people of the Middle West than any of the city's great industries. Every farmer boy who goes into the city on a freight train with his father's cattle and every young merchant who goes into the city to order his stock, takes a look at the pictures. There are thousands of people all over the prairies who have seen their first and only good pictures there. They select their favorites and go back to see them year after year. The men grow old and careworn themselves, but they find that these things of beauty are immortally joy-giving and immortally young. You will find hundreds of merchants and farmer boys all over Nebraska and Kansas and Iowa who remember Jules Breton's beautiful "Song of the Lark," and perhaps the ugly little peasant girl standing barefooted among the wheat fields in the early morning has taught some of these people to hear the lark sing for themselves.

Some of the most appreciative art criticisms I ever heard were made by two sunbrowned Kansas boys as they looked at George Inness' "Prairie Fire," there in the Cyrus H. McCormick loan exhibition. Of all the lighthouses along the Great Harbor, there is none that throws its light so far.

Paderewski's theory of buying pictures and getting people to look at them has been exemplified in at least three cities in the United States: New York, Chicago and Pittsburgh. As a result those three cities contain nearly all the important private collections in the United States.

There is no reason why Pittsburgh, for instance, should display any greater interest in art than Kansas City or Denver or Omaha or San Francisco. It is not a city

of culture; the city is entirely given over to manufacturing industries, and the only standard of success recognized is the pecuniary standard. But one thing Carnegie did; he bought pictures and got people to look at them.

Whether art itself can be propagated by infusion or no, has not been proven; but in some measure taste can be.

There is no reason why the common people of Chicago, the people who read Marie Corelli and go to see *The Pride of Jennico*,* should know any more about pictures than the people of any other big city, but they do. Any stranger in the city who spends much time about the Art Institute must notice the comparatively enlightened conversation of the people who frequent the building on free days.

For some reason the institution is much nearer to the people of Chicago than the Metropolitan art gallery is to the people of New York. Perhaps it is because the spirit of caste is less perceptible in western cities, and the relations between employers and employees are more cordial. When any one of the Deerings or McCormicks buys an Inness or a Corot, he exhibits the picture in the Art Institute and their workmen drop in to have a look at it some Sunday and decide that they could have done something better with the money, if it had been theirs. The convenient and attractive location of the building may also have something to do with its popularity.

The collection of pictures is such that it would be impossible to cultivate a false or florid taste there. With the exception of several Bouguereaus, there is not a poor picture in the gallery. Yet there are hundreds of pictures there that the veriest Philistine can admire and, to a great extent, appreciate; people who read *Under Two Flags* and enjoy comic opera and ice-cream soda.

The real fault of popular taste, when we get down to the heart of the matter, is that the people prefer the pretty to the true. That is a fault, certainly; but not so grave a one as the Young Art Student makes it. Indeed, there are times when I would take the Philistine's word for a picture, long before I would the Young Art Student's; for the Philistine is always governed by moderation, and he is always honest with himself.

There are certain painters whom the Philistine seems to get quite as much pleasure from in his way as the Art Student does in his. Take, for instance, Josef Israels' Dutch interiors, and especially his pictures of mothers and children. The simplicity and directness of his treatment and the sombre tenderness of his coloring are by no means lost on the Philistine, though he may not stop to reason about it and may attribute all the pleasure he experiences to the mere beauty of the subject.

The Pride of Jennico by Abby S. Richardson and G. Furniss, starring James K. Hackett, had played one hundred eleven performances after its opening March 6, 1900.

H. O. Tanner, the colored painter, who handles Biblical subjects with the power and conviction of the Old Masters, is another favorite with the people. I have seen country preachers and solemn old ladies in ill-fitting black gloves stand before his "Suicide of Judas" with visible emotion.

There is something about Tanner's work that makes the people and places and life of Palestine real to us as nothing else has ever done. The Old Masters painted Italian Christs and Dutch Marys and Spanish Josephs; but this man paints the Orient, not the Orient of the midway and bazaar, dressed up and tricked out for a show, but the work-a-day Palestine, where men plowed and sowed and prayed.

There is a tradition that Biblical subjects should be painted in a highly decorative manner, and that Orientalism means crimson and ultramarine; but Mr. Tanner produces his most Oriental effect with low colors. He paints with a realism so unaffected, a sympathy with the life of the people, that there seems to be an almost national touch in his pictures. There is something about his insistent use of the silvery gray of the olives and the parched yellow clay hills of Palestine that recalls Pierre Loti's faculty of infusing absolute personality into environment, if one may compare two such different mediums as prose and paint.

Another great favorite with the Philistine is gay Master Rico, whose name to the Young Art Student is as the red rag to the bull. Now, Master Rico chooses to be pretty, and that, in the eye of the Art Student, is an unpardonable sin. You will find a copy of one of his Venetian scenes in every picture-loving home of the middle class; very blue skies, a silvery canal, white and red houses, bridges and gay gondolas, and in the foreground the dear Lombard poplars, the gayest and saddest of trees, rustling green and silver in the sunlight. The people like to think of Venice as a pretty place, where people forget their troubles, and therefore they like Master Rico's pictures better than those of the greater painters than he who have darkened the canals of the city with the shadows of her past.

The Young Art Student can find no place in life for the dainty, the trivial or the gay; but would have us live in Gothic cathedrals and marry the noble but angular ladies of Puvis de Chavannes. Rico is only a hummingbird, if you will, or a yellow rose in June, but the Philistine will stand by him because he adds somewhat to the gayety of life.

Painters sometimes call Gari Melchers a hard painter, but the people know his worth, and they feel the poetry in his subjects, even if they do not know the tricks of craft by which he presents it.

Every woman who has ever carried a baby will stop and smile at his young Dutch mothers, with their plump, uncorseted figures and their pudgy little children with wooden shoes on their feet.

The densest person cannot miss the beautiful and homely sentiment in "The Sailor and His Sweetheart." The Philistine is partial to fireside scenes and domestic and sentimental subjects generally. He knows that sentiment is the most vital motive in society, in his own life and in the lives of his friends. That it wrecks banks and controls the markets, directly or indirectly, and he demands that the comings and goings and courtings and festivals and farewells that make up the gladness and sadness of his life be somehow put into art. He will accept it even when it is badly done for the sake of the sentiment; but I believe that in time he will prefer it well done. Do we not all admit that the man who can make these homely subjects into art is the greatest of all artists, and that the peasant folk of Millet are worthier a man of genius than the ballet dancers of Degas?

THE PHILISTINE IN THE ART GALLERY

When the Young Art Student visits the Carnegie gallery he is inclined to wonder what pretext the thousands of visitors who are not art students have for going there at all. They either admire the wrong pictures, he says, or the wrong things in the right pictures, or they see the entire collection of paintings with a distorted vision, so he argues that they had far better go to see *A Guilty Mother,* or confine themselves to some form of recreation better suited to their state of enlightenment. But the truth is that there are thousands of people who go to the gallery in family parties, who do not stand squinting before a picture, through half closed eyes, or making measurements with a lead pencil and who do not talk about "atmosphere" or "color scheme," who sincerely and genuinely enjoy the exhibit, and it is for their enjoyment rather than the Young Art Student's that these pictures are gathered together. There is this year in the collection an unusually large proportion of those pictures which the most unpretentious Philistine can enjoy, pictures that are not only well painted, but which treat subjects which the Philistine thinks worth treating.

For the first time since the annual exhibits at the institute were inaugurated, there is, among the prize pictures, one which is universally popular. Hitherto Sergeant Kendall's "Mother and Child" was the most popular picture which had ever received a prize at the institute, but, in the regard of the people who come and go, it has been quite overshadowed by Ellen Ahren's portrait of an old lady sewing, which was awarded the medal of the class.* The Philistine may not notice how simple, and yet how wonderfully effective is the composition, one of those things which we see every day, and which only a master can force us to regard seriously,

*Sergeant Kendall (1869–1938), American painter; Ellen Ahren (1859–19??), won the thousand-dollar Founder's Day Prize in 1900.

but he will see something that to him is more important than this. He will see a wonderfully thrifty, executive old woman, one who is the prop of a household and community; who has brought her own family up well and, if need be, could bring up her son's children; who could take up a business that was run down, or a family of children that had run wild, and institute order and discipline and thrift; a woman of strong prejudices and narrow of sympathy, tireless in energy and unsparing in the administration of justice; who, with more of common sense than imagination, has made a decent, practical, substantial success of living, though she probably sees very little worth while in Browning or Chopin. The Philistine will note, too, the successful coloring of the hair and the lines in the forehead, and the decision with which the old lady speeds the needle with her middle finger. Only yesterday afternoon I heard a typewriter girl, viewing the pictures in her half holiday, remark that the "old lady made her think of one of Mary Wilkins' short stories, somehow," and that is a comparison that the Young Art Student himself would not have been ashamed of.

The picture, which was awarded the medal of the first class, is less fortunate. Will there ever be a first-prize picture of which our mothers and great aunts will approve? This "Arrangement" of Maurer's* they declare aimless and meaningless. "It's nothing in the world, Myrtle, but a girl sewing the binding on her skirt," declared the typewriter girl, in a tone of amazement and disappointment. The peculiar difficulties in the drawing, the remarkable painting of the white silk shirtwaist appealed not at all to Edna, the stenographer, because a shirtwaist is a thing of common use and how can it possibly have anything to do with art? She sees nothing in the picture simply because it tells no story, because her imagination finds no delight, no pleasurable suggestion in "skirt binding." If the girl were leaning over to pick up a child, or to solemnly burn love letters, or to weep beside a bier, both Edna and Myrtle would have found the picture resplendent with beauty, they would really have experienced pleasure in looking at it.

Tarbell's "Venetian Blind" did not fare much better at their hands; the painting of it puzzled and altogether confounded them. They wanted to know where the light on the model's shoulder came from, and twisted themselves into the most grotesque positions trying to illustrate that it could not possibly have fallen on her in that way, and that the painter "didn't know what he was talking about." It seemed, too, that from the name of the picture they had expected to find a Venetian scene of some sort, and felt unjustly defrauded of blue canals, etc.

Certainly the most popular picture in the gallery is Louis Deschamps' "Abandoned."† I shall be surprised if the artist does not sell the picture here. It is no

*Louis Maurer (1832–1932), best known for his watercolors.
†Louis Deschamps (1846–1902), French painter.

exaggeration to say that there has never been a painting in the gallery which has given such universal pleasure. People of all classes and conditions of servitude, young and old, have stood before it with smiles and exclamations of pleasure. Not the Young Art Student himself can derive more pleasure from the picture than the yearning grandmothers in old-fashioned bonnets and skirts that dip behind, who declare that they "want to take it up."

As a rule, the Philistine likes Gari Melchers, he catches the spirit of the painter's Dutch mothers and fisher folk as he did of James Herne's *Shore Acres*. I saw Edna's face light up as she came upon his "Wedded." Myrtle, indeed, declared that the girl was insufferably ugly, and that the whole thing was horrid. "Nobody could say that girl is pretty as a picture," she remarked contemptuously, and thereby revealed much as to her attitude. The gory Segantini,* Myrtle declared, resembled a fresco at the Alvin, and the Alma-Tadema (she not undiscriminatingly remarked) looked like Sarah Bernhardt. Edna was much impressed by the Abbey, and the splendor of the nobles and prelates made her more indignant than ever with the "skirt-binding picture," as she called Maurer's picture, and she suggested that it might do for [a] streetcar advertisement by some binding manufacturer. She enthusiastically admired Cecelia Beaux's disagreeable portrait, not for its exquisite painting, but for certain *Ladies' Home Journal*ish mannerisms that have become more and more marked in Miss Beaux's work of late years. Both girls heartily admired Chase's "Japanese Print." Surely Chase has the trick of pleasing if ever a man had it; "the fatal trick of pleasing," the Young Art Student terms it, with a curl of his lip, but he has an old grudge against Chase because he pleases so unfailingly and paints so well. Chase never painted a bad thing, and the Young Art Student knows it, yet nobody calls him crazy, and American millionaires buy his pictures, therefore, he is a thorn in the flesh of unappreciated genius.

POPULAR PICTURES

One widely popular picture in the corner of the art gallery is Marianne Stokes' "Little Brother and Sister."† The picture is an illustration of the old Grimm fairy tale about the little brother and sister who were driven out into the forest by their cruel stepmother, and when they came to a brook and stopped to drink the brook cried out:

> "Who drinks of me
> A bear will be."

*Giovanni Segantini (1858–1890), Italian impressionist. In the next sentence: Edwin A. Abbey (1852–1911), had three pictures in the original collection, best known for his *Harper's Weekly* illustrations and his manuals in the Boston Public Library.
†Marianne Stokes (1855–1927), whose "Aucassin and Nicolete" hung in the gallery.

For the wicked stepmother had laid a spell on all the brooks in the forest. When they came to another, it cried out:

> "Who drinks of me
> A bear will be."

But the little brother was so thirsty that he must drink at any cost, and the picture illustrates the moment of his transformation. The little sister is at that age when nothing seems more natural than such a transformation, and she accepts it quite unquestionably, as Alice did the transformation of the Duchess' baby into a pig, her only expression being one of commiseration and a grave "I told you so."

It is well enough that Fritz Thaulow's picture of Pittsburgh is protected by glass, or before the exhibit closes the paint would be literally worn away by the pudgy fingers of the countless small boys, who surround it every afternoon, pointing out exact localities. The people who stand peering at this picture with puzzled expression feel something there which is not in the actual scene; a certain power of coordination, a certain revelatory treatment. We all knew that the mills on the South Side opposite Second Avenue were impressive, but why had we never noted the picturesqueness of the old cobble-paved streets and bald, green-shuttered red and brown houses on this side of the river, and why had we never perceived their striking and peculiar relation to the river and the flaming mills along and point that out to us?

Scarcely a man has gone through the gallery who has not paused for a long look at Tuke's "Diver,"* and the older the spectator, the longer he pauses. This is only another instance of how good a popular picture may be. I stood near a family party who were showing an old uncle from Greensburg through the gallery; at first the old gentleman seemed somewhat uncomfortable because of the presence of his young great-nieces, but when they wandered off to conjecture about the "Assault of St. Quentin," he smiled long and wistfully at the picture, now with his spectacles on his nose, and now with them on his forehead. I daresay he thought little enough of the original treatment of the water, or the splendid sunlight, or the painting of the fine, firm young flesh, or the hitch of preparation in the diver's shoulder blades, but he knew why the face of the boy in the rear end of the boat is as radiant with happiness as with sunlight, and he knew that the state of kings is small pickings to that of the diver. I accosted him, and we became friends on the strength of old memories of a common and a lost kingship.

Becher's "Italian Landscape,"† the somber Italy of Guelph and Ghibelline,

*Henry S. Tuke (1858–1929), English painter of youthful nudes.
†Arthur E. Becher (1877–19??), American painter and illustrator. In the same paragraph, Edmond Aman-Jean (1869?–1936), French painter; Mary Macomber has slipped into obscurity.

blood-drenched and legend-haunted, meets with but little favor, and is usually supposed to be a scene on the Rhine, the Rhine being the one river in Europe of which the popular mind has become convinced. Aman-Jean's delicate and subtle "Comedy" is passed with equal carelessness. Mary Macomber's sentimental picture, "The Hour Glass," on the other hand, causes the populace to think better of the judges than it otherwise would do. Everyone stops to look at the old lady who is watching the hour glass. "The sands are almost run for her," remarked Edna in a subdued tone.

Both De Forest Brush's pictures, "The Silence Broken" and "The King and the Sculptor,"* are, of course, popular, as they are so largely story. People like them because they know something of the subject matter, just as people who are not at all musical often like Tschaikowsky's "1812" symphony [Festival Overture] because they recognize the strains of the "Marseillaise" and the Russian national hymn, and because it makes them think about the burning of Moscow and Napoleon's retreat from Russia.

Among the landscapes that are best liked are André's "Autumn Scene on the Seine," hanging over the staircases, and Birge Harrison's "Christmas Eve,"† representing a quiet village, shrouded in snow and a sort of holy stillness, under a blue winter night.

The most pleasurable feature about the exhibit is that so many of the pictures are by artists who have exhibited frequently before and with whose work and style the city has grown fairly familiar. "Did any manufacturing city ever evince any taste for art?" they say in the New York studios; "Can you make a city in the likeness of Mammon and then introduce art by inoculation?" The question can only be answered by time and patience, but in the meantime the thousands of people who troop through the gallery yearly are becoming familiar with the work and style of hundreds of the best painters of their generation. There are just three kinds of people who visit the gallery; those who enjoy simply and know nothing about the technique of picture painting; those whose enjoyment is marred by the consideration of what they ought or ought not to enjoy, and those who are so apprehensive that they might enjoy the wrong thing that they cannot enjoy at all.

*George de Forest (1855–1941), whose portrait of President McKinley hung in the gallery.
†Birge Harrison (1854–1929), American landscape painter.

1895

JOSÉ ORTEGA Y GASSET

On Point of View in the Arts

1.

When history is what it should be, it is an elaboration of cinema. It is not content to install itself in the successive facts and to view the moral landscape that may be perceived from here; but for this series of static images, each enclosed within itself, history substitutes the image of a movement. "Vistas" which had been discontinuous appear to emerge one from another, each prolonging the other without interruption. Reality, which for one moment seemed an infinity of crystallized facts, frozen in position, liquifies, springs forth, and flows. The true historical reality is not the datum, the fact, the thing, but the evolution formed when these materials melt and fluidify. History moves; the still waters are made swift.

2.

In the museum we find the lacquered corpse of an evolution. Here is the flux of that pictorial anxiety which has budded forth from man century after century. To conserve this evolution, it has had to be undone, broken up, converted into fragments again and congealed as in a refrigerator. Each picture is a crystal with unmistakable and rigid edges, separated from the others, a hermetic island.

And, nonetheless, it is a corpse we could easily revive. We would need only to arrange the pictures in a certain order and then move the eye—or the mind's eye—quickly from one to the other. Then, it would become clear that the evolution of painting from Giotto to our own time is a unique and simple action with a beginning and an end. It is surprising that so elementary a law has guided the variations

of pictorial art in our Western world. Even more curious, and most disturbing, is the analogy of this law with that which has directed the course of European philosophy. This parallel between the two most widely separated disciplines of culture permits us to suspect the existence of an even more general principle which has been active in the entire evolution of the European mind. I am not, however, going to prolong our adventure to this remote arcanum, and will content myself, for the present, with interpreting the visage of six centuries that has been Occidental painting.

3.

Movement implies a mover. In the evolution of painting, what is it that moves? Each canvas is an instant in which the mover stands fixed. What is this? Do not look for something very complicated. The thing that varies, the thing that shifts in painting, and which by its shifts produces the diversity of aspects and styles, is simply the painter's point of view.

It is natural enough. An abstract idea is ubiquitous. The isosceles triangle presents the same aspect on Earth as on Sirius. On the other hand, a sensuous image bears the indelible mark of its localization, that is, the image presents something seen from a definite point of view. This localization of the sensible may be strict or vague, but it is inevitable. A church spire, a sail at sea, present themselves to us at a distance that for practical purposes we may estimate with some accuracy. The moon or the blue face of heaven are at a distance essentially imprecise, but quite characteristic in their imprecision. We cannot say that they are so many miles away; their localization in distance is vague, but this vagueness is not indetermination.

Nonetheless, it is not the geodetic *quantity* of distance which decisively influences the painter's point of view, but its optical *quality*. "Near" and "far" are relative, metrically, while to the eye they may have a kind of absolute value. Indeed, the *proximate vision* and the *distant vision* of which physiology speaks are not notions that depend chiefly on measurable factors, but are rather two distinct ways of seeing.

If we take up an object, an earthen jar, for example, and bring it near enough to the eyes, these converge on it. Then, the field of vision assumes a peculiar structure. In the center there is the favored object, fixed by our gaze; its form seems clear, perfectly defined in all its details. Around the object, as far as the limits of the field of vision, there is a zone we do not look at, but which, nevertheless, we see with an indirect, vague, inattentive vision. Everything within this zone seems to be situ-

ated behind the object; this is why we call it the "background." But, moreover, this whole background is blurred, hardly identifiable, without accented form, reduced to confused masses of color. If it is not something to which we are accustomed, we cannot say what it is, exactly, that we see in this indirect vision.

The proximate vision, then, organizes the whole field of vision, imposing upon it an optical hierarchy: a privileged central nucleus articulates itself against the surrounding area. The central object is a luminous hero, a protagonist standing out against a "mass," a visual *plebs*, and surrounded by a cosmic chorus.

Compare this with distant vision. Instead of fixing a proximate object, let the eye, passive but free, prolong its line of vision to the limit of the visual field. What do we find then? The structure of our hierarchized elements disappears. The ocular field is homogeneous; we do not see one thing clearly and the rest confusedly, for all are submerged in an optical democracy. Nothing possesses a sharp profile; everything is background, confused, almost formless. On the other hand, the duality of proximate vision is succeeded by a perfect unity of the whole visual field.

4.

To these different modes of seeing, we must add another more important one.

In looking close-up at our earthen jar, the eye-beam strikes the most prominent part of its bulge. Then, as if shattered at this point of contact, the beam is splintered into multiple lines which glide around the sides of the vase and seem to embrace it, to take possession of it, to emphasize its rotundity. Thus the object seen at close range acquires the indefinable corporeality and solidity of filled volume. We see it "in bulk," convexly. But this same object placed farther away, for distant vision, loses this corporeality, this solidity and plentitude. Now it is no longer a compact mass, clearly rotund, with its protuberance and curving flanks; it has lost "bulk," and become, rather, an insubstantial surface, an unbodied spectre composed only of light.

Proximate vision has a tactile quality. What mysterious resonance of touch is preserved by sight when it converges on a nearby object? We shall not now attempt to violate this mystery. It is enough that we recognize this quasi-tactile density possessed by the ocular ray, and which permits it, in effect, to embrace, to touch the earthen jar. As the object is withdrawn, sight loses its tactile power and gradually becomes pure vision. In the same way, things, as they recede, cease to be filled volumes, hard and compact, and become mere chromatic entities, without resistance, mass or convexity. An age-old habit, founded in vital necessity, causes men to consider as "things," in the strict sense, only such objects solid enough to offer resistance to their hands. The rest is more or less illusion. So in passing from prox-

imate to distant vision an object becomes illusory. When the distance is great, there on the confines of a remote horizon—a tree, a castle, a mountain range—all acquire the half-unreal aspect of ghostly apparitions.

5.

A final and decisive observation.

When we oppose proximate to distant vision, we do not mean that in the latter the object is farther away. To look means here, speaking narrowly, to focus both ocular rays on a point which, thanks to this, becomes favored, optically privileged. In distant vision we do not fix the gaze on any point, but rather attempt to embrace the whole field, including its boundaries. For this reason, we avoid focusing the eyes as much as possible. And then we are surprised to find that the object just perceived—our entire visual field—is concave. If we are in a house the concavity is bordered by the walls, the roof, the floor. This border or limit is a surface that tends to take the form of a hemisphere viewed from within. But where does the concavity begin? There is no possibility of doubt: it begins at our eyes themselves.

The result is that what we see at a distance is hollow space as such. The content of perception is not strictly the surface in which the hollow space terminates, but rather the whole hollow space itself, from the eyeball to the wall or the horizon.

This fact obliges us to recognize the following paradox: the object of sight is not farther off in distant than in proximate vision, but on the contrary is nearer, since it begins at our cornea. In pure distant vision, our attention, instead of being directed farther away, has drawn back to the absolutely proximate, and the eyebeam, instead of striking the convexity of a solid body and staying fixed on it, penetrates a concave object, glides into a hollow.

6.

Throughout the history of the arts in Europe, then, the painter's point of view has been changing from proximate to distant vision, and painting, correspondingly, which begins with Giotto as painting of bulk, turns into painting of hollow space.

This means there has been nothing capricious in the itinerary followed by the painter's shift of attention. First it is fixed upon the body or volume of an object, then upon what lies between the body of the object and the eye, that is, the hollow space. And since the latter is in front of the object, it follows that the journey of the pictorial gaze is a retrogression from the distant—although close by—toward what is contiguous to the eye.

According to this, the evolution of Western painting would consist in a retraction from the object toward the subject, the painter.

The reader may test for himself this law that governs the movement of pictorial art by a chronological review of the history of painting. In what follows, I limit myself to a few examples that are, as it were, stages on such a journey.

7. THE QUATTROCENTO

The Flemish and the Italians cultivate with passion the painting of bulk. One would say they paint with their hands. Every object appears unequivocally solid, corporeal, tangible. Covering it is a polished skin, without pores or growth, which seems to delight in asserting its own rounded volume. Objects in the background receive the same treatment as those of the foreground. The artist contents himself with representing the distant as smaller than the proximate, but he paints both in the same way. The distinction of planes is, then, merely abstract, and is obtained by pure geometrical perspective. Pictorially, everything in these pictures is in one plane, that is, everything is painted from close-up. The smallest figure, there in the distance, is as complete, spherical and detached as the most important. The painter seems to have gone to the distant spot where they are, and from near at hand to have painted them as distant.

But it is impossible to see several objects close-up at the same time. The proximate gaze must shift from one to the other to make each in turn the center of vision. This means that the point of view in a primitive picture is not single, but as many points of view as there are objects represented. The canvas is not painted as a unity, but as a plurality. No part is related to any other; each is perfect and separate. Hence the best means of distinguishing the two tendencies in pictorial art—painting of bulk and painting of hollow space—is to take a portion of the picture and see whether, in isolation, it is enough to represent something fully. On a canvas of Velásquez, each section contains only vague and monstrous forms.

The primitive canvas is, in a certain sense, the sum of many small pictures, each one independent and each painted from the proximate view. The painter has directed an exclusive and analytic gaze at each one of the objects. This accounts for the diverting richness of these Quattrocento catalogues. We are never done looking at them. We always discover a new little interior picture that we had not observed closely enough. On the other hand, they cannot be seen as a whole. The pupil of our eye has to travel step by step along the canvas, pausing in the same point of view that the painter successively took.

8. RENAISSANCE

Proximate vision is exclusive, since it apprehends each object in itself and separates it from the rest. Raphael does not modify this point of view, but introduces in

the picture an abstract element that affords it a certain unity; this is composition, or architecture. He continues to paint one object after another, like a primitive; his visual apparatus functions on the same principle. But instead of limiting himself, like the primitive, to paint what he sees as he sees it, he submits everything to an external force: the geometrical idea of unity. Upon the analytic form of objects, there is imperatively fixed the synthetic form of composition, which is not the visible form of an object, but a pure rational schema. (Leonardo, too, for example in his triangular canvases.)

Raphael's pictures, then, do not derive from, and cannot be viewed in, a unified field of vision. But there is already in them the rational basis of unification.

9. TRANSITION

If we pass from the primitive and the Renaissance toward Velásquez, we find in the Venetians, but especially in Tintoretto and El Greco, an intermediate stage. How shall we define it?

In Tintoretto and El Greco two epochs meet. Hence the anxiety, the restlessness that marks the work of both. These are the last representatives of painting in bulk, and they already sense the future problems of painting in hollow space without, however, coming to grips with them.

Venetian art, from the beginning, tends to a distant view of things. In Giorgione and Titian, the bodies seem to wish to lose their hard contours, and float like clouds or some diaphanous fabric. However, the will to abandon the proximate and analytic point of view is still lacking. For a century, there is a struggle between both principles, with victory for neither. Tintoretto is an extreme example of this inner tension, in which distant vision is already on the point of victory. In the canvases of the Escorial he constructs great empty spaces. But in this undertaking he is forced to lean on architectonic perspective as on a crutch. Without those columns and cornices that flee into the background, Tintoretto's brush would fall into the abyss of that hollow space he aspired to create.

El Greco represents something of a regression. I believe that his modernity and his nearness to Velásquez has been exaggerated. El Greco is still chiefly preoccupied with volume. The proof is that he may be accounted the last great foreshortener. He does not seek empty space; in him there remains the intention to capture the corporeal, filled volume. While Velásquez, in *The Ladies in Waiting* and *The Spinners*, groups his human figures at the right and left, leaving the central space more or less free—as if space were the true protagonist—El Greco piles up solid masses over the whole canvas that completely displace the air. His works are usually stuffed with flesh.

However, pictures like *The Resurrection, The Crucified* (Prado) and *Pentecost,* pose the problems of painting in depth with rare power.

But it is a mistake to confuse the painting of depth with that of hollow space or empty concavity. The former is only a more learned way of asserting volume. On the other hand, the latter is a total inversion of pictorial intention.

What we find in El Greco is that the architectonic principle has completely taken over the represented objects and forced these, with unparalleled violence, to submit to its ideal schema. In this way, the analytic vision, which seeks volume by emphasizing each figure for its own sake, is mitigated and neutralized, as it were, by the synthetic intention. The formal dynamic schema that dominates the picture imposes on it a certain unity and fosters the illusion of a single point of view.

Furthermore, there appears already in the work of El Greco another unifying element: chiaroscuro.

10. THE CHIAROSCURISTS

Raphael's composition, El Greco's dynamic schema, are postulates of unity that the artist throws upon his canvas;—but nothing more. Every object in the picture continues as before to assert its volume, and, consequently, its independence and particularism. These unities, then, are of the same abstract lineage as the geometrical perspective of the primitives. Derived from pure reason, they show themselves incapable of giving form to the materials of the picture as a whole; or, in other words, they are not pictorial principles. Each section of the picture is painted without their intervention.

Compared to them, chiaroscuro signifies a radical and more profound innovation.

When the eye of the painter seeks the body of things, the objects placed in the painted area will demand, each for itself, an exclusive and privileged point of view. The picture will possess a feudal constitution in which every element will maintain its personal rights. But here, slipping between them, is a new object gifted with a magic power that permits it—even more—obliges it to be ubiquitous and occupy the whole canvas without having to dispossess the others. This magic object is light. It is everywhere single and unique throughout the composition. Here is a principle of unity that is not abstract but real, a thing among other things, not an idea or schema. The unity of illumination or chiaroscuro imposes a unique point of view. The painter must now see his entire work as immersed in the ample element of light.

Thus Ribera, Caravaggio, and the young Velásquez (*The Adoration of the Magi*). They still seek for corporeality according to accepted practice. But this no

longer interests them primarily. The object in itself begins to be disregarded and
have no other role than to serve as support and background for the light playing
upon it. One studies the trajectory of light, emphasizing the fluidity of its passage
over the face of volumes, over bulkiness.

Is it not clear what shift in the artist's point of view is implied by this? The Velás-
quez of *The Adoration of the Magi* no longer fixes his attention upon the object as
such but upon its surface, where the light falls and is reflected. There has occurred,
then, a retraction of vision, which has stopped being a hand and released its grasp
of the rounded body. Now, the visual ray halts at the point where the body begins
and light strikes resplendently; from there it seeks another point on another object
where the same intensity of illumination is vibrating. The painter has achieved a
magic solidarity and unification of all the light elements in contrast to the shadow
elements. Things of the most disparate form and condition now become equiva-
lent. The individualistic primacy of objects is finished. They are no longer inter-
esting in themselves, and begin to be only a pretext for something else.

11. VELÁSQUEZ

Thanks to chiaroscuro, the unity of the picture becomes internal, and not merely
obtained by extrinsic means. However, under the light, volumes continue to lurk,
the painting of bulk persists through the refulgent veil of light.

To overcome this dualism, art needed a man of disdainful genius, resolved to
have no interest in bodies, to deny their pretensions to solidity, to flatten their pet-
ulant bulk. This disdainful genius was Velásquez.

The primitive, enamored of objective shapes, seeks them arduously with his
tactile gaze, touches them, embraces them. The chiaroscurist, already less taken
with corporeality, lets his ray of vision travel, as along a railway track, with the light
ray that migrates from one surface to the next. Velásquez, with formidable audac-
ity, executes the supreme gesture of disdain that calls forth a whole new painting:
he halts the pupil of the eye. Nothing more. Such is this gigantic revolution.

Until then, the painter's eye had Ptolemaically revolved about each object, fol-
lowing a servile orbit. Velásquez despotically resolves to fix the one point of view.
The entire picture will be born in a single act of vision, and things will have to con-
trive as best they may to move into the line of vision. It is a Copernican revolution,
comparable to that promoted by Descartes, Hume and Kant in philosophic
thought. The eye of the artist is established as the center of the plastic Cosmos,
around which revolve the forms of objects. Rigidly, the ocular apparatus casts its
ray directly forward, without deviating to one side or the other, without preference
for any object. When it lights on something, it does not fix upon it, and, conse-

quently, that something is converted, not into a round body, but into a mere surface that intercepts vision. *

The point of view has been retracted, has placed itself farther from the object, and we have passed from proximate to distant vision, which, strictly speaking, is the more proximate of the two kinds of vision. Between the eye and the bodies is interposed the most immediate object: hollow space, air. Floating in the air, transformed into chromatic gases, formless pennons, pure reflections, things have lost their solidity and contour. The painter has thrown his head back, half-closed his eyelids, and between them has pulverized the proper form of each object, reducing it to molecules of light, to pure sparks of color. On the other hand, his picture may be viewed from a single point of view, as a whole and at a glance.

Proximate vision dissociates, analyzes, distinguishes—it is feudal. Distant vision synthesizes, combines, throws together—it is democratic. The point of view becomes synopsis. The painting of bulk has been definitively transformed into the painting of hollow space.

12. IMPRESSIONISM

It is not necessary to remark that, in Velásquez, the moderating principles of the Renaissance persisted. The innovation did not appear in all its radicalism until the Impressionists and Post-Impressionists.

The premises formulated in our first paragraphs may seem to imply that the evolution had terminated when we arrive at the painting of hollow space. The point of view, transforming itself from the multiple and proximate to the single and distant, appears to have exhausted its possible itinerary. Not at all! We shall see that it may retreat even closer to the subject. From 1870 until today, the shift of viewpoint has continued, and these latest stages, precisely because of their surprising and paradoxical character, confirm the fatal law to which I alluded at the beginning. The artist, starting from the world about him, ends by withdrawing into himself.

I have said that the gaze of Velásquez, when it falls on an object, converts it into a surface. But, meanwhile, the visual ray has gone along its path, enjoying itself by perforating the air between the cornea and distant things. In *Ladies in Waiting* and *The Spinners*, we see the satisfaction with which the artist has accentuated hollow space as such. Velásquez looks straight to the background; thus, he encounters the enormous mass of air between it and the boundary of his eye. Now, to look at something with the central ray of the eye is what is known as direct vision or vision *in modo recto*. But behind the axial ray the pupil sends out many others at oblique an-

*If we look at an empty sphere from without, we see a solid volume. If we enter the sphere we see about us a surface that limits the interior concavity.

gles, enabling us to see *in modo obliquo*. The impression of concavity is derived from the *modo recto*. If we eliminate this—for example, by blinking the eyes—we have only oblique vision, those side-views "from the tail of the eye" which represent the height of disdain. Thus, the third dimension disappears and the field of vision tends to convert itself entirely into surface.

This is what the successive impressionisms have done. Velásquez's background has been brought forward, and so of course ceases to be background since it cannot be compared with a foreground. Painting tends to become planimetric, like the canvas on which one paints. One arrives, then, at the elimination of all tactile and corporeal resonance. At the same time, the atomization of things in oblique vision is such that almost nothing remains of them. Figures begin to be unrecognizable. Instead of painting objects as they are seen, one paints the experience of seeing. Instead of an object as impression, that is, a mass of sensations. Art, with this, has withdrawn itself completely from the world and begins to concern itself with the activity of the subject. Sensations are no longer things in any sense; they are subjective states through which and by means of which things appear.

Let us be sure we understand the extent of this change in the point of view. It would seem that in fixing upon the object nearest the cornea, the point of view is as close as possible to the subject and as far as possible from things. But no—the inexorable retreat continues. Not halting even at the cornea, the point of view crosses the last frontier and penetrates into vision itself, into the subject himself.

13. CUBISM

Cézanne, in the midst of his impressionist tradition, discovers volume. Cubes, cylinders, cones begin to emerge on his canvases. A careless observer might have supposed that, with its evolution exhausted, pictorial art had begun all over again and that we had relapsed back to the point of view of Giotto. Not at all! In the history of art there have always been eccentric movements tending toward the archaic. Nevertheless, the main stream flows over them and continues its inevitable course.

The cubism of Cézanne and of those who, in effect, were cubists, that is, stereometrists, is only one step more in the internalizing of painting. Sensations, the theme of impressionism, are subjective states; as such, realities, effective modifications of the subject. But still further within the subject are found the ideas. And ideas, too, are realities present in the individual, but they differ from sensations in that their content—the ideated—is unreal and sometimes even impossible. When I conceive a strictly geometrical cylinder, my *thought* is an effective act that takes place in me; but the geometric cylinder of which I think is unreal. Ideas,

then, are subjective realities that contain virtual objects, a whole specific world of a new sort, distinct from the world revealed by the eye, and which emerges miraculously from the psychic depths.

Clearly, then, there is no connection between the masses evoked by Cézanne and those of Giotto; they are, rather, antagonists. Giotto seeks to render the actual volume of each thing, its immediate and tangible corporeality. Before his time, one knew only the Byzantine two-dimensional image. Cézanne, on the other hand, substitutes for the bodies of things non-existent volumes of his own invention, to which real bodies have only a metaphorical relationship. After Cézanne, painting only paints ideas—which, certainly, are also objects, but ideal objects, immanent to the subject or intrasubjective.

This explains the hodge-podge that, in spite of misleading interpretations, is inscribed on the muddy banner of so-called *cubism*. Together with volumes that seem to accord major emphasis to the rotundity of bodies, Picasso, in his most typical and scandalous pictures, breaks up the closed form of an object and, in pure Euclidian planes, exhibits their fragments—an eyebrow, a mustache, a nose—without any purpose other than to serve as a symbolic cipher for ideas.

This equivocal cubism is only a special manner within contemporary expressionism. In the impression, we reached the minimum of exterior objectivity. A new shift in the point of view was possible only if, leaping behind the retina—a tenuous frontier between the external and internal—painting completely reversed its function and, instead of putting us within what is outside, endeavored to pour out upon the canvas what is within: ideal invented objects. Note how, by a simple advance of the point of view along the same trajectory it has followed from the beginning, it arrives at an inverse result. The eyes, instead of absorbing things, are converted into projectors of private flora and fauna. Before, the real world drained off into them; now, they are reservoirs of irreality.

It is possible that present-day art has little aesthetic value; but he who sees in it only a caprice may be very sure indeed that he has not understood either the new art or the old. Evolution has conducted painting—and art in general—inexorably, fatally, to what it is today.

14.

The guiding law of the great variations in painting is one of disturbing simplicity. First, things are painted; then, sensations; finally, ideas. This means that in the beginning the artist's attention was fixed on external reality; then, on the subjective; finally, on the intrasubjective. These three stages are three points on a straight line.

Now, Occidental philosophy has followed an identical route, and this coincidence makes our law even more disturbing.

Let us annotate briefly this strange parallelism.

The painter begins by asking himself what elements of the universe ought to be translated onto canvas, that is, what class of phenomena is pictorially essential. The philosopher, for his part, asks what class of objects is fundamental. A philosophical system is an effort to reconstruct the universe conceptually, taking as a point of departure a certain type of fact considered as the firmest and most secure. Each epoch of philosophy has preferred a distinct type, and upon this has built the rest of the construction.

In the time of Giotto, painter of solid and independent bodies, philosophy believed that the ultimate and definitive reality were individual substances. Examples given of such substances in the schools were: this horse, this man. Why did one believe to have discovered in these the ultimate metaphysical value? Simply because in the practical and natural idea of the world, every horse and every man seems to have an existence of his own, independent of other things and of the mind that contemplates them. The horse lives by himself, complete and perfect, according to his mysterious inner energy; if we wish to know him, our senses, our understanding must go to him and turn humbly, as it were, in his orbit. This, then, is the substantialist realism of Dante, a twin brother to the painting of bulk initiated by Giotto.

Let us jump to the year 1600, the epoch in which the painting of hollow space began. Philosophy is in the power of Descartes. What is cosmic reality for him? Multiple and independent substances disintegrate. In the foreground of metaphysics there is a single substance—an empty substance—a kind of metaphysical hollow space that now takes on a magical creative power. For Descartes, the *real* is space, as for Velásquez it is hollow space.

After Descartes, the plurality of substance reappears for a moment in Leibniz. These substances are no longer corporeal principles, but quite the reverse: the monads are subjects, and the role of each—a curious symptom—is none other than to represent a *"point de vue."* For the first time in the history of philosophy we hear a formal demand that science be a system which submits the universe to a point of view. The monad does nothing but provide a metaphysical situs for this unity of vision.

In the two centuries that follow, subjectivism becomes increasingly radical, and toward 1880, while the impressionists were putting pure sensations on canvas, the philosophers of extreme positivism were reducing universal reality to pure sensations.

The progressive dis-realization of the world, which began in the philosophy of the Renaissance, reaches its extreme consequences in the radical sensationalism of Avenarius and Mach. How can this continue? What new philosophy is possible?

A return to primitive realism is unthinkable; four centuries of criticism, of doubt, of suspicion, have made this attitude forever untenable. To remain in our subjectivism is equally impossible. Where shall we find the material to reconstruct the world?

The philosopher retracts his attention even more and, instead of directing it to the subjective as such, fixes on what up to now has been called "the content of consciousness," that is, the intrasubjective. There may be no corresponding reality to what our ideas project and what our thoughts think; but this does not make them purely subjective. A world of hallucination would not be real, but neither would it fail to be a world, an objective universe, full of sense and perfection. Although the imaginary centaur does not really gallop, tail and mane in the wind, across real prairies, he has a peculiar independence with regard to the subject that imagines him. He is a virtual object or, as the most recent philosophy expresses it, an ideal object.* This is the type of phenomena which the thinker of our times considers most adequate as a basis for his universal system. Can we fail to be surprised at the coincidence between such a philosophy and its synchronous art, known as expressionism or cubism?

*The philosophy to which Ortega refers, but which unfortunately he neglects to name, is obviously Husserlian phenomenology. (Translator's Note—J. F.)

1949

Translated from the Spanish by Paul Snodgrass and Joseph Frank